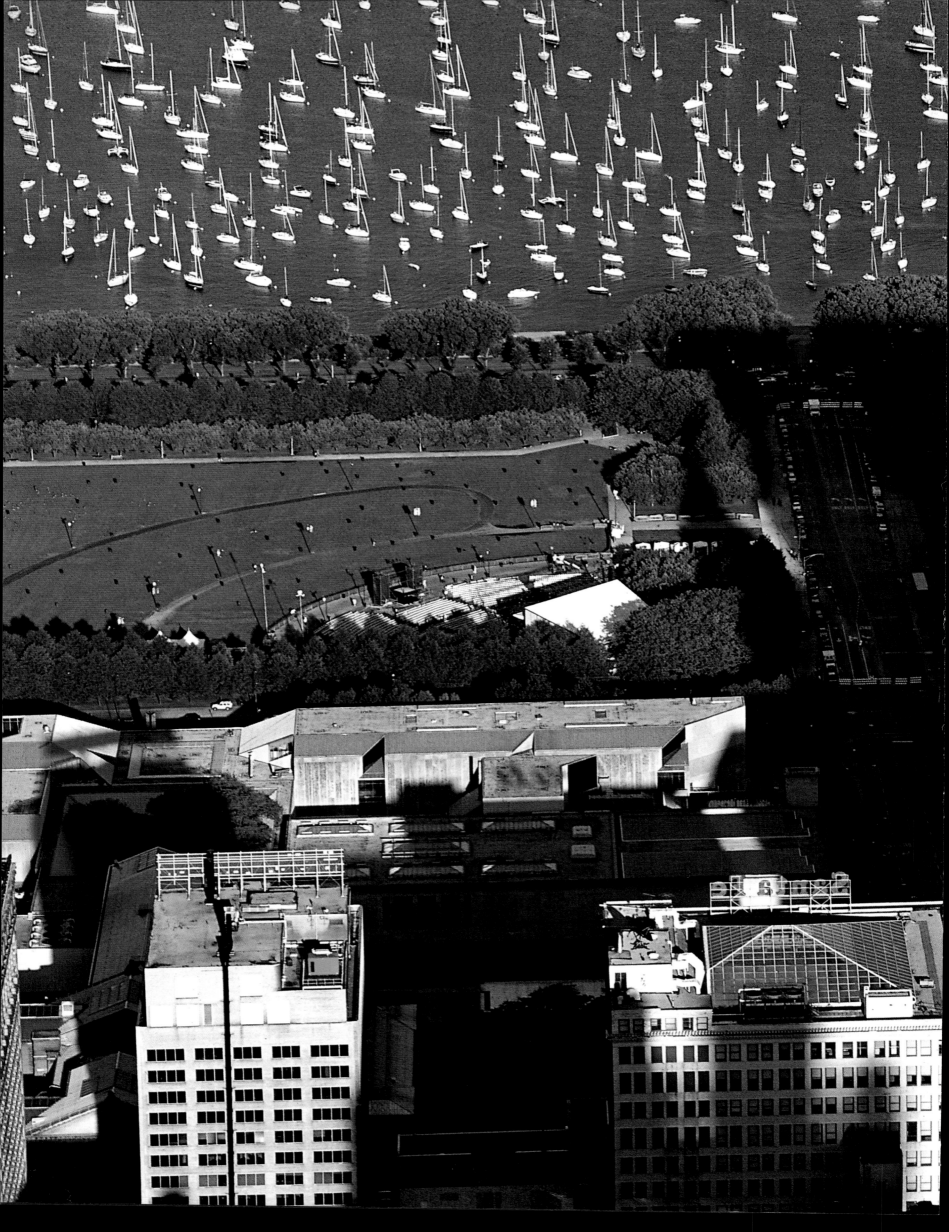

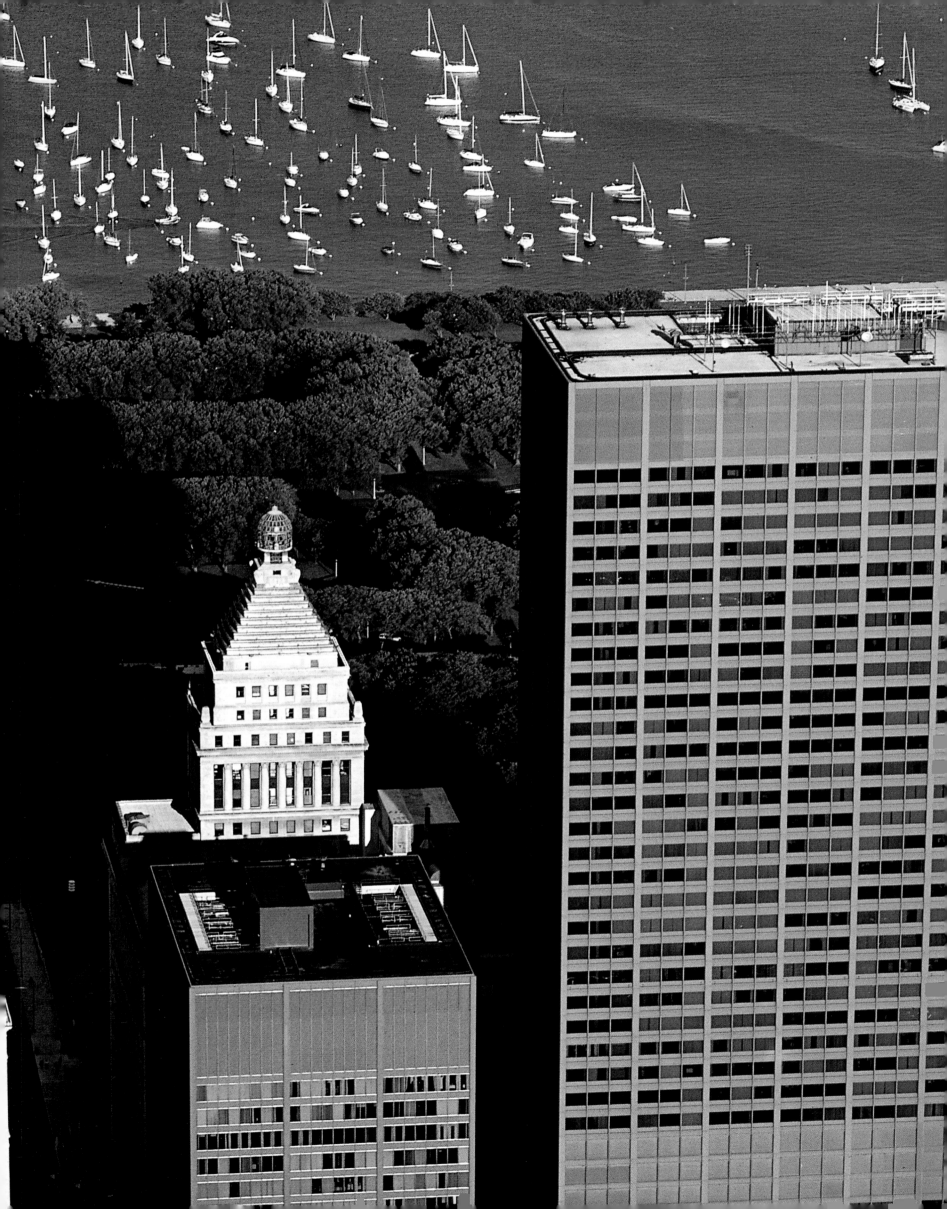

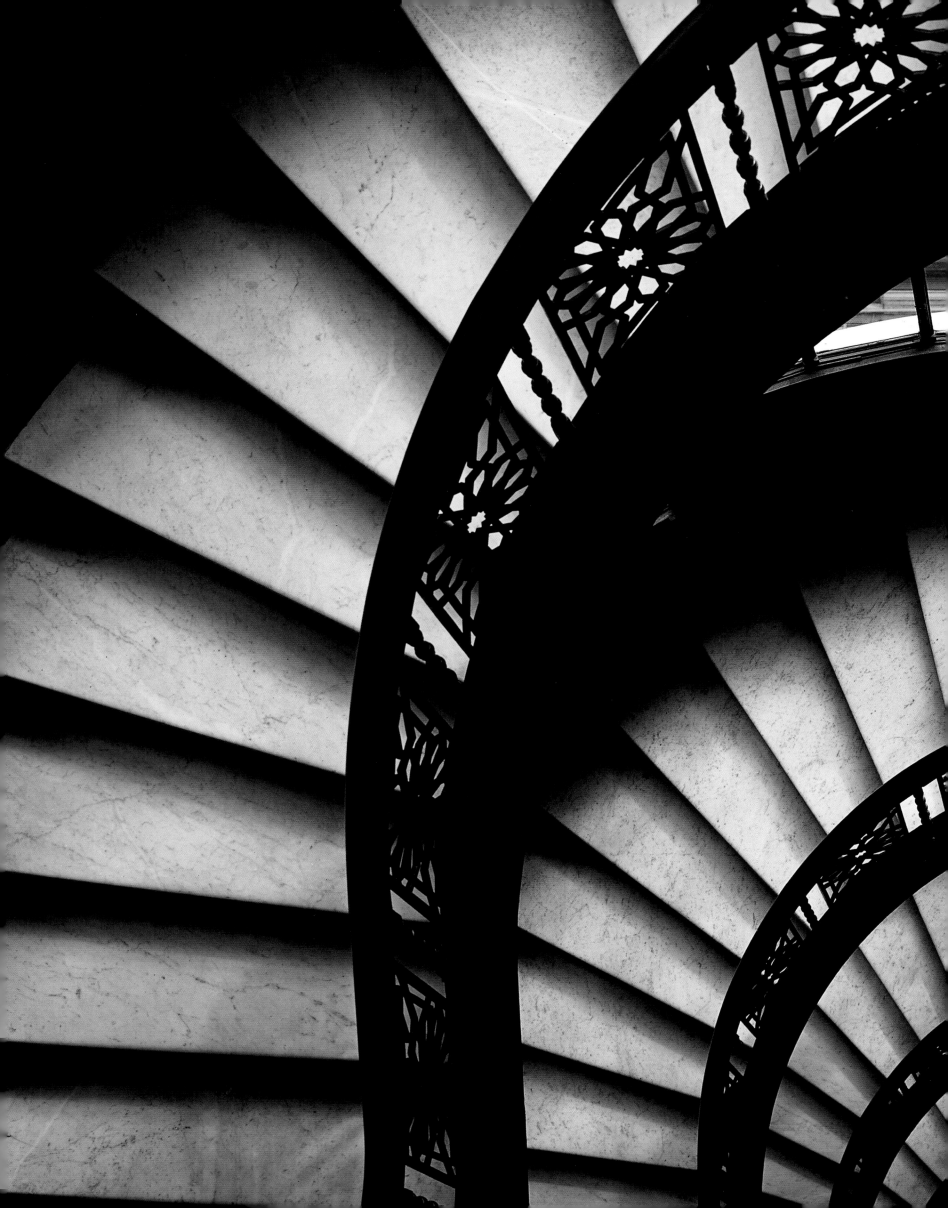

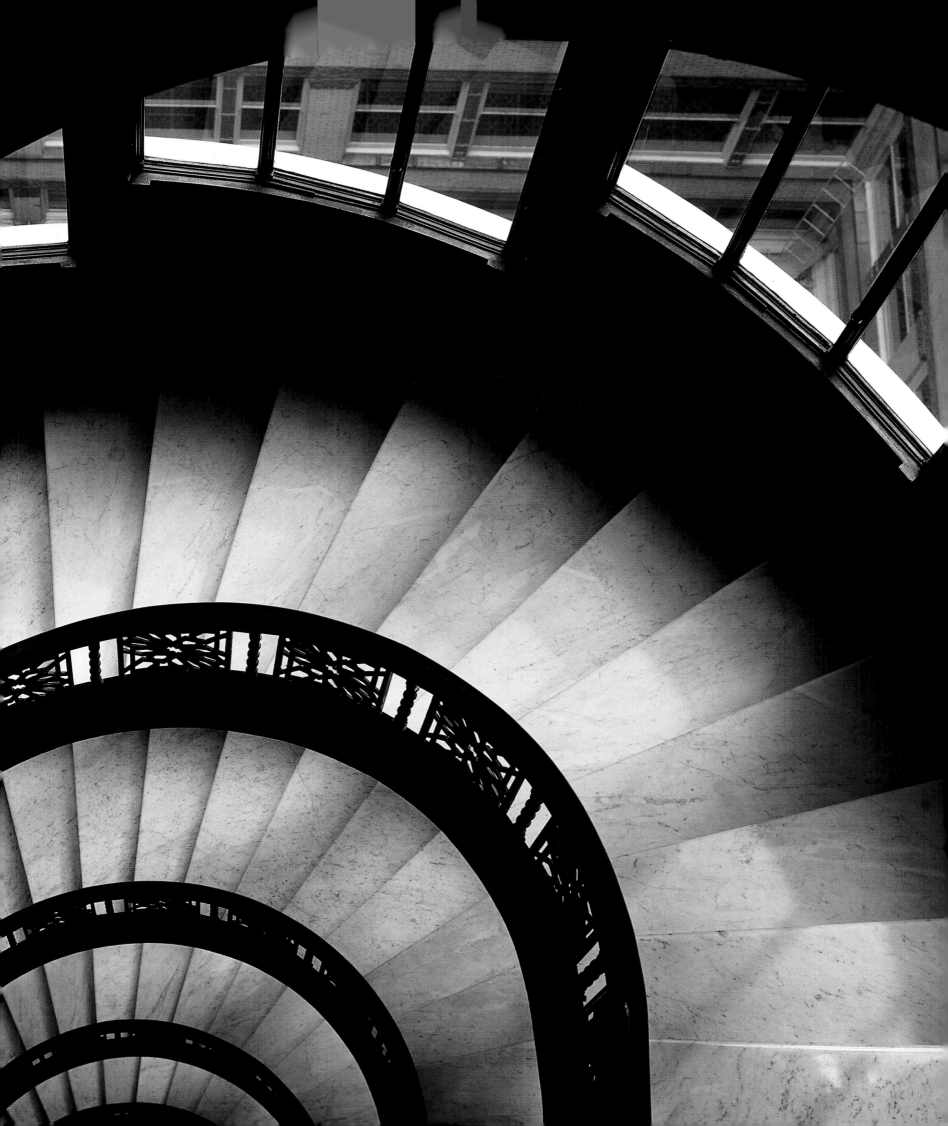

CHIC

CAGO

PHOTOGRAPHS BY SANTI VISALLI / INTRODUCTION BY STANLEY TIGERMAN

Rizzoli

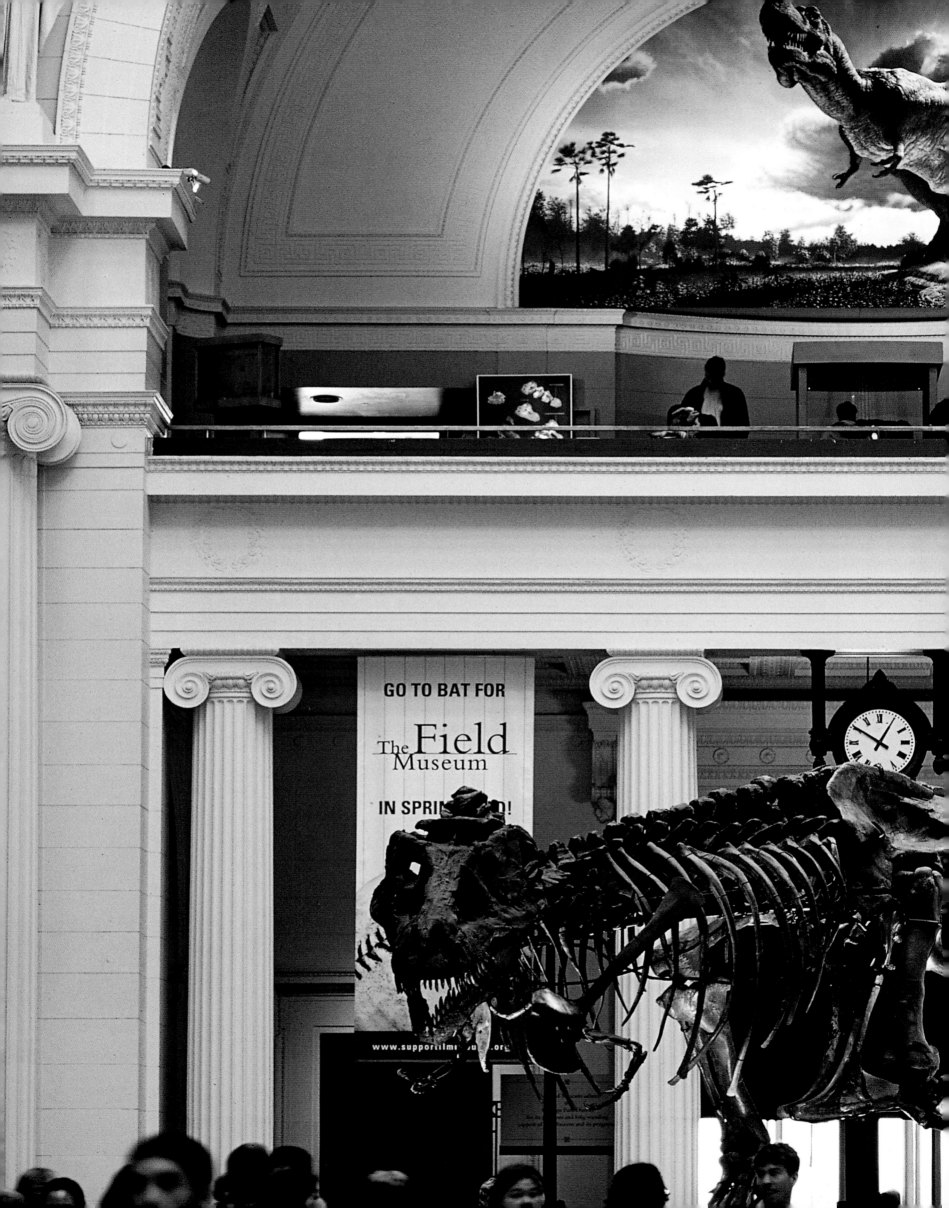

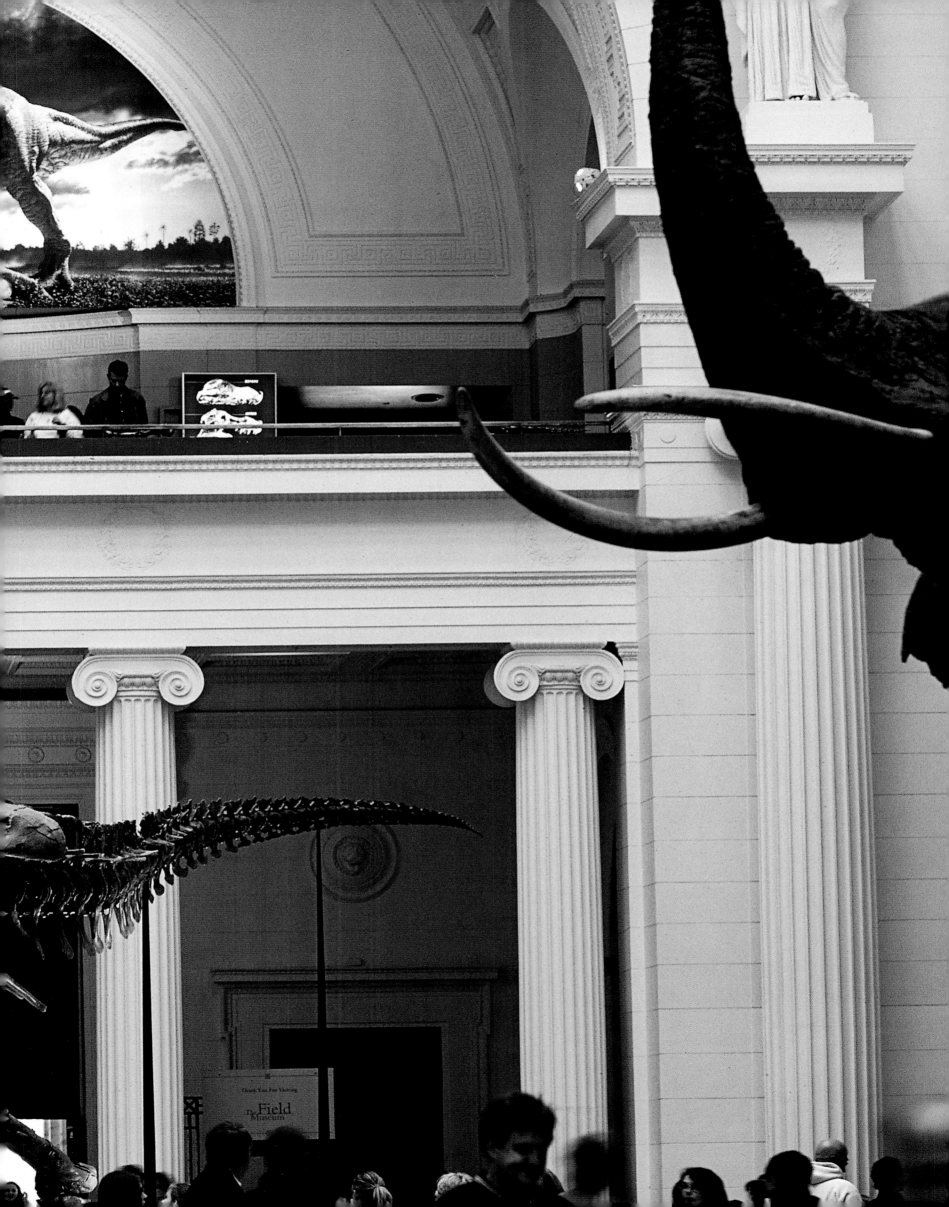

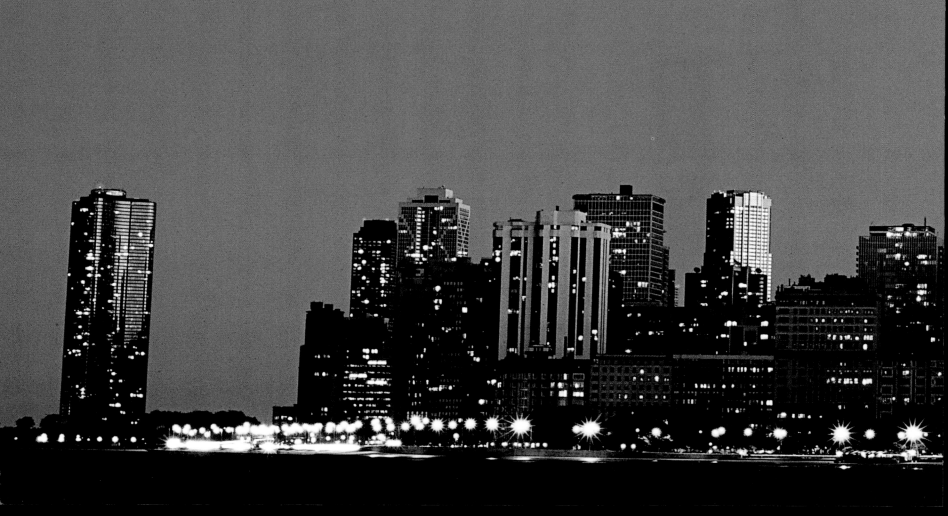

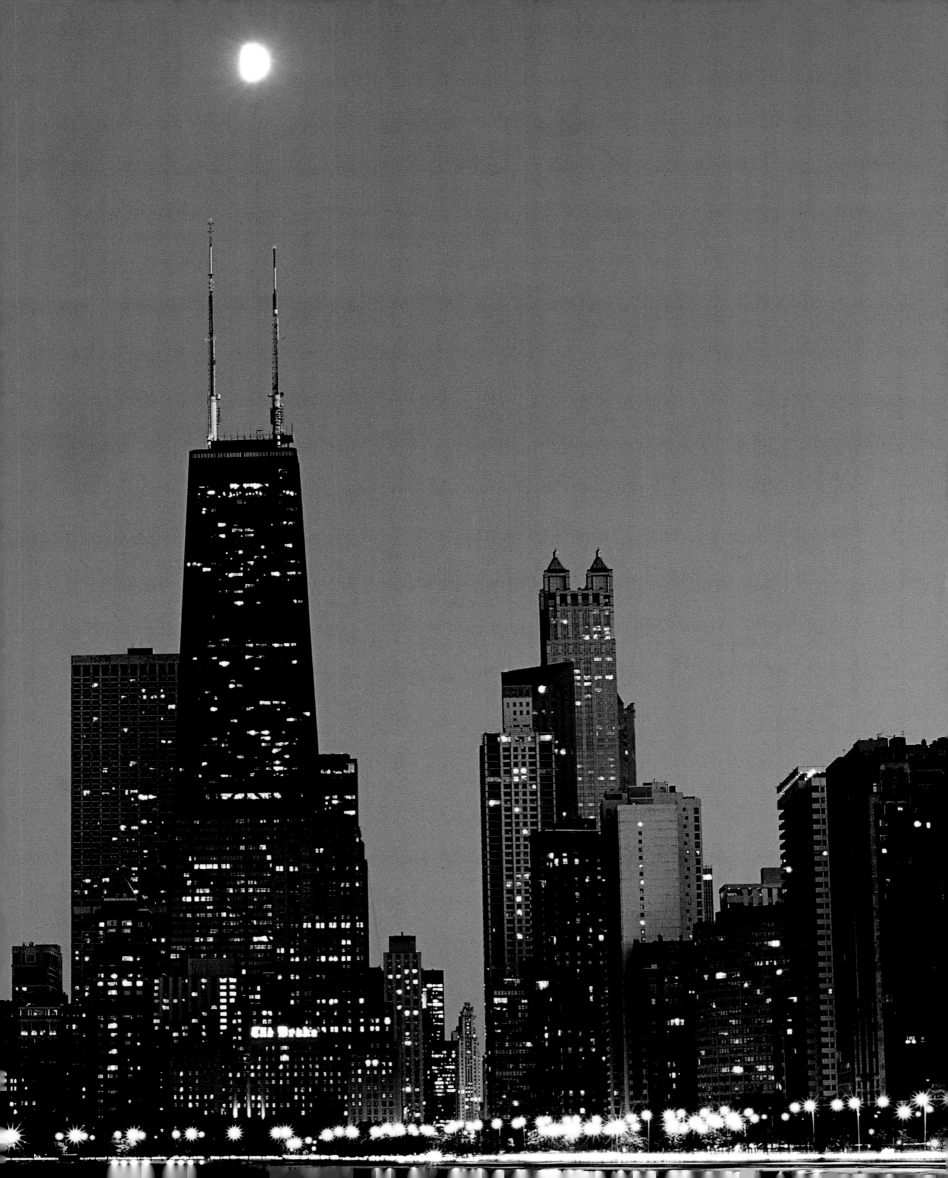

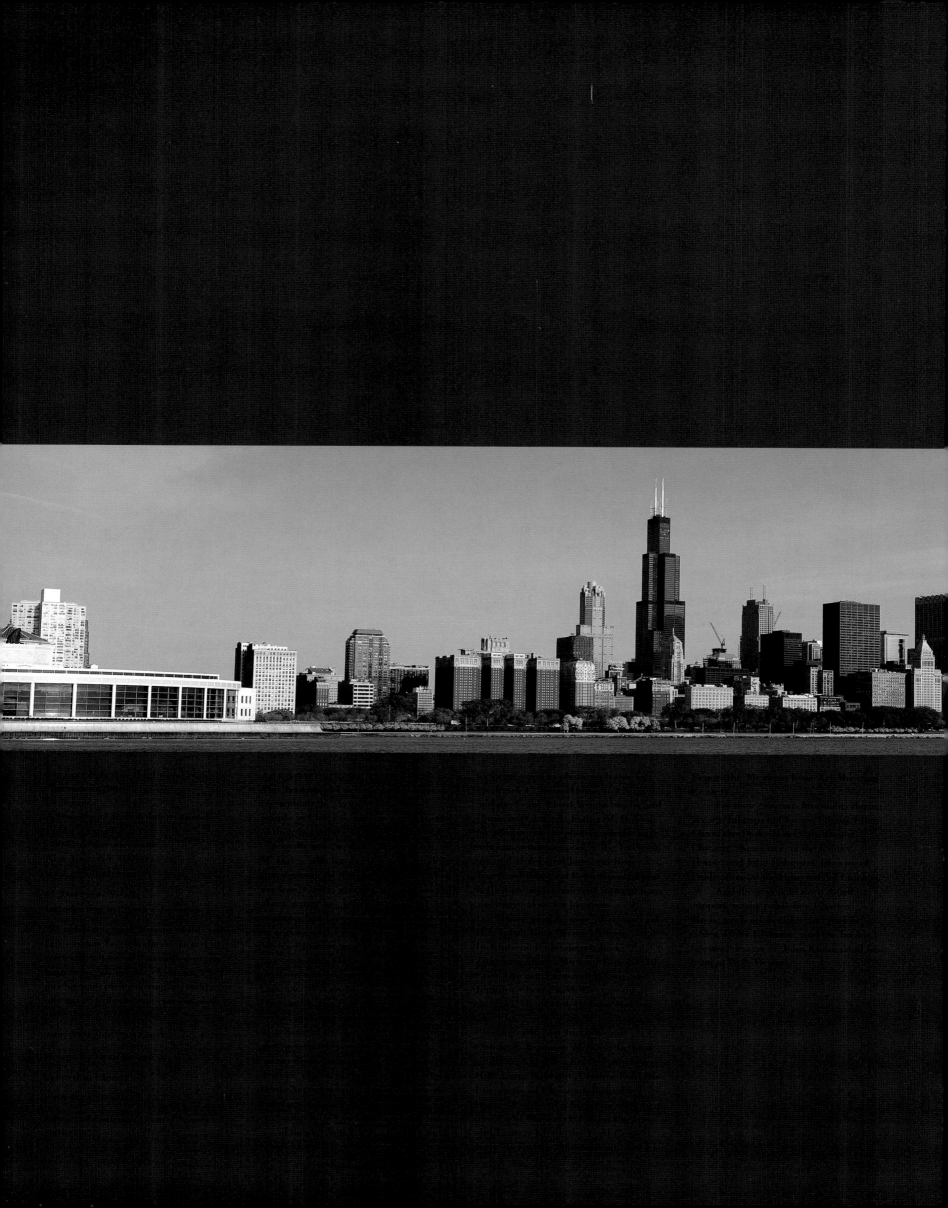

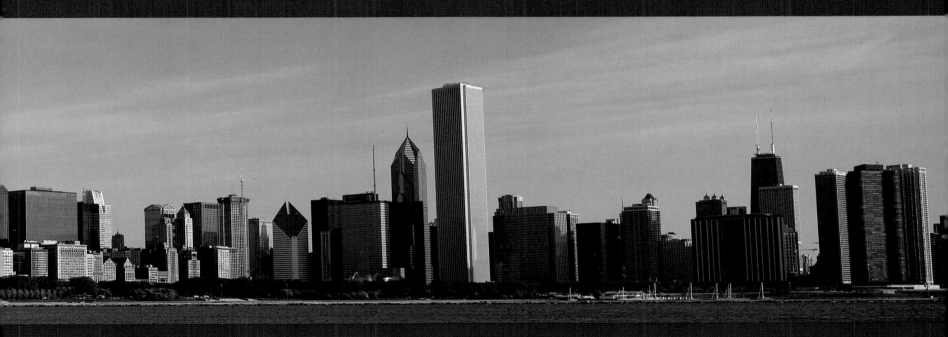

14

CHICAGO'S HISTORY AS OBSERVED (simplistically, yet importantly) by its cabbies, has alternately benefited from and been burdened by: the Native American origin of its name ("Chicagou" means "smelly onion"); the infamous—made famous by Upton Sinclair—Stock Yards; Al "Scarface" Capone; a substantial middle-European blue-collar working class (not particularly noted for its tolerance of others); unpredictable (but almost always marginal) professional sports teams; and lastly, modern architecture (with a Capital "A!"). At some level, the etymology of the final category can be largely attributed to the 1871 inferno that virtually destroyed the city's Central Business District. Consequently, Chicago had to rebuild instantaneously so as to keep the city both commercially viable and competitive with other emerging American "power places."

Two conditions came about as a result of the heroic struggle to raise our modern Midwest metropolis. The first big change was that modern technology was for the first time exploited as much as it could be, from the use of cast iron structural framing to the electronic elevator. Less tangible was the phoenix that emerged from this latter-nineteenth century conflagration: The now-famous Chicago "I will!" spirit kicked into overdrive.

ONLY (MUCH) LATER DID ARCHITECTURAL HISTORIANS and the general public come to understand—and then to belatedly elevate—what at first seemed to be building expediently to the level of architecture-as-art. Then, and only then, did Chicago come to be known as the most modern city on earth.

Imagine, if you will, a man-made oasis situated on the seam separating an inland sea from an endless prairie. Now imagine the Jeffersonian one hundred x one hundred meter grid-iron plan tilted up into space *après le deluge* as a three-dimensional constructional matrix: Voila, you now understand the structural—and more importantly, the visual—authority that the "First Chicago School of Architecture" superposed upon Chicago!

Ten of Chicago's nineteenth century architectural forerunners were particularly legendary, even in their own time: Daniel Burnham, Henry Ives Cobb, William Holabird, William Le Baron Jenney, Dwight Perkins, Martin Roche, John Wellborn Root, Howard van Doren Shaw, Louis Henri Sullivan, and Frank Lloyd Wright. Almost a half century later, the eleventh and perhaps most seminal architect, Ludwig Mies van der Rohe, arrived on our shores. It would be in his name that the so-called "Second Chicago School" would come into being.

With the exception of Shaw, none were native to Chicago, but all understood that to be an architect in Chicago was like having the provenance of being a Muslim in Mecca. They also

seemed to understand the open-ended opportunities offered to those who would stake their future on a city whose indeterminacy was its most overarching characteristic.

JUST TO PLUCK TWO NAMES from this Pantheon of architectural giants: Frank Lloyd Wright and Mies van der Rohe. As the "Mister Chips" of architectural history, Vincent Scully once observed (sarcastically as Easterners are wont to do): "Frank Lloyd Wright was the greatest architect of the nineteenth century." If that was indeed the case, then for many of us, Mies van der Rohe was arguably the greatest architect of the twentieth century. Wright himself left behind more than fifty houses in greater Chicago, while Mies authored forty-five buildings conceived and built during the (final) thirty-two years of his life here. Clearly, Chicago was a privileged city: Wright and Mies produced more in Chicago than in any other locale.

Lesser—but not so lesser—architectural luminaries have worked in Chicago through-out time, but they needn't be mentioned here simply to prove the city's singular reputation historically as the world's primary modern architectural Mecca. The preponderance of so many jewels in the city's architectural crown has fed upon itself through the many generations since the Great Fire: These architects seek simply to keep up with the high level of quality that their predecessors left behind, that they laid down as a gauntlet.

But it is not only the tall building (the skyscraper, the high-rise) upon which Chicago's preeminent architectural reputation resides. The "prairie school" that Frank Lloyd Wright initiated was followed by his many talented successors whose domestic work influenced several generations of architects throughout the United States. The open kitchen, the corner window, the cantilevered roof, the wing wall—all of these innovations influenced (for better and for worse) suburban tract housing countrywide.

THE ABSENCE OF COMPETING LANDFORMS, like hills and dales, mountains, and forested topologies, has allowed for a kind of Tabula Rasa for Chicago's architects. In the end, the broad sweep of both lake and prairie seem continuously fresh as a daisy, apparently just waiting for man-made new forms to make a mark. Think of "the machine in the garden," something that architects at their most poetic can accomplish, at least from a dialectical point of view.

There is something else that is uniquely optimistic about Chicago's open-ended brand of architecture and the way it relates to how our city's population presents itself to those new to the "Capital of Middle America." The perception begins with the gridiron plan of the city itself. That Cartesian grid is open, democratic, and yet, in equal terms, alienating. Unlike European hierarchically disposed street patterns that favor either the Church and/or the Town Square,

only to quickly fade to residential "*Quartier(s)*," Chicago's undifferentiated ground plan refers to the optimistic, multivalent inclusion that is uniquely representative of American democracy.

THE CITY'S RESULTING ARCHITECTURE is equally open-ended and non-hierarchical. Chicago is, in many ways, our most American city. Not excessively representative of either European, Asian, African, or Latin influence, and geographically far enough from our coastlines to be perceivably detached from them, ours is the ultimate example of a hybridized amalgam of many cultures. The architecture of the American heartland may have nothing about it that emanates directly from history, but its originality is precisely that—a hybridization of every prior precedent, which seems to constitute an original.

Multiple linguistic readings of architectural form are available here for continuous interpretation by all: For every European basilica, in America's heartland it is transmuted into a barn, just as Europe's many *campanile* become silos. Nowhere else in America do images get more blurred from the religious to the vernacular than in our farm country—and Chicago is the capital of those American values freed from historic influence.

Of course, there is a bit of a dark side to all of this as well. The same shimmering oasis that visitors flying into the city perceive through the clouds also happens to be situated in the virtual geographical center of an apparently conservative—some think fundamentalist—farm country. In that sense, it always amazes me just how open Chicagoans are to new architectural forms. Visiting architects are always startled by Chicago's brand of architectural Valhalla—both quantitatively and qualitatively. They wonder how a not-particularly intellectual center can be so supportive of an amazing level of innovation. But that's just it! It is because we are not overly burdened by the notorious "Eastern intellectual foreplay" that we are able to work unfettered by unnecessary verbal rationalizations of the nature of our architectural production.

AND THEN THERE IS OUR LESS-THAN-WELCOMING CLIMATE. It is said that the severity of Chicago's winters are such that "one can only make babies or buildings" during that bleak time of year. From an urbanistically spatial point of view, Chicago is a bit like Goldilocks: Where New York's skyscrapers seem to be oppressively close together for their height, and Los Angeles's a bit too far apart to even define the street, Chicago's Central Business District highrises seem to be "just right."

On the other hand, Chicago's low-rise housing stock is something like Melbourne, Australia's, in that the "bungalow" in both cases produces a context that is, domestically speaking, welcoming. Chicago's recent low-rise housing developments are a bit more compressed

speaking, welcoming. Chicago's recent low-rise housing developments are a bit more compressed then the detached housing that evolved a century ago, but they preserve the inviting sense of neighborhood, while being only slightly more dense than their predecessor's domestic typology.

BUT CHICAGO IS NOT ONLY ABOUT "CONTEXT" in the most polite sense of the word. Increasingly, the idiosyncratic one-off building appears on the scene as a refreshing change to what would otherwise be frankly boring as hell. Case in point: the less-than-scintillating high-rise condominium craze is more than once refreshingly disrupted by delightful experiments in multi-family living high above street level, proving that Chicago's newest generation of architects is not intimidated by precedent, good or bad.

Which brings me to that newest architectural generation itself. The element that most influenced our youngest architects to be formally, structurally, constructionally, and contextually free from the past, came about in part as a result of breaking the stranglehold that our own one-dimensional reputation provided—both here as well as abroad. Both Chicago Schools of Architecture have now been, happily or less so, relegated to history. Of course, we respect our brilliant but often one-dimensional past (and their authors, naturally, as well); but we are free of them at last. Their dominance, and more than occasionally, their preservation, both in education as well as in practice, is over. The resulting freedom represents another kind of Tabula Rasa that now establishes an open-ended set of circumstances that welcomes young architects to our shores as never before.

———————

So now comes this exquisite photographic document of many structures (and some interiors as well) authored by many of the above-listed legendary architects, together with the work of their descendants (both sycophantic and rebellious). Comparisons will no doubt abound: Suffice it to say that architecture is alive and well and at home in Chicago.

Stanley Tigerman
Chicago, March 2004

TO THE PEOPLE OF CHICAGO

ENTRANCE CLOSED
Please use Main or South Entrance

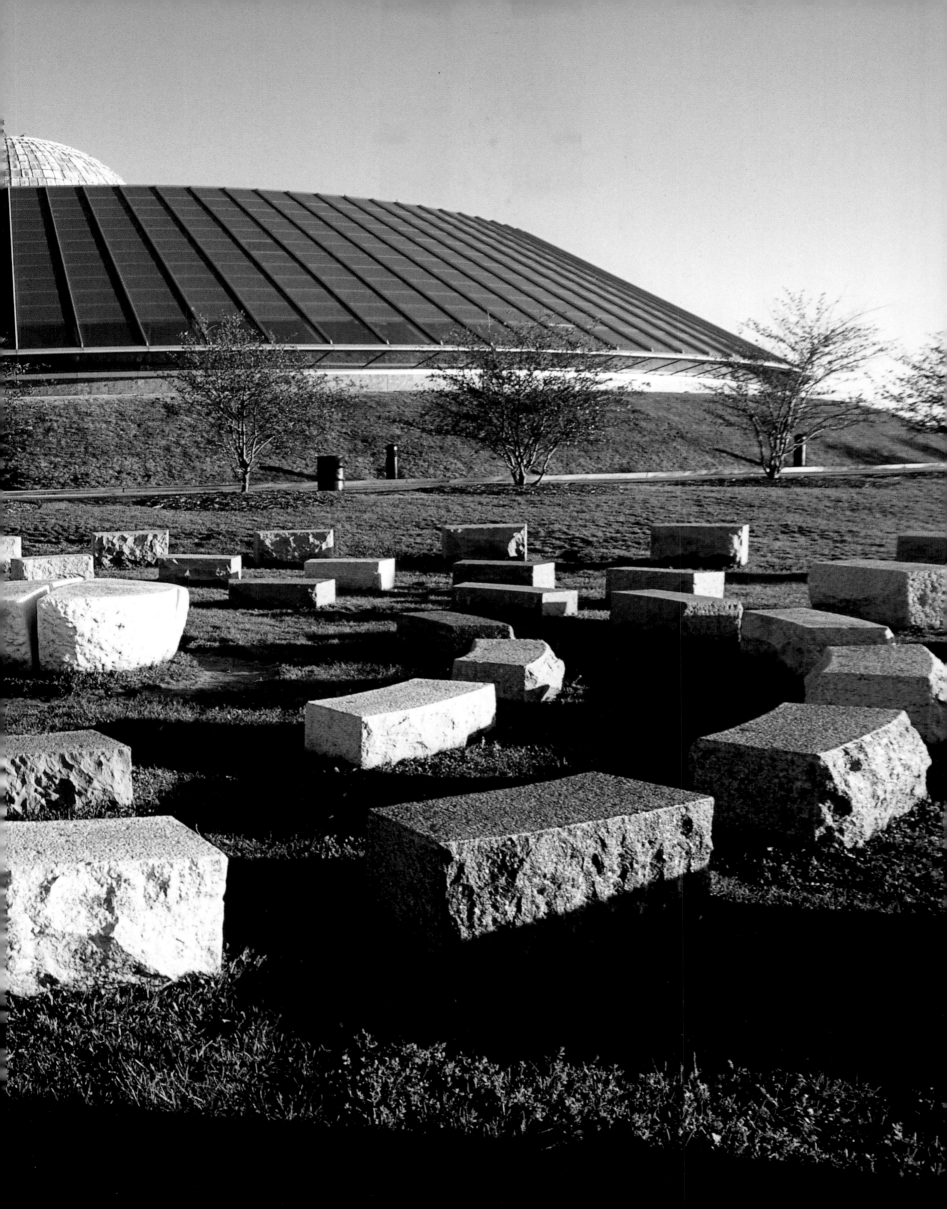

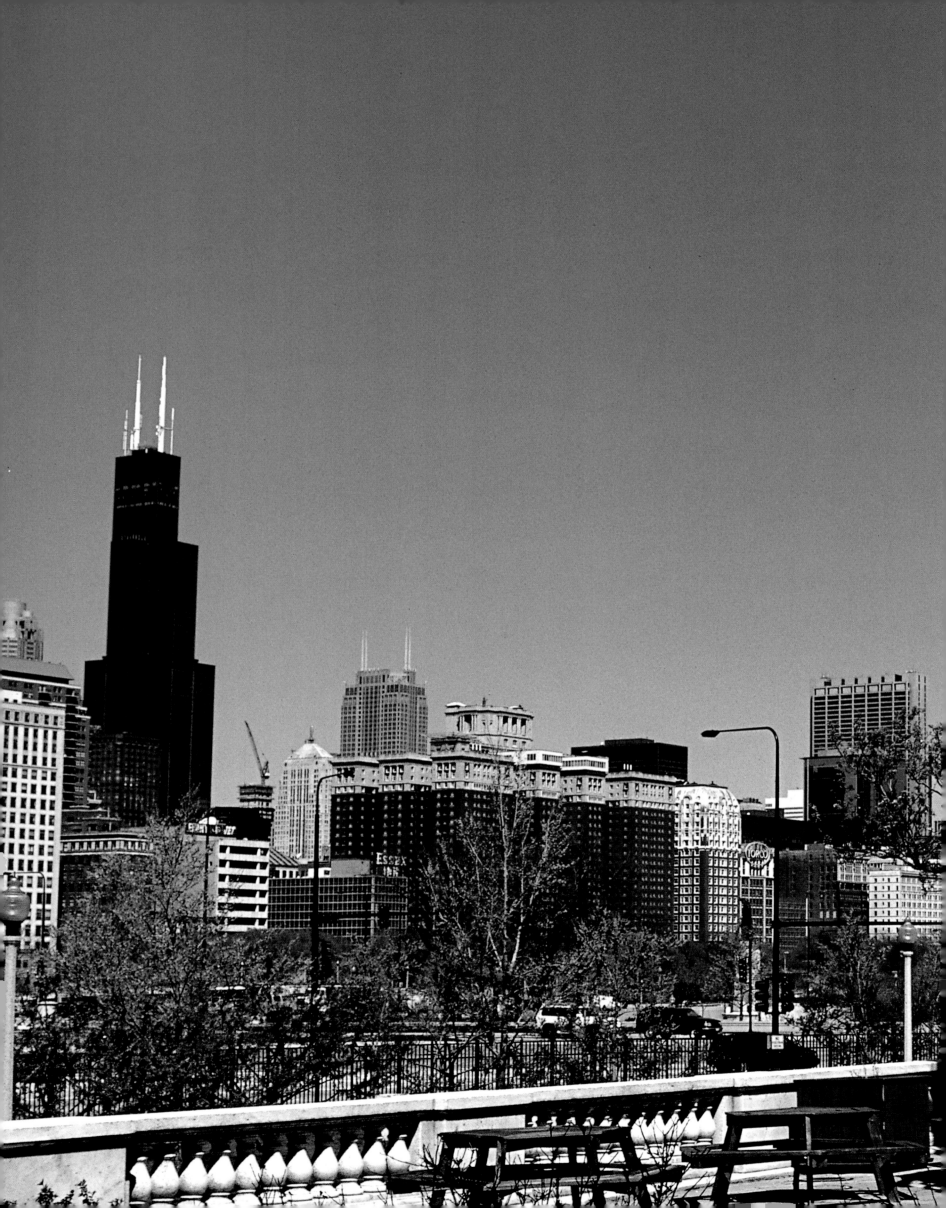

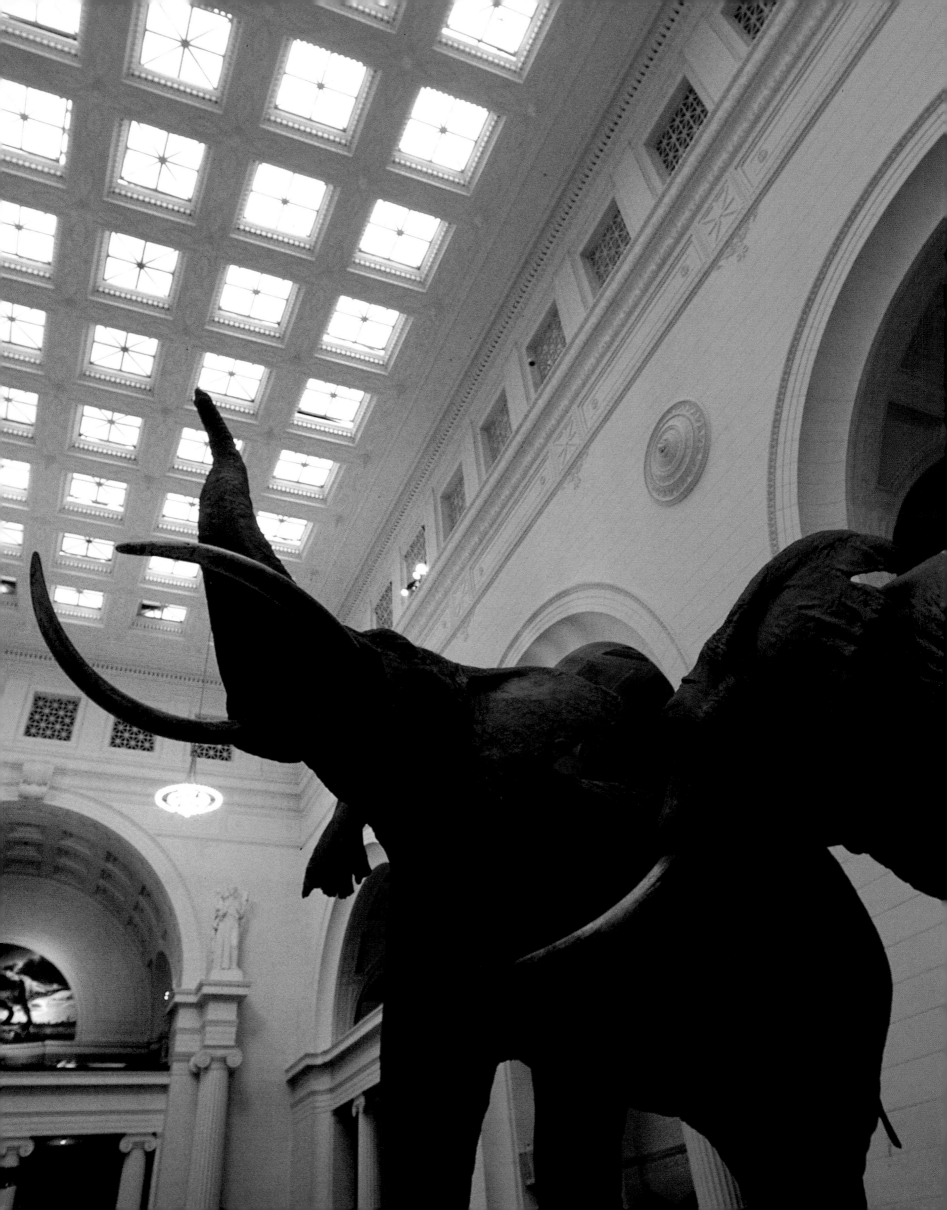

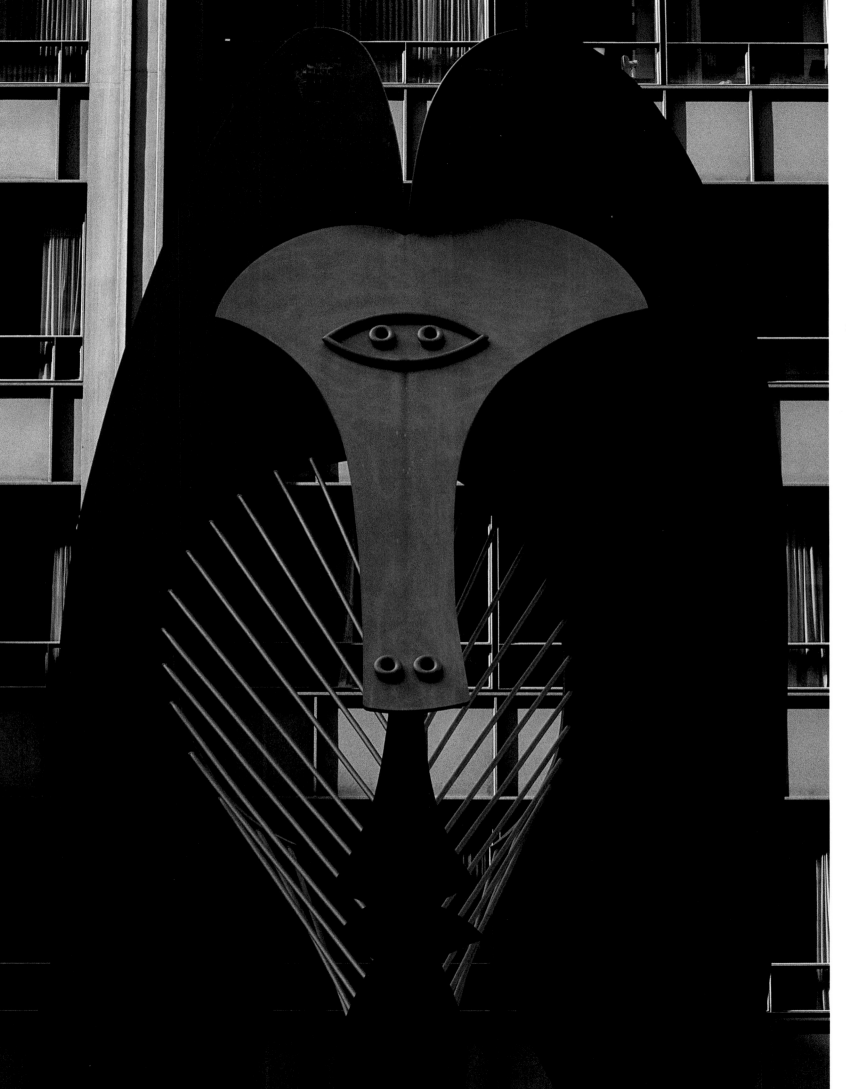

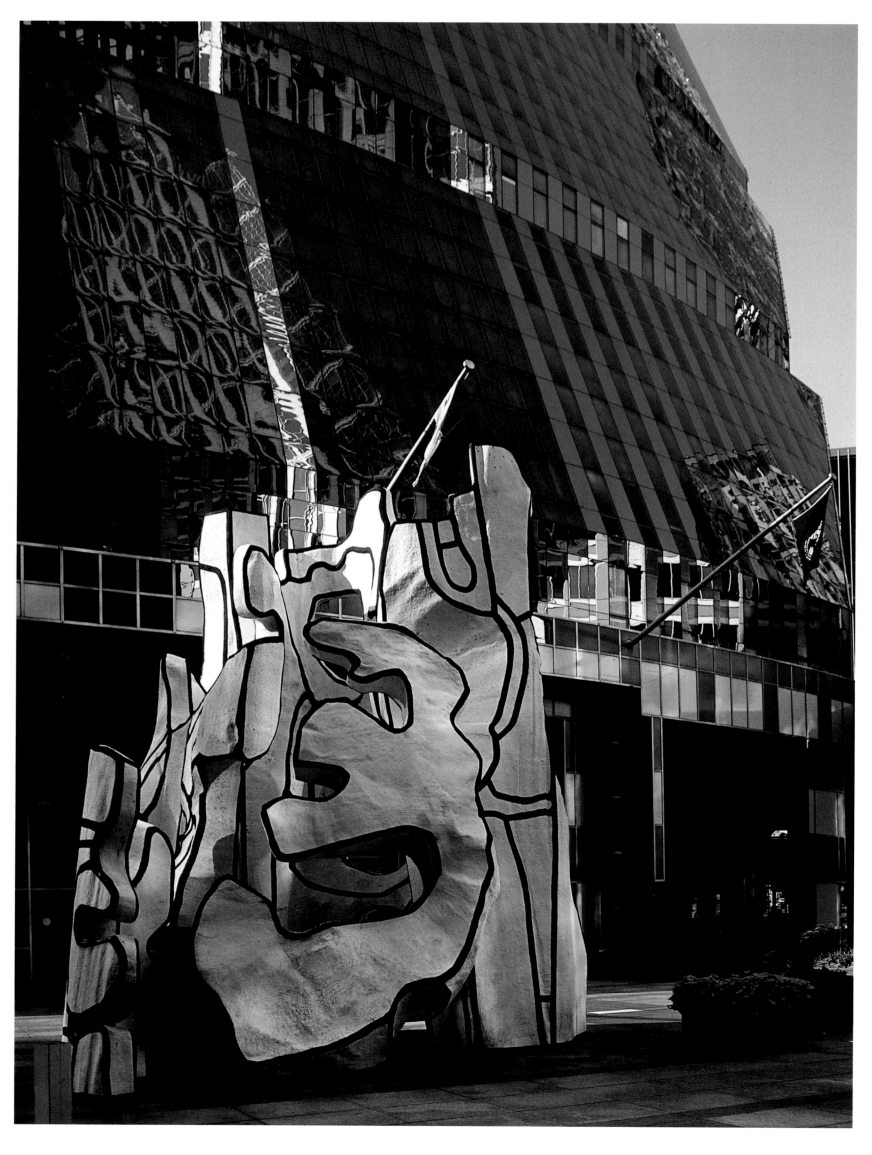

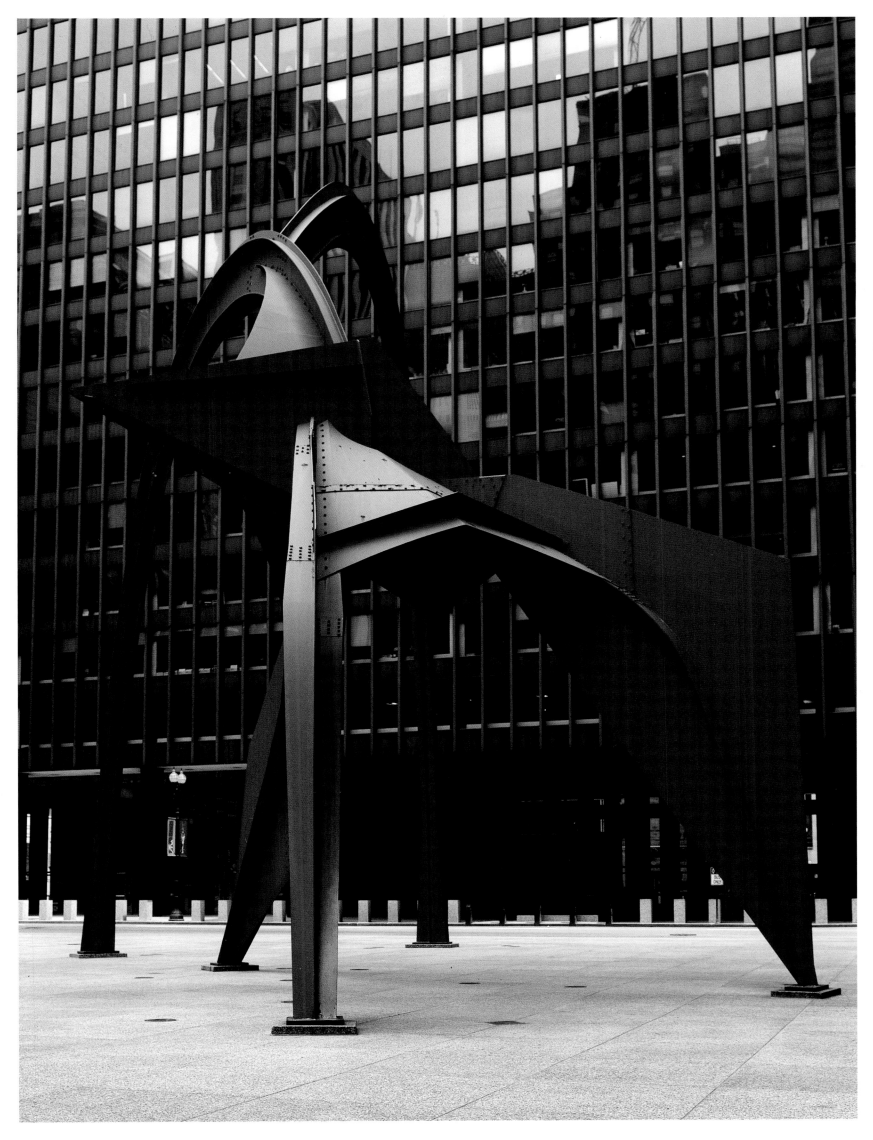

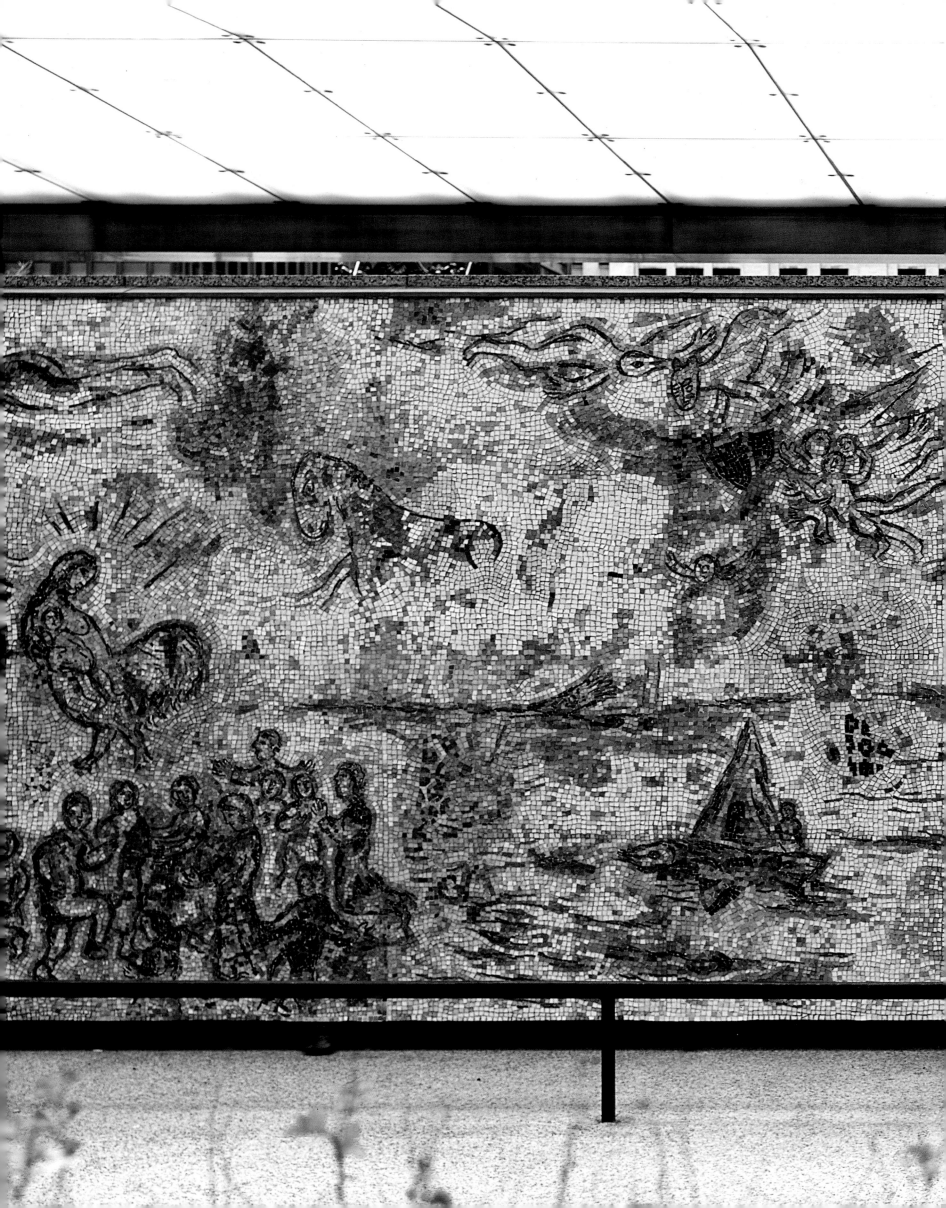

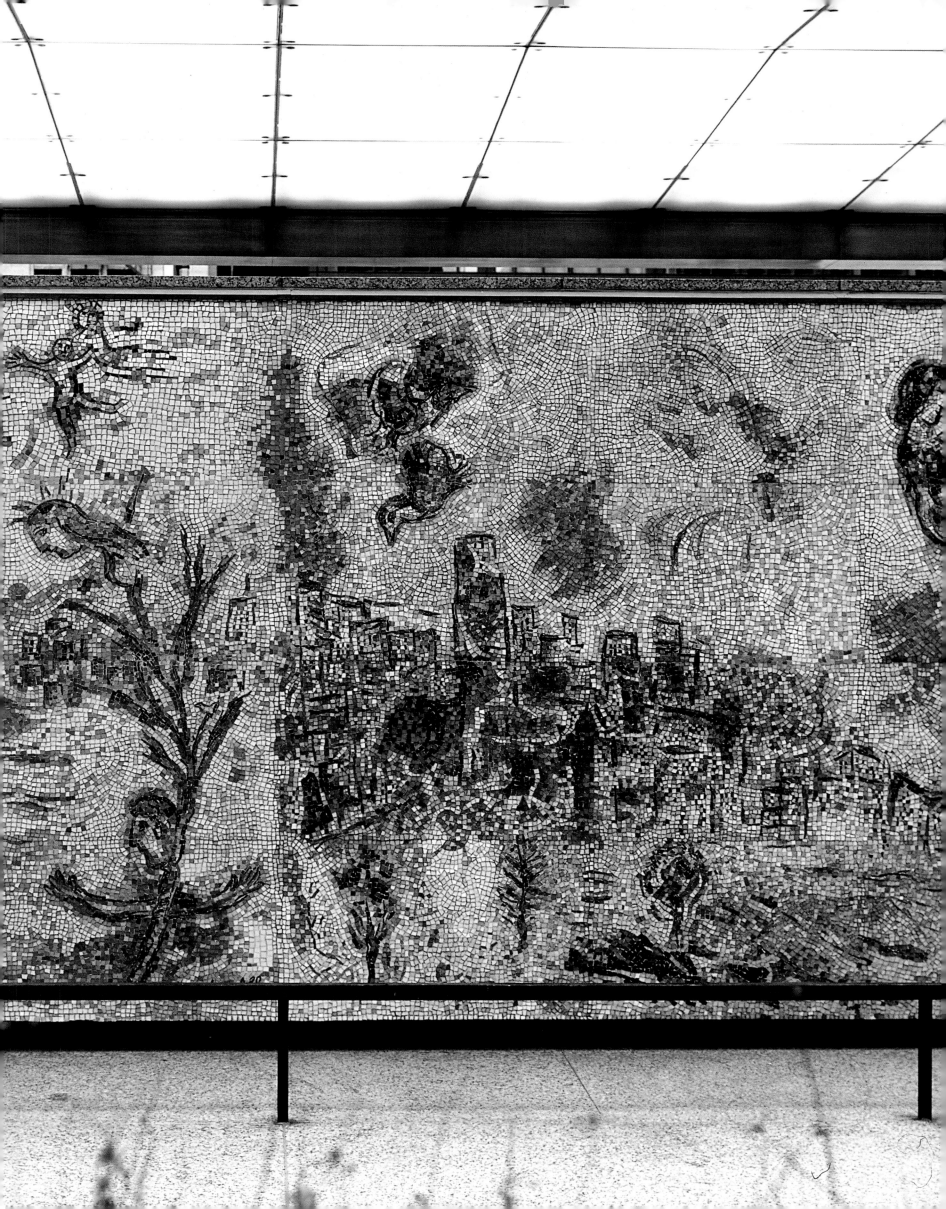

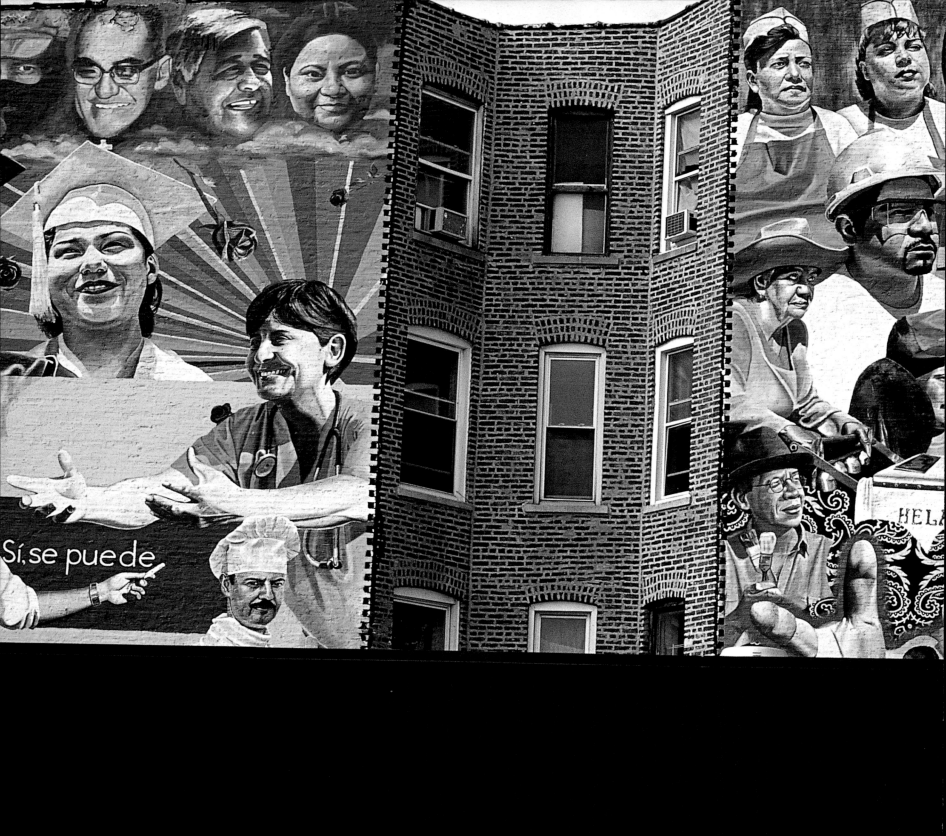

Sí, se puede

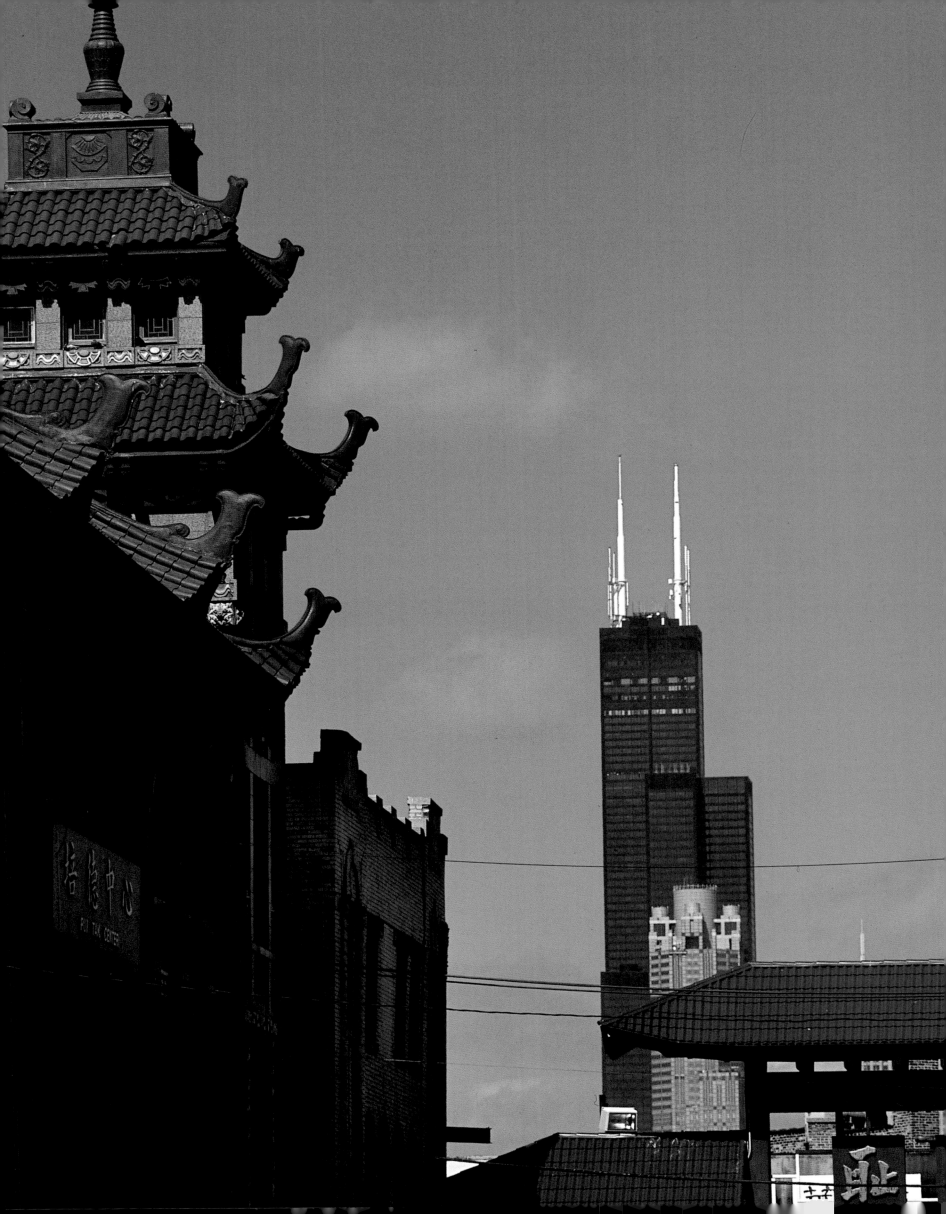

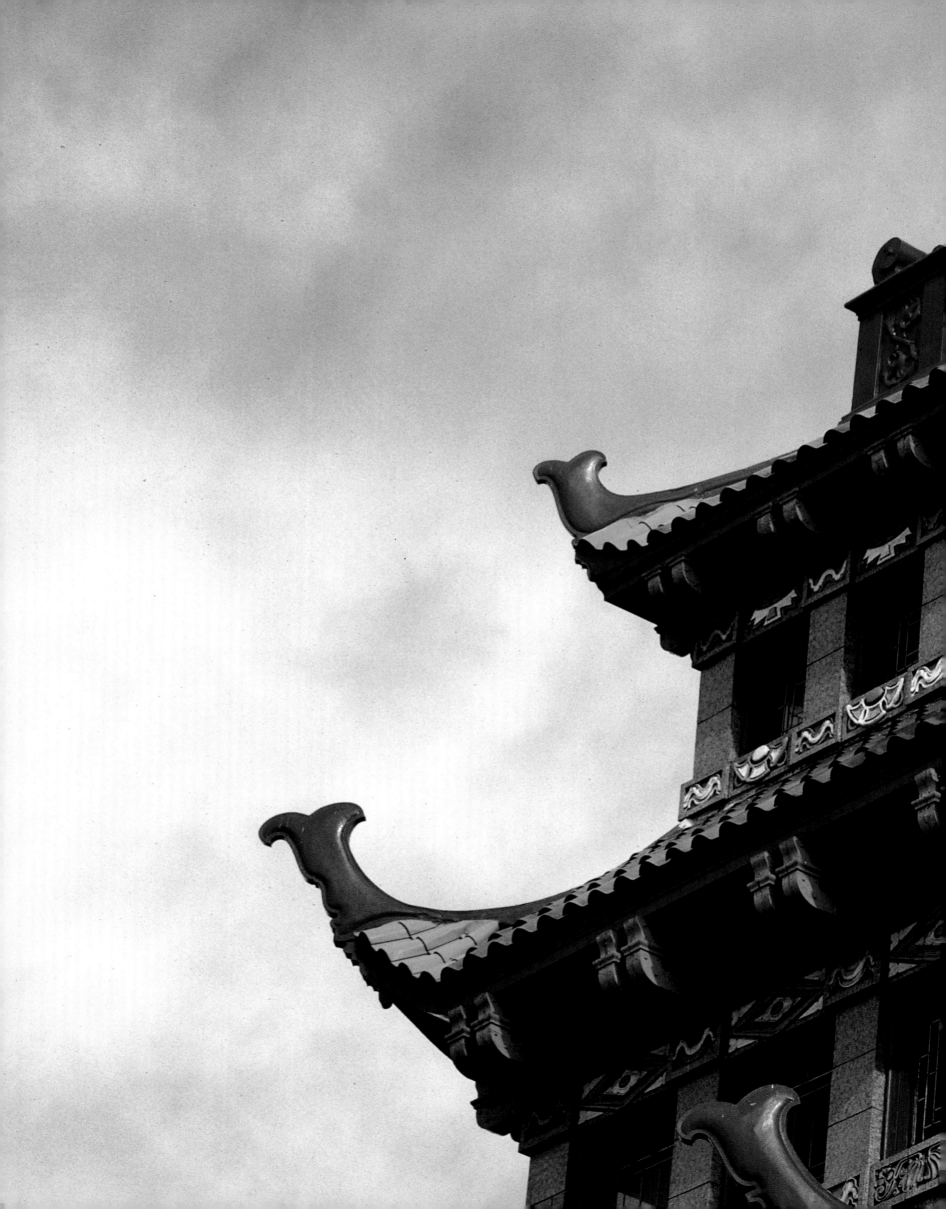

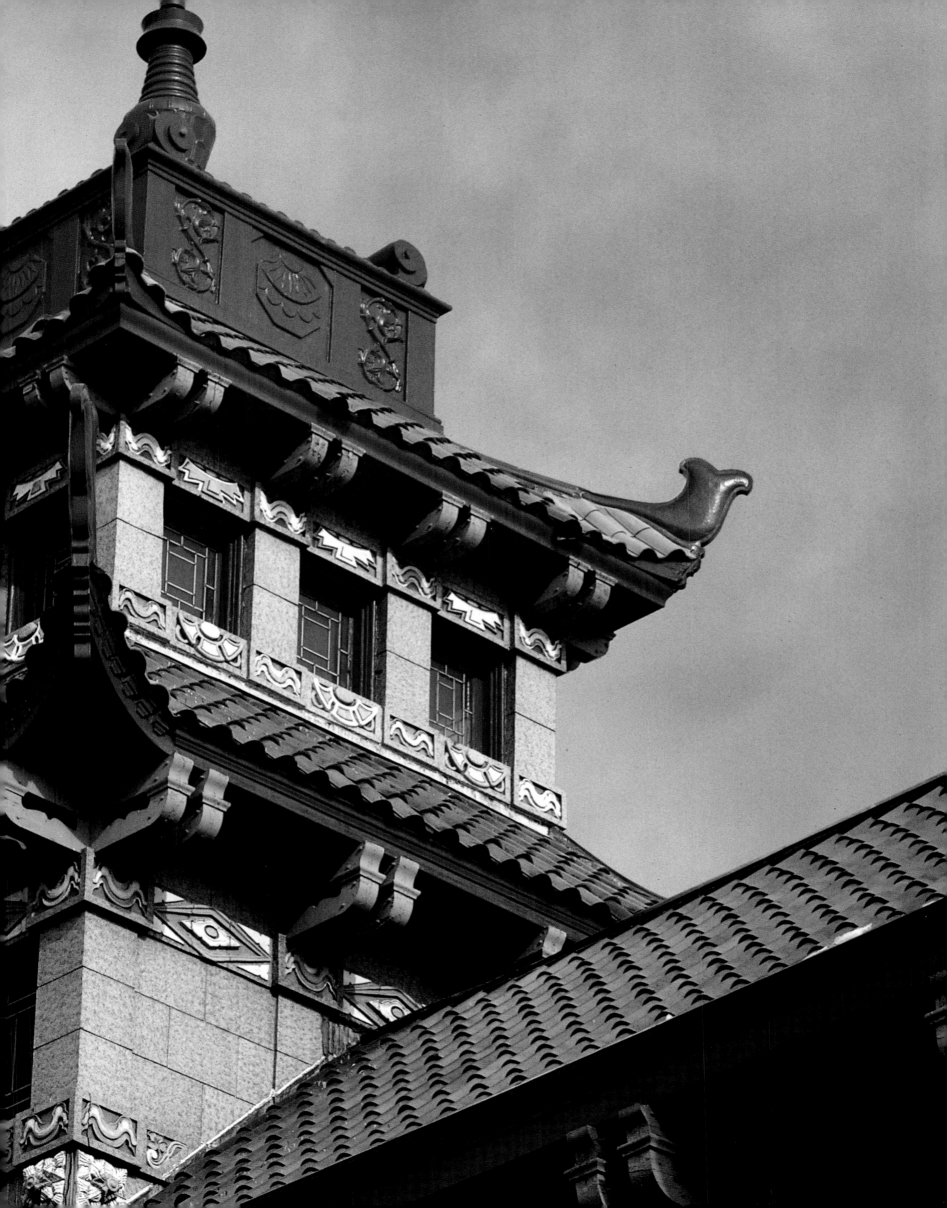

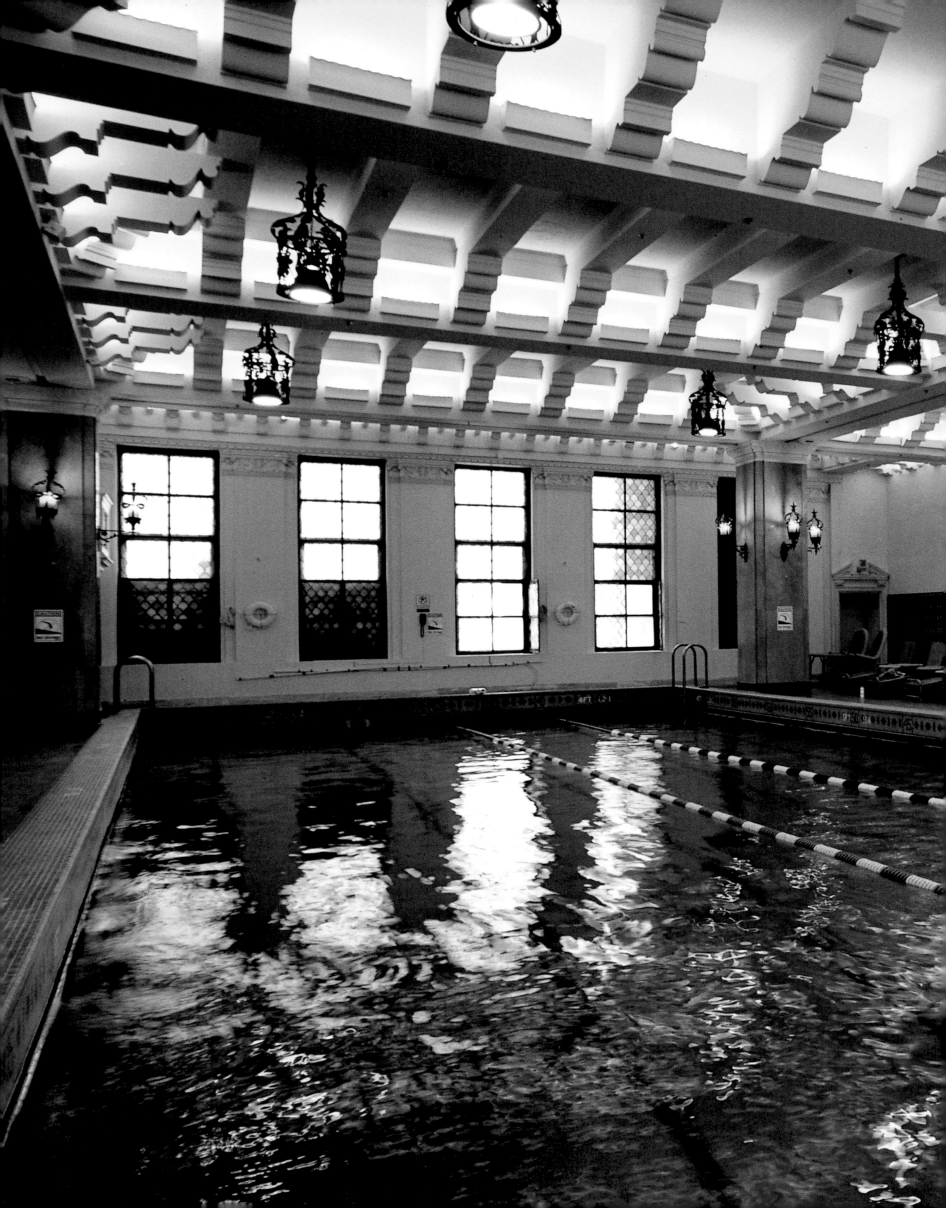

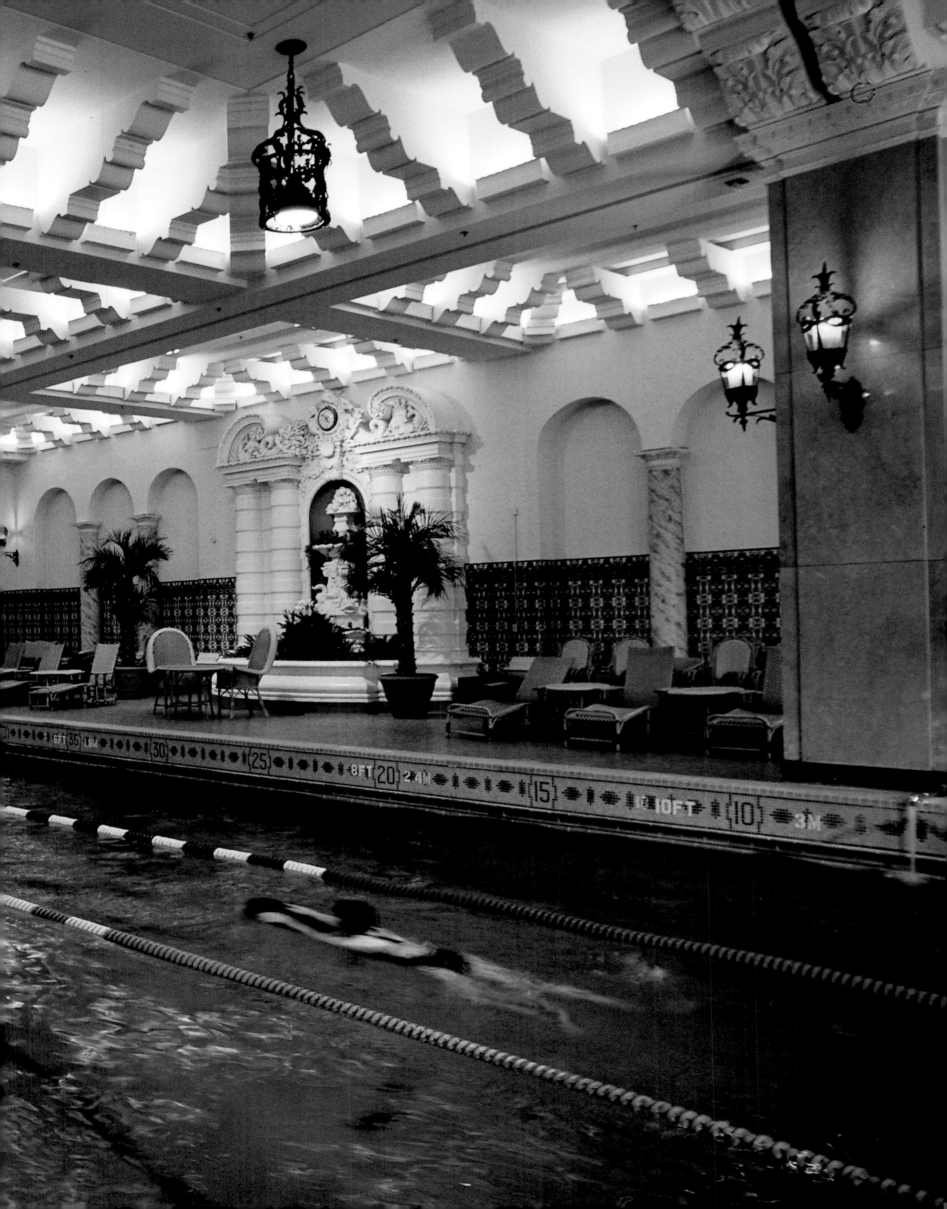

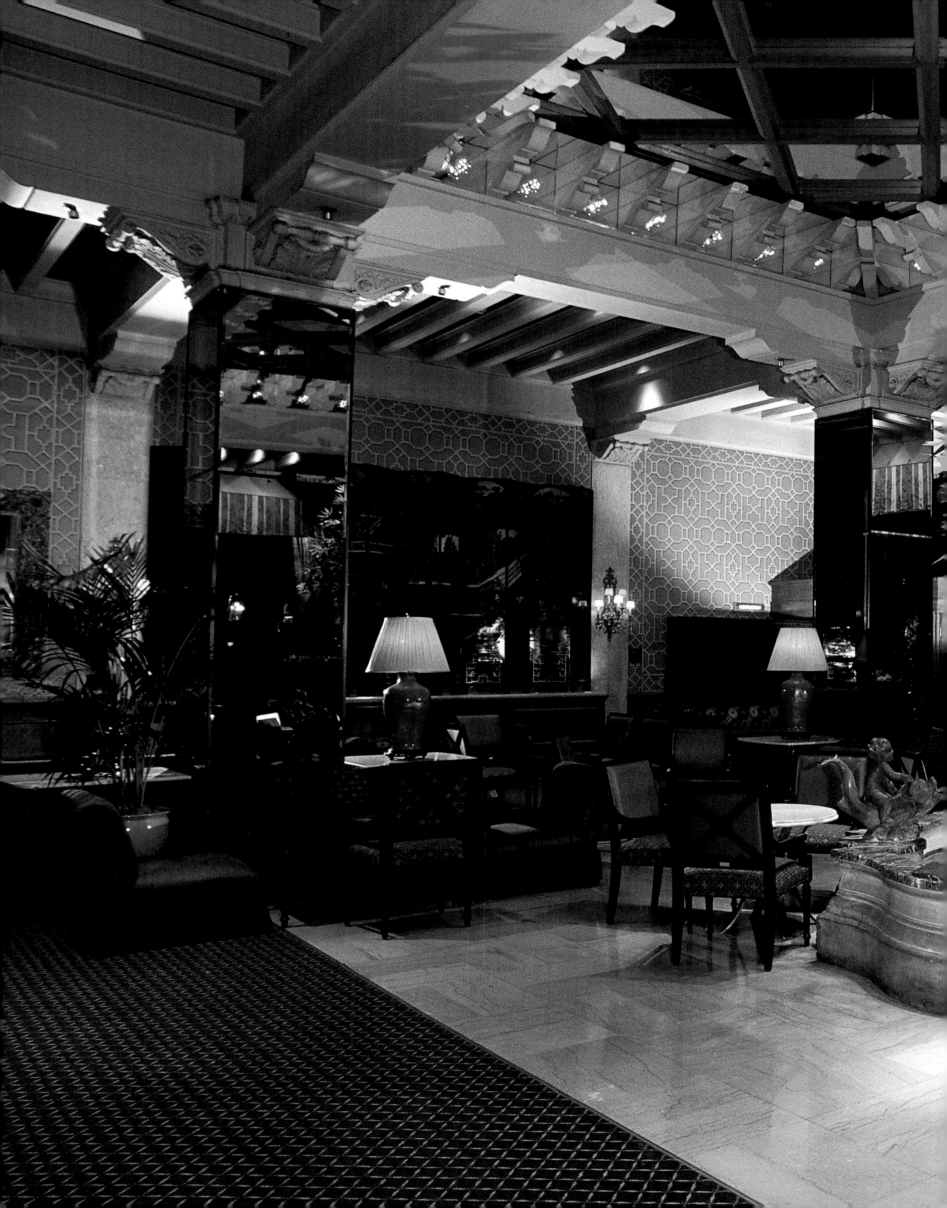

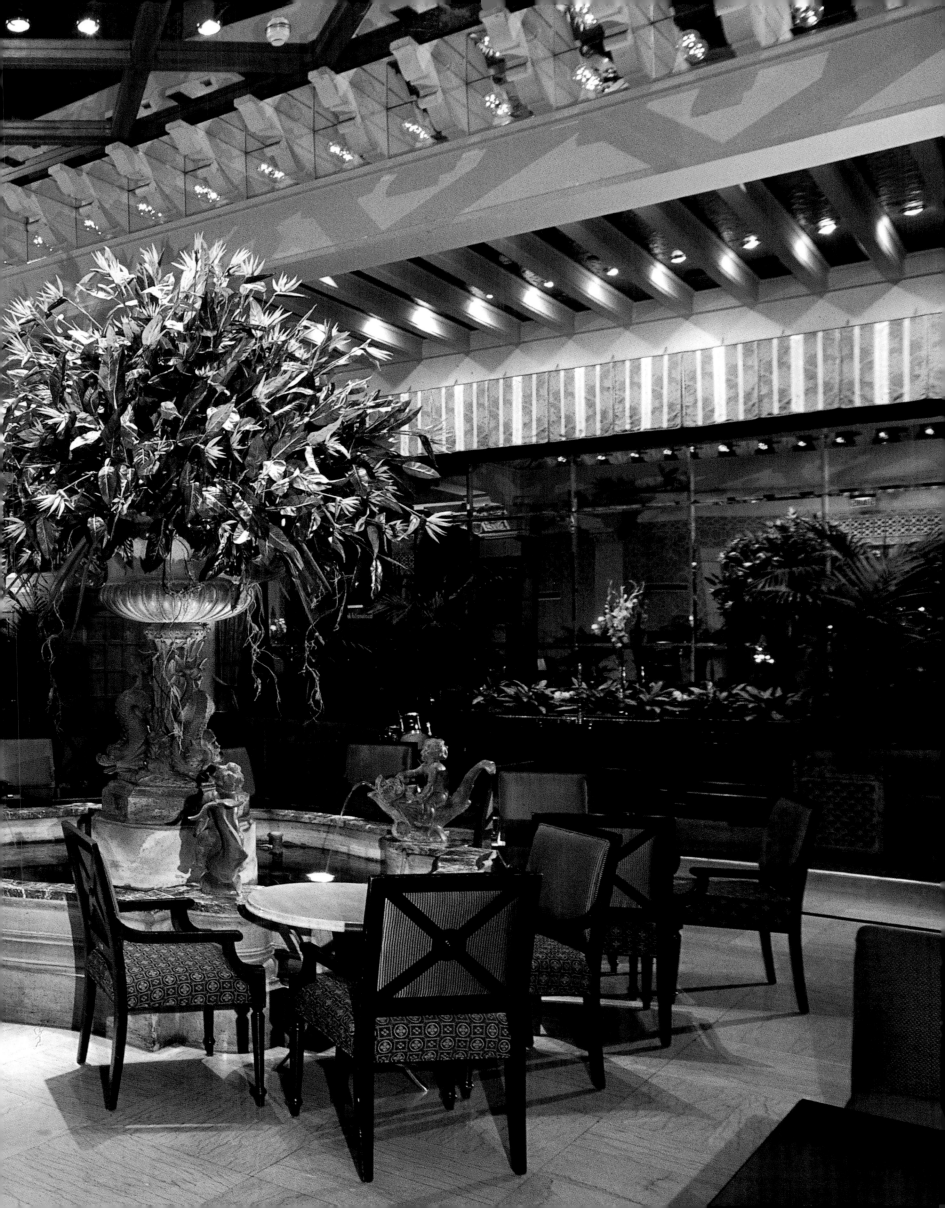

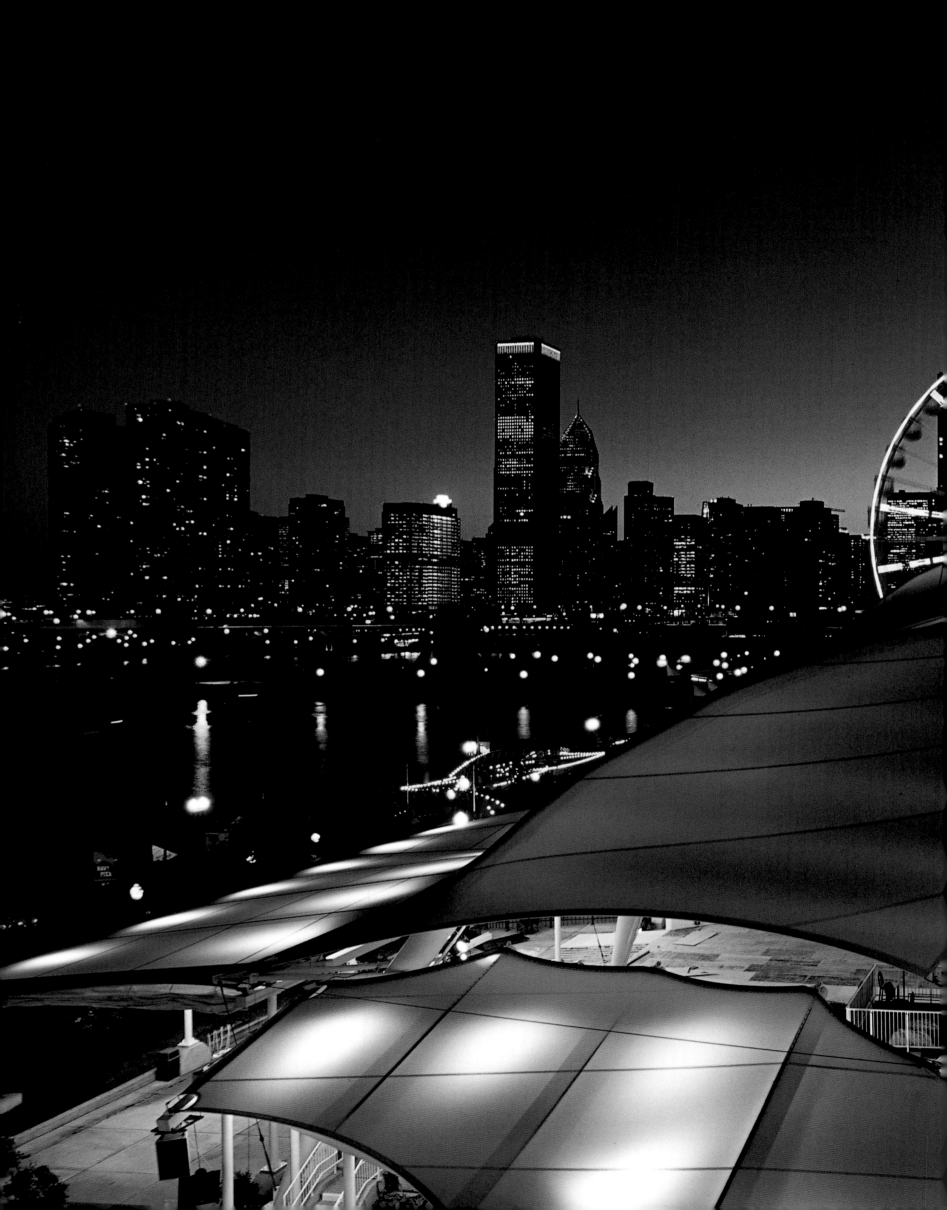

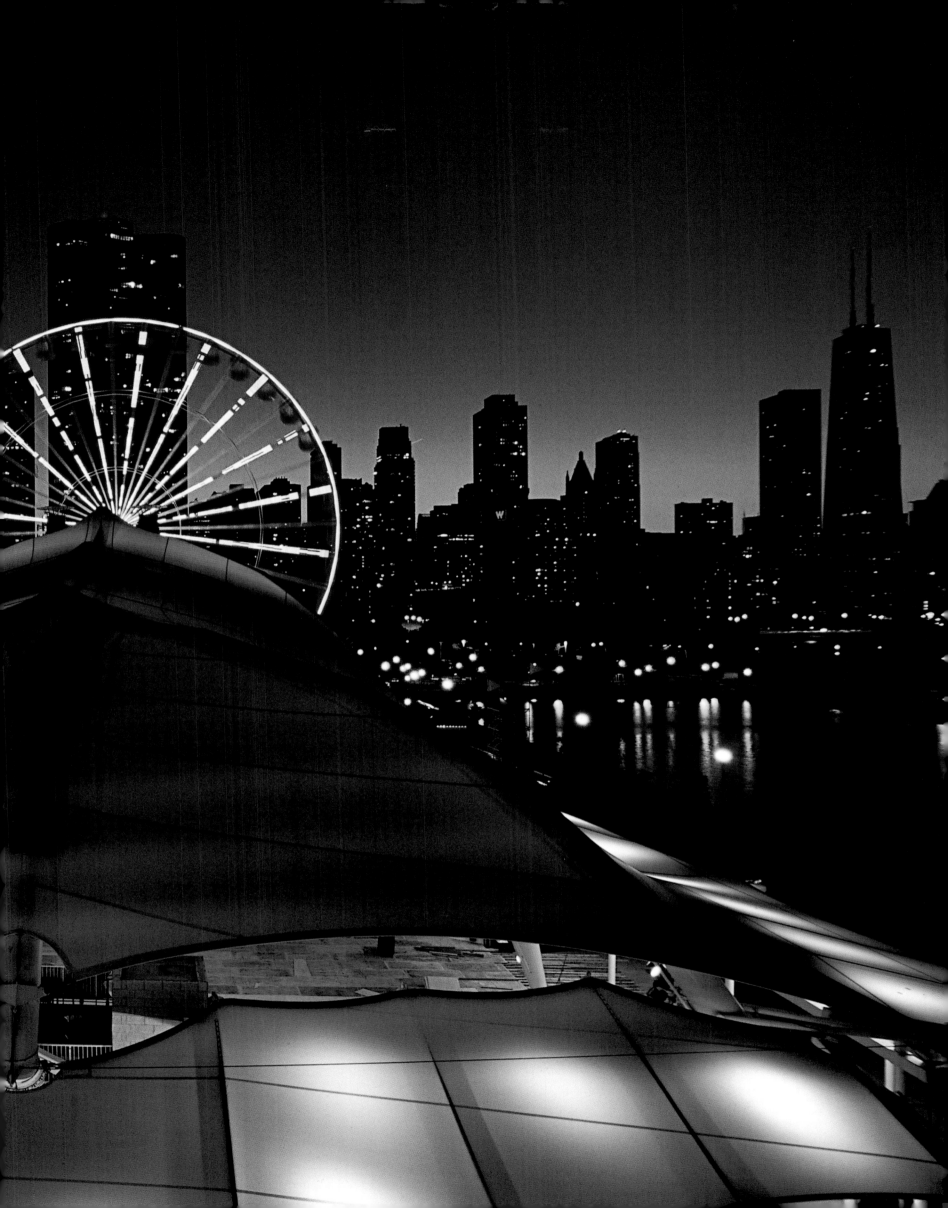

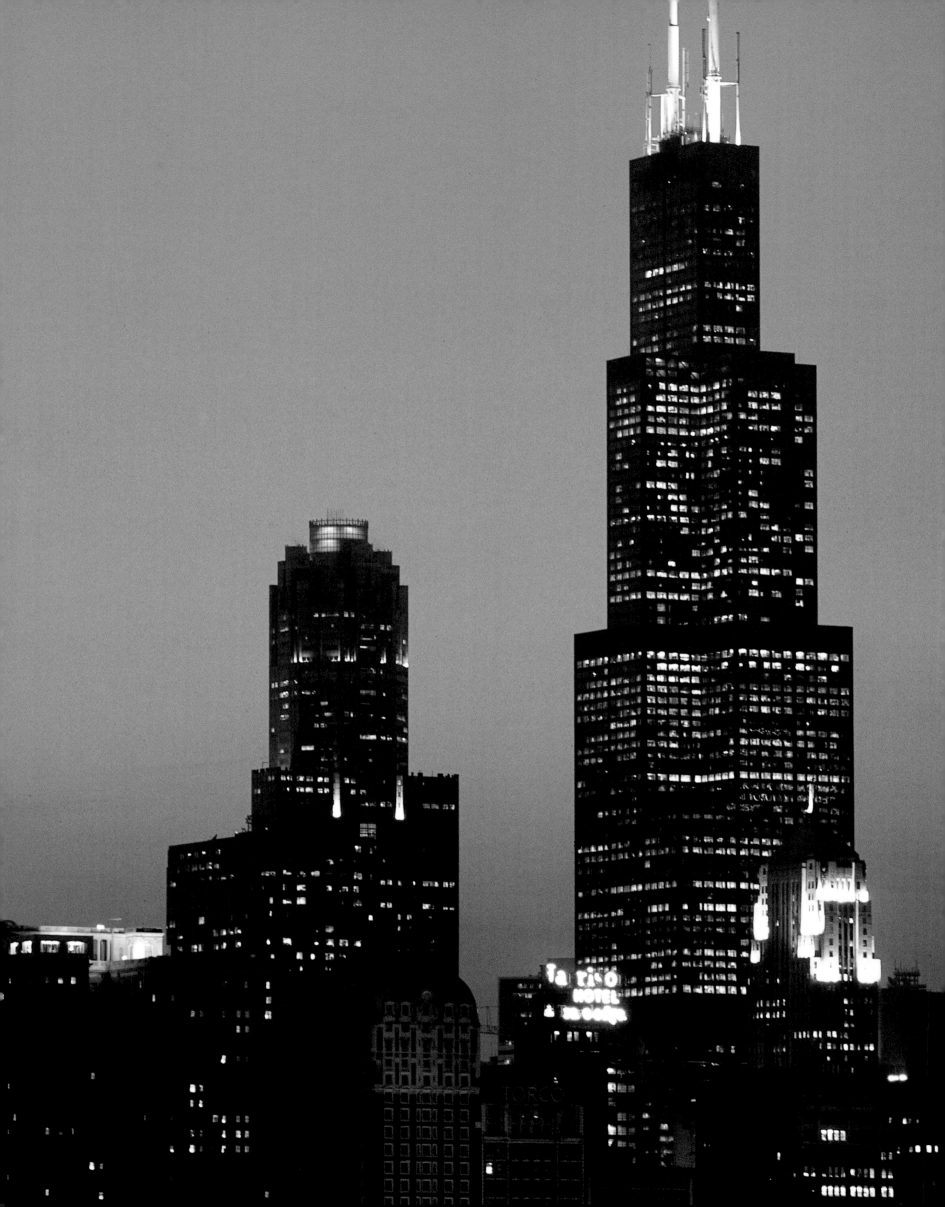

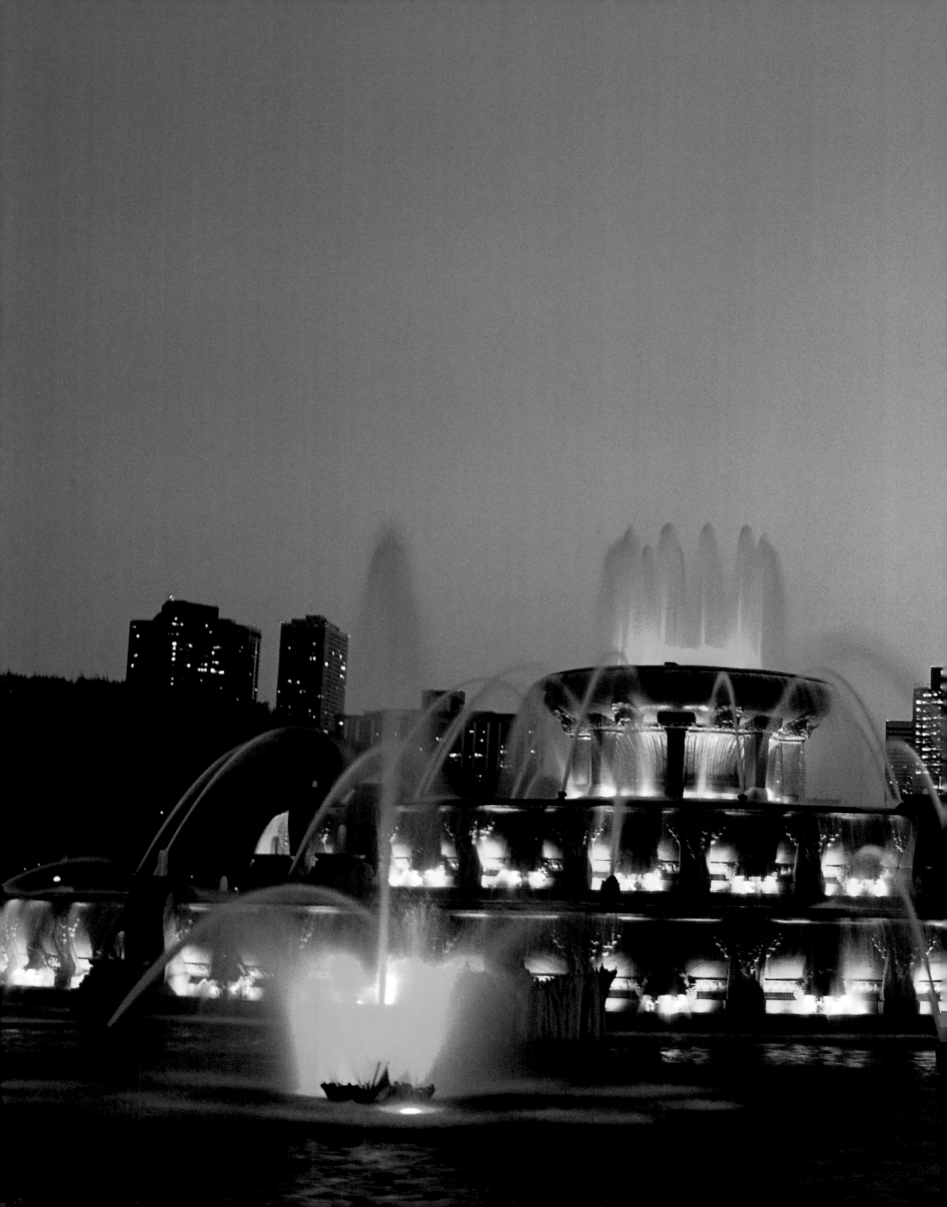

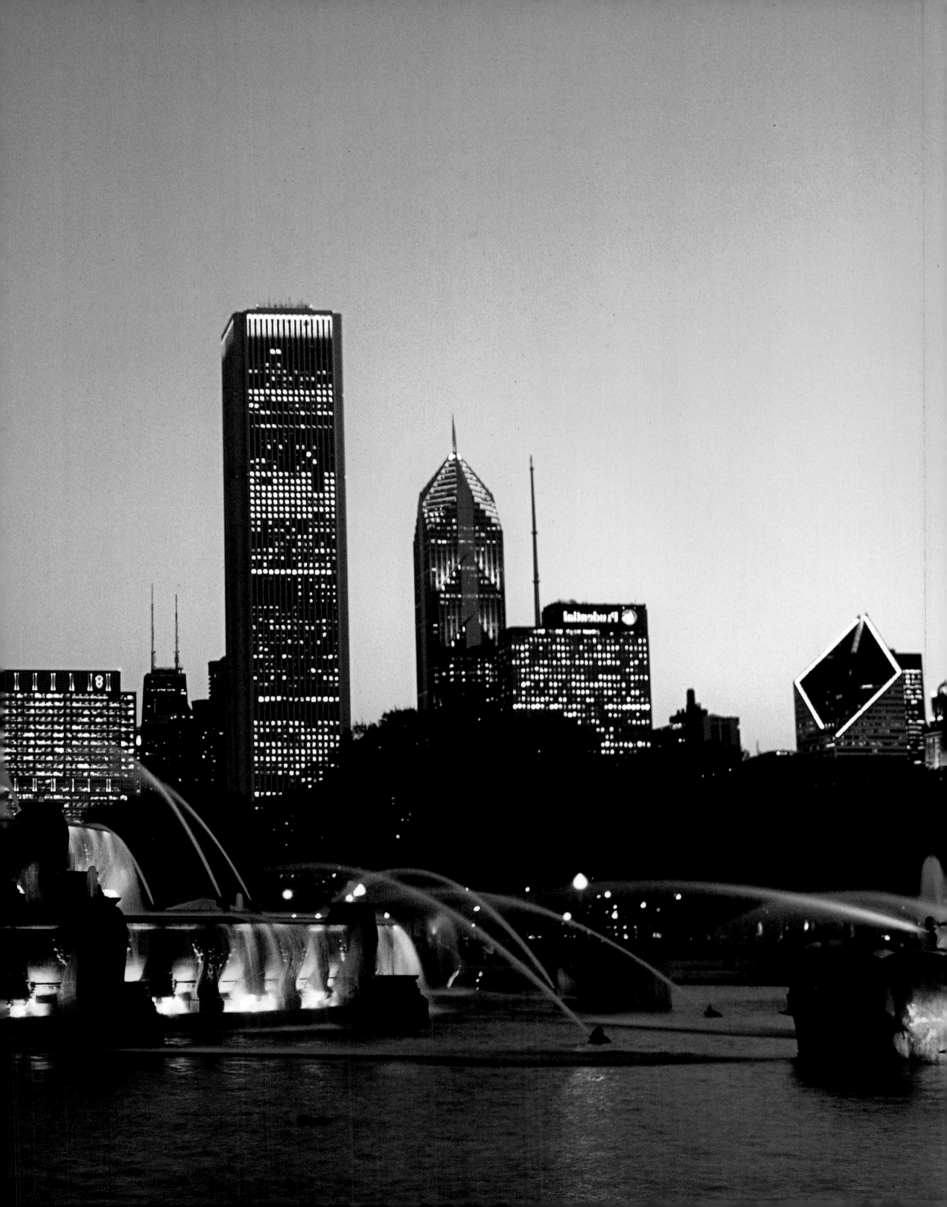

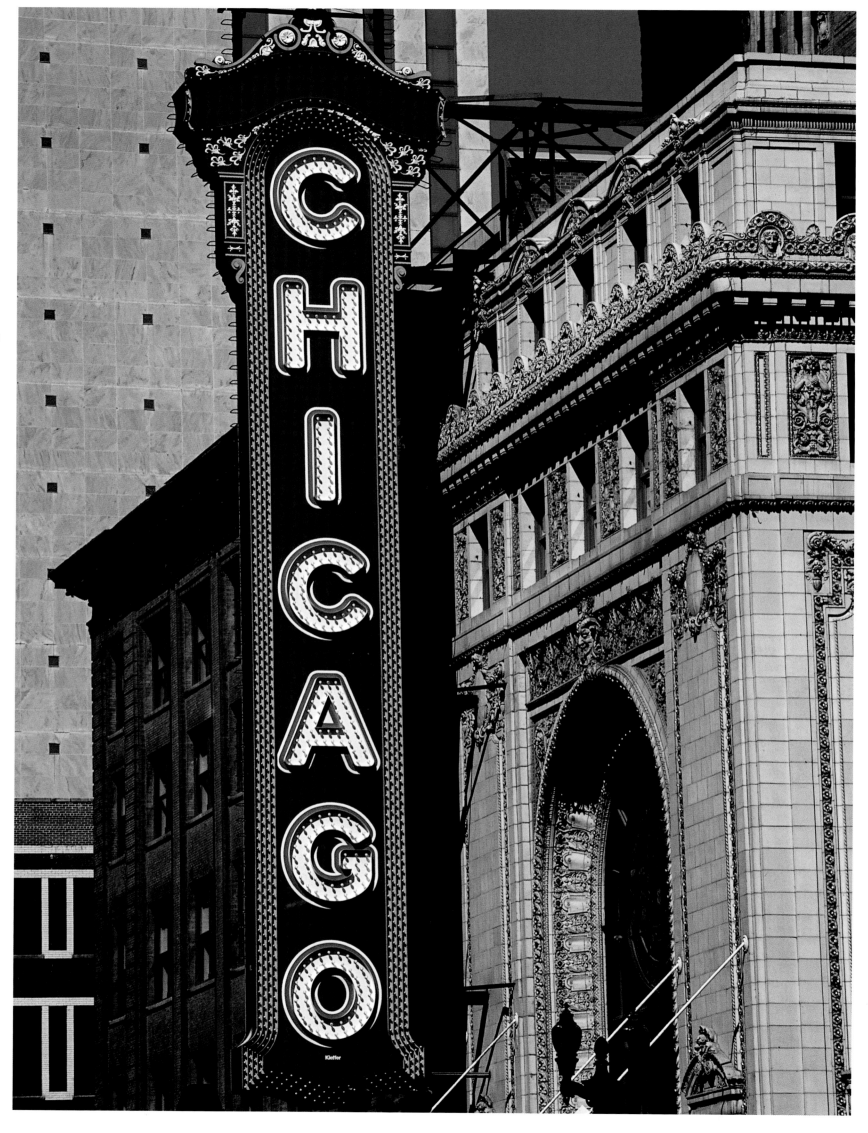

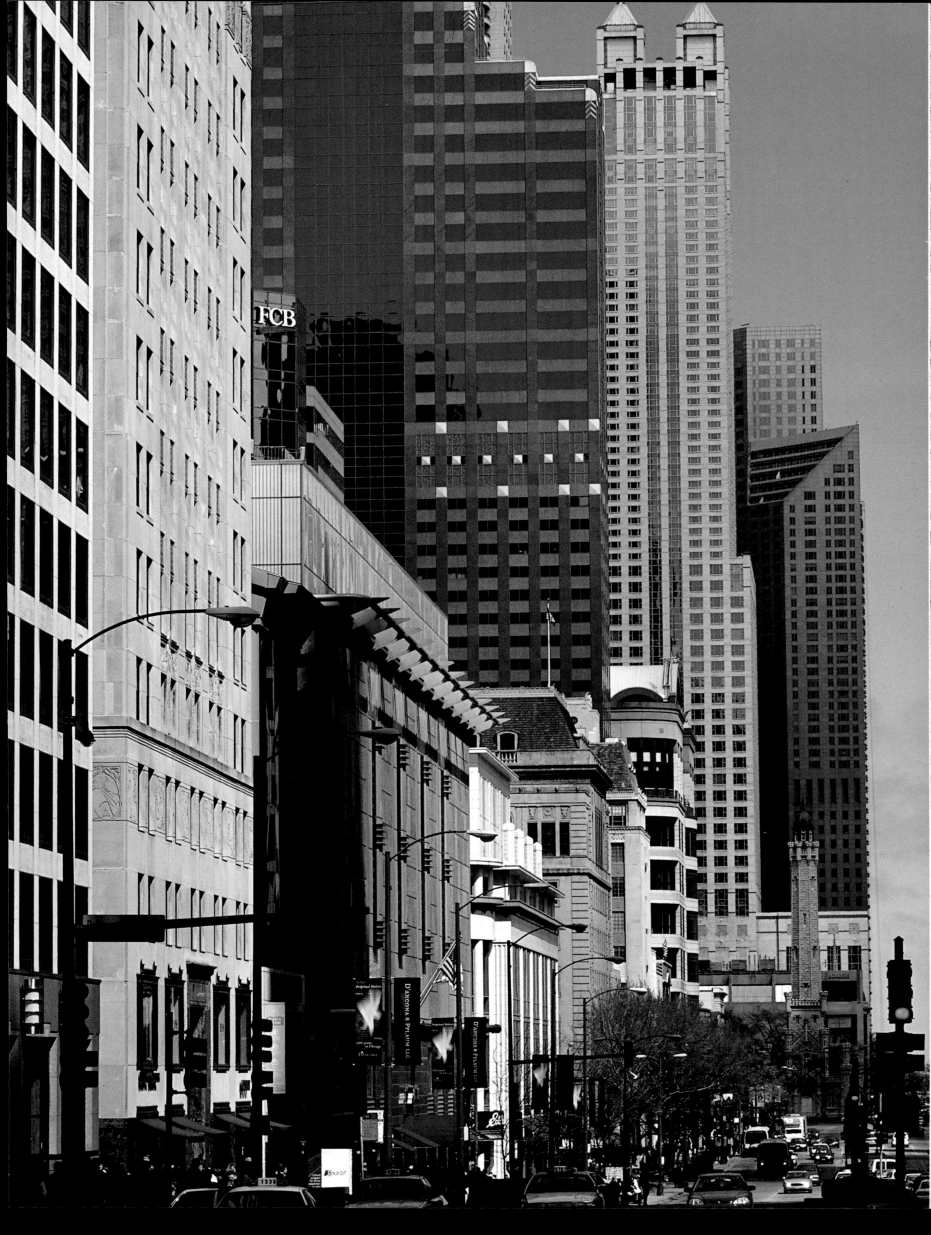

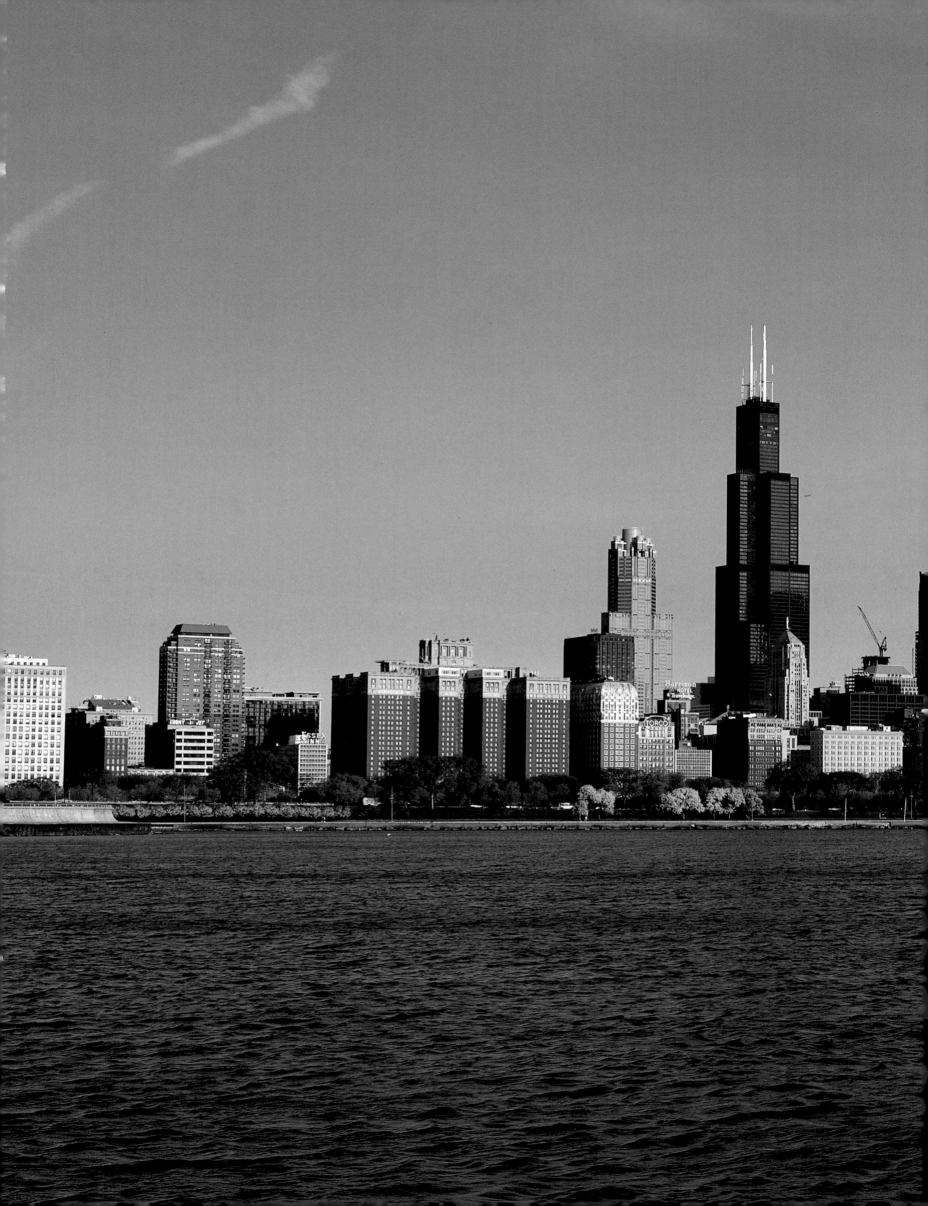

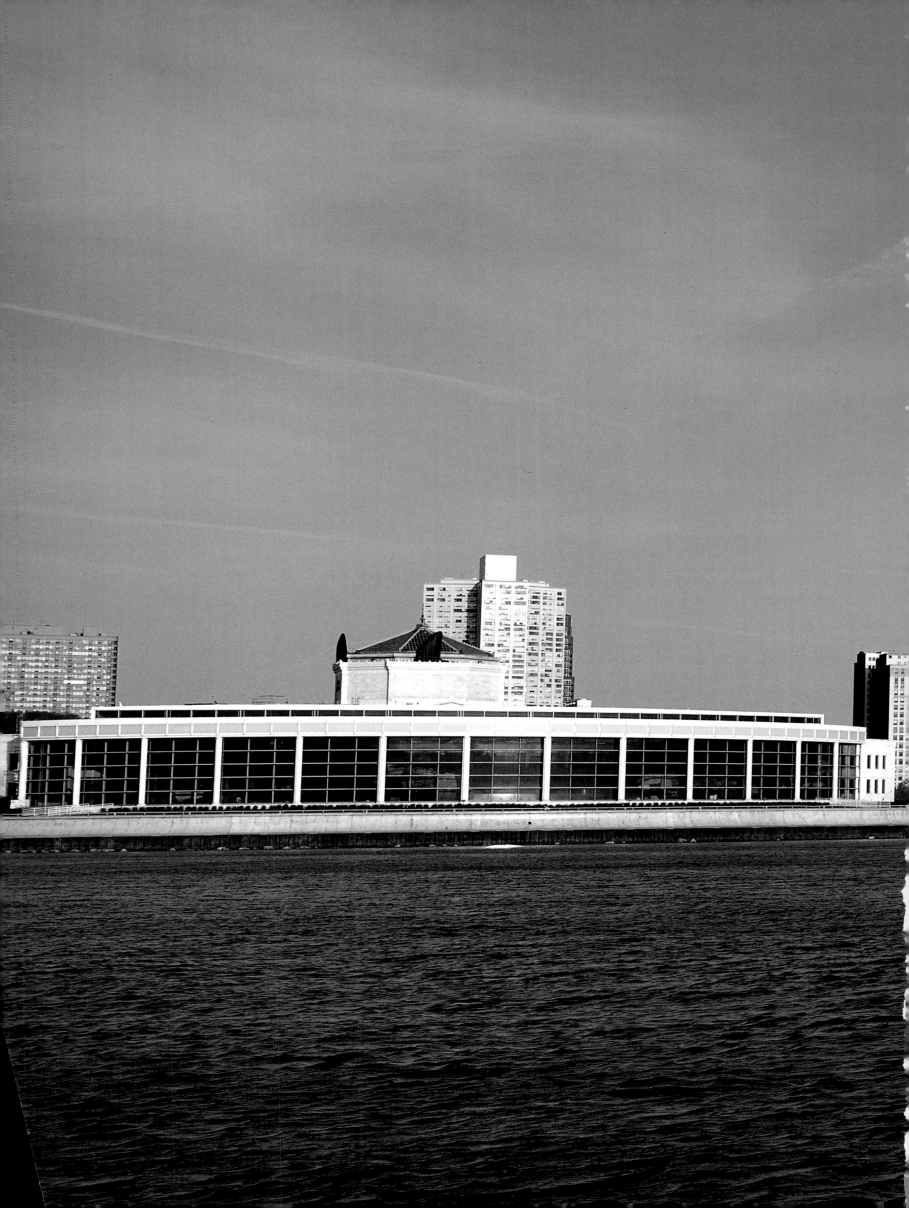

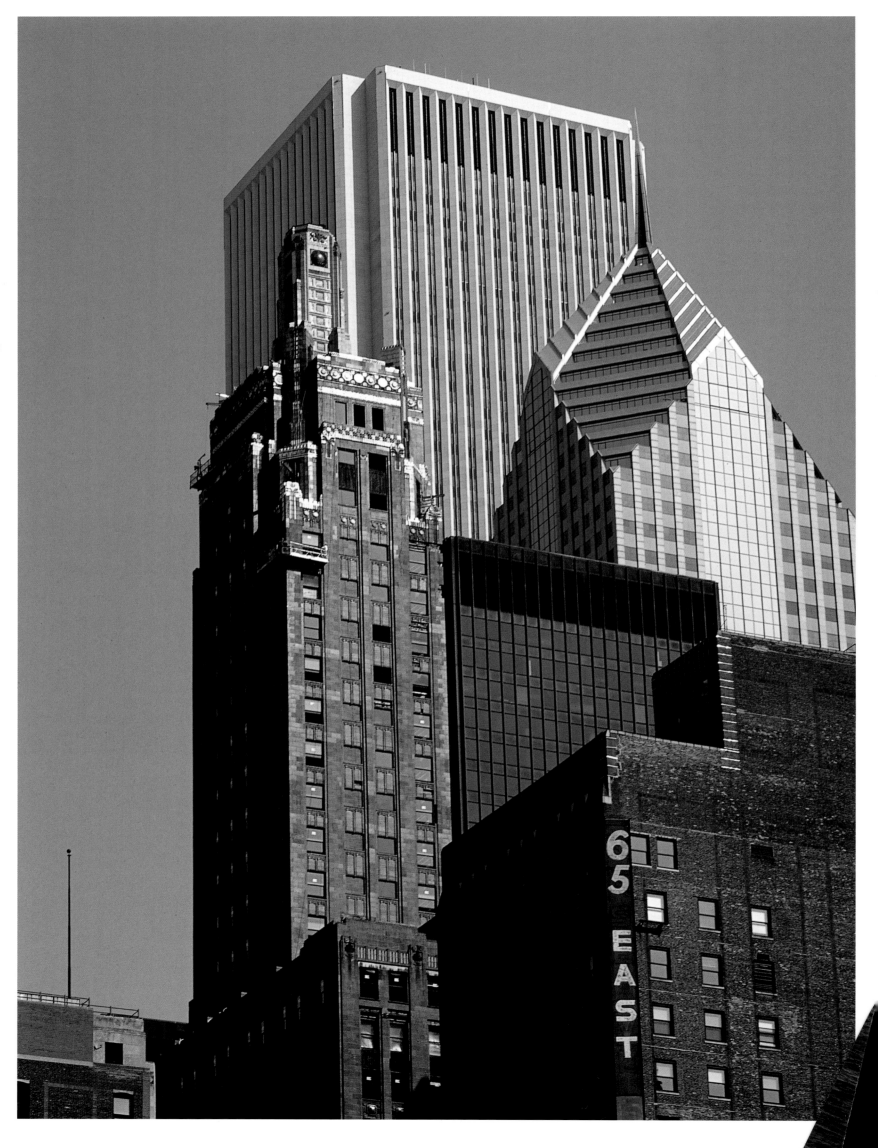

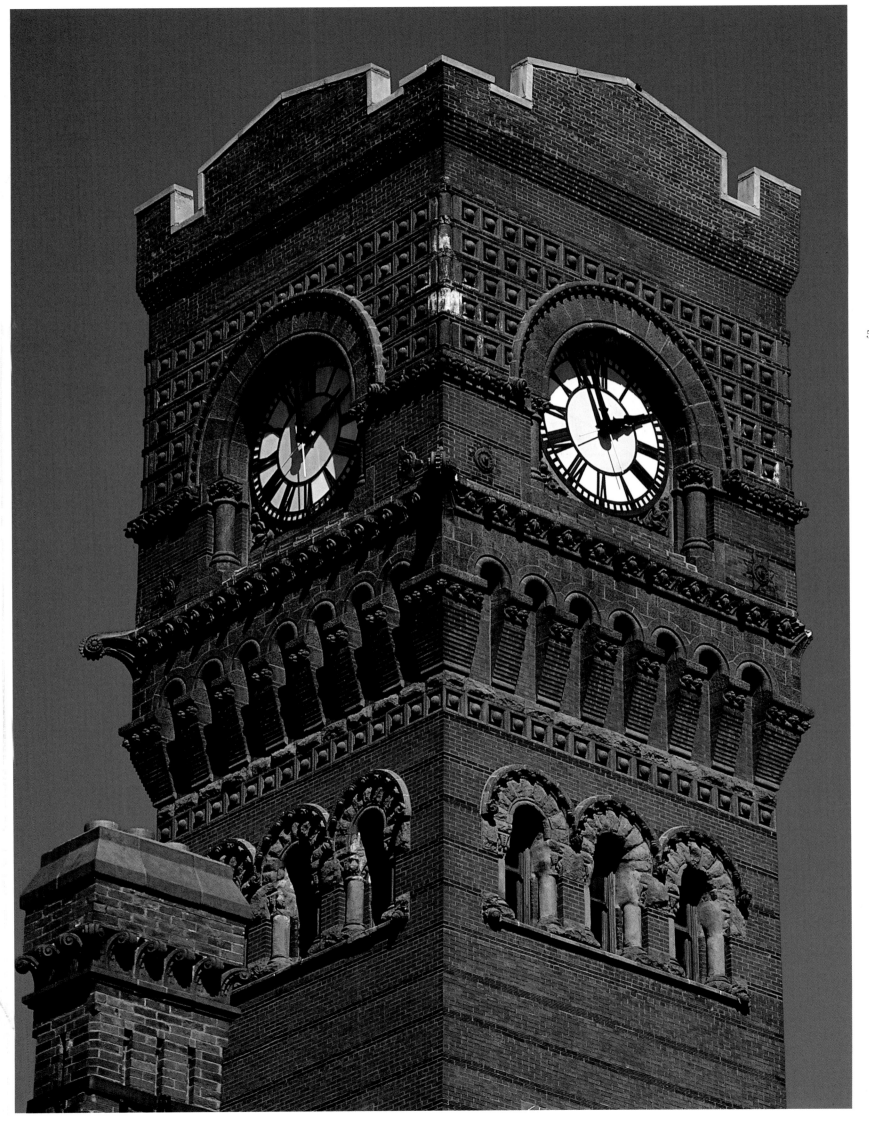

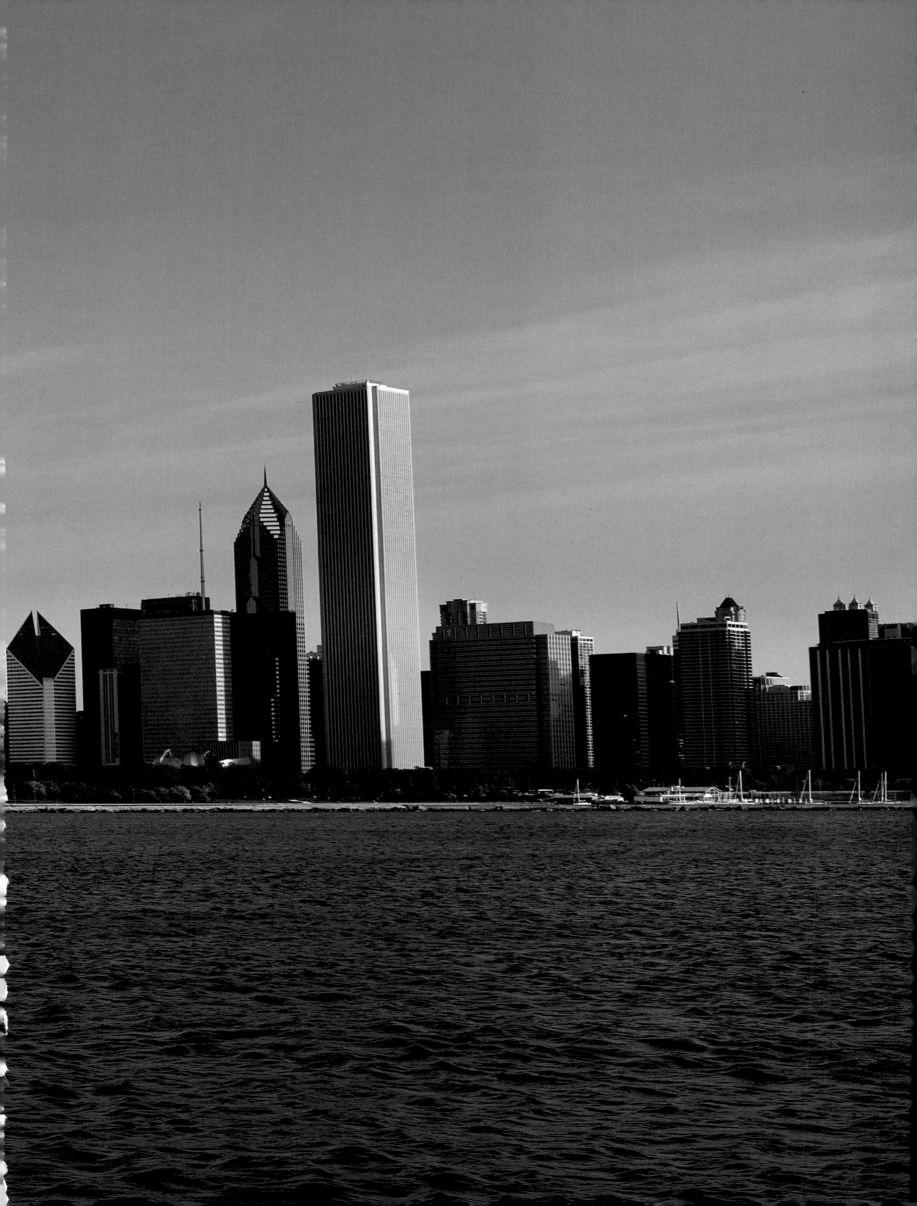

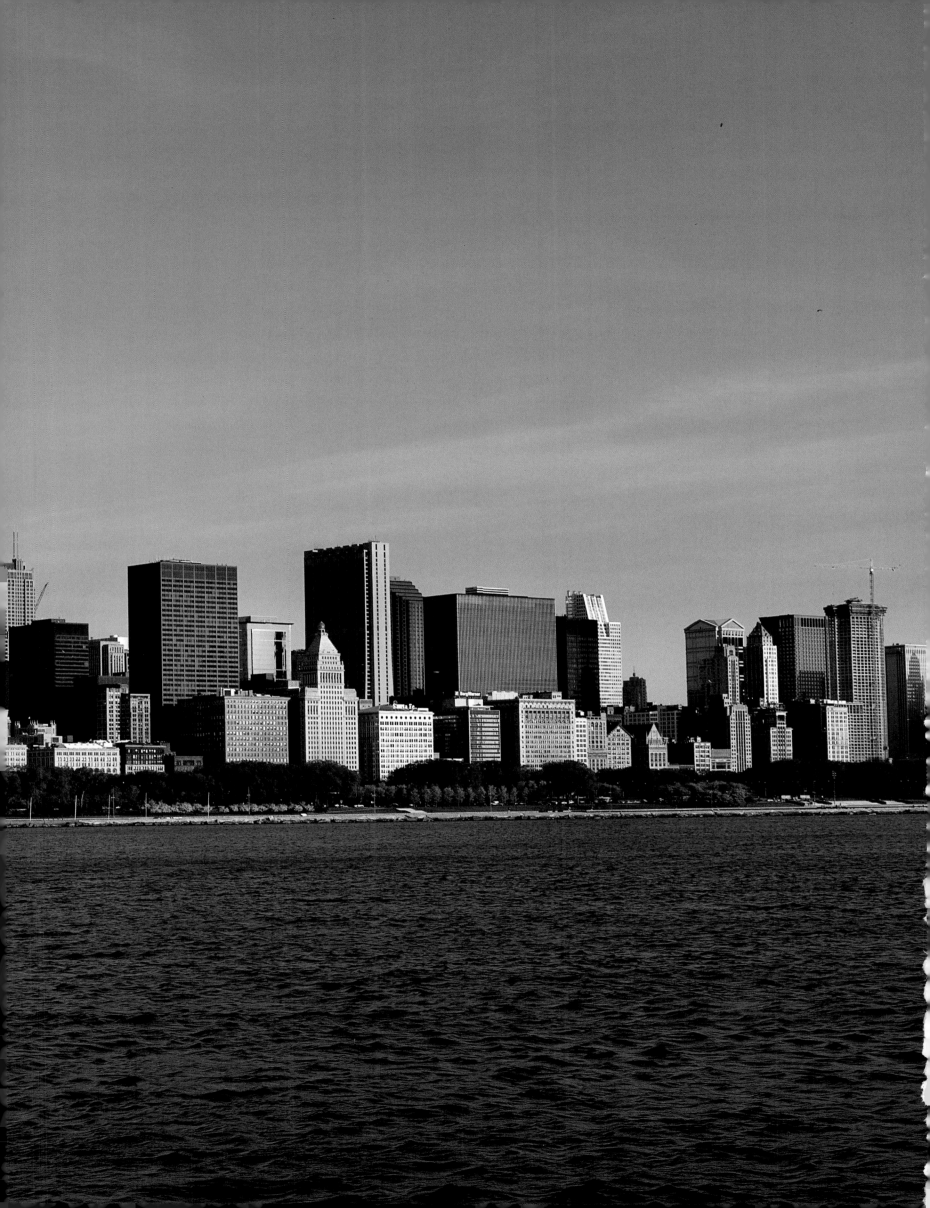

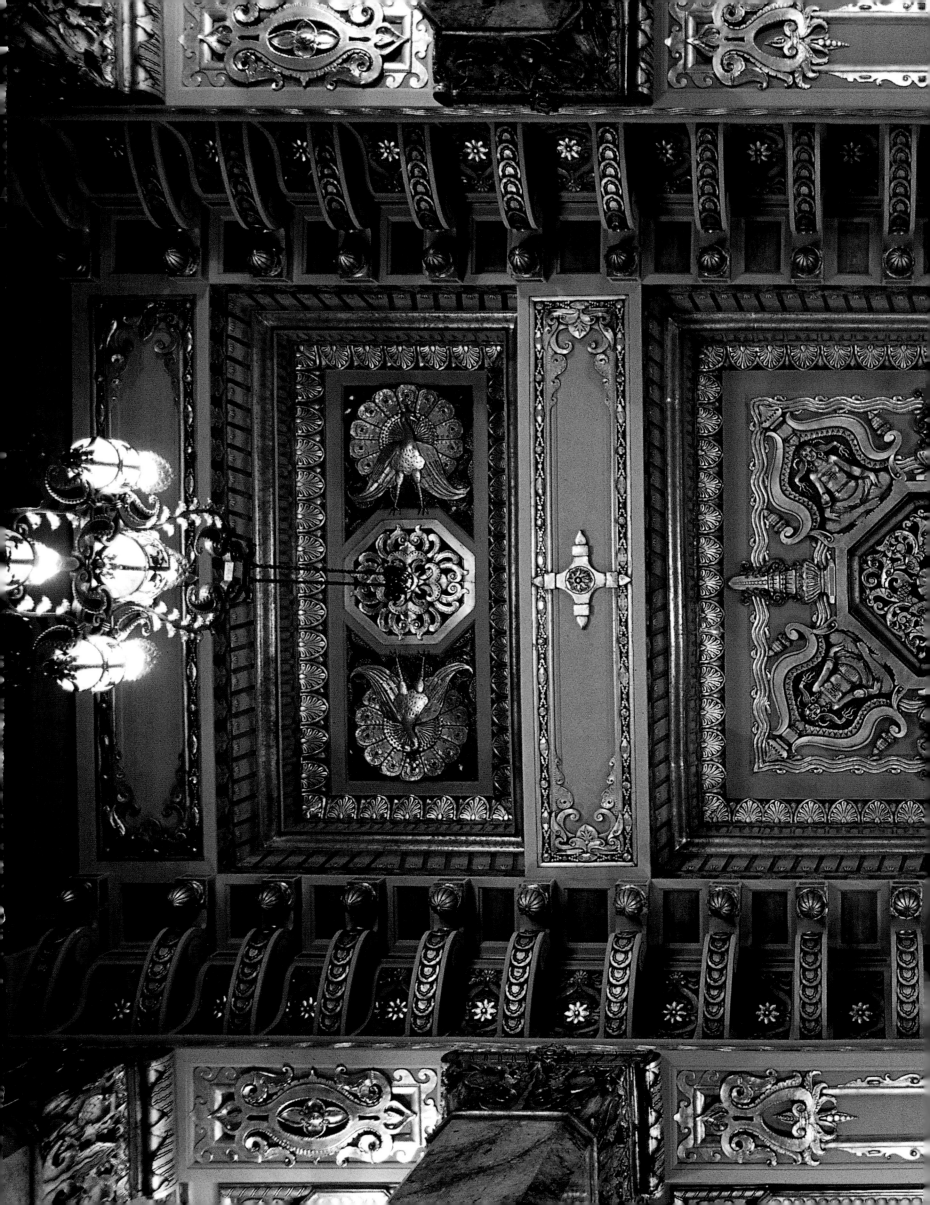

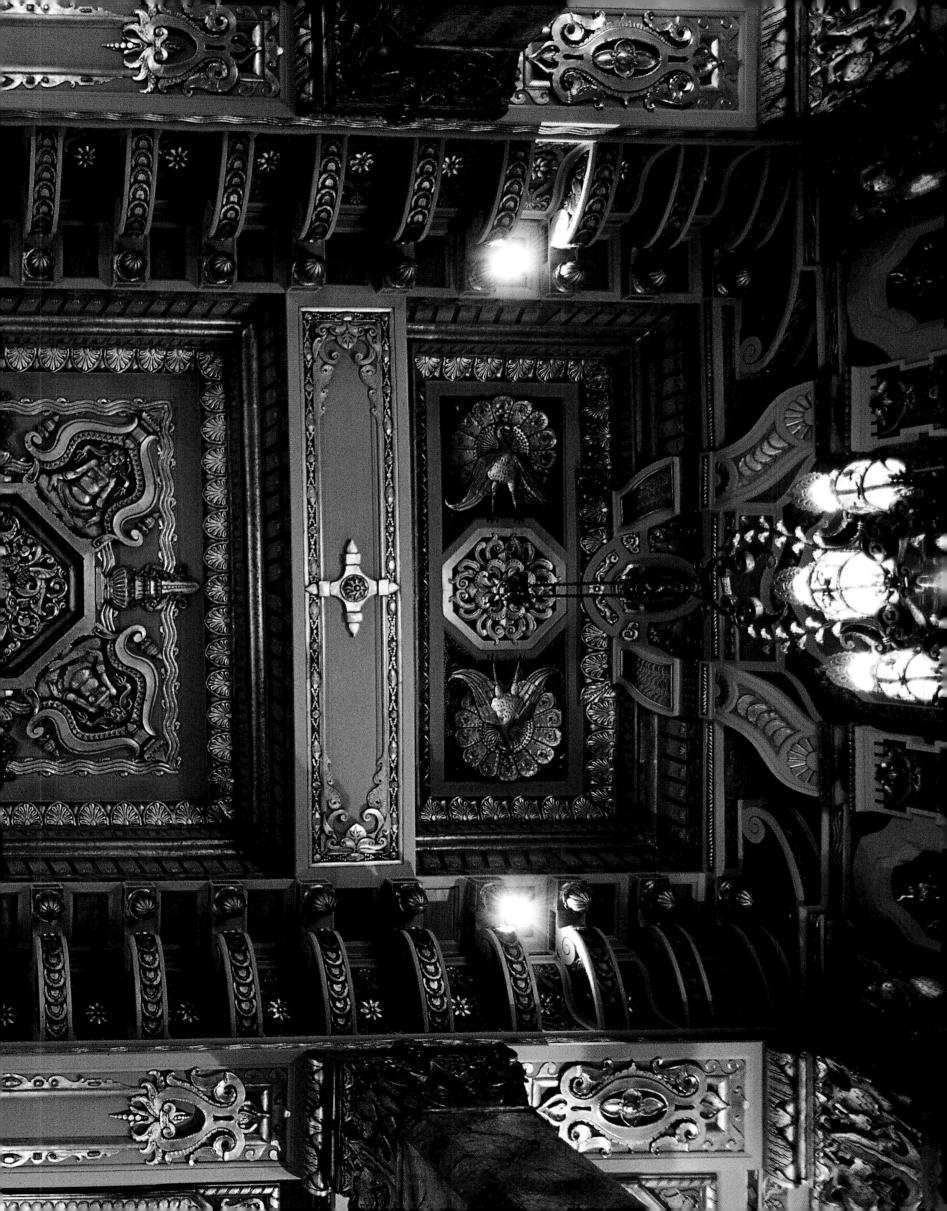

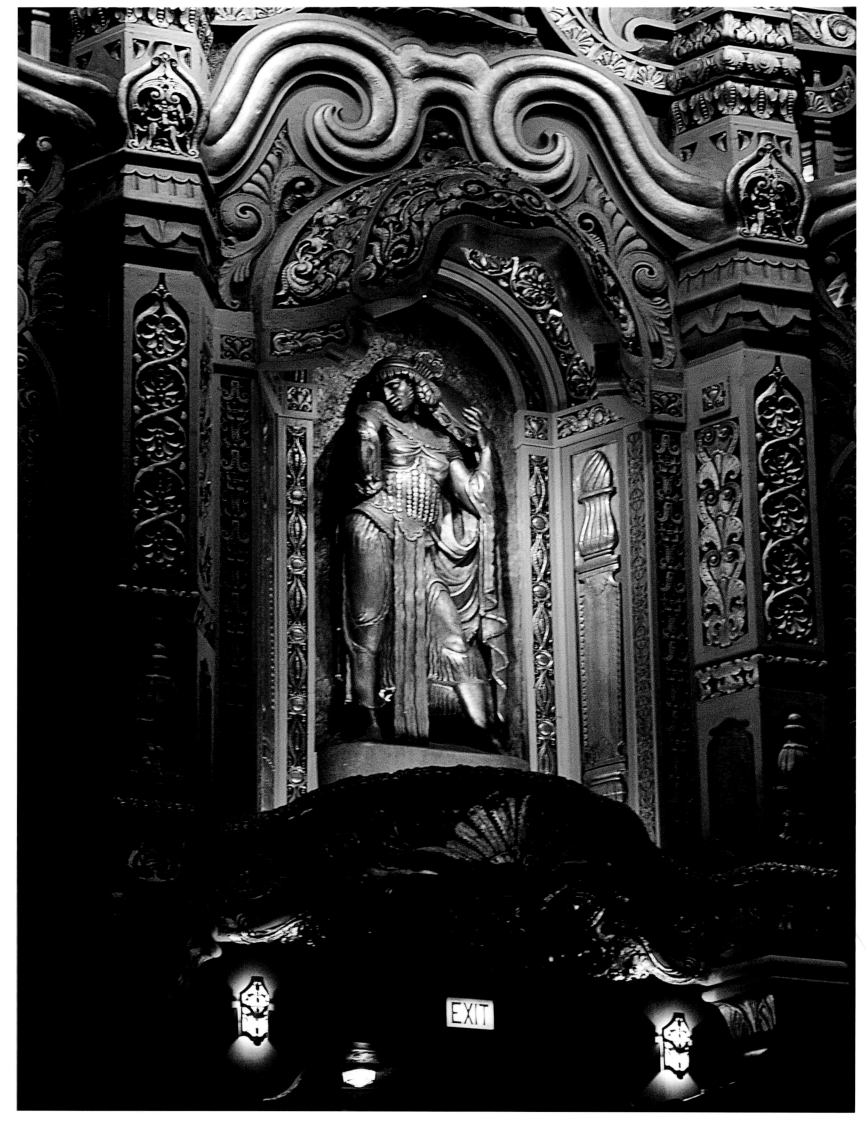

EXIT

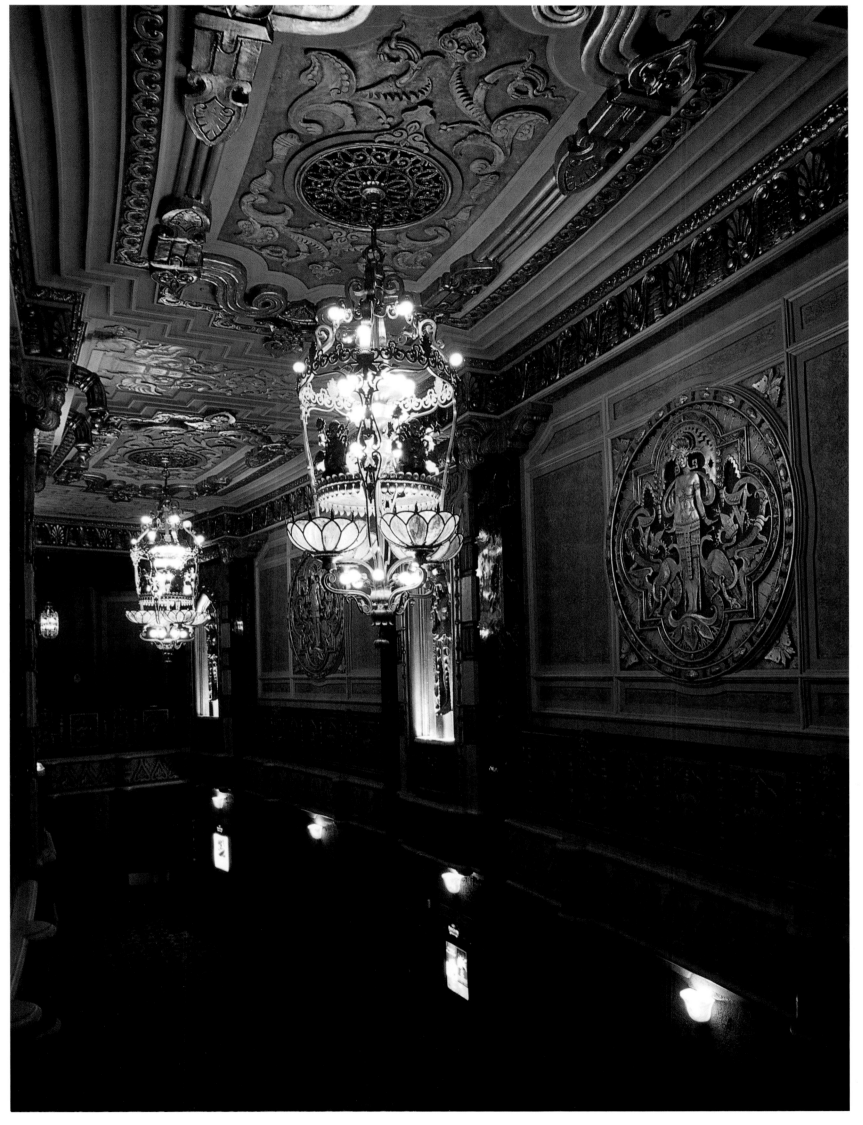

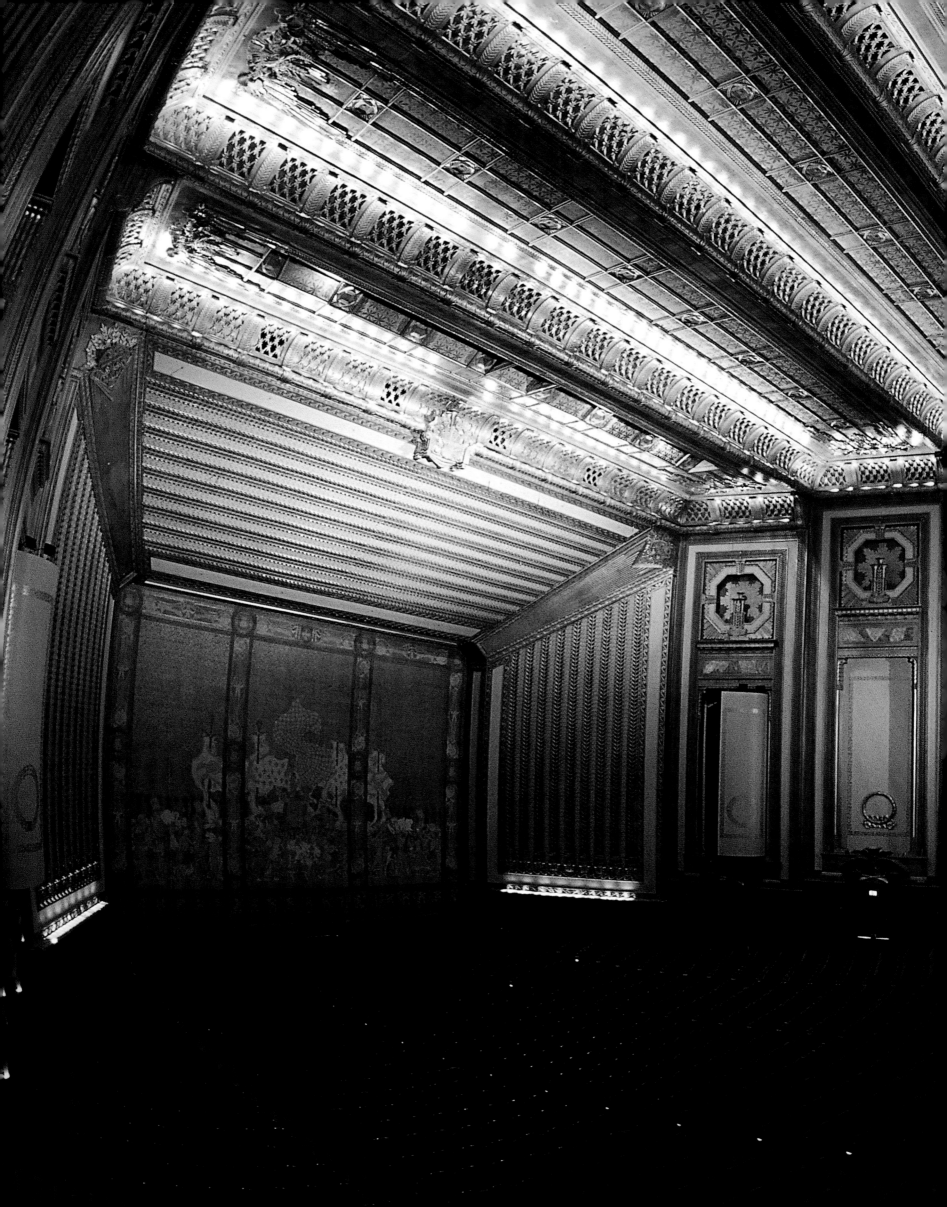

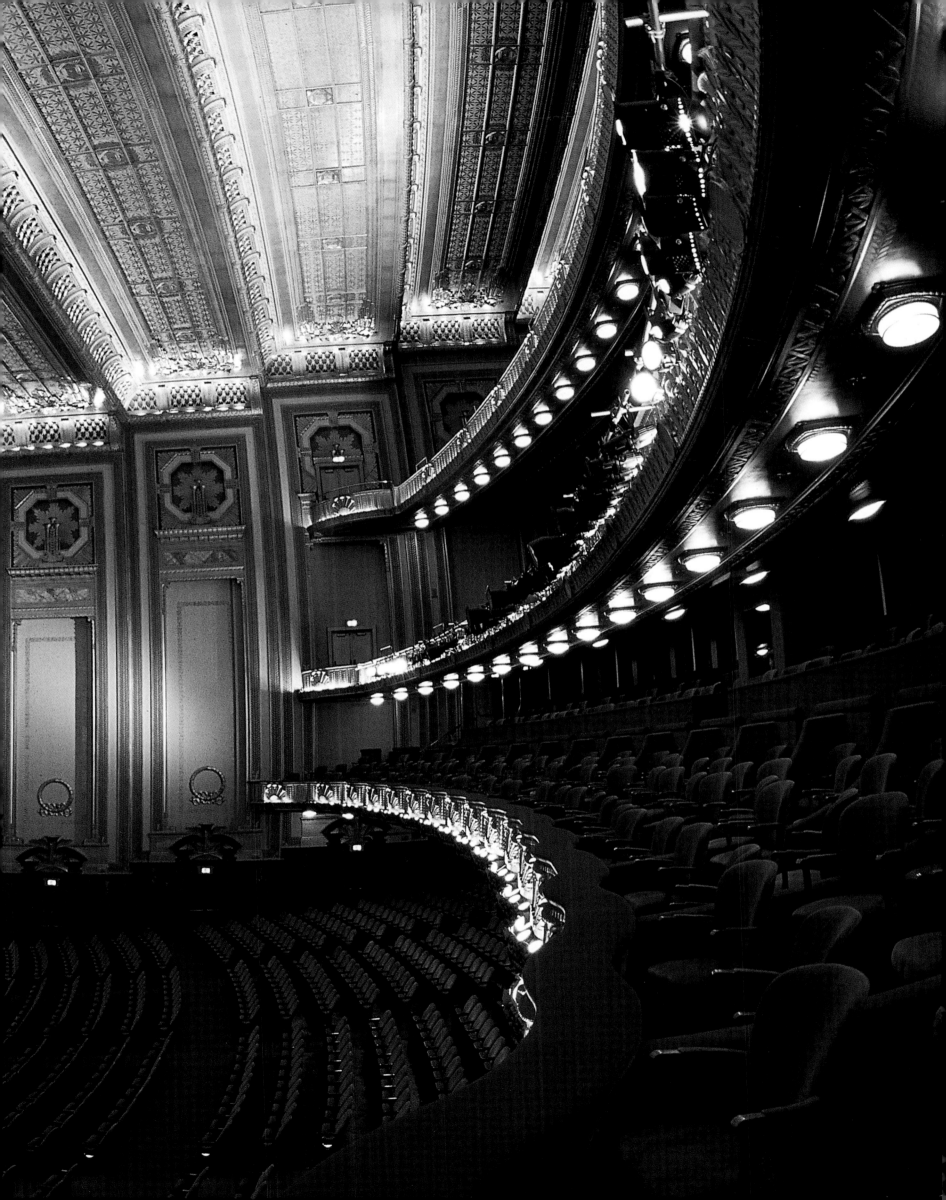

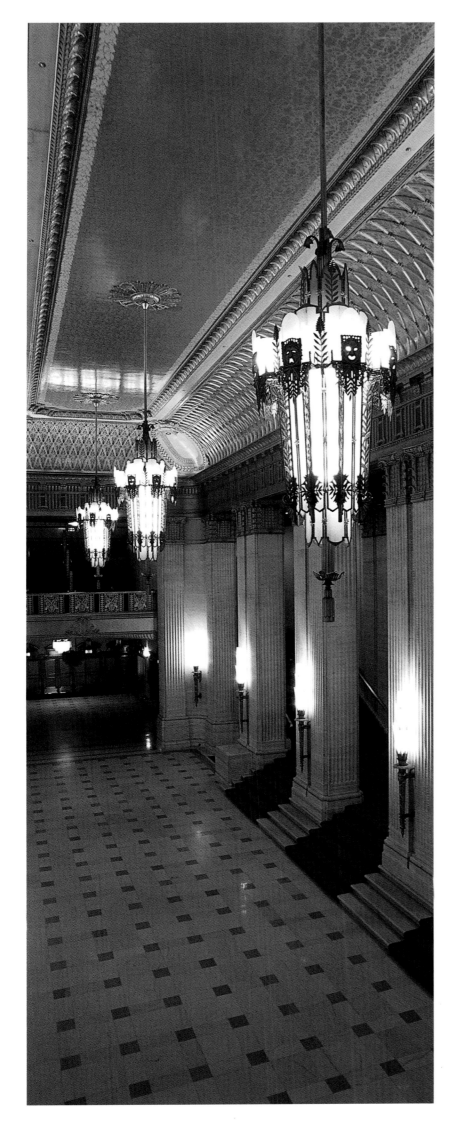
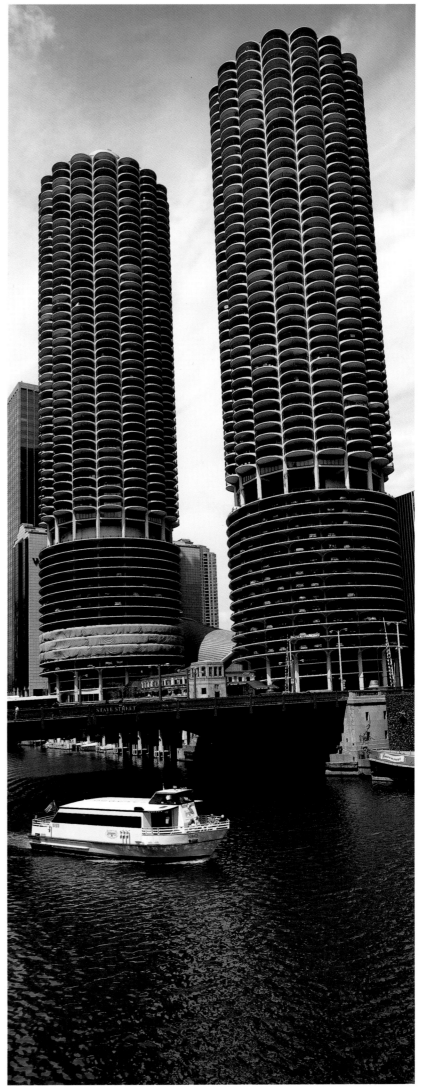

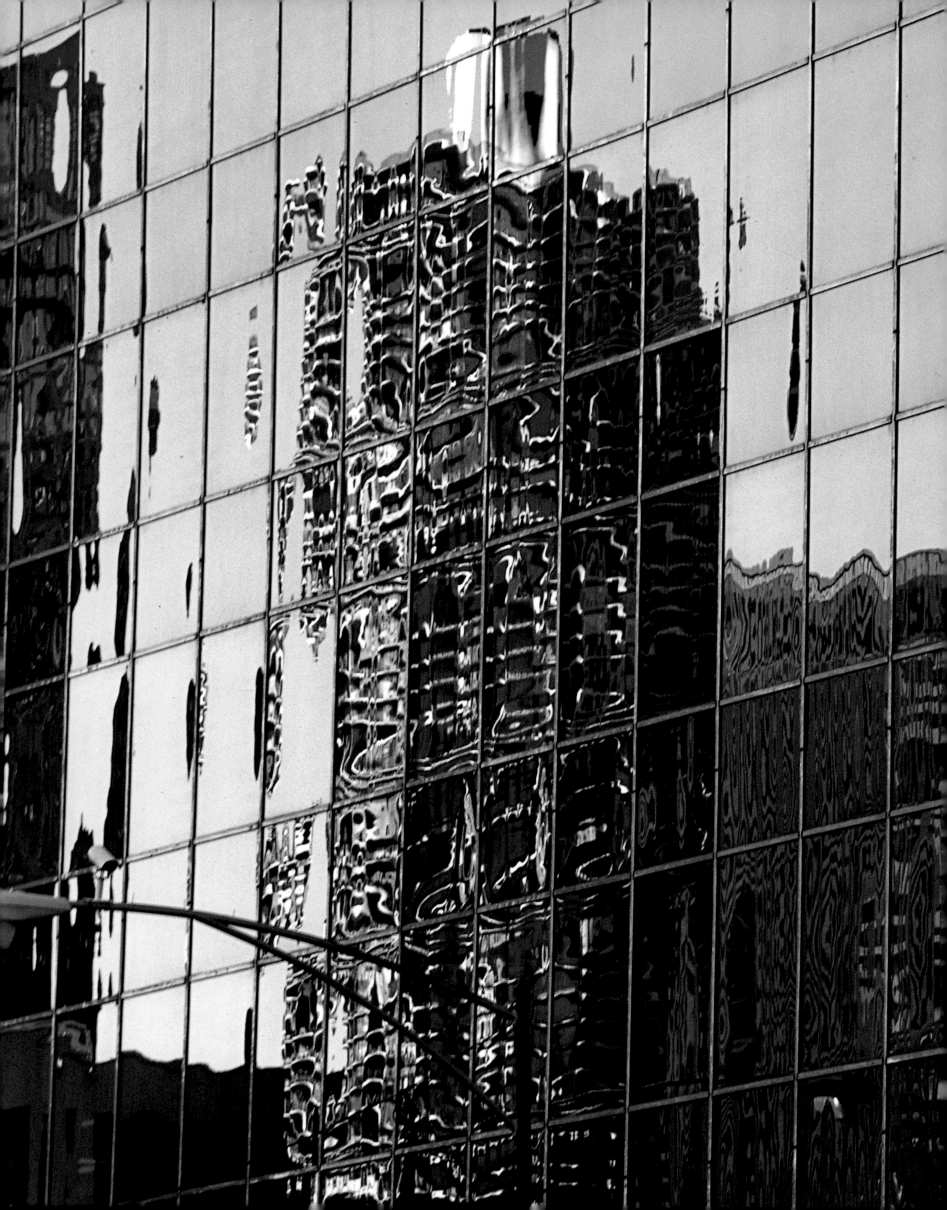

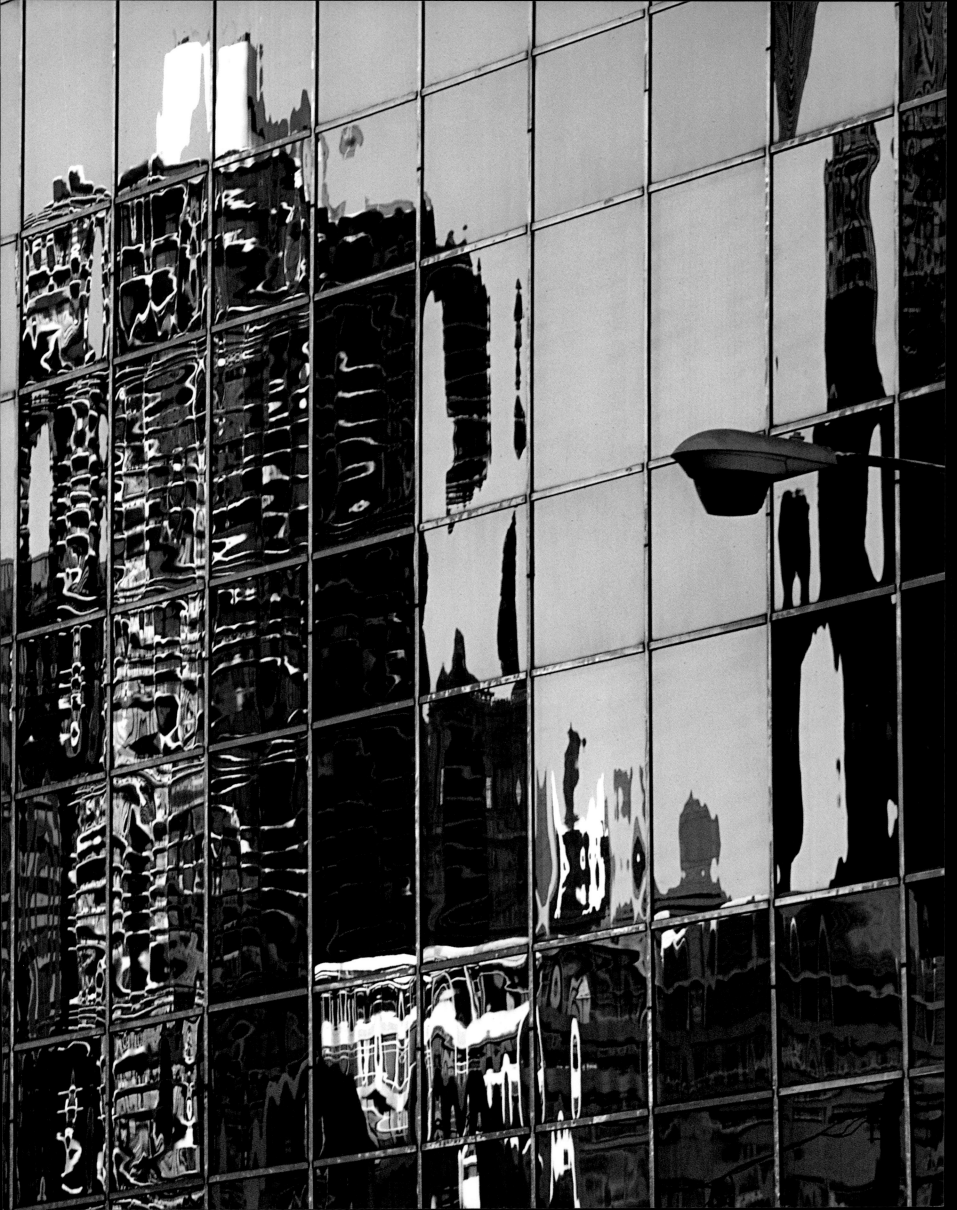

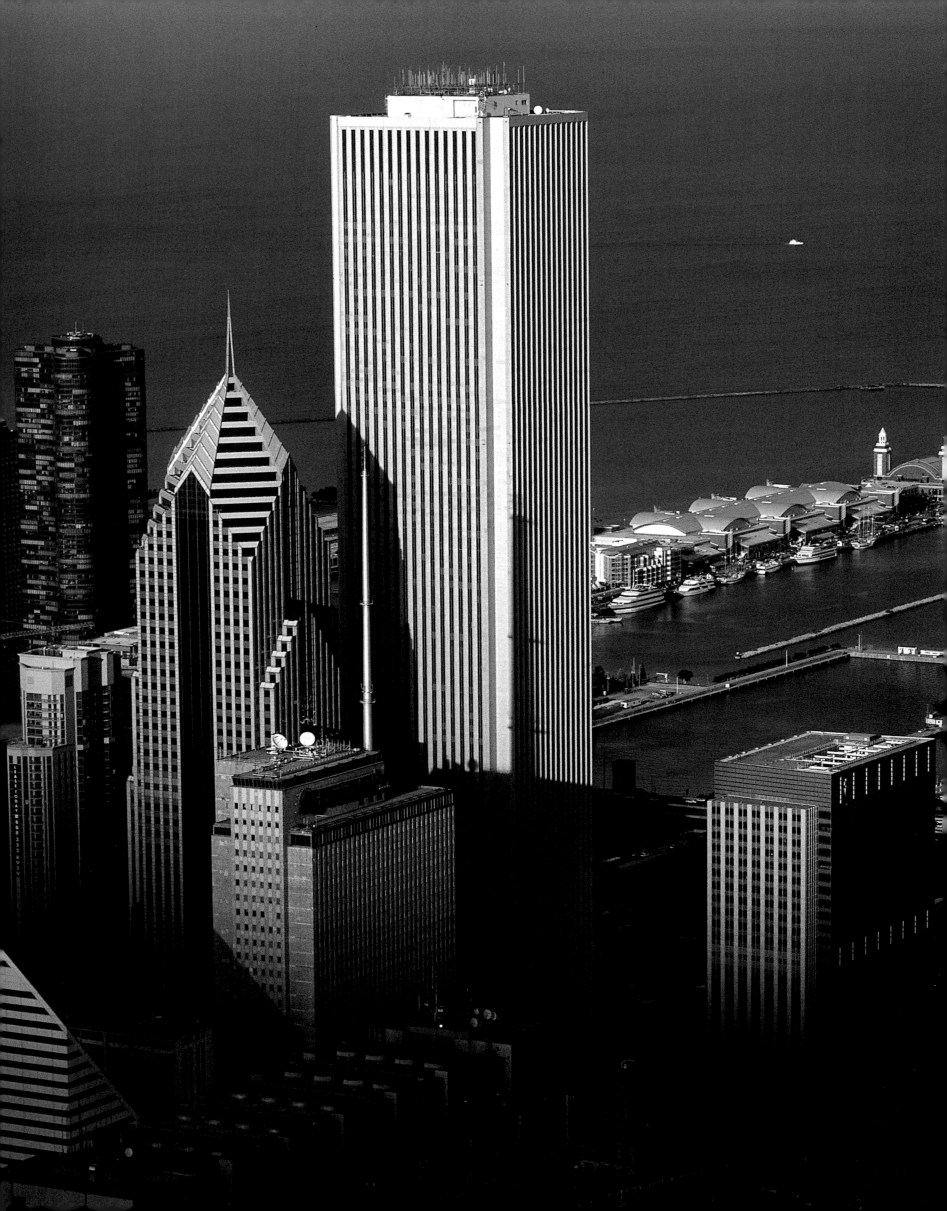

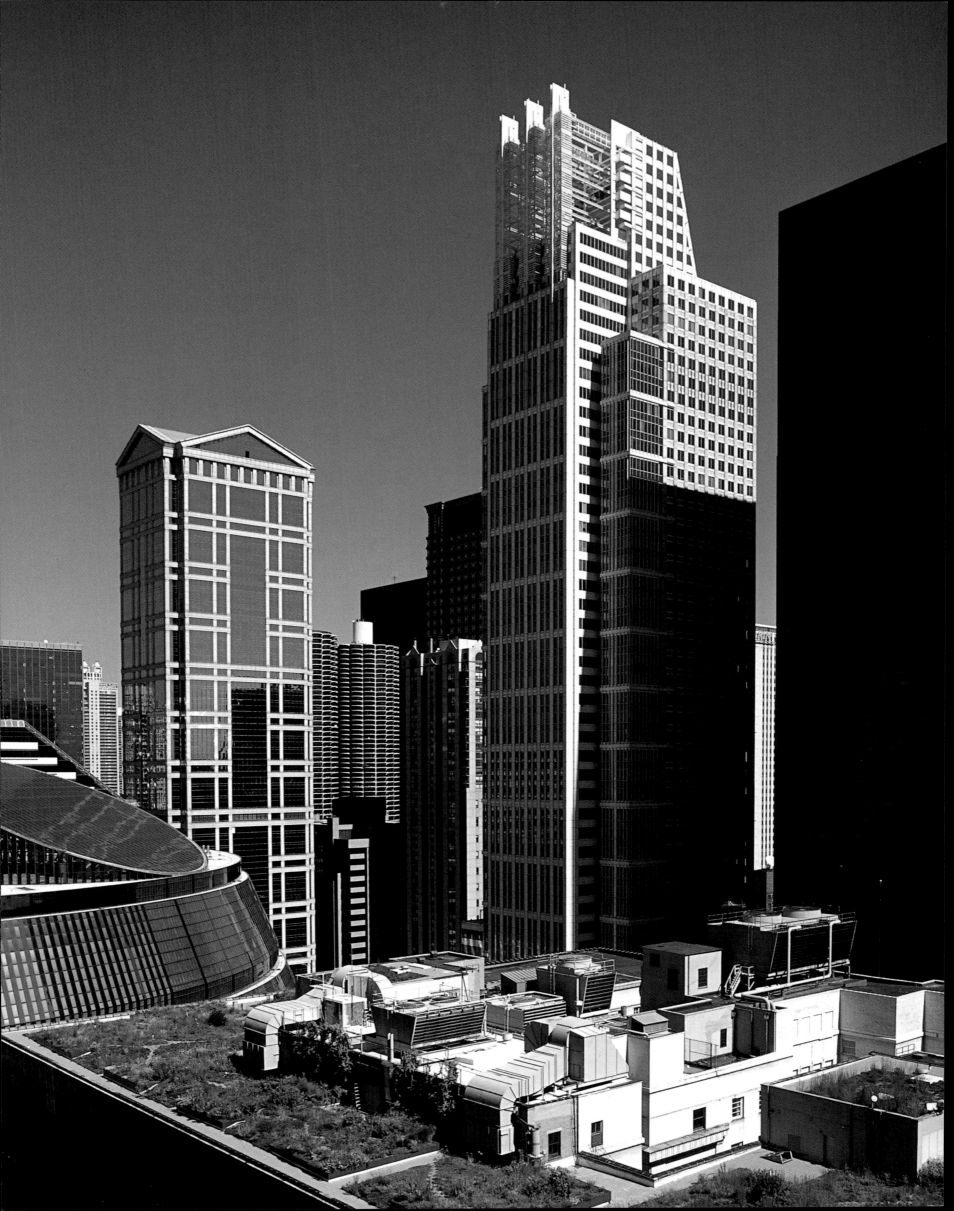

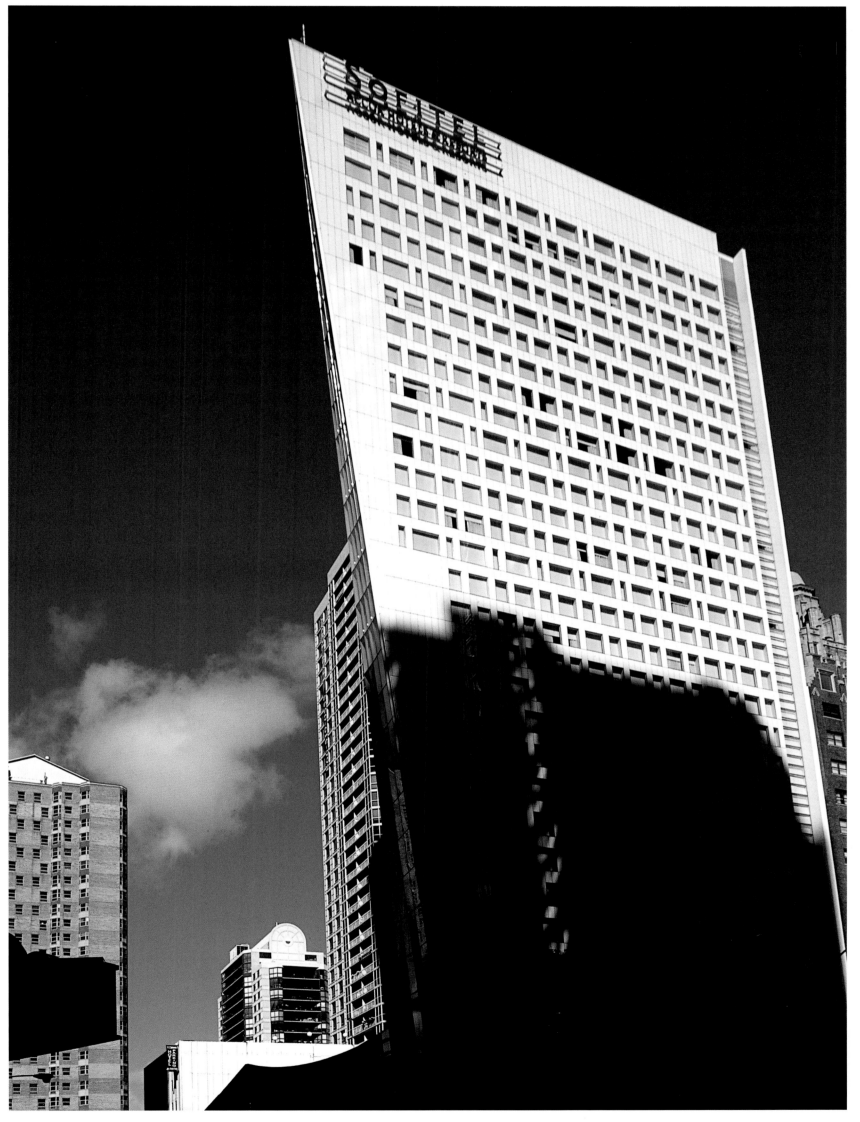

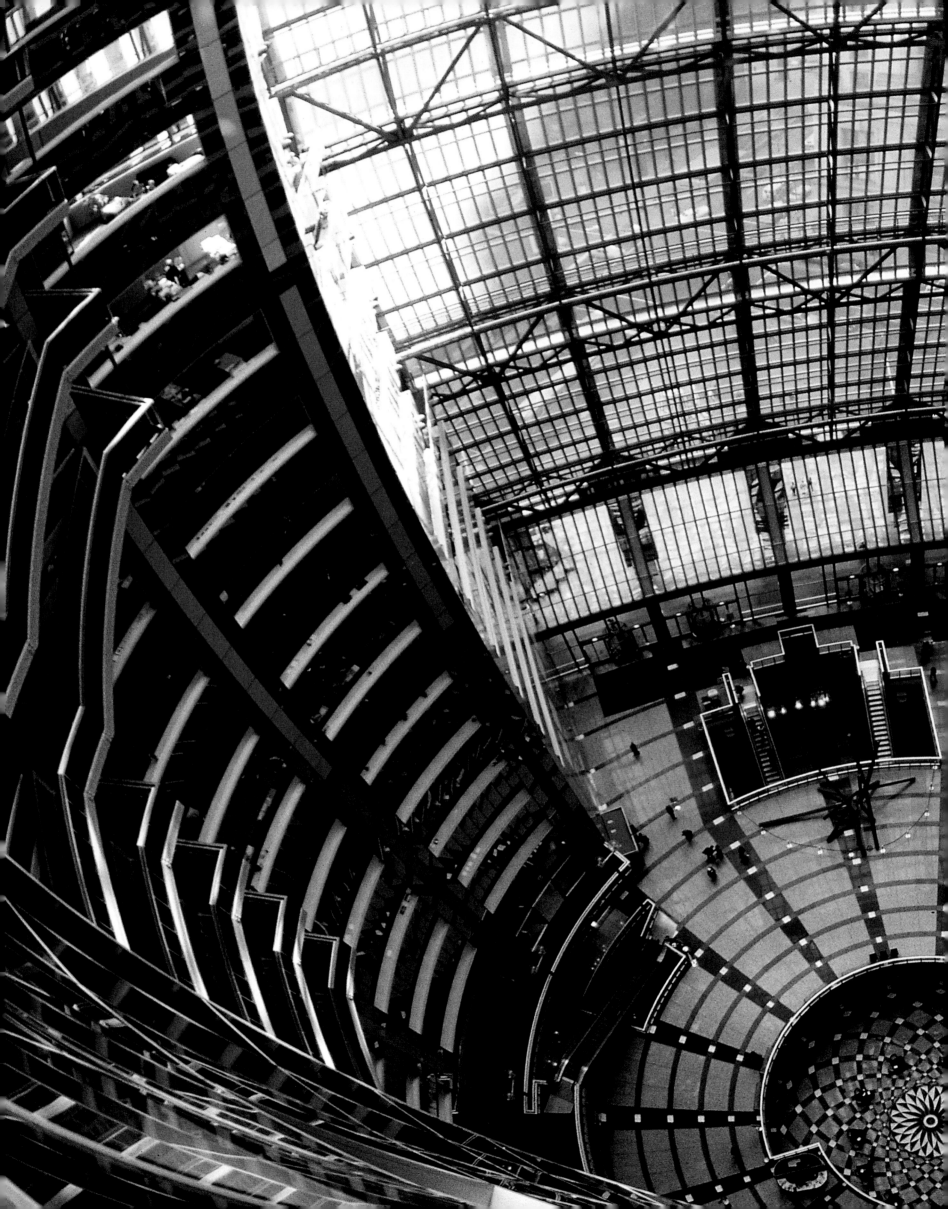

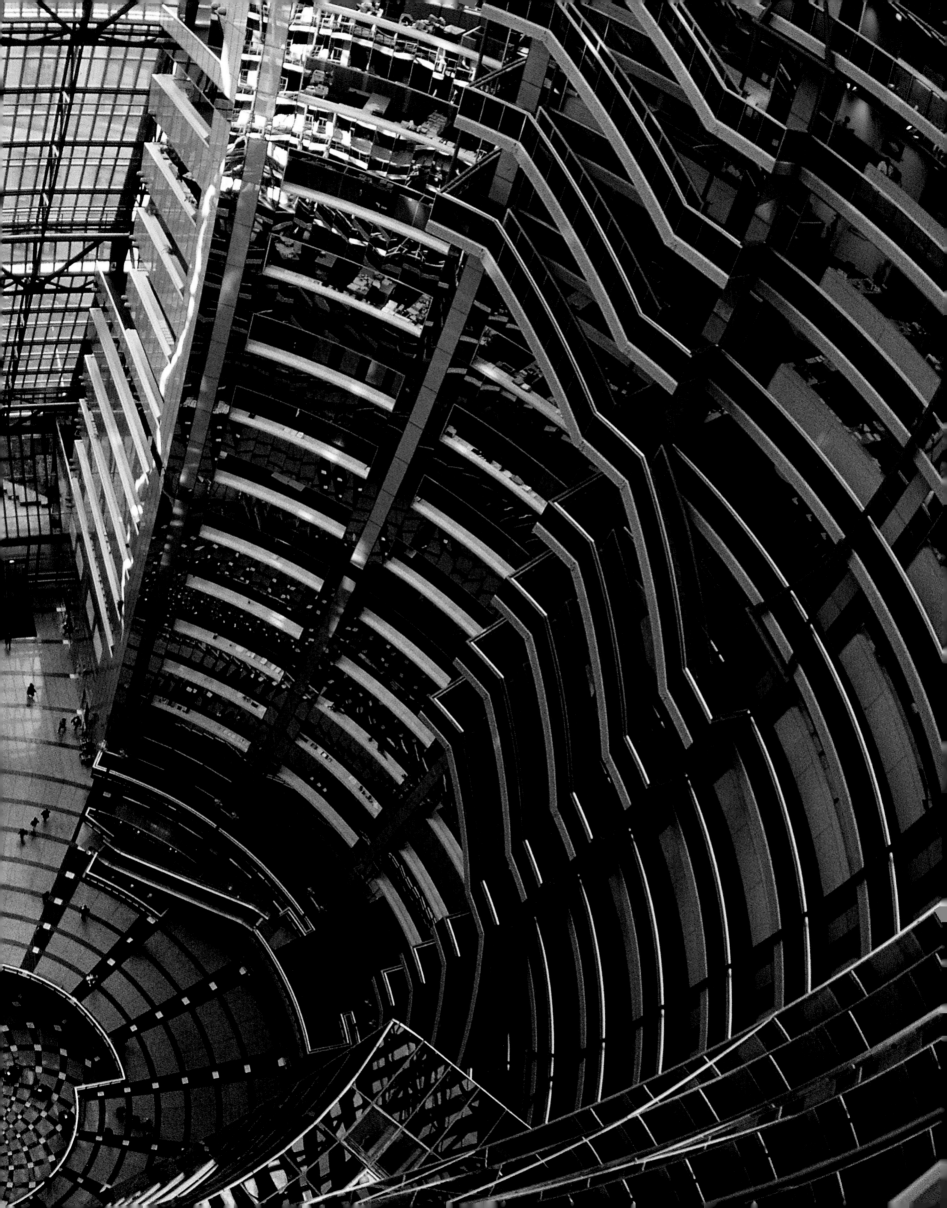

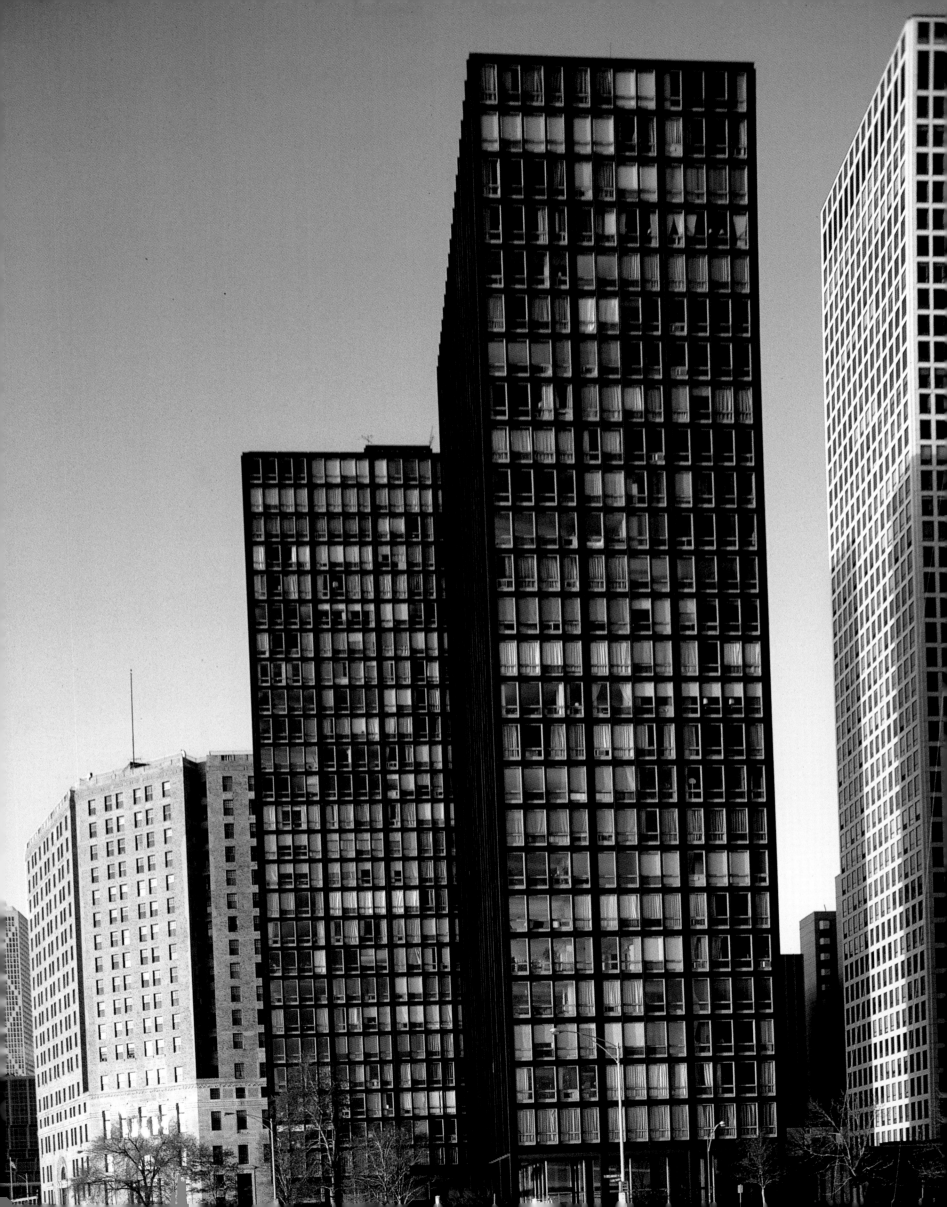

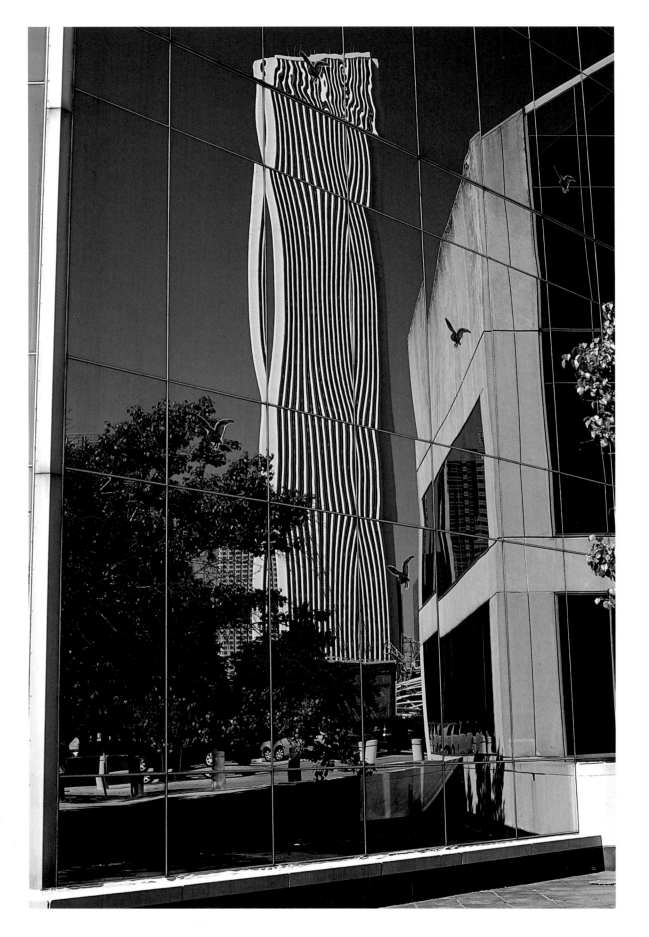
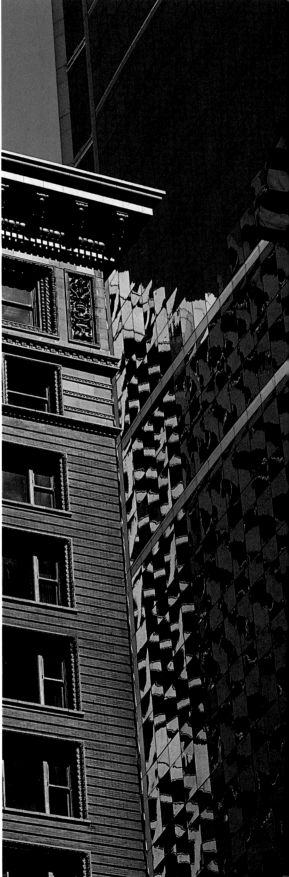

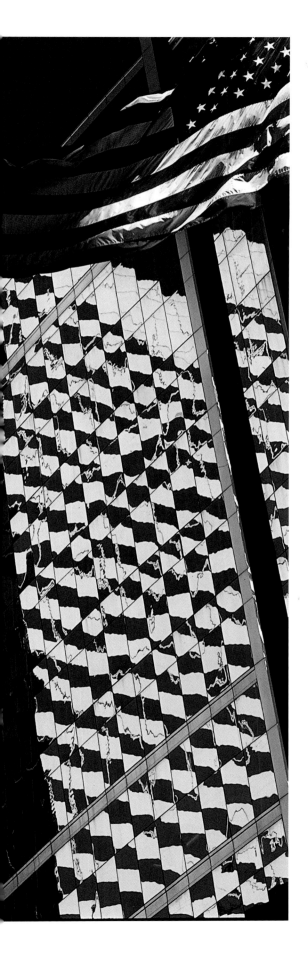
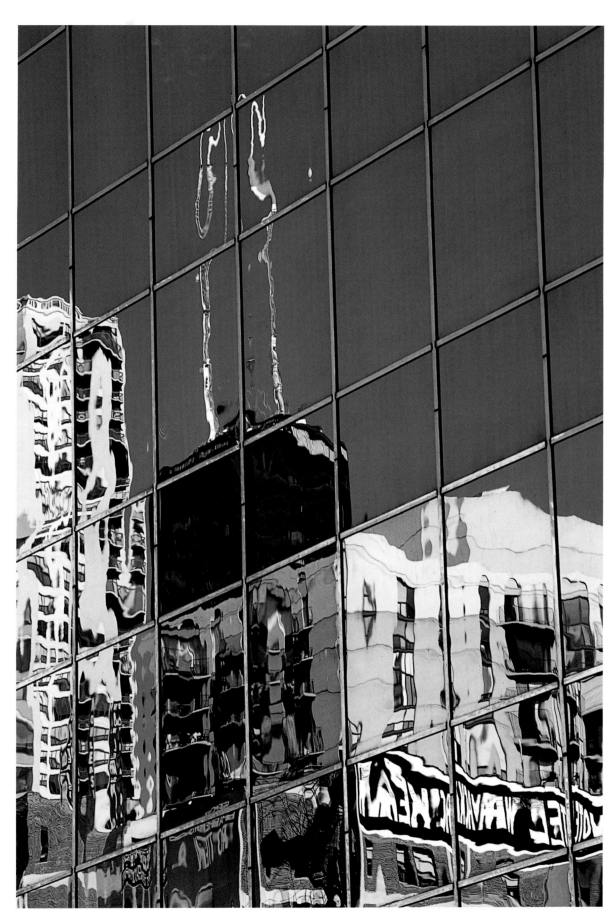

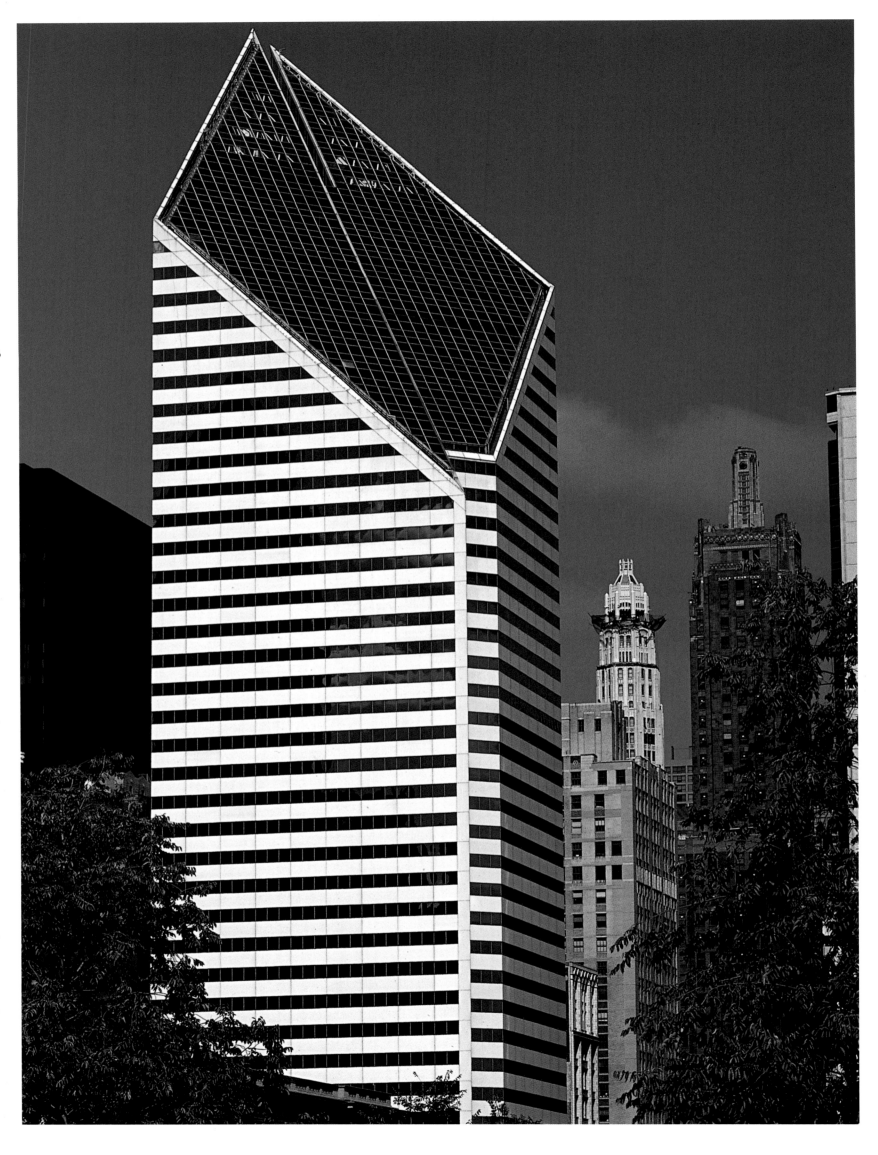

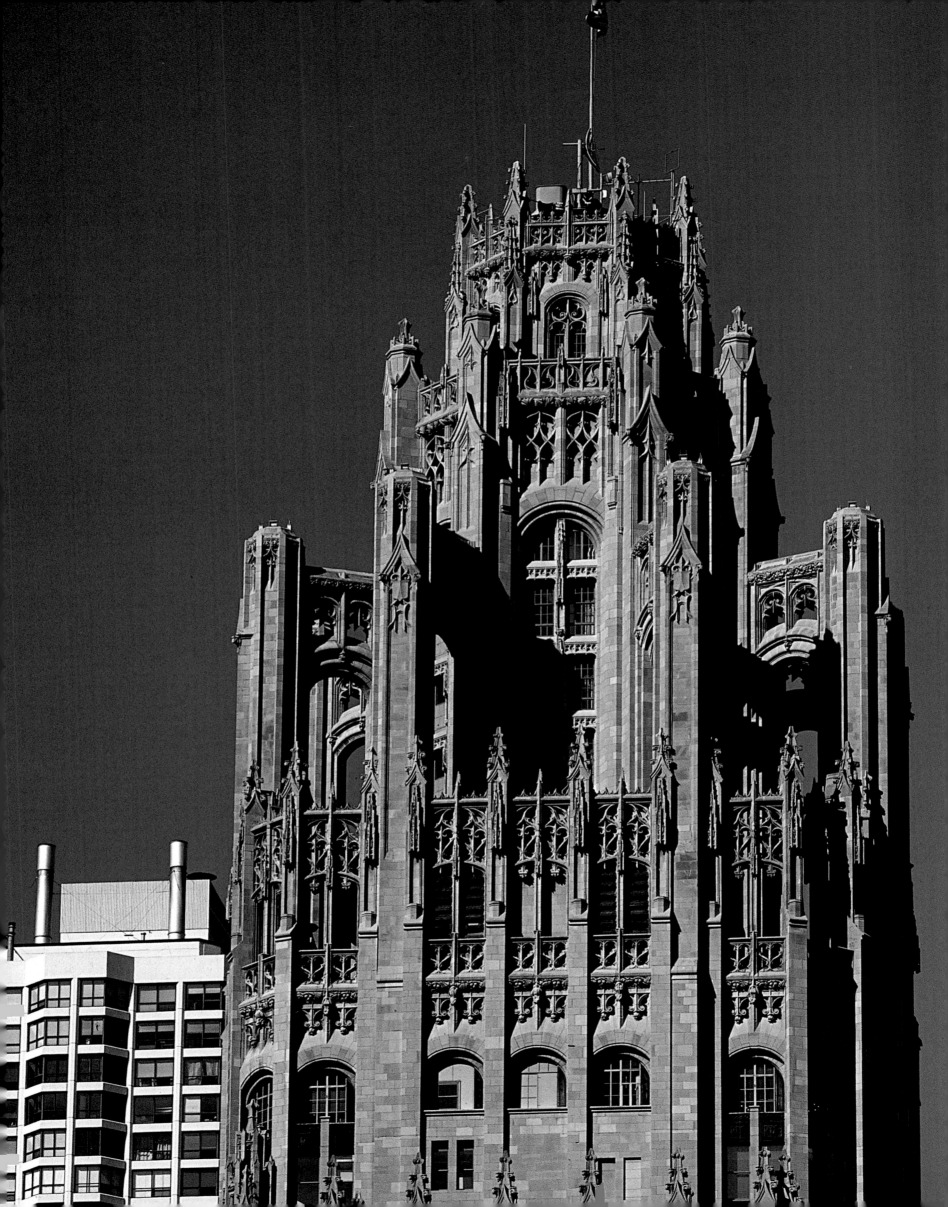

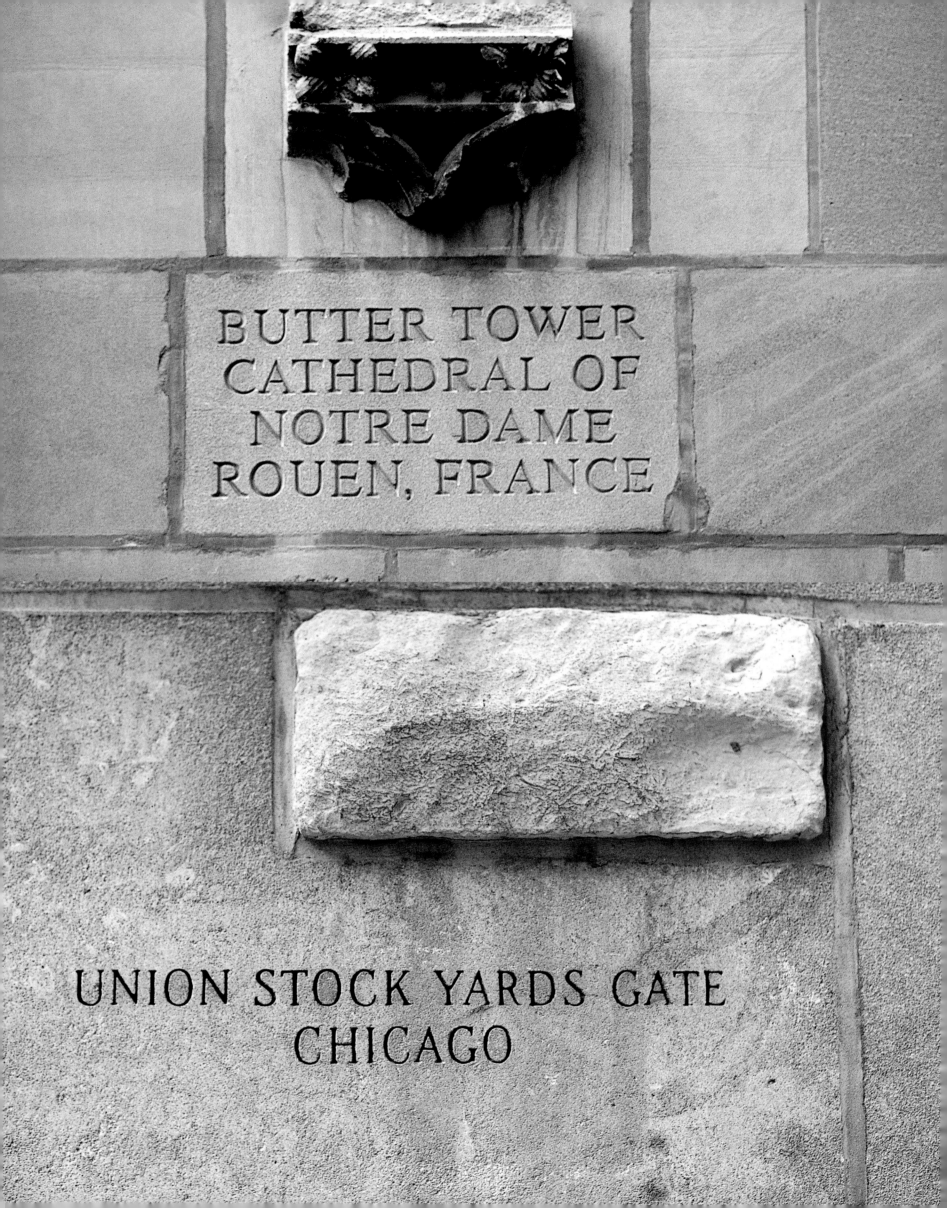

BUTTER TOWER
CATHEDRAL OF
NOTRE DAME
ROUEN, FRANCE

UNION STOCK YARDS GATE
CHICAGO

REIMS CATHEDRAL
REIMS FRANCE

HOLY DOOR
ST. PETER'S
ROME

R·F·S·P

A·IVBILÆI
MCM

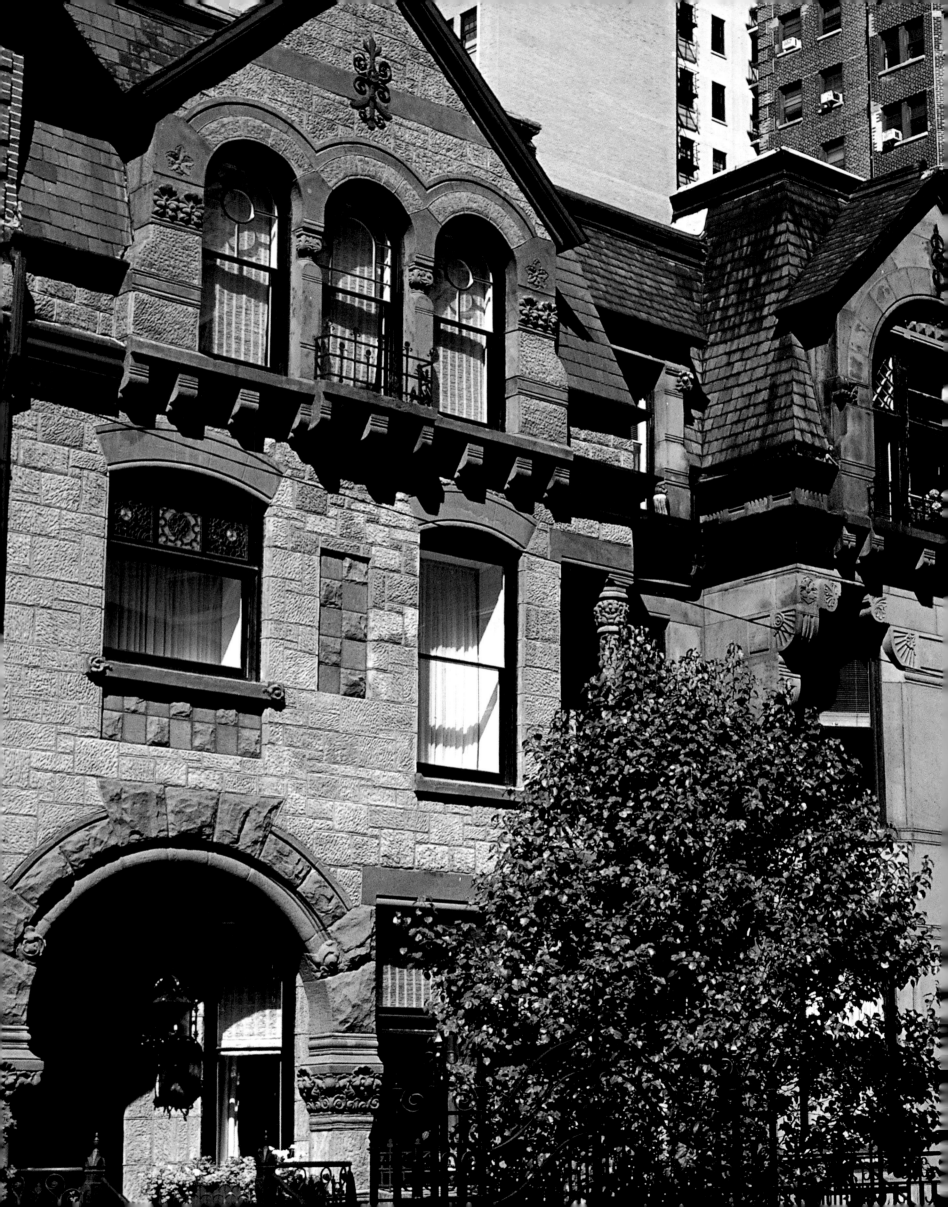

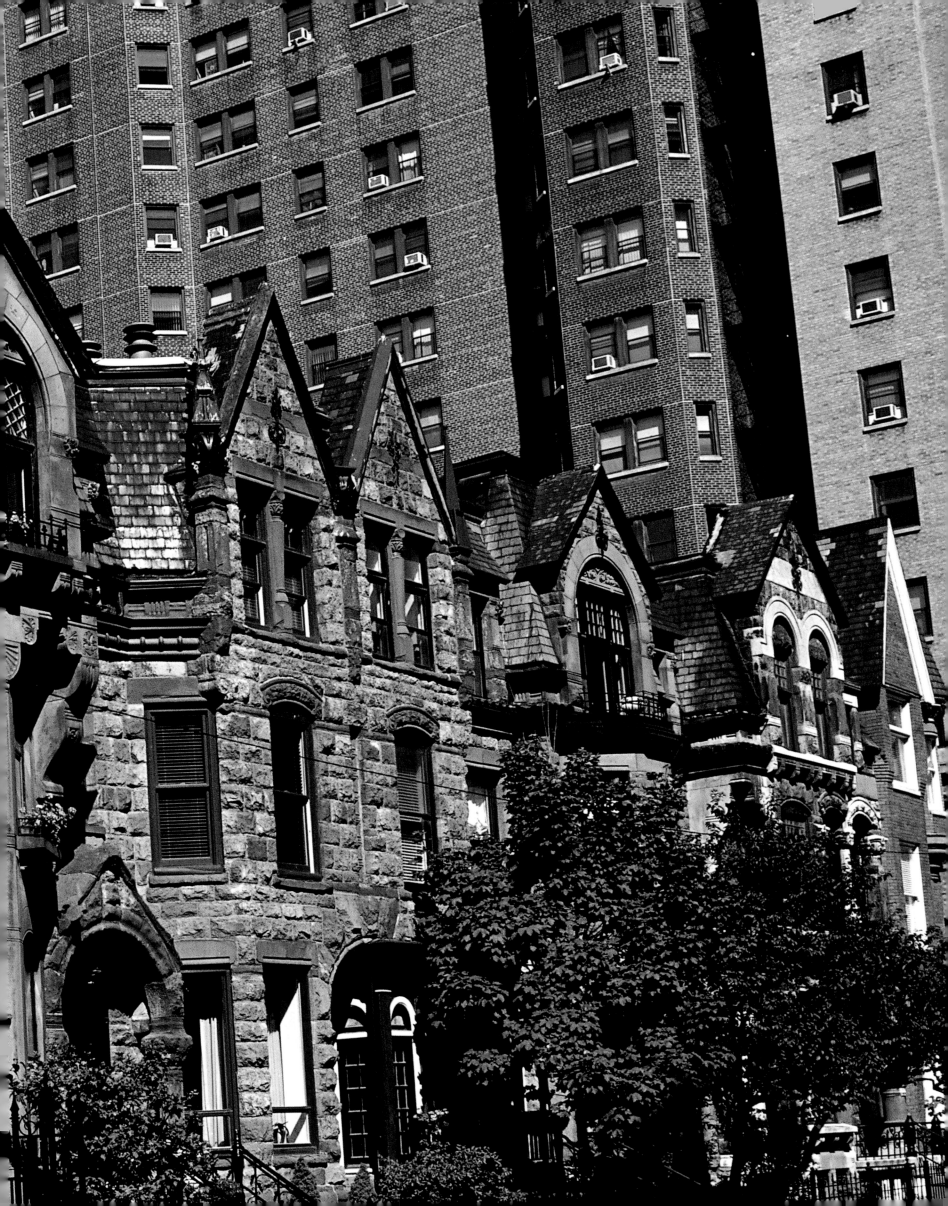

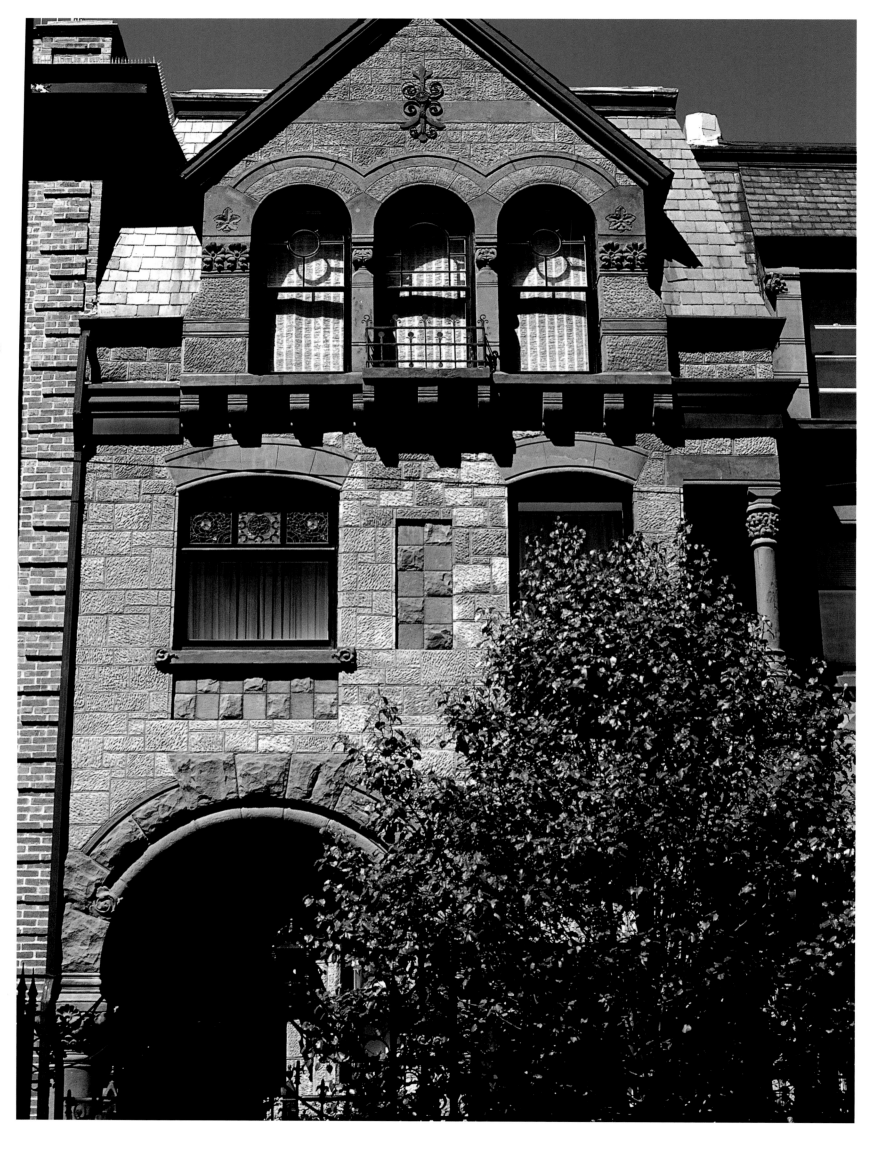

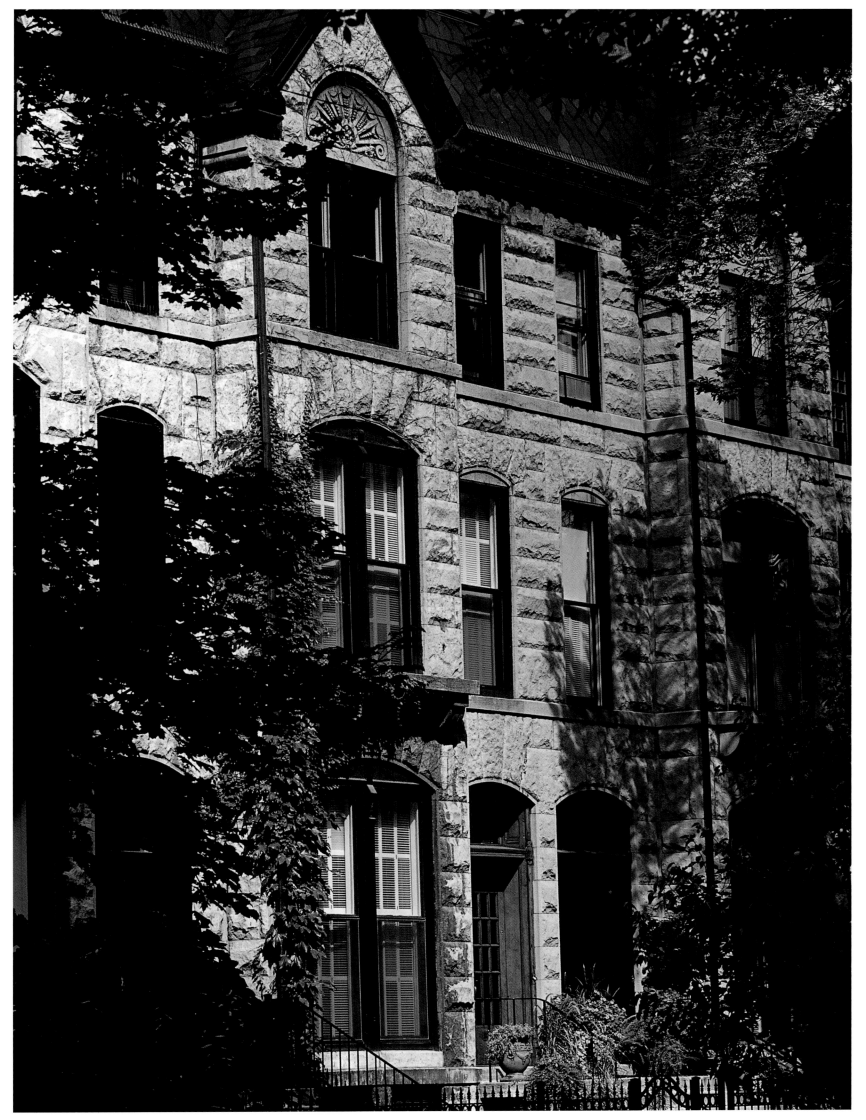

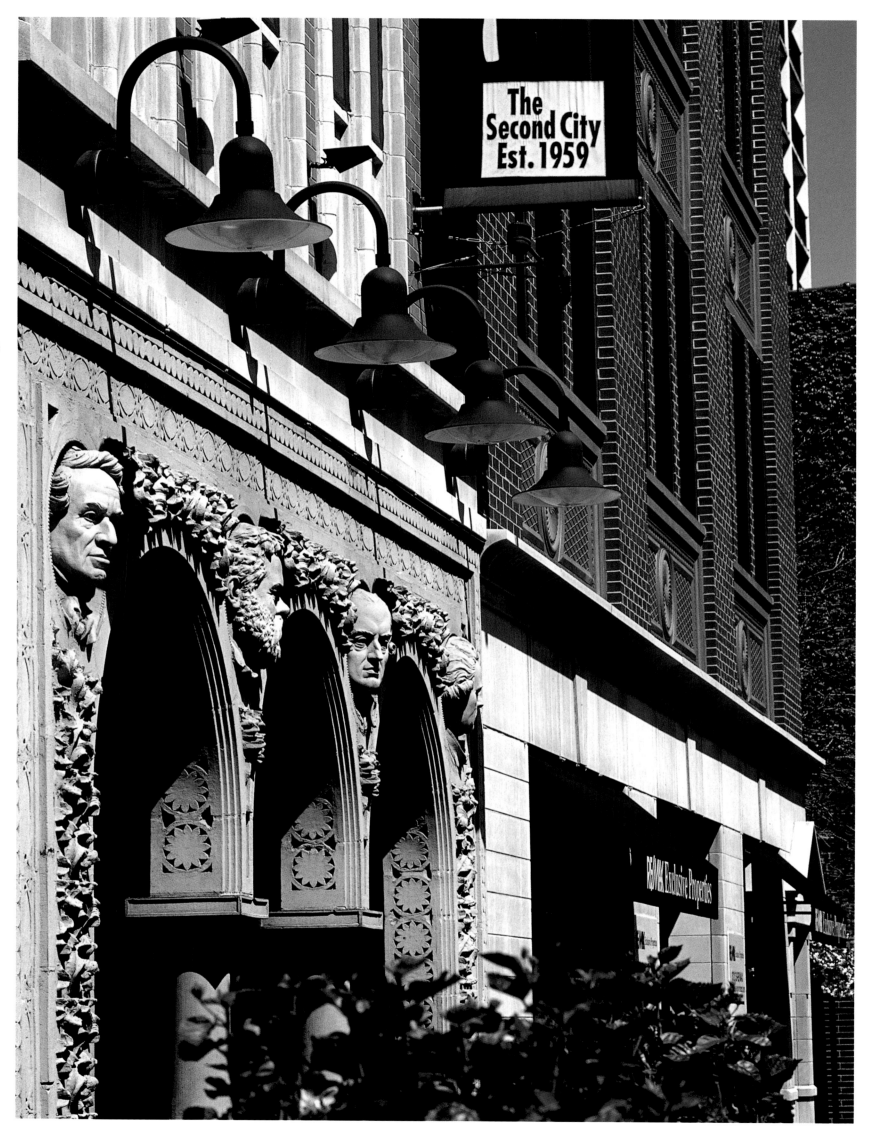

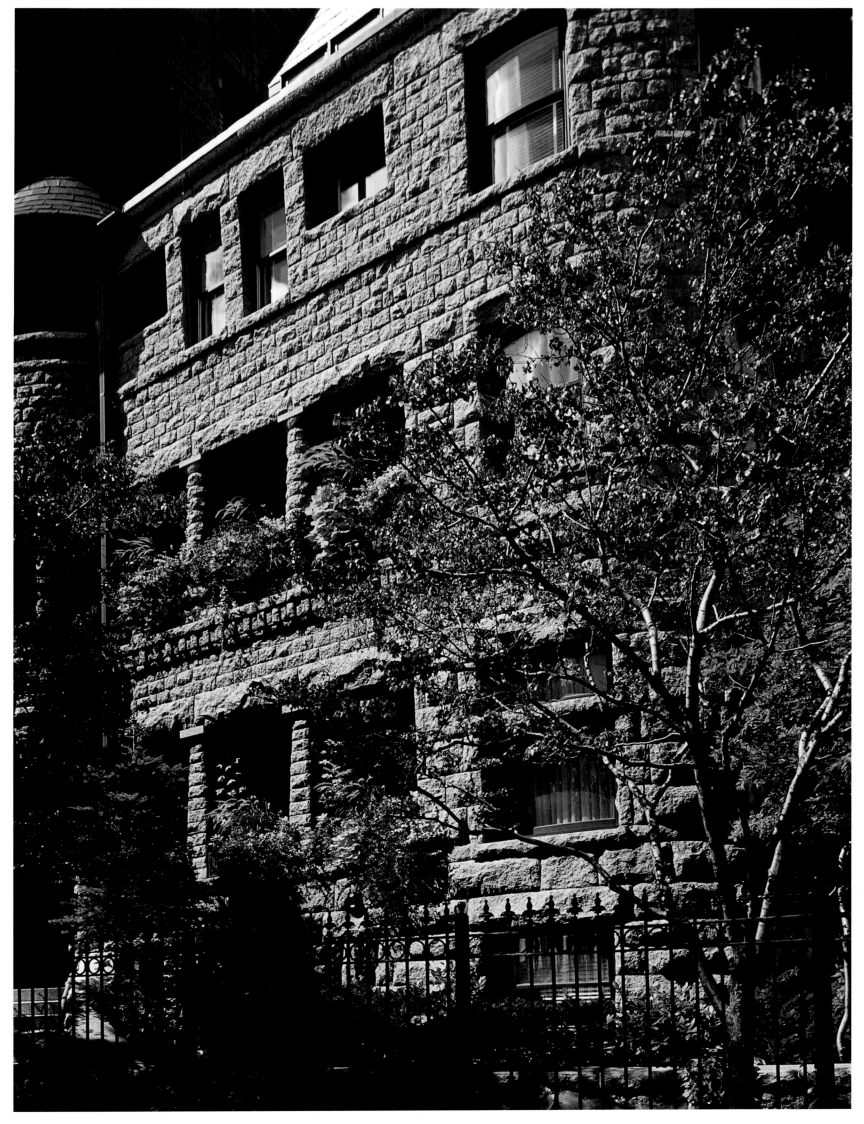

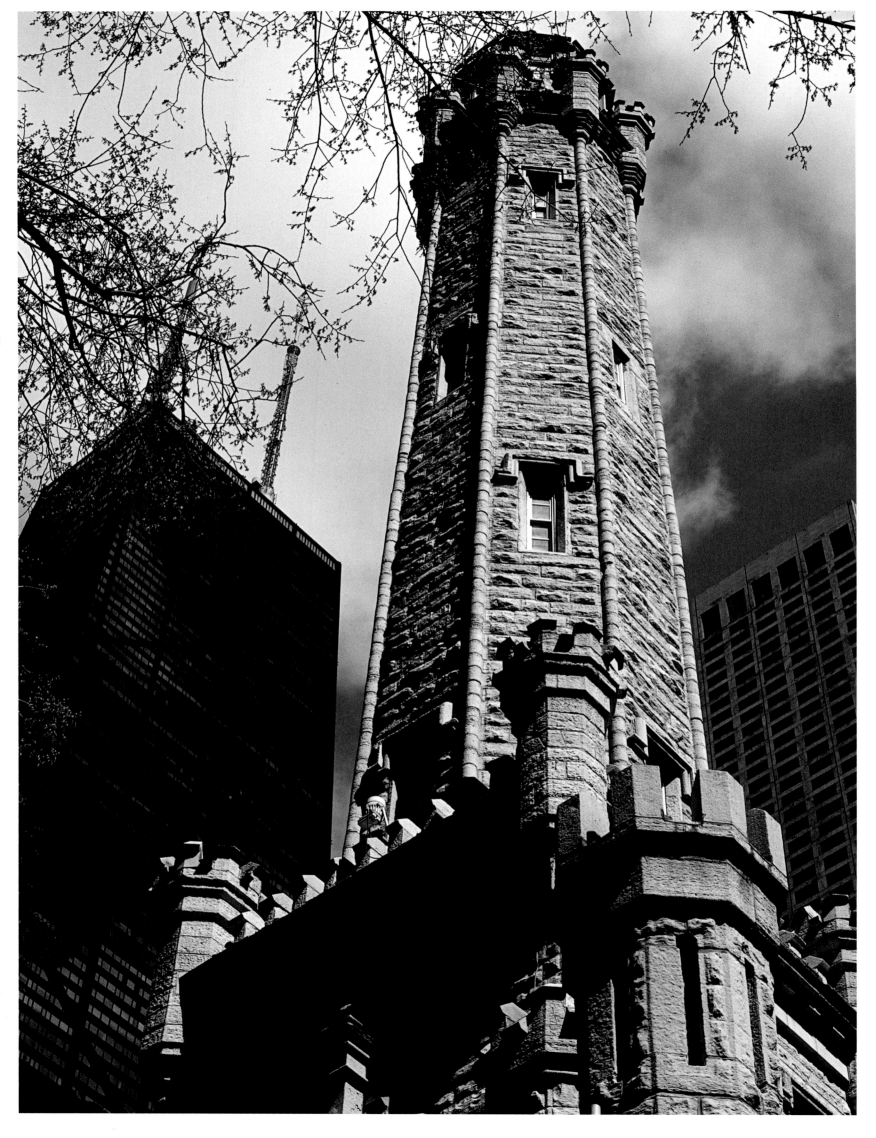

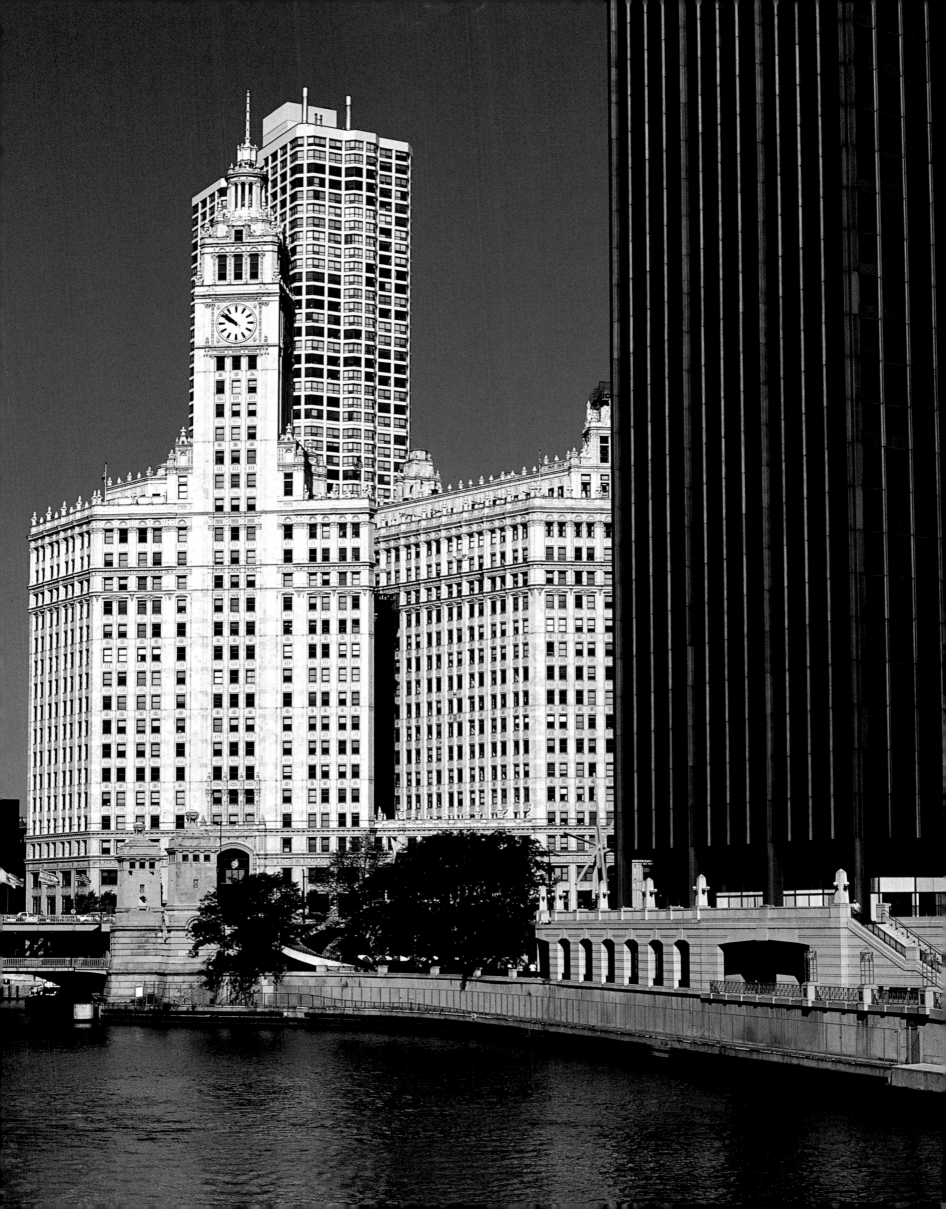

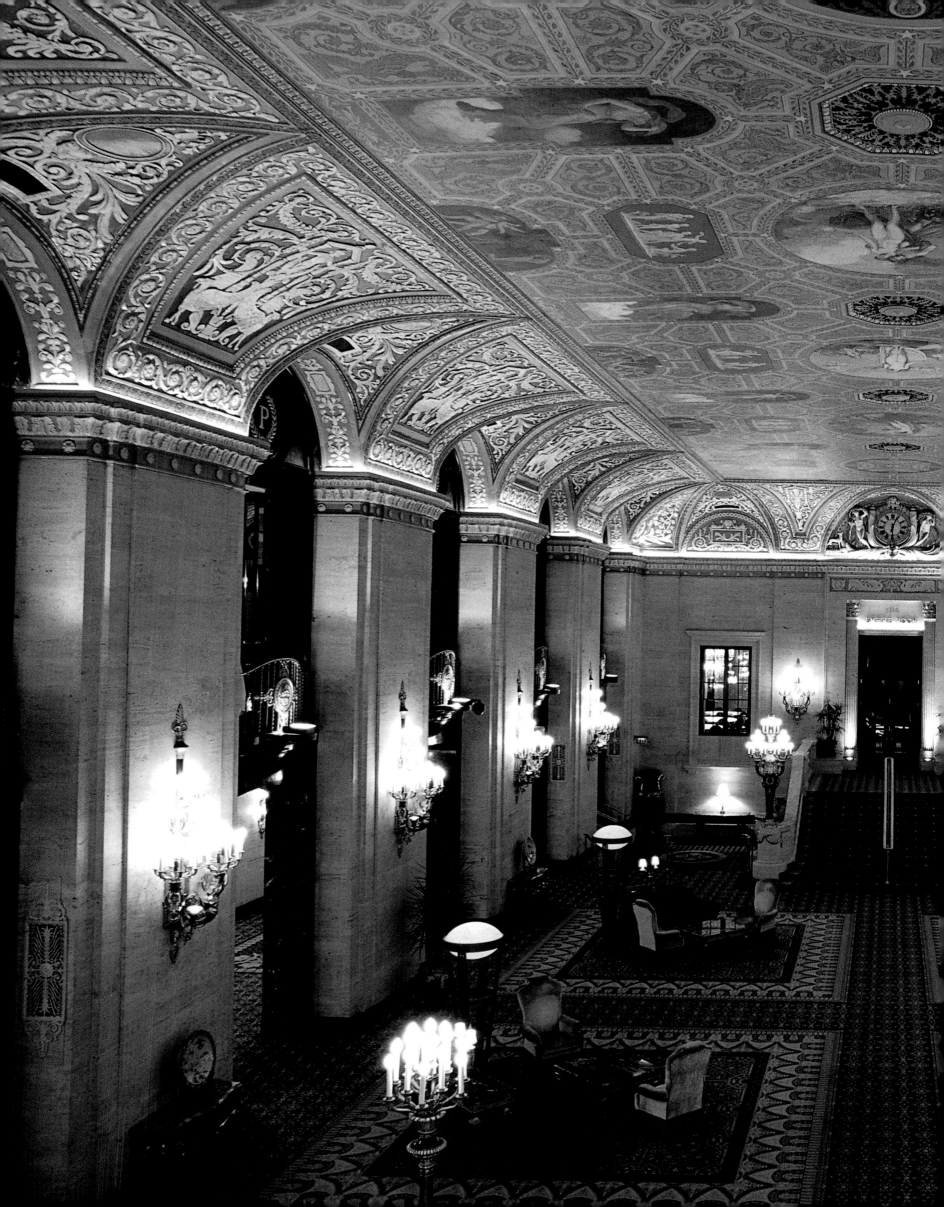

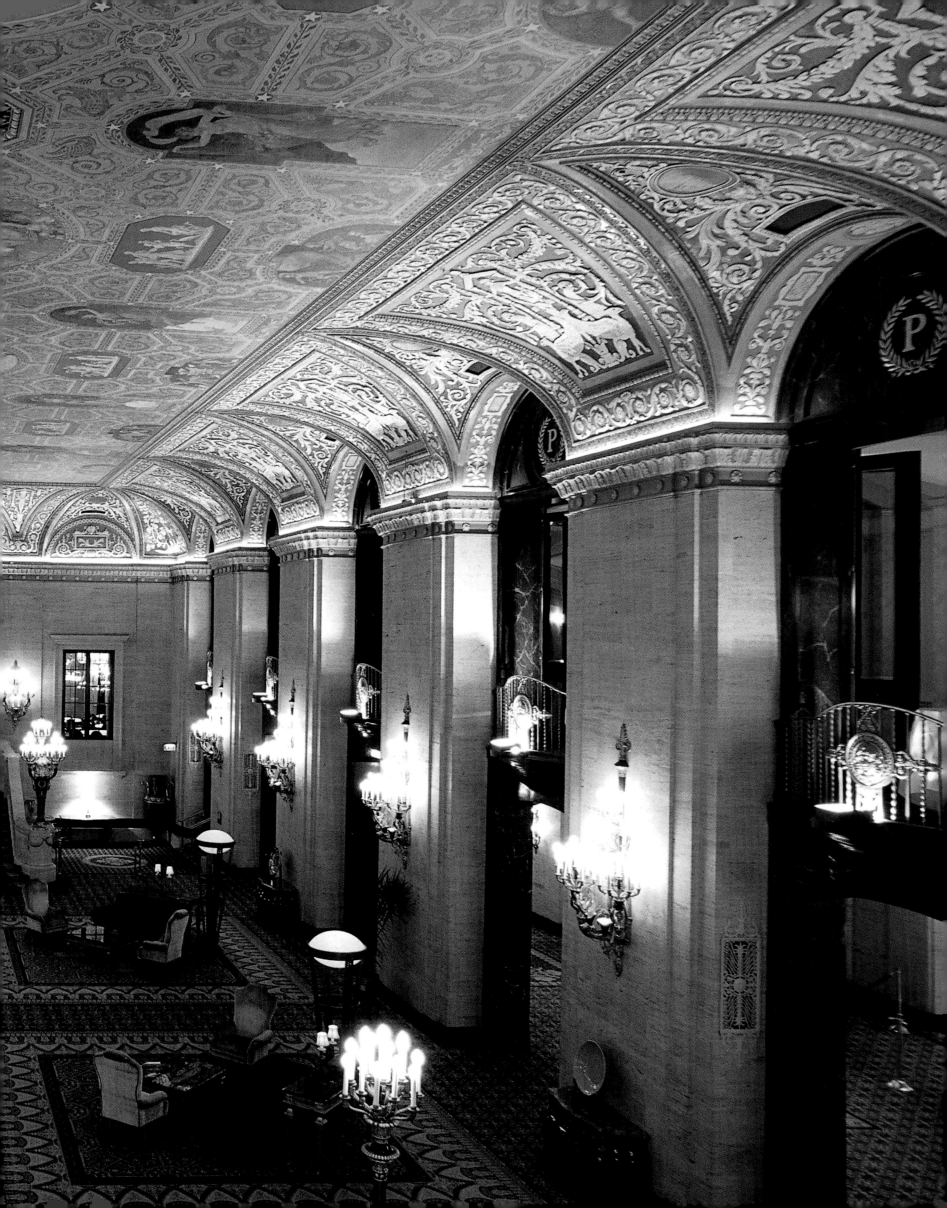

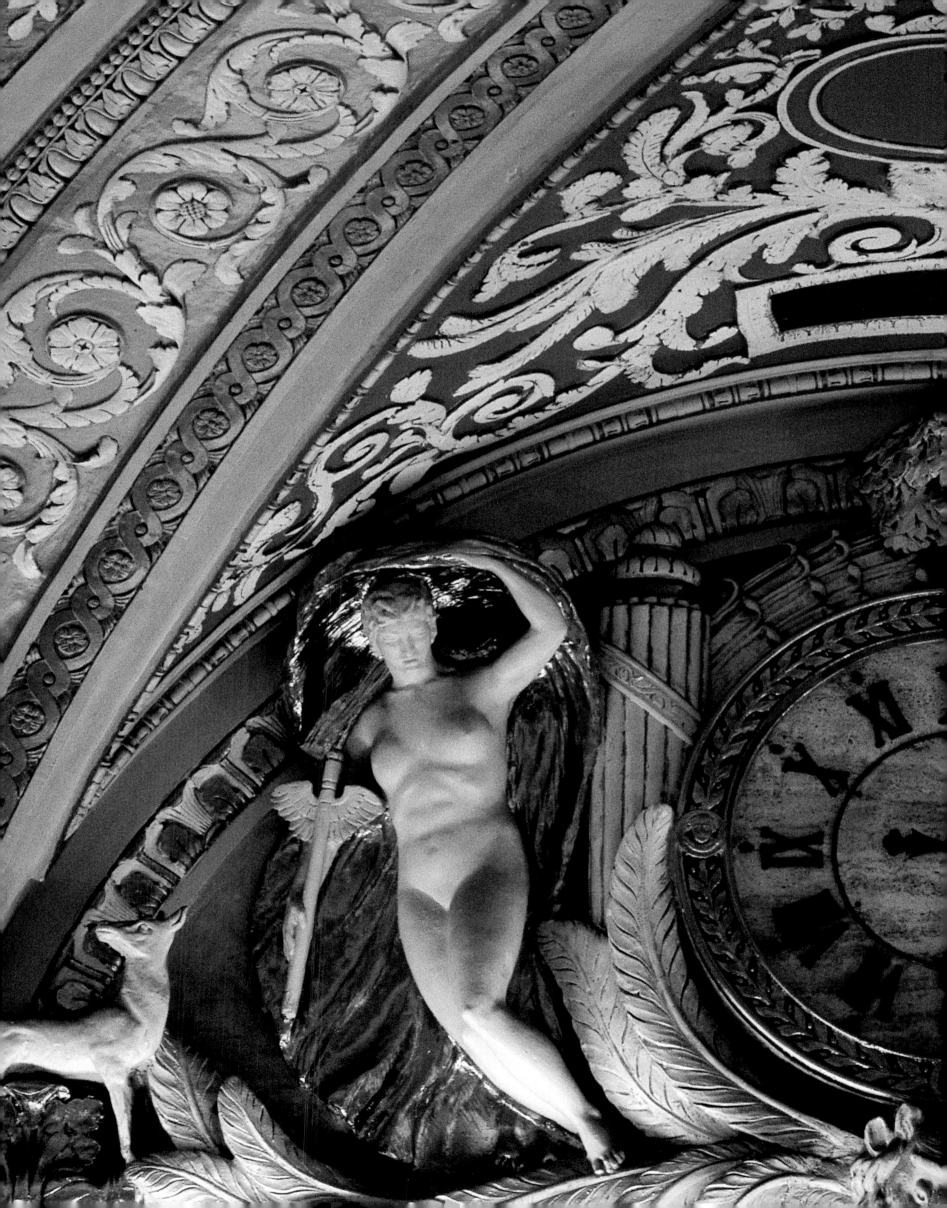

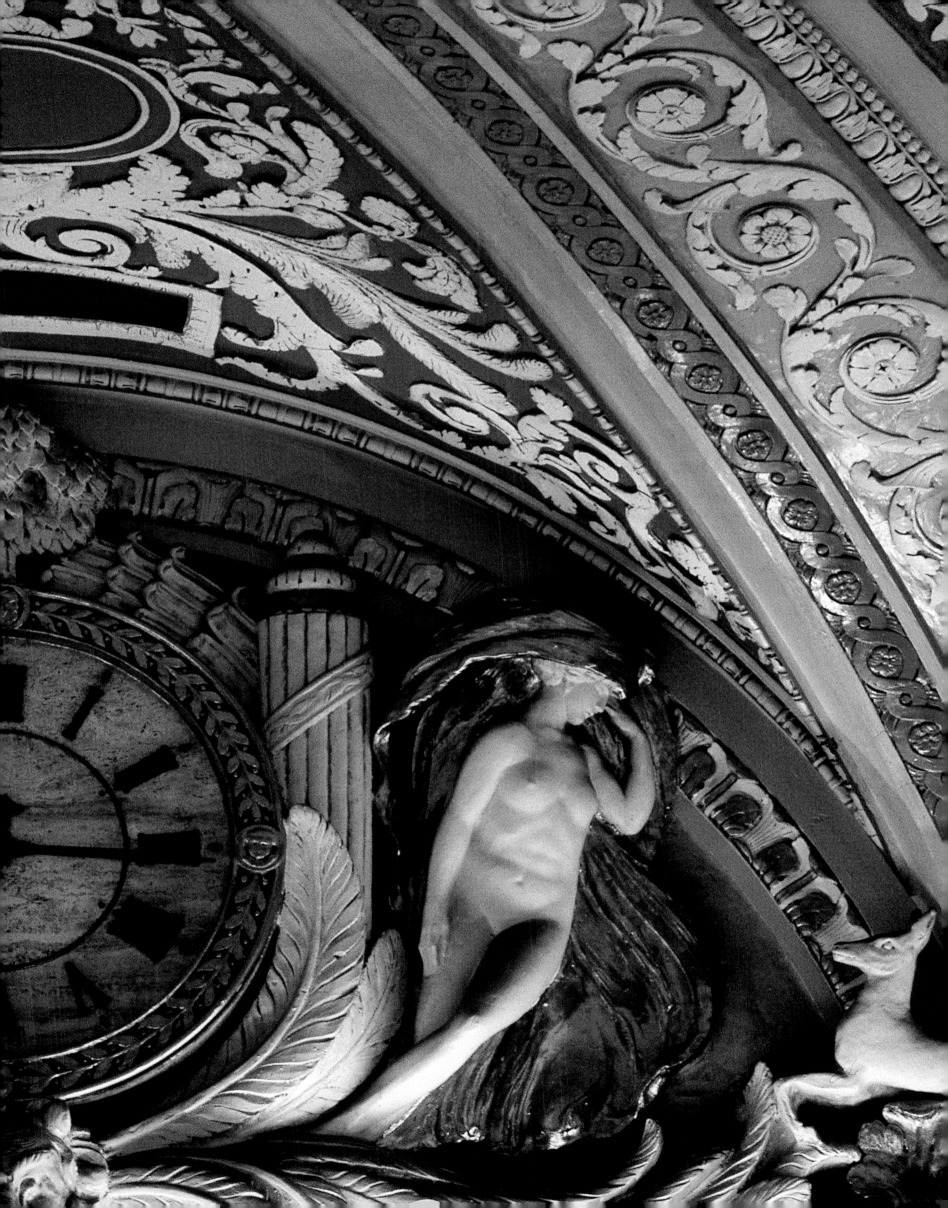

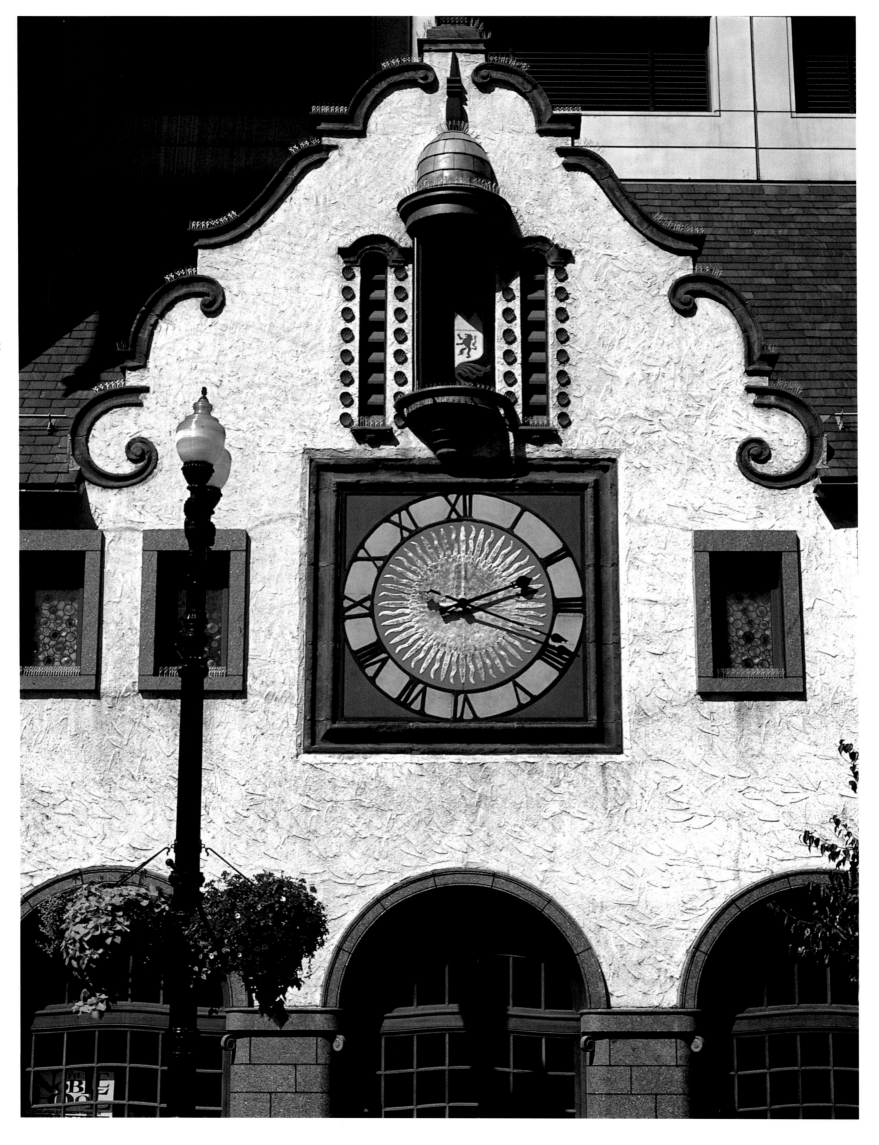

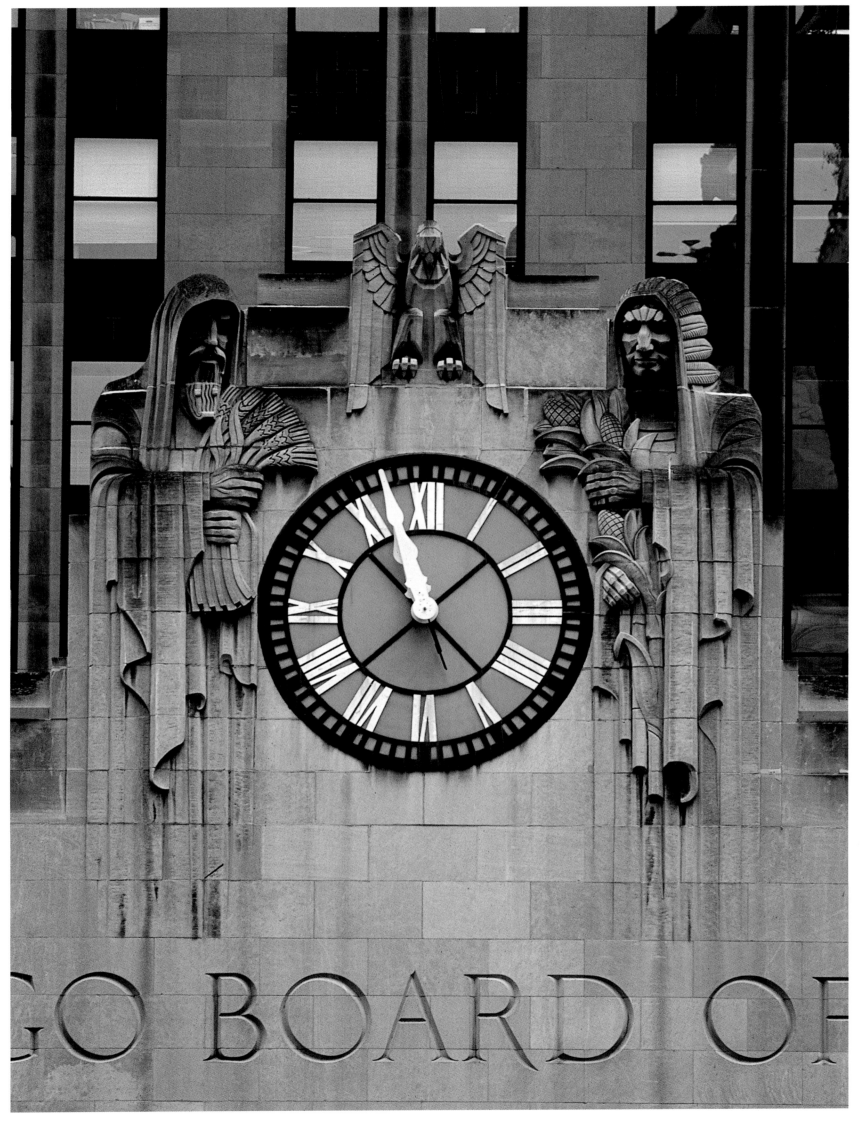

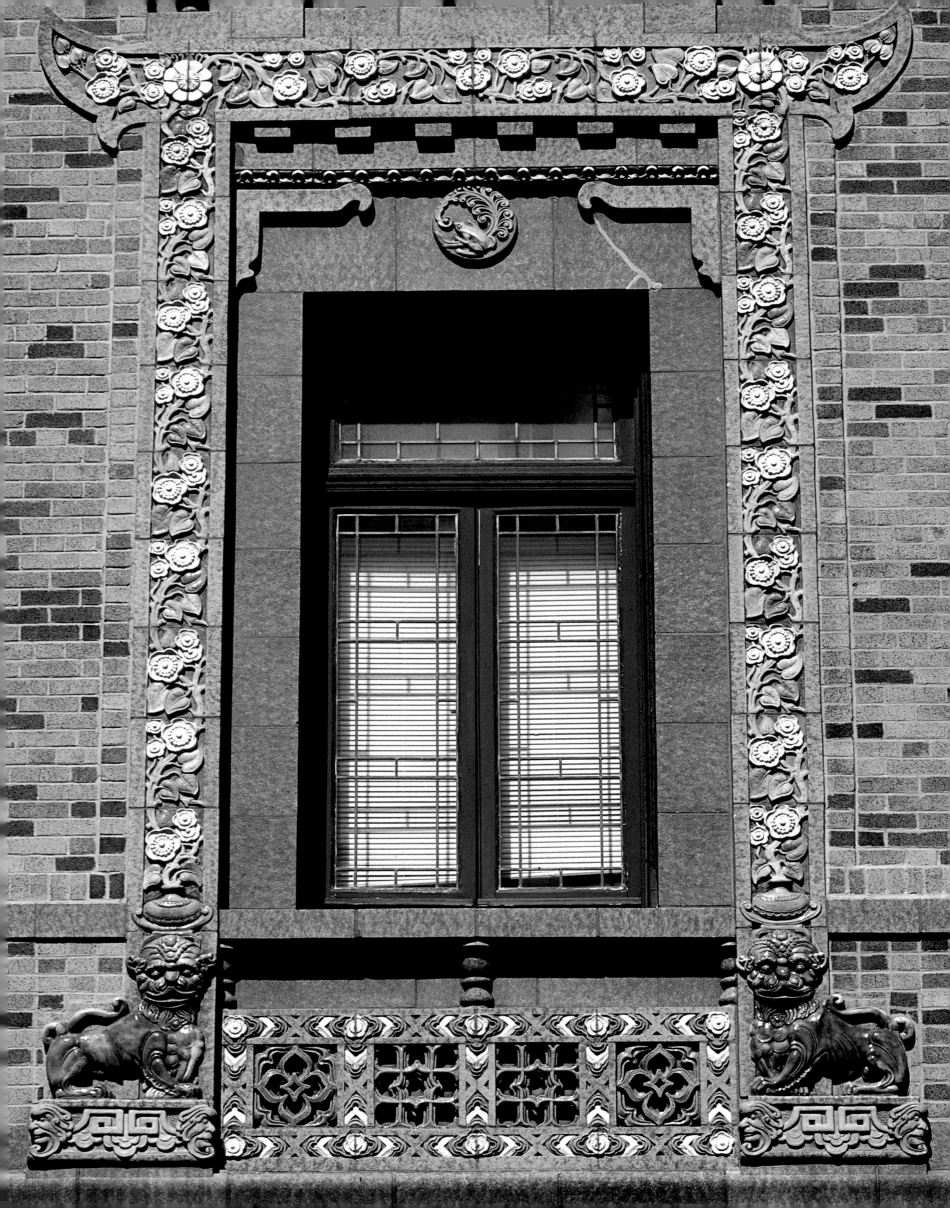

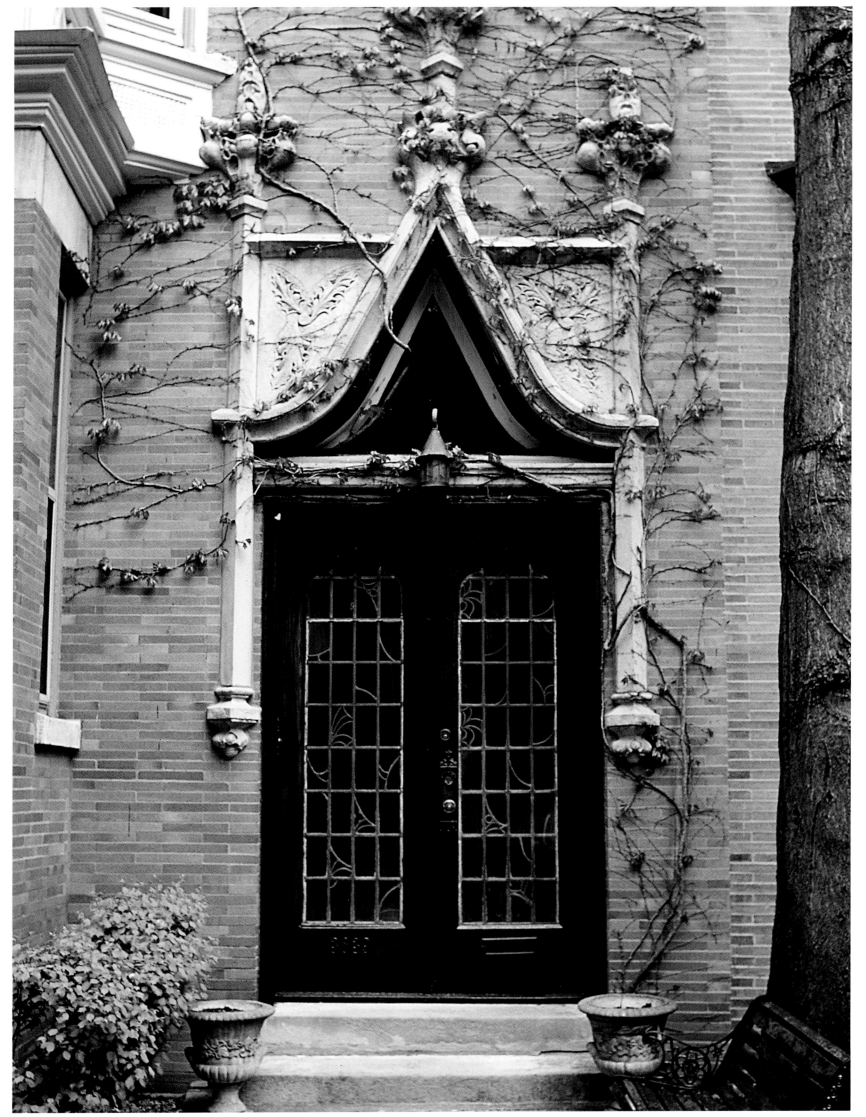

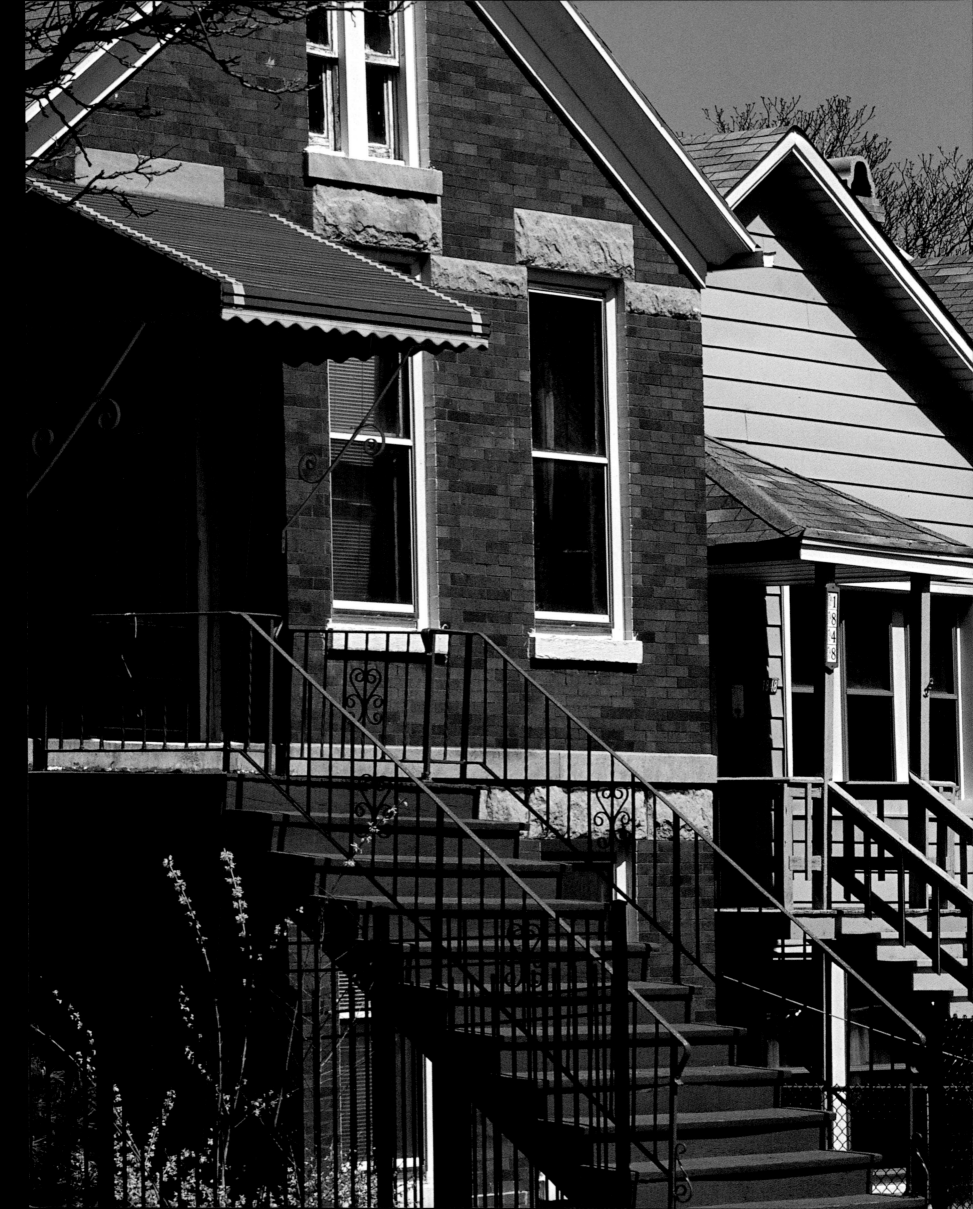

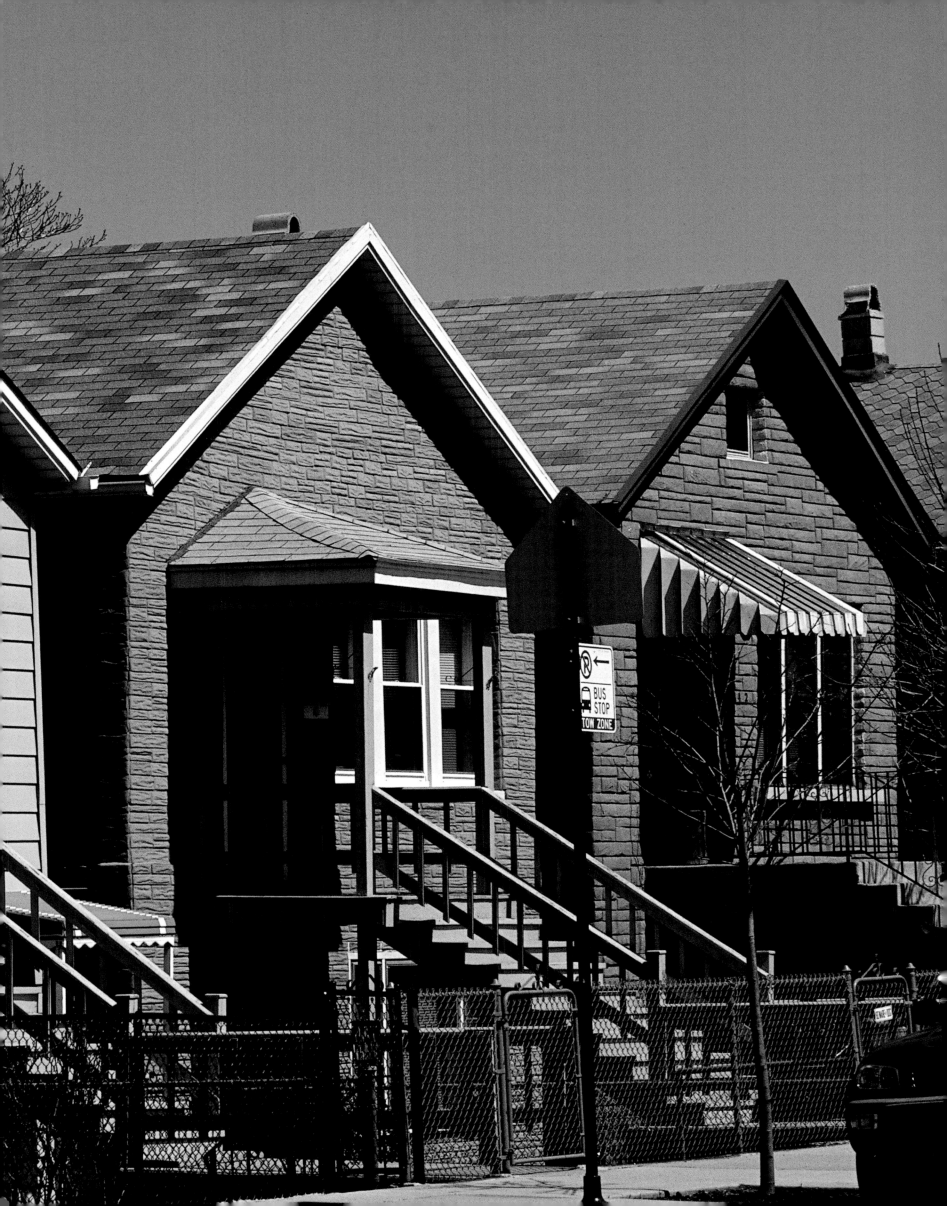

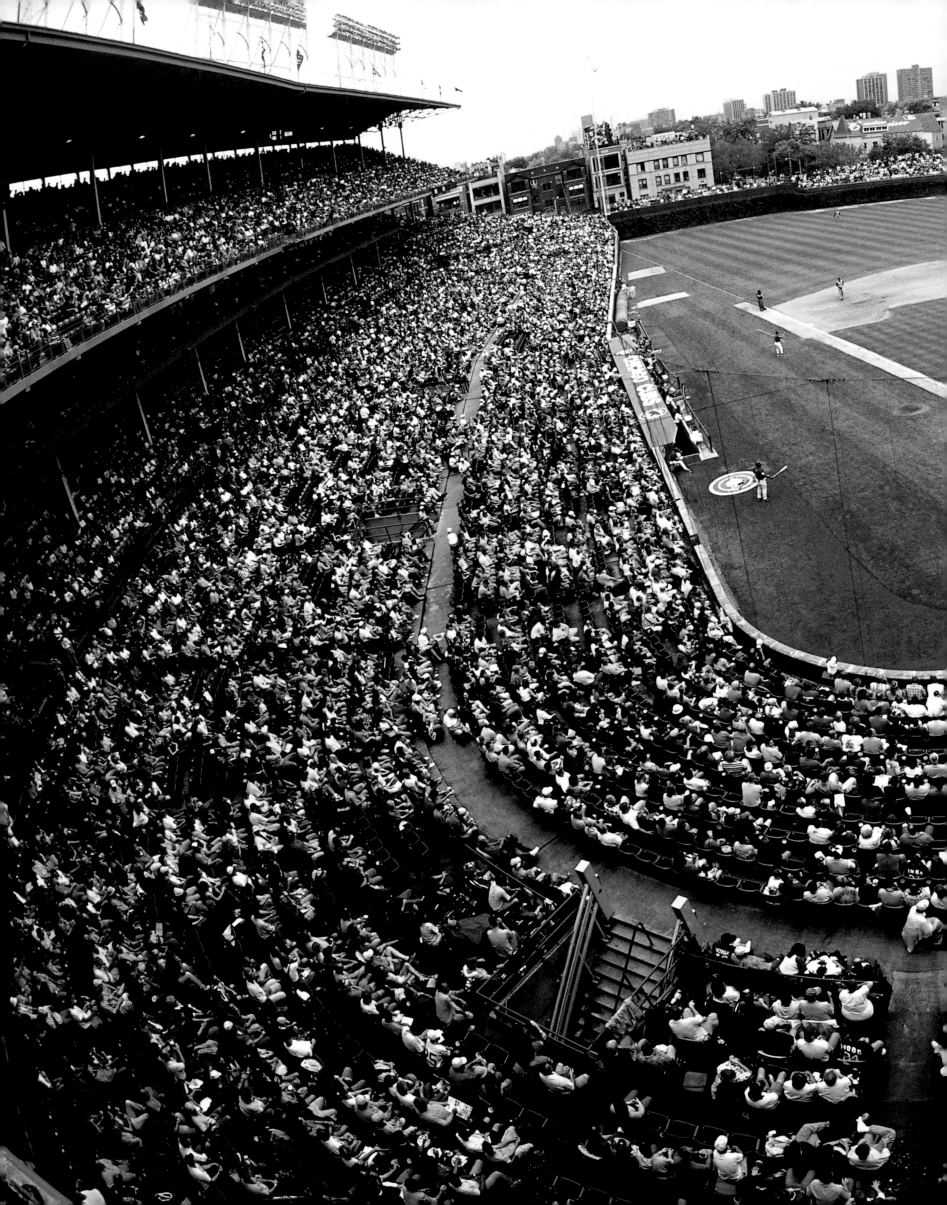

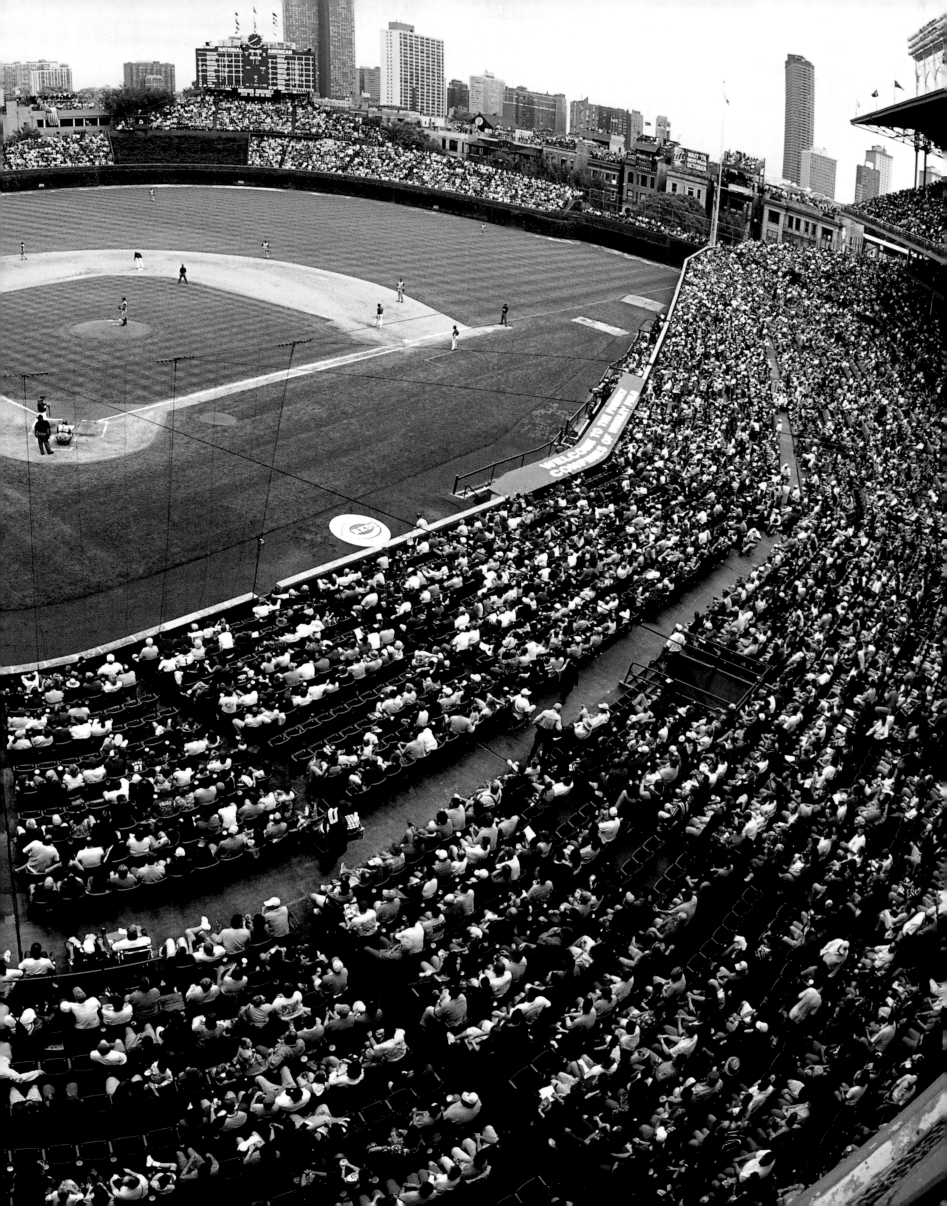

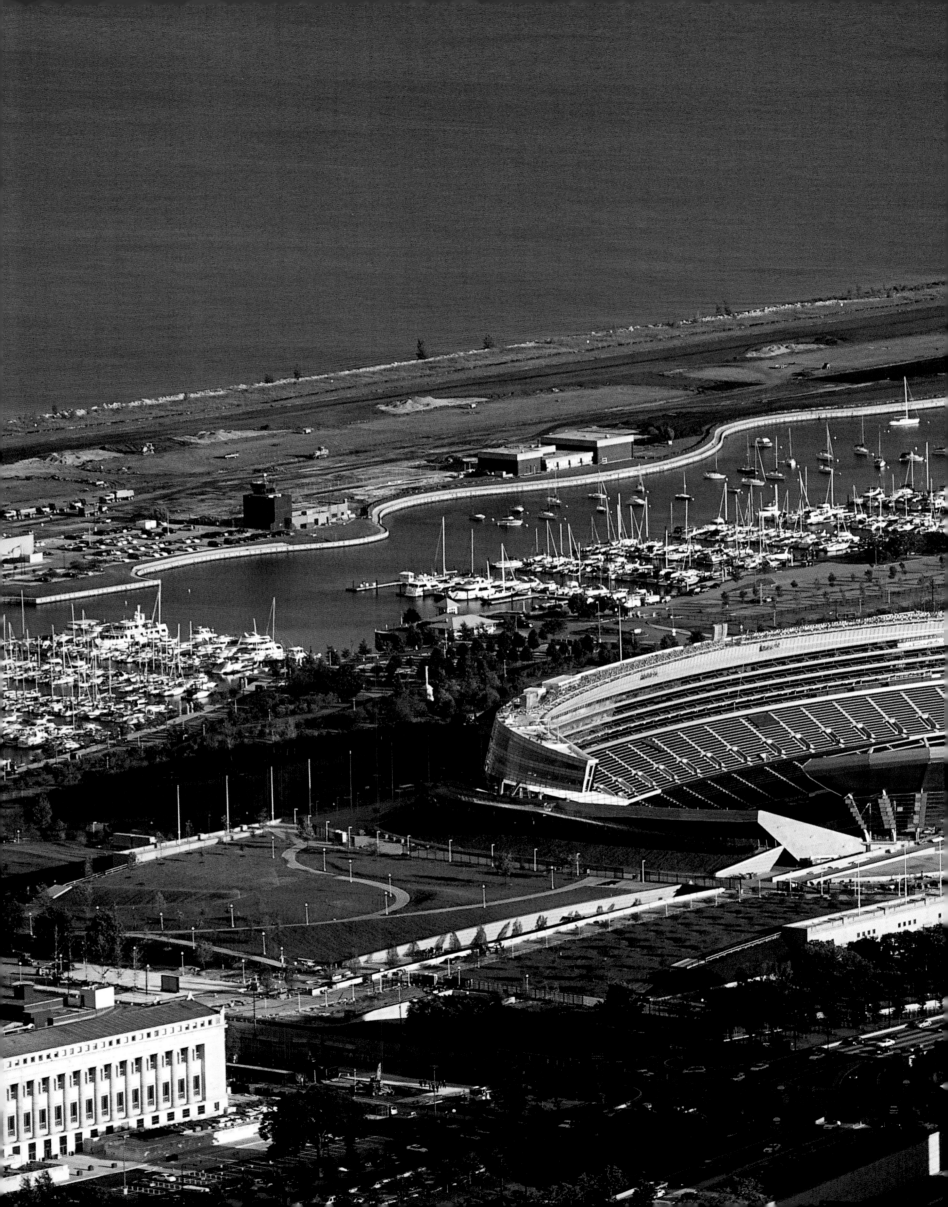

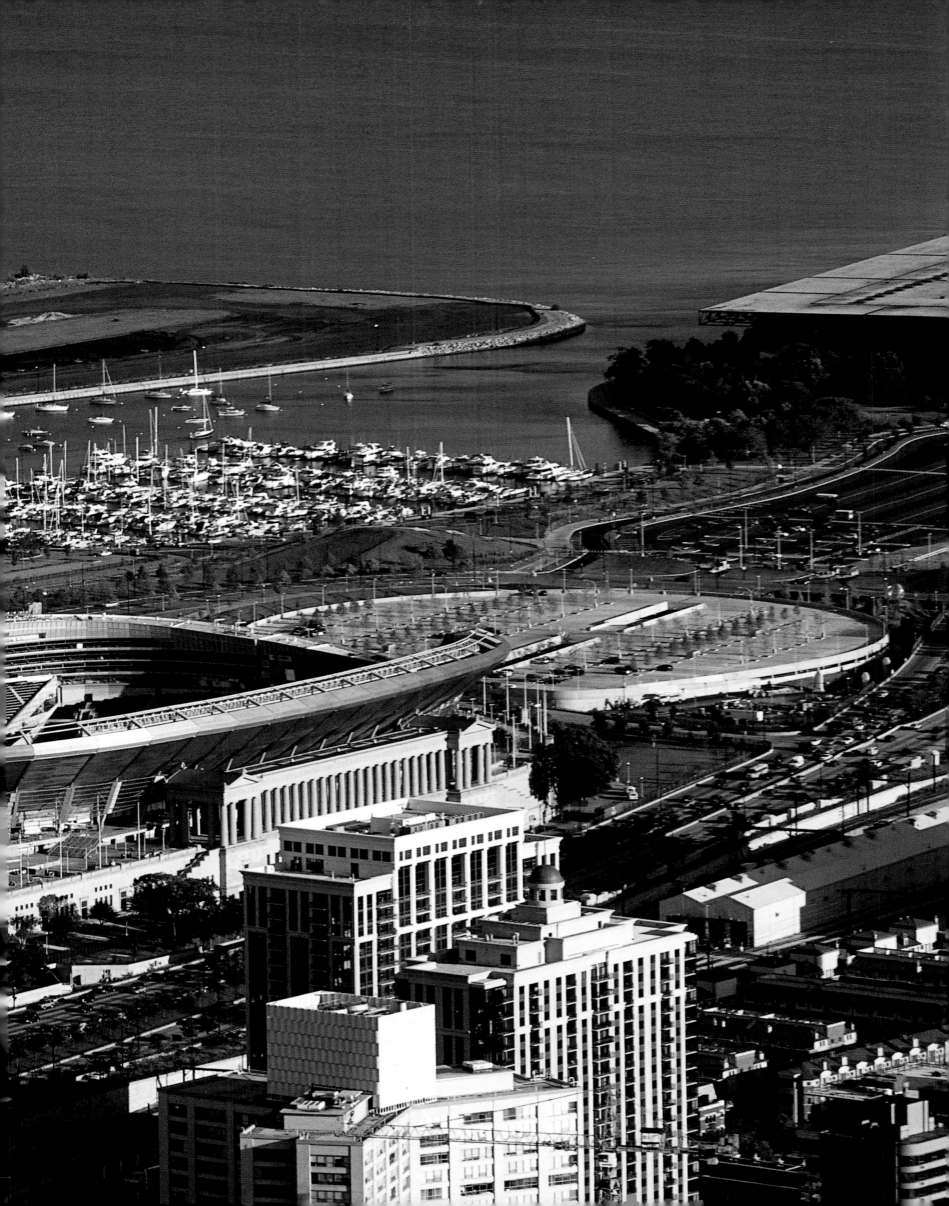

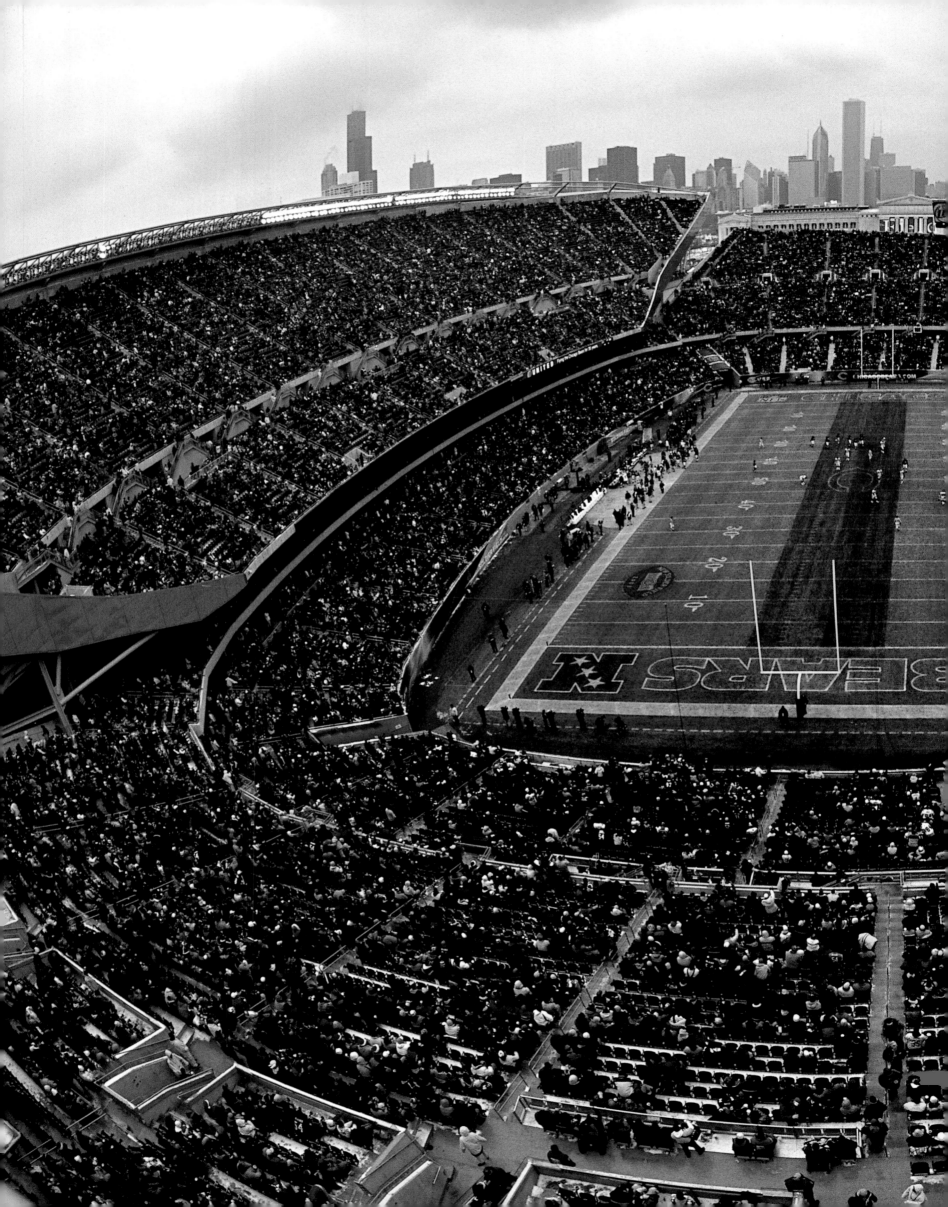

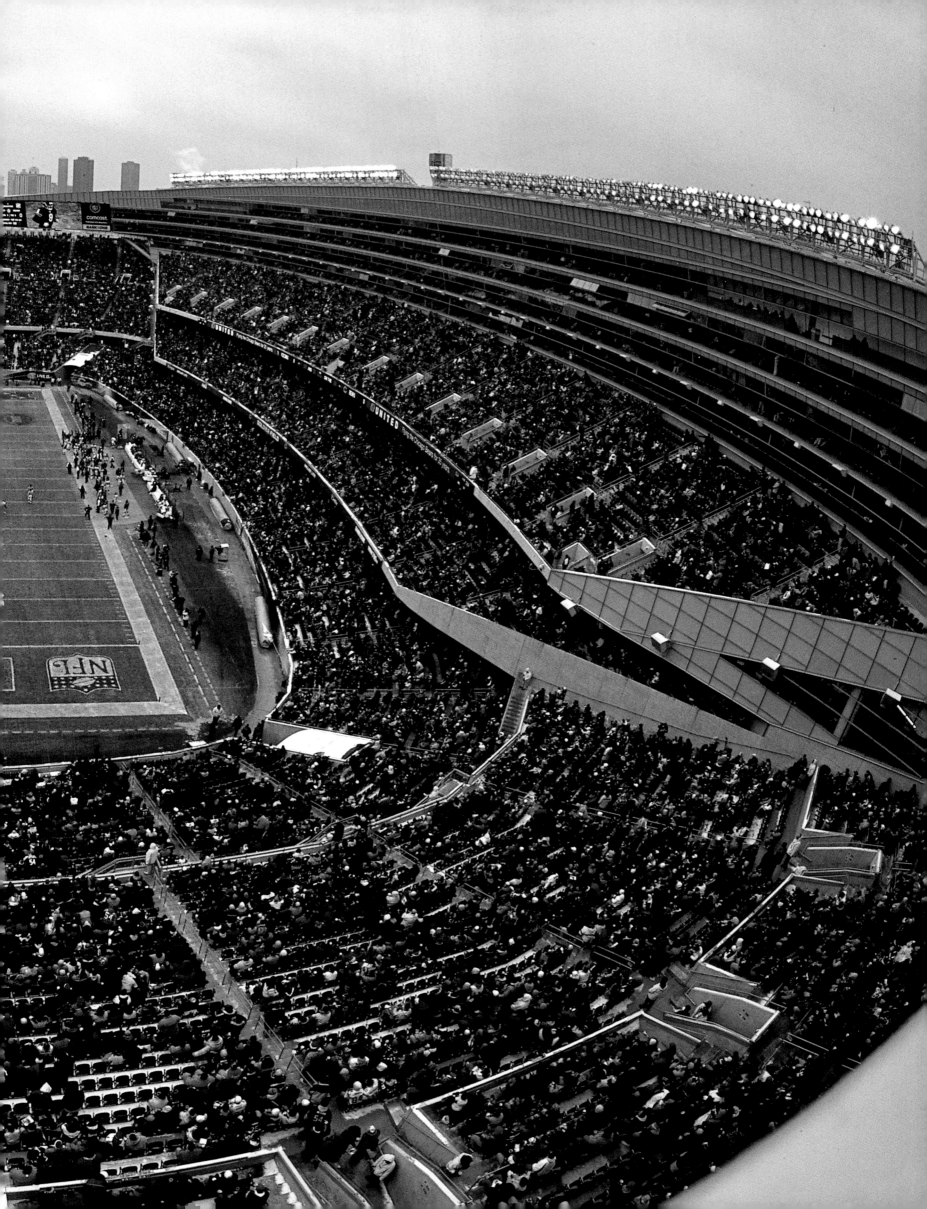

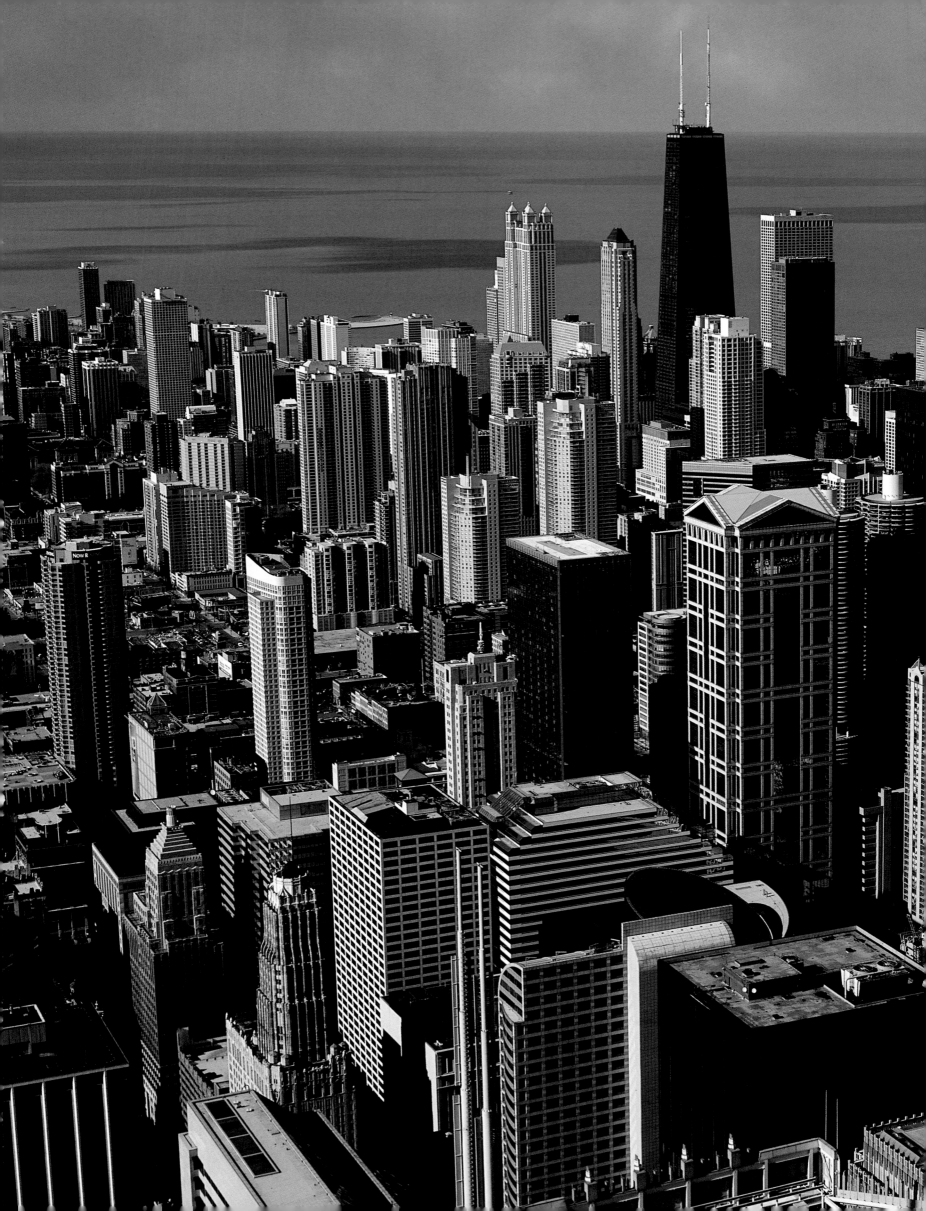

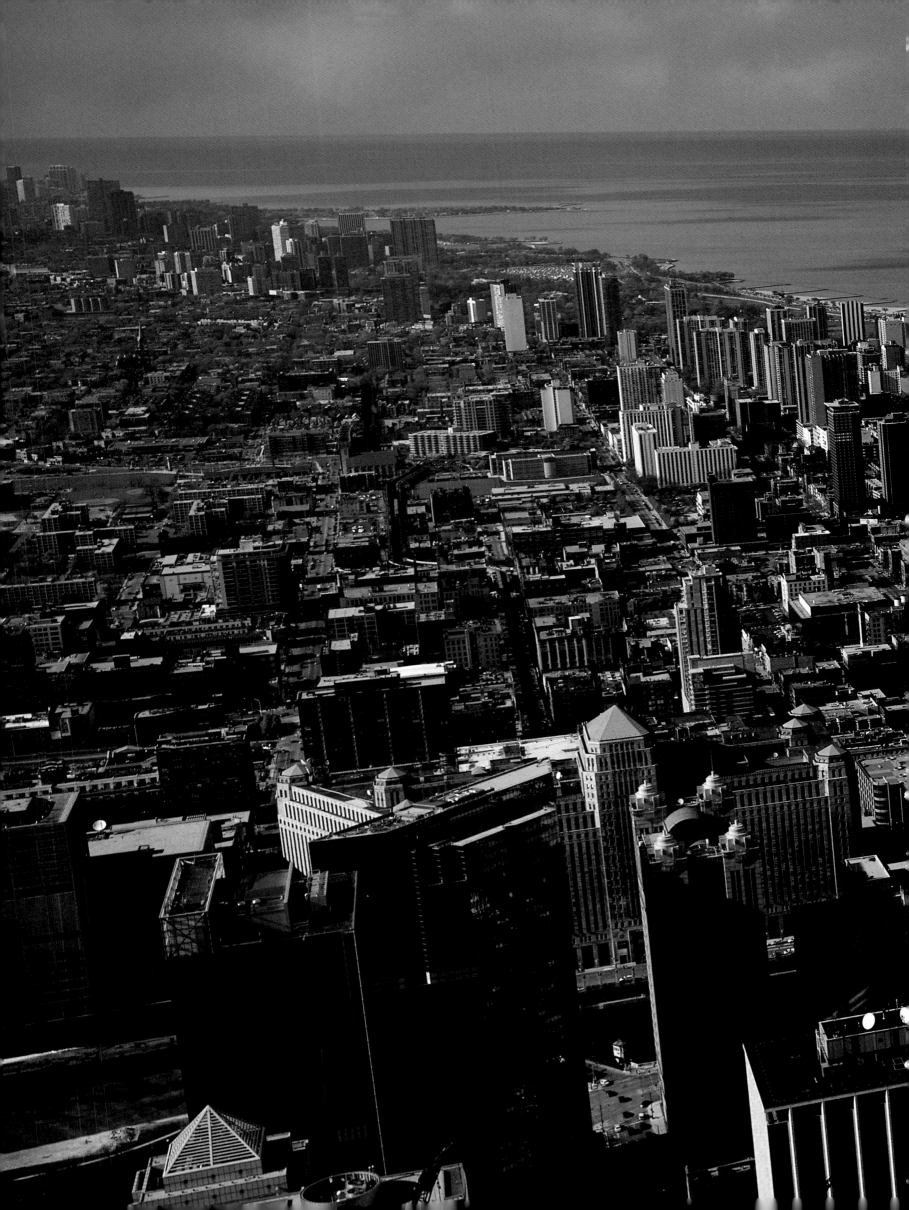

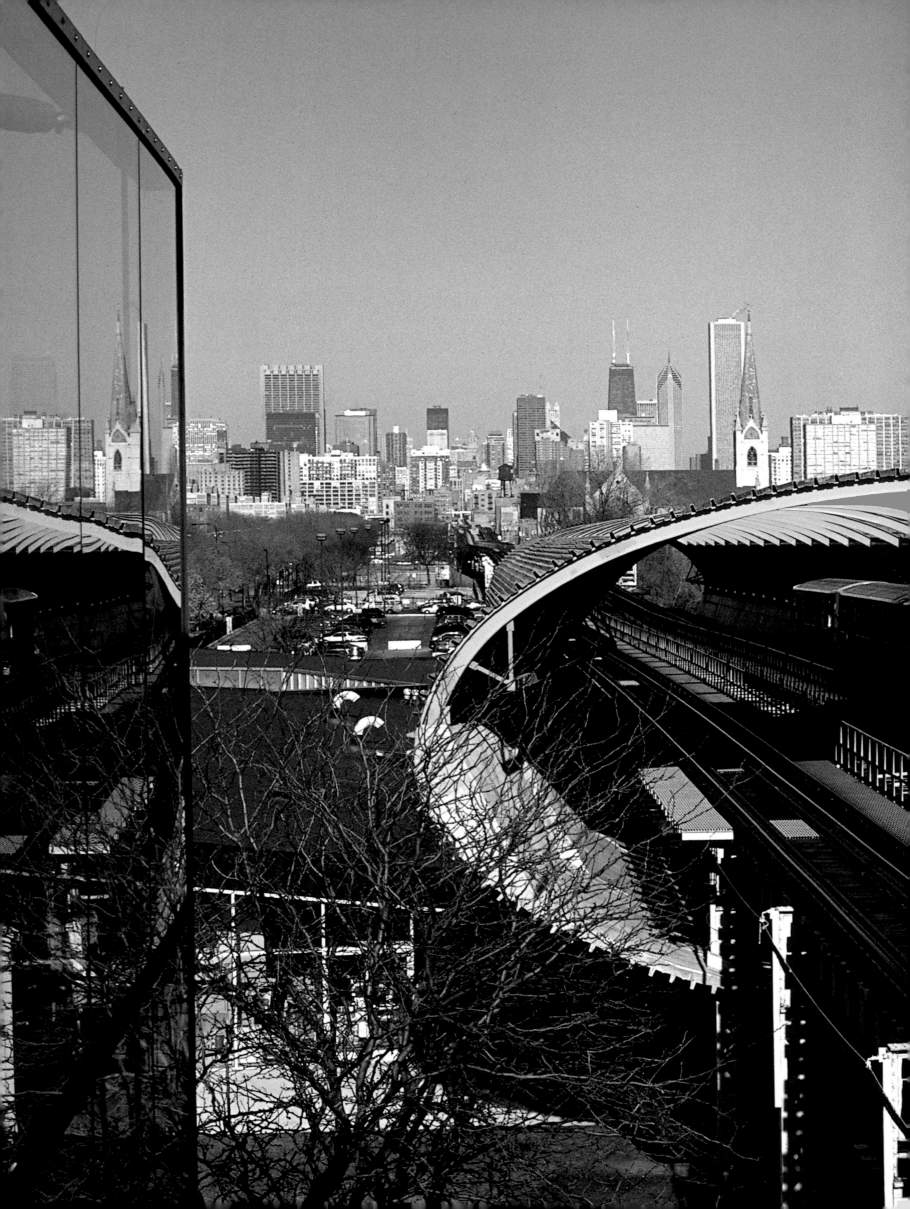

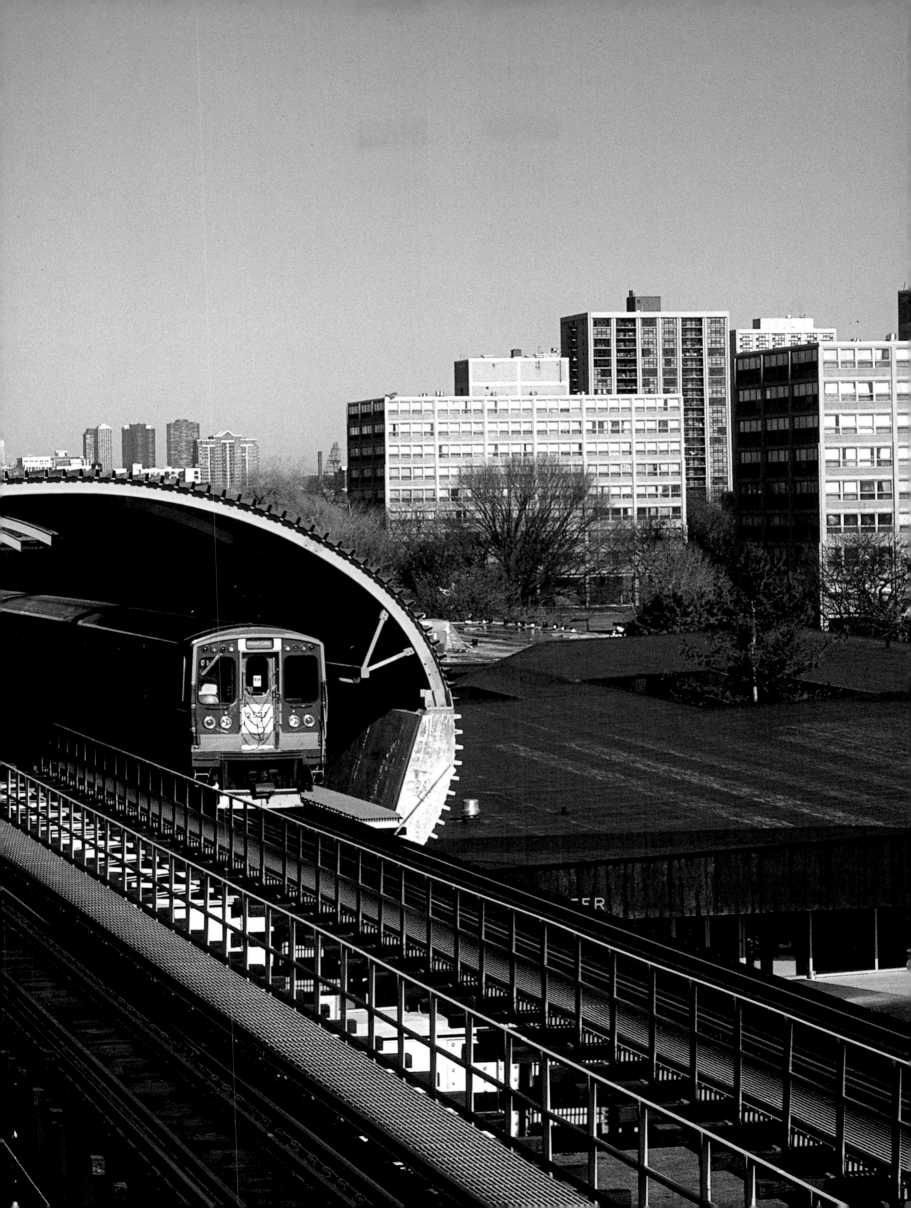

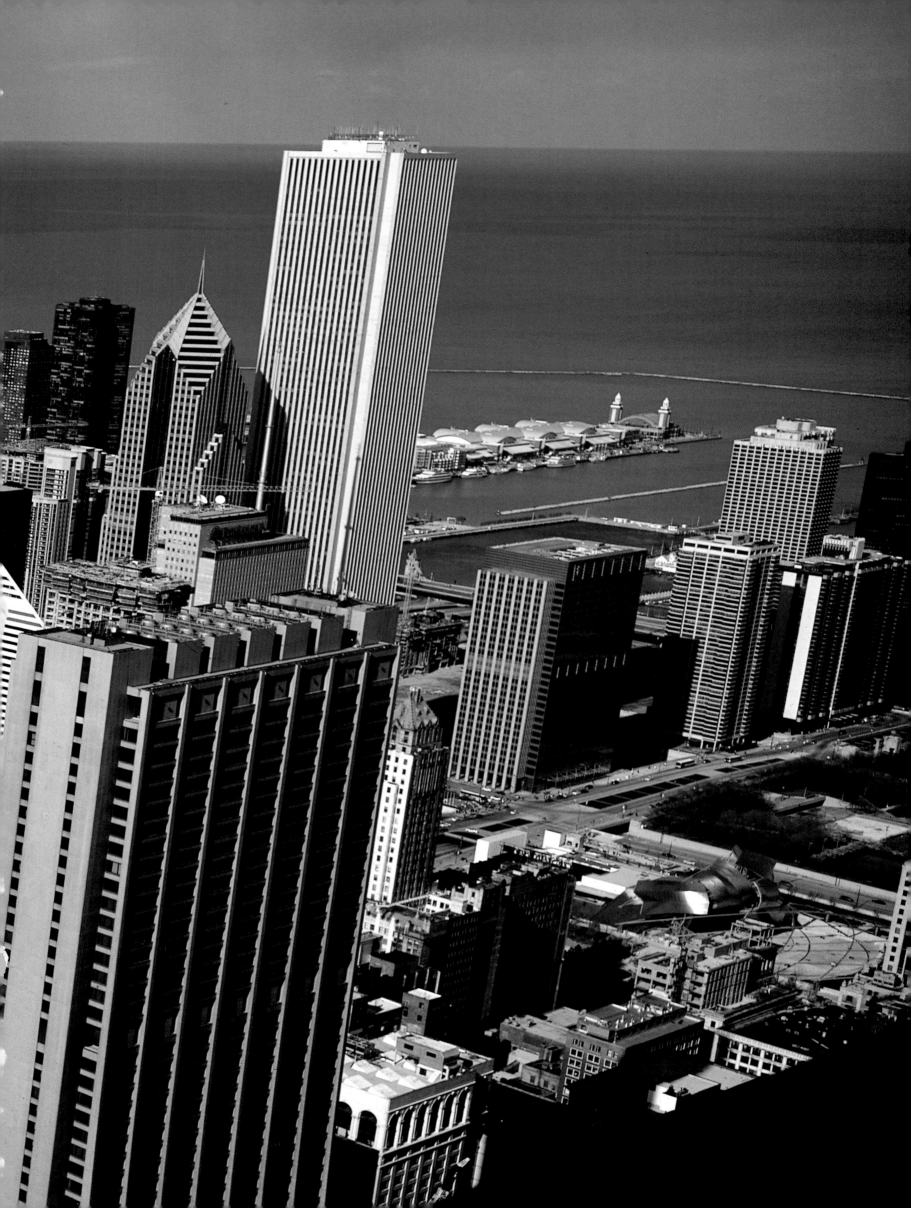

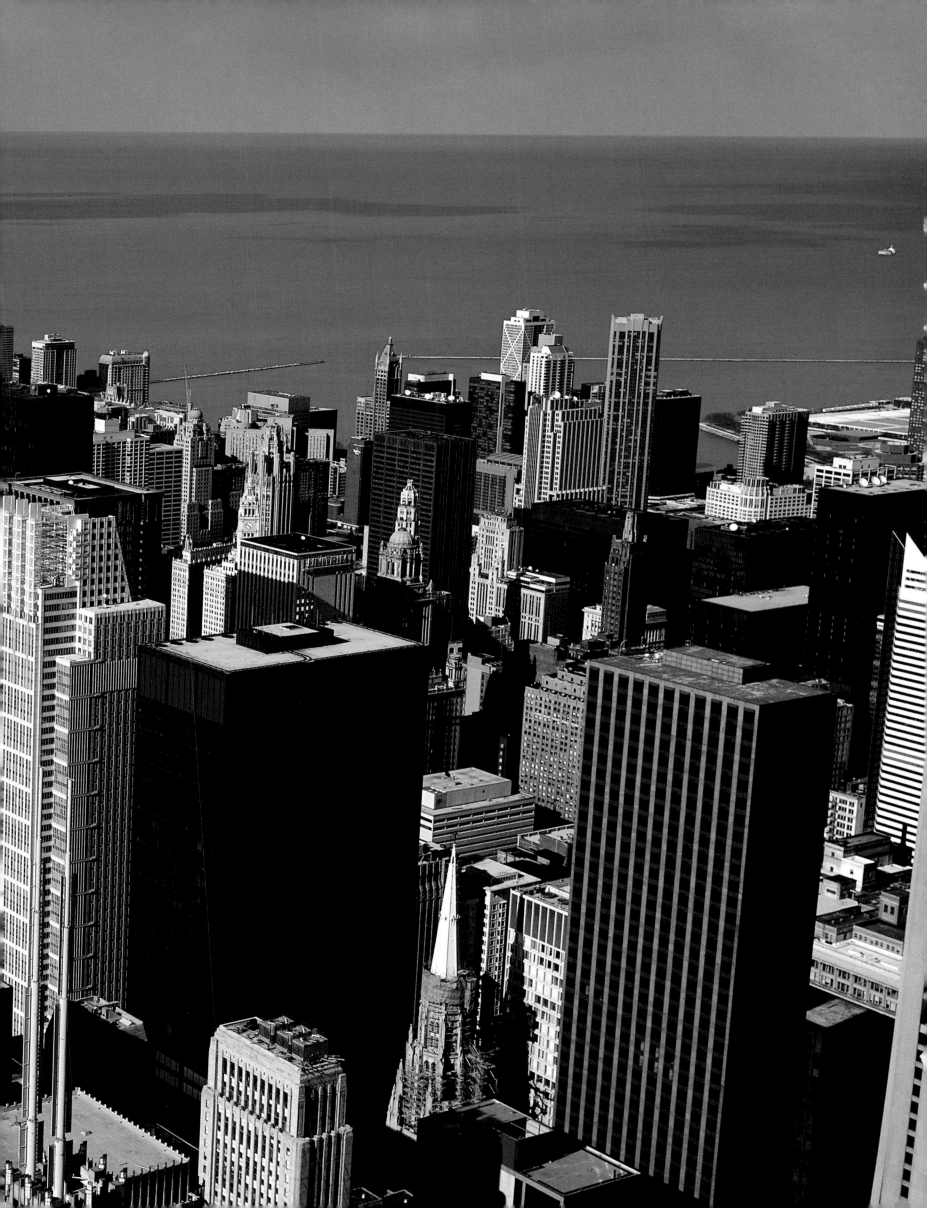

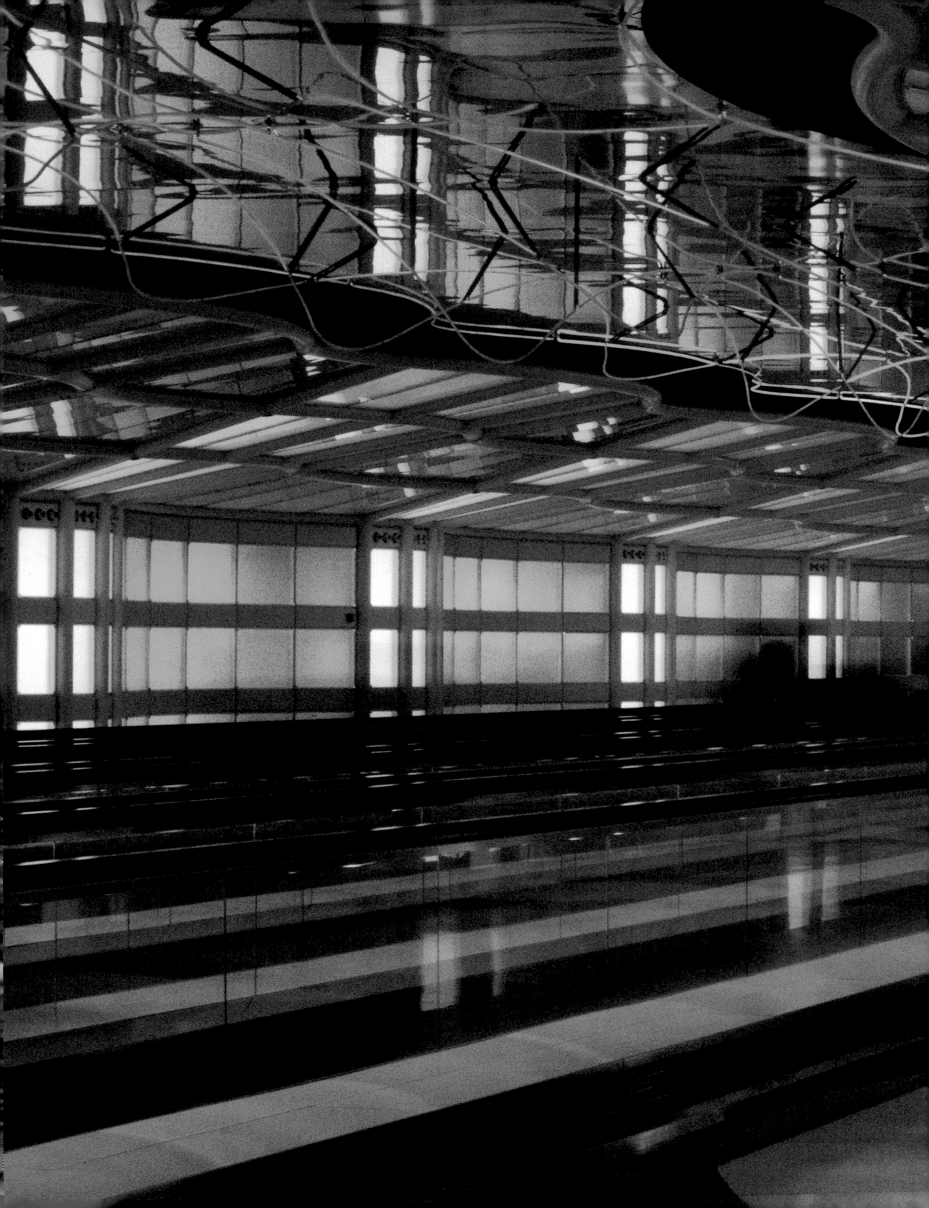

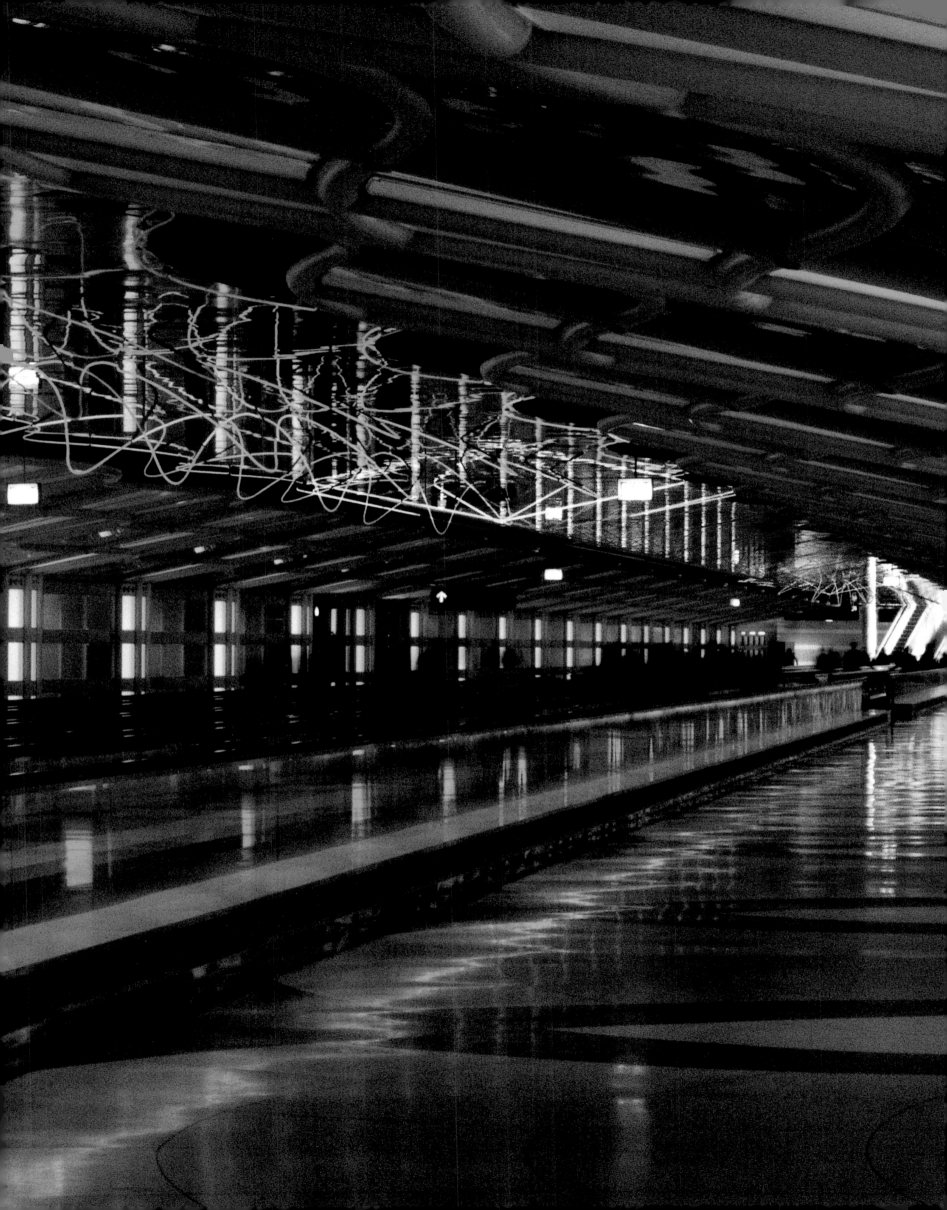

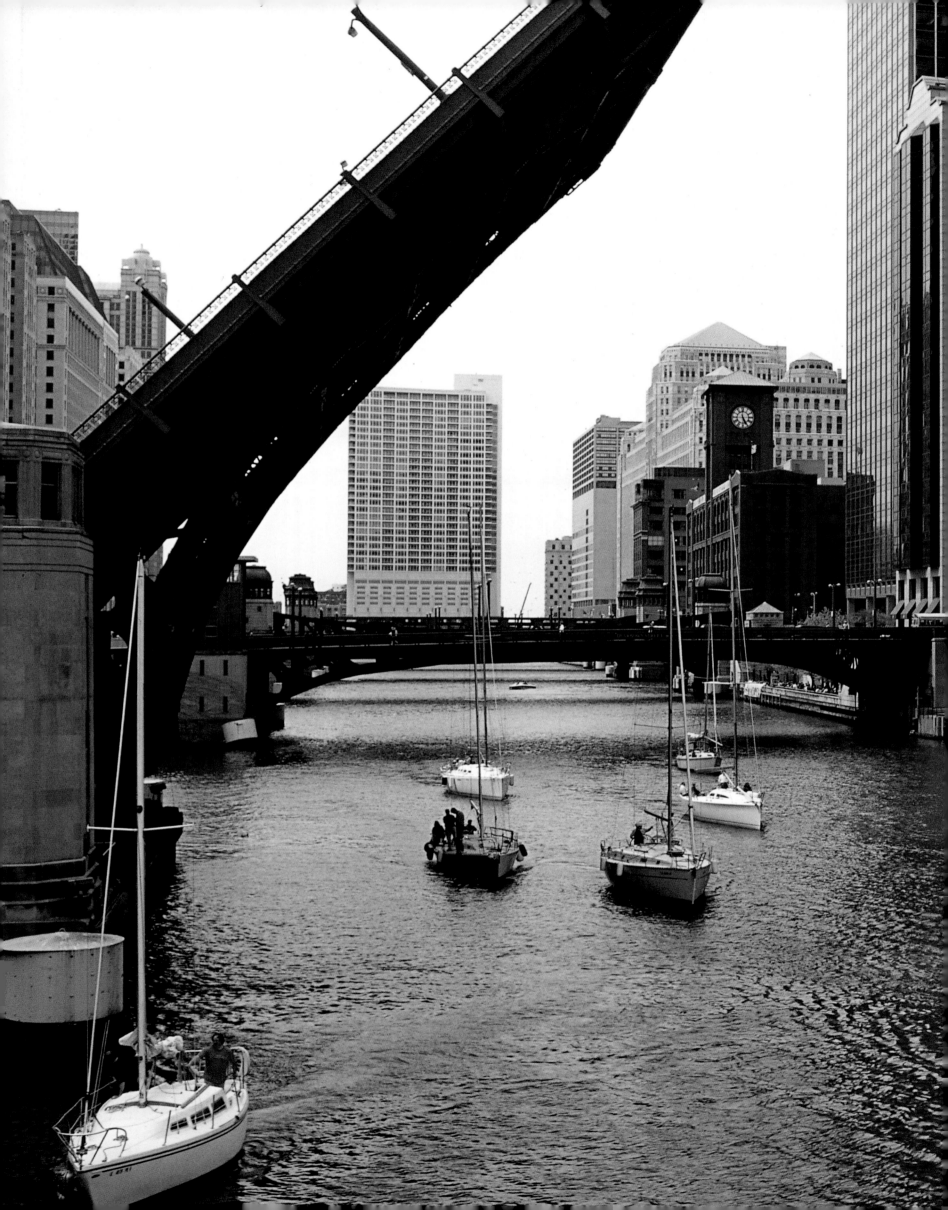

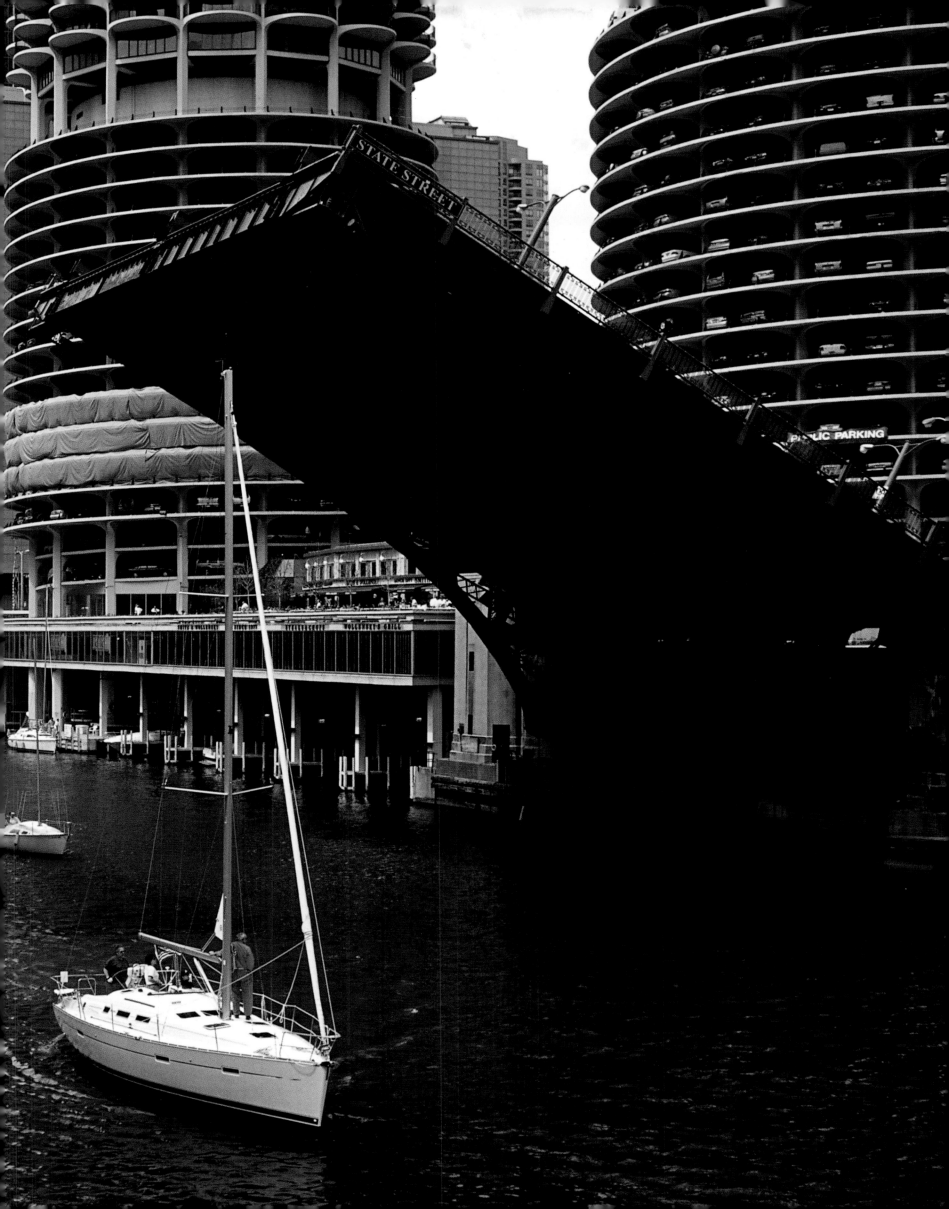

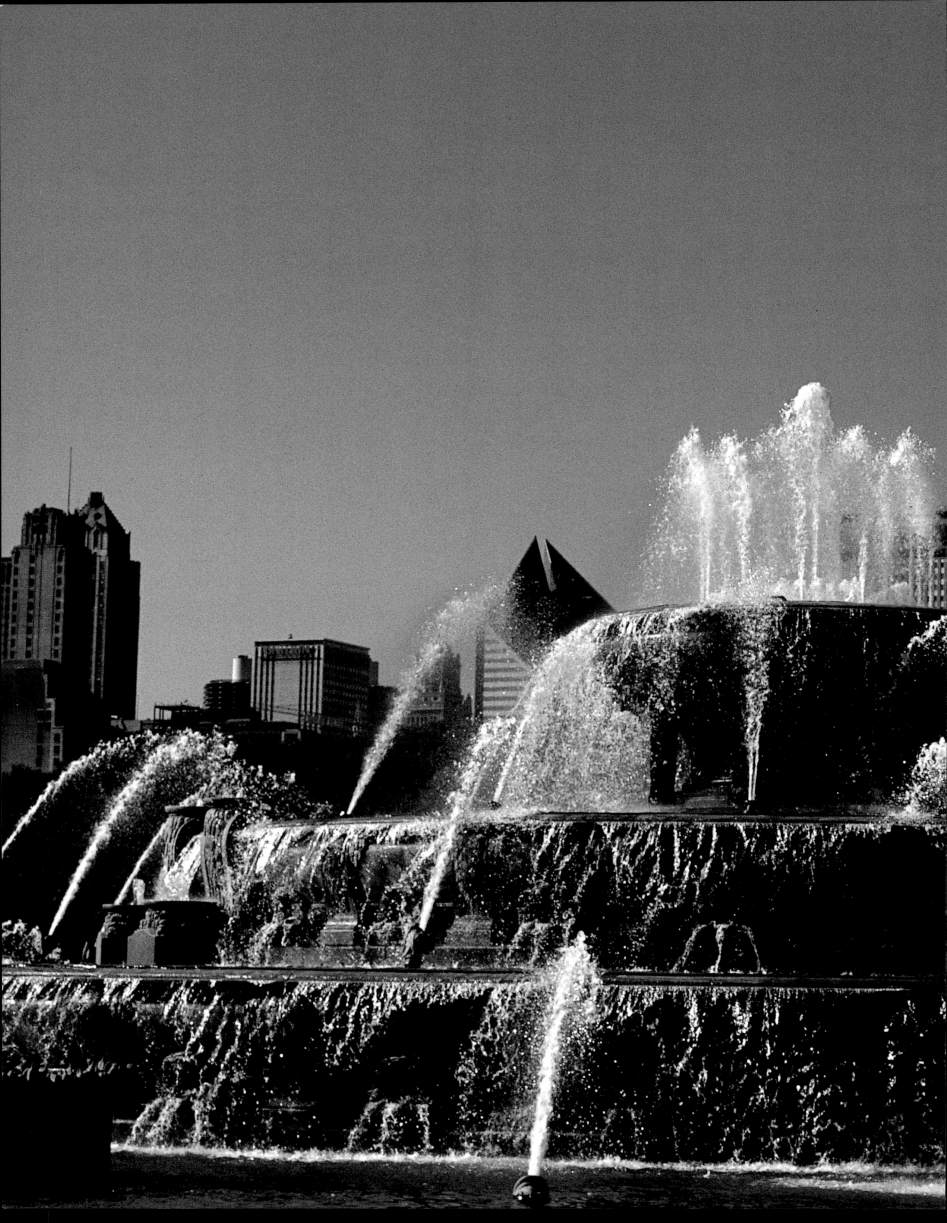

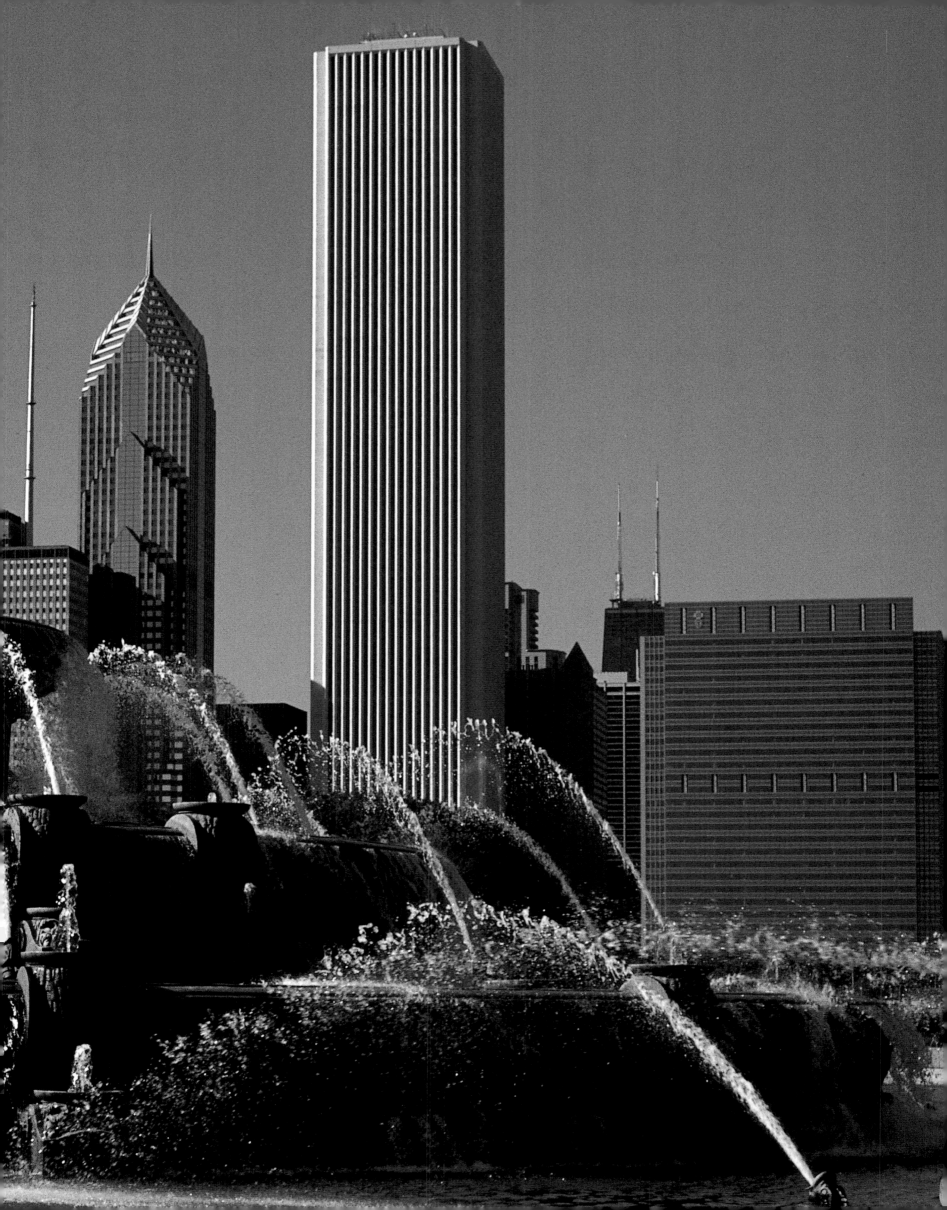

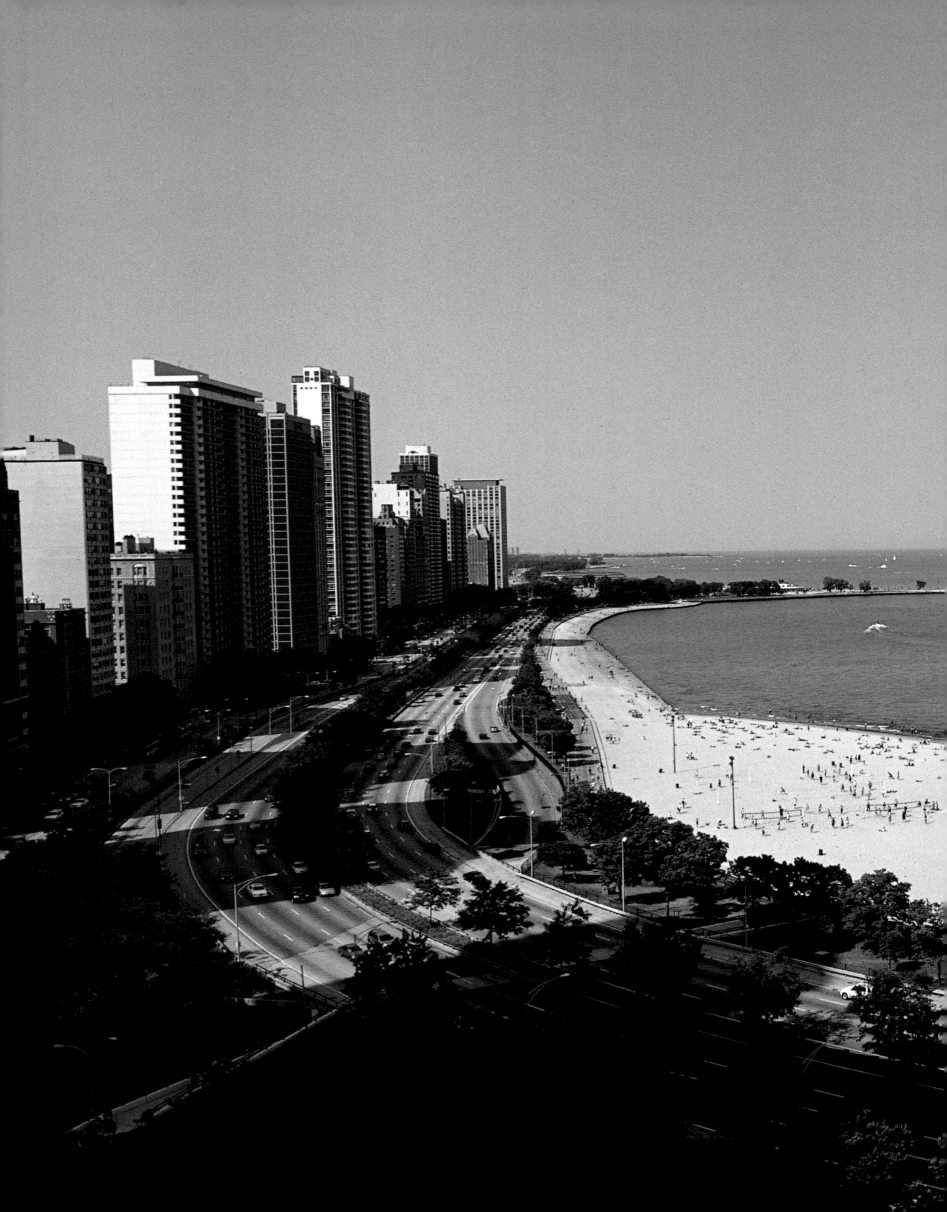

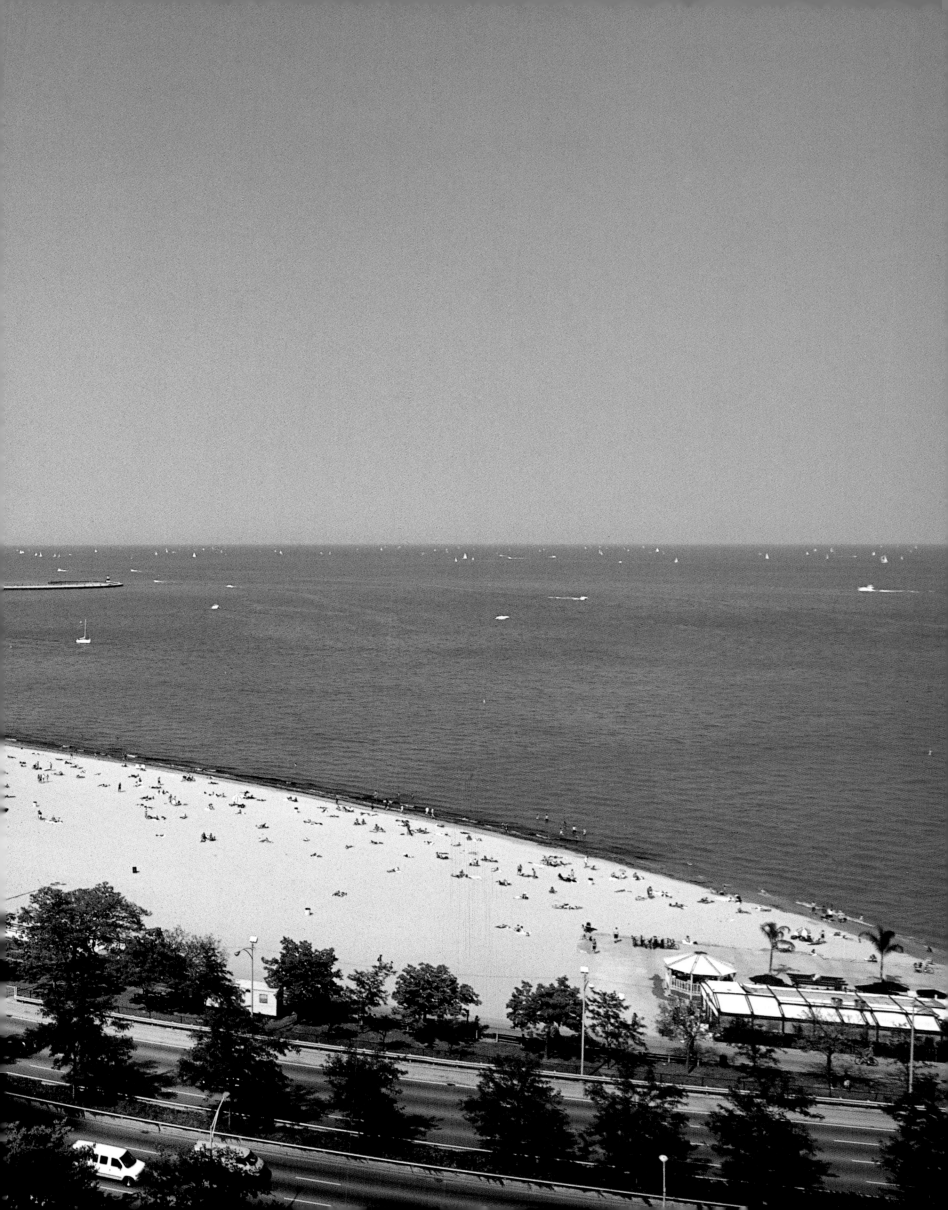

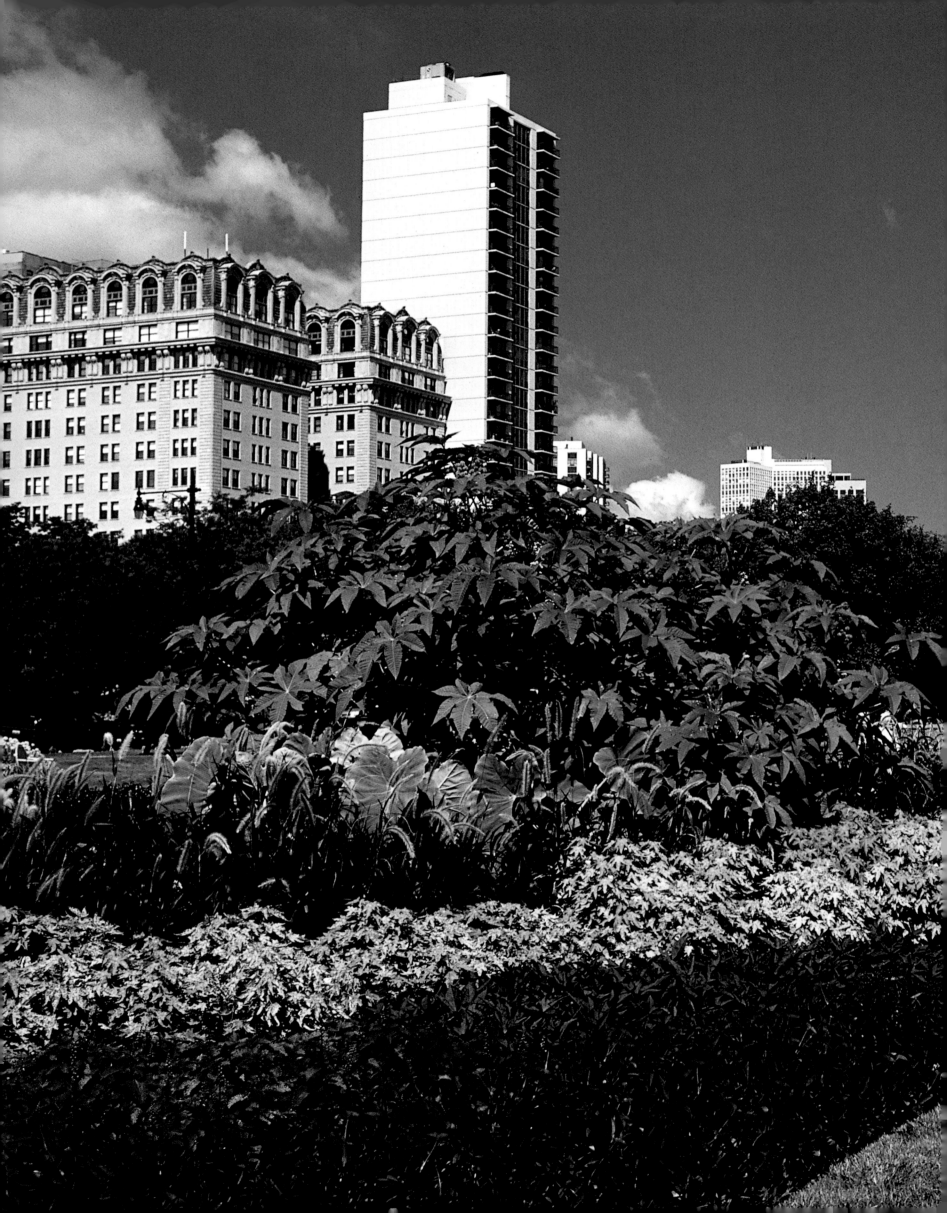

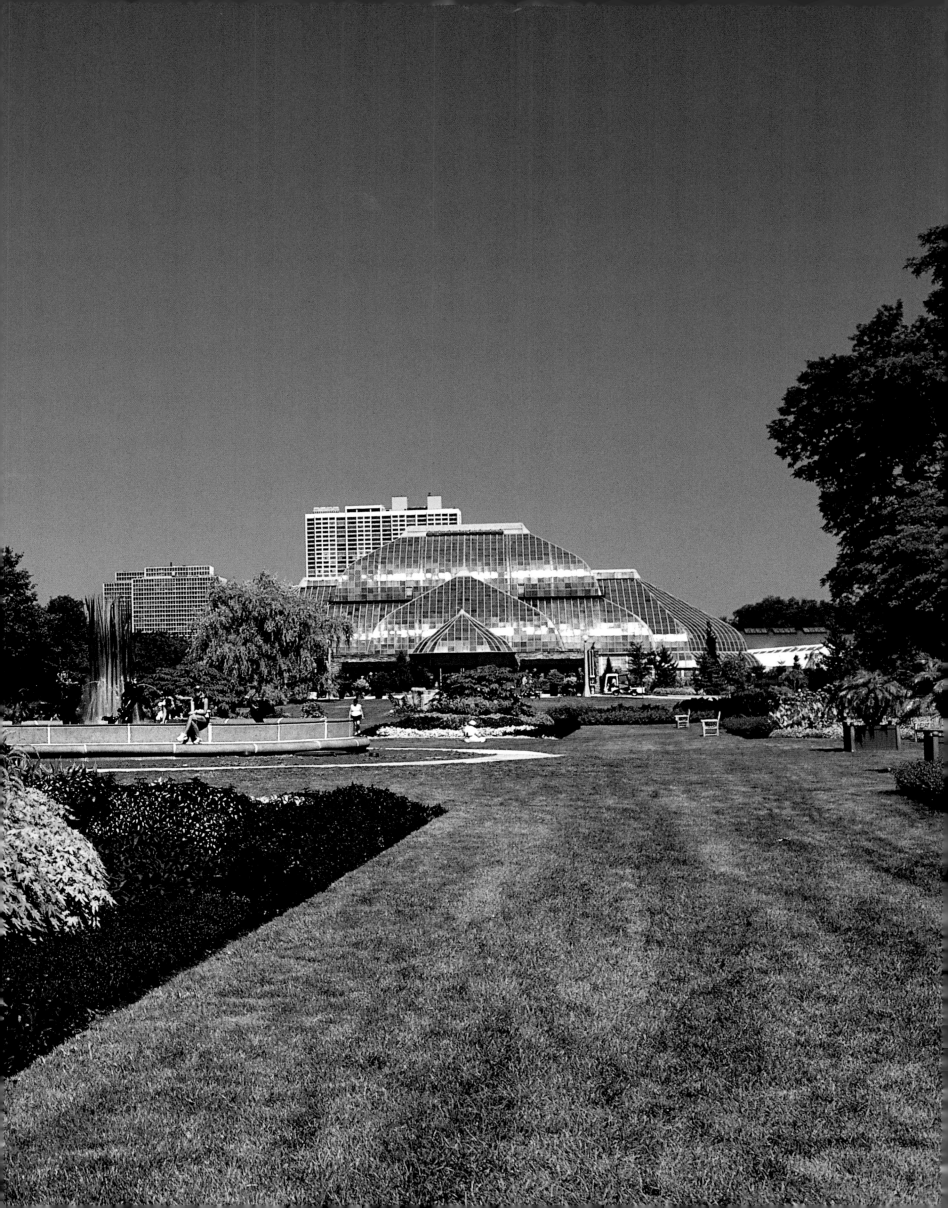

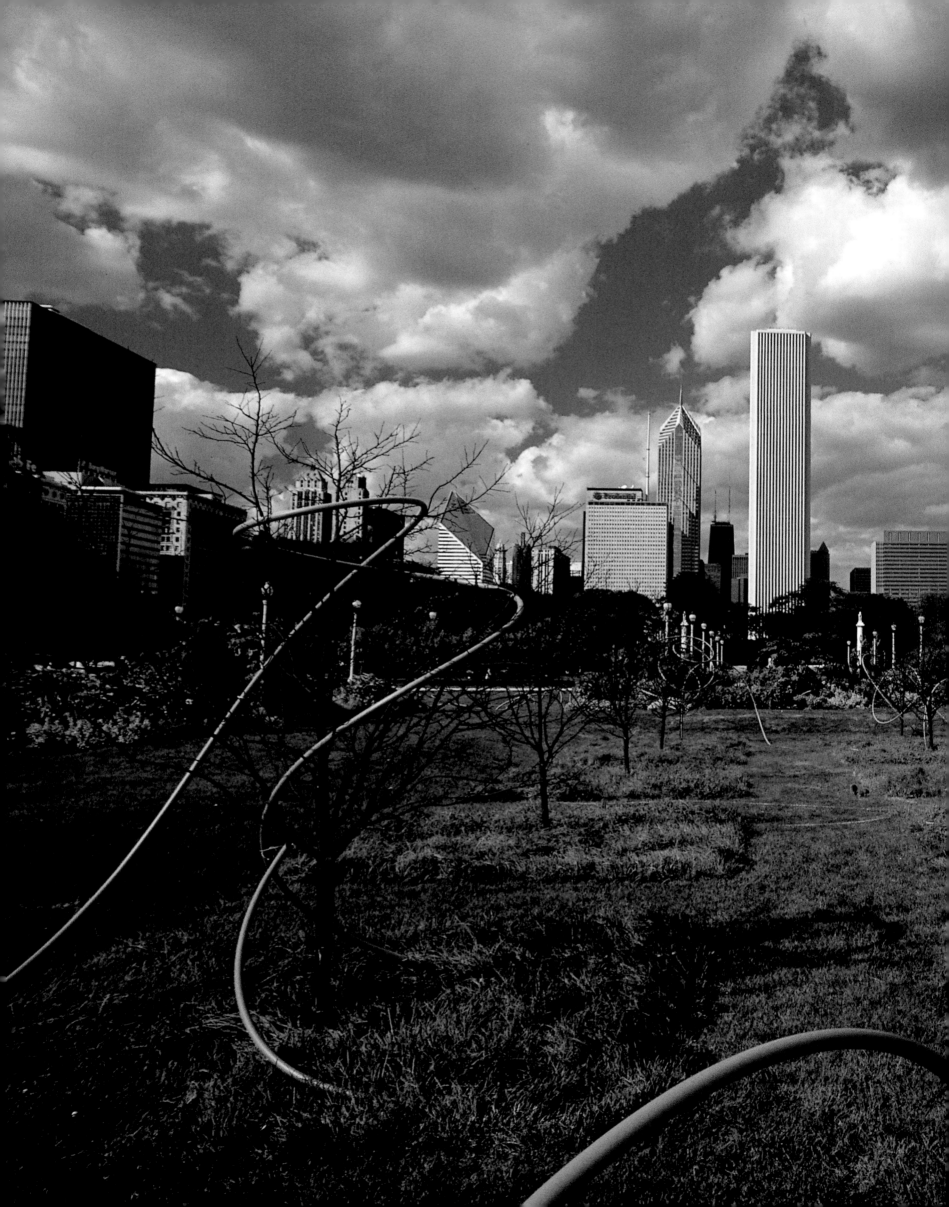

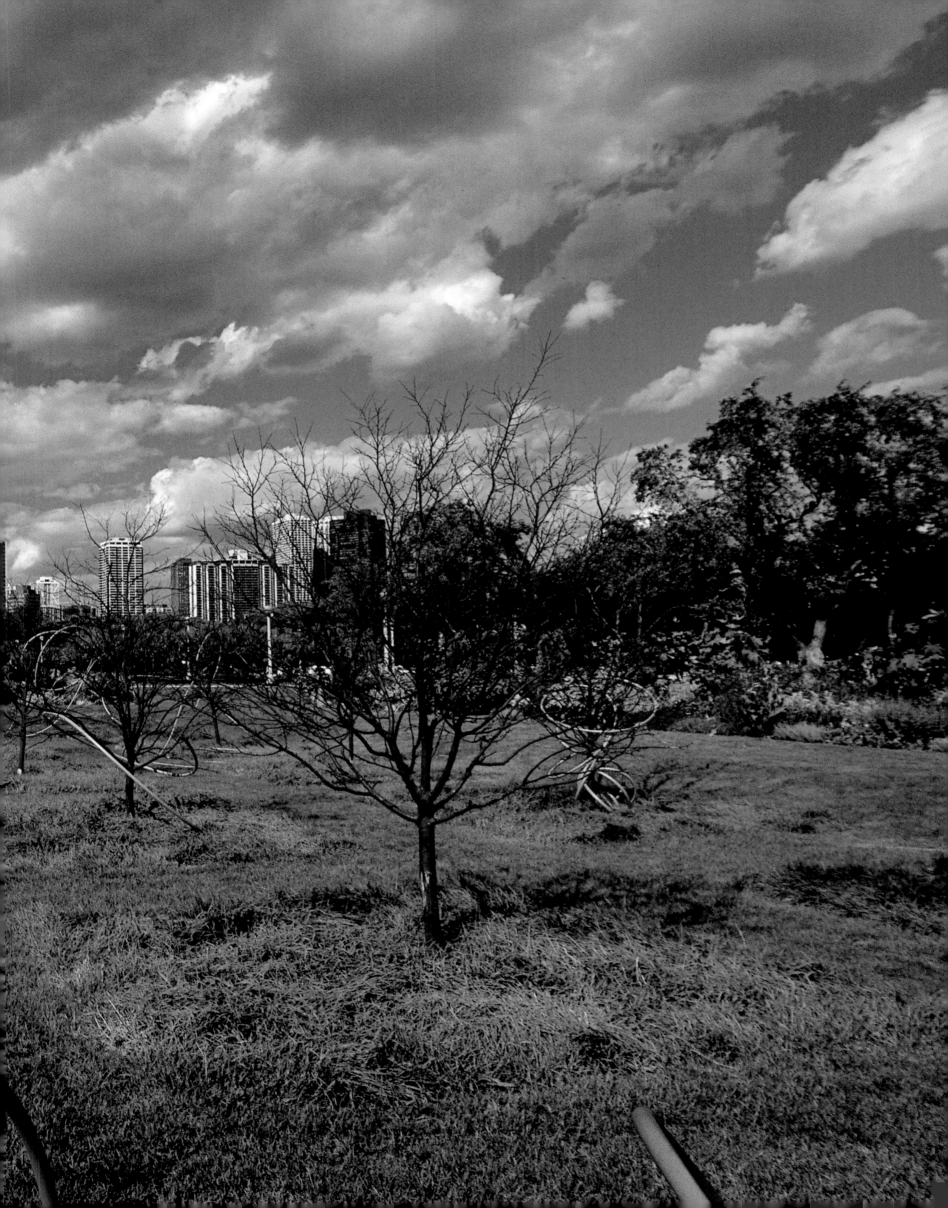

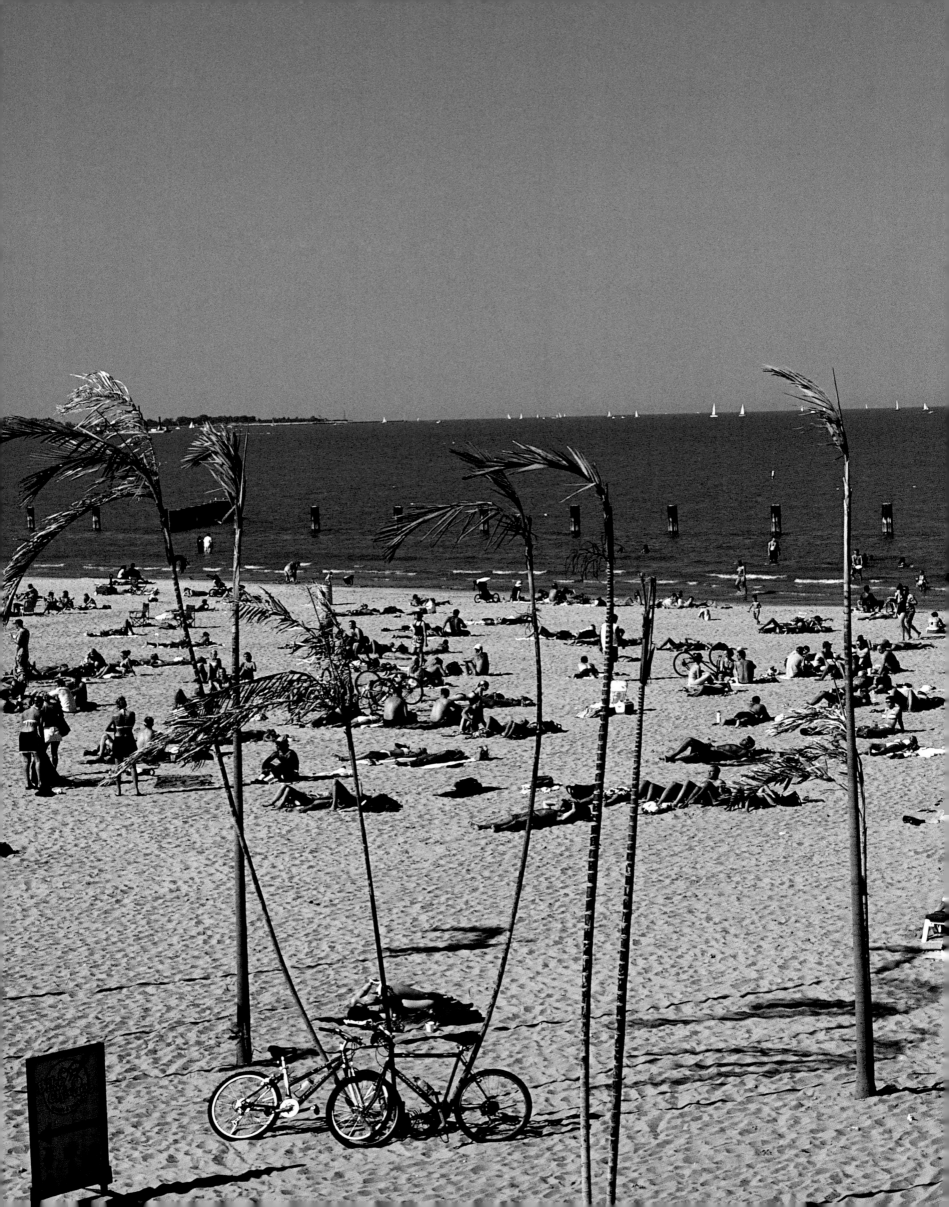

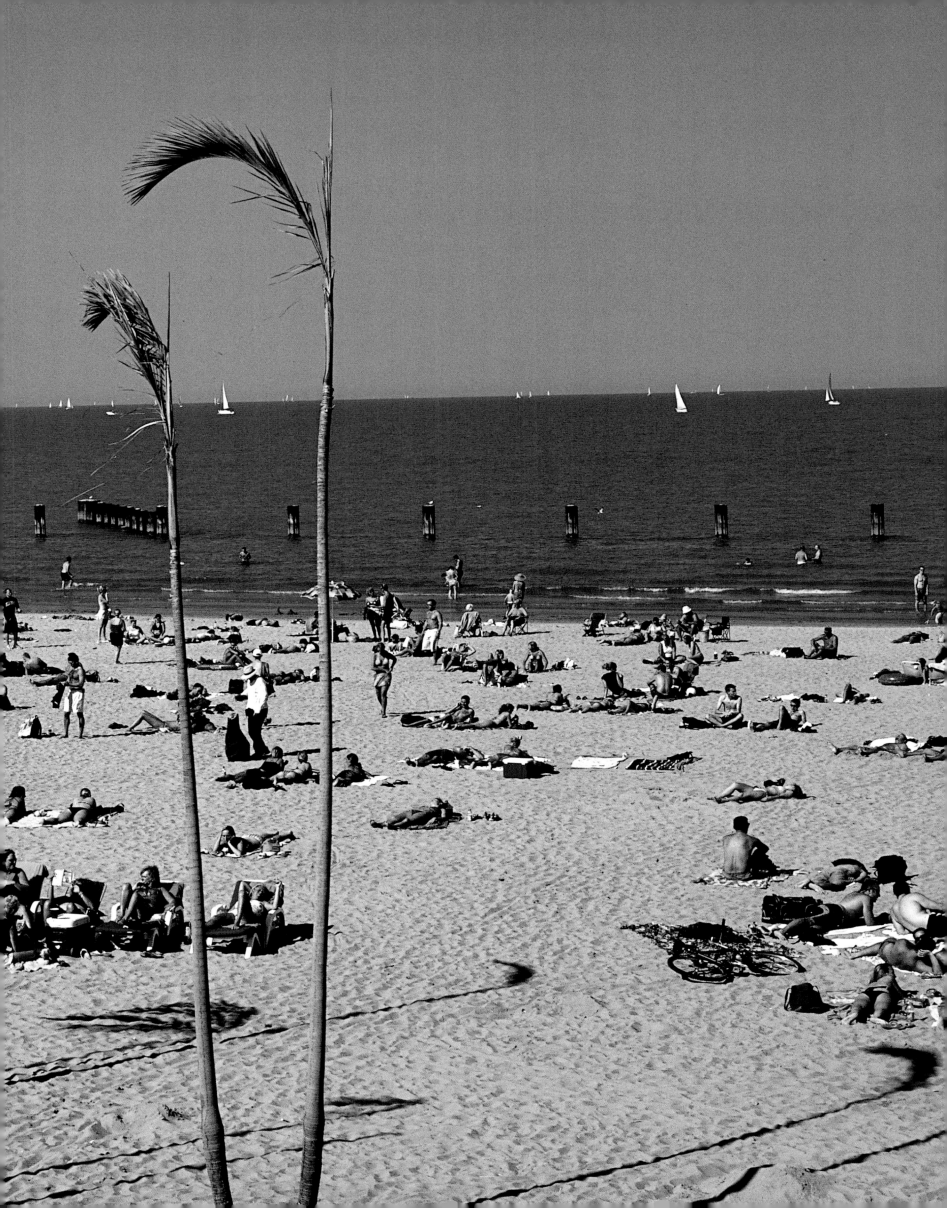

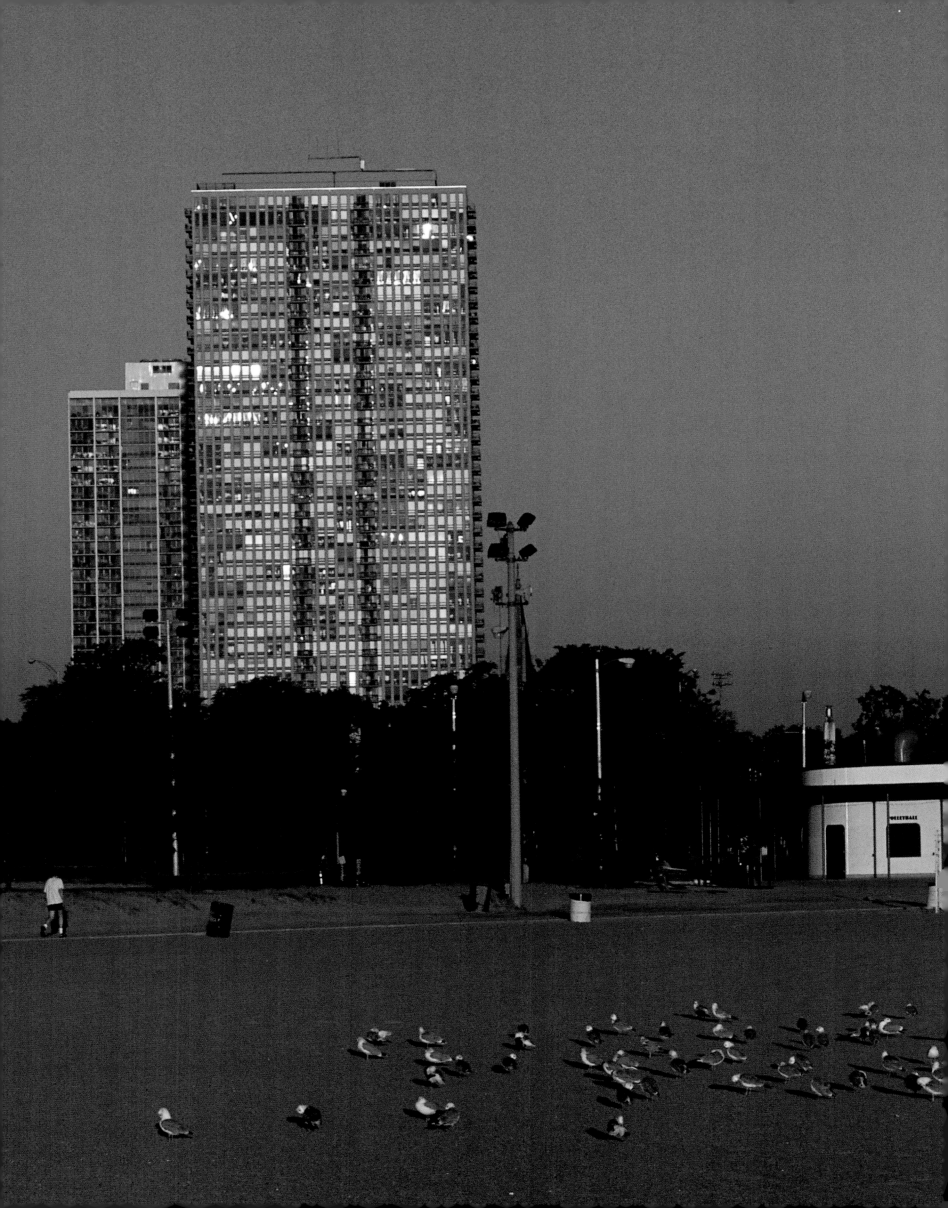

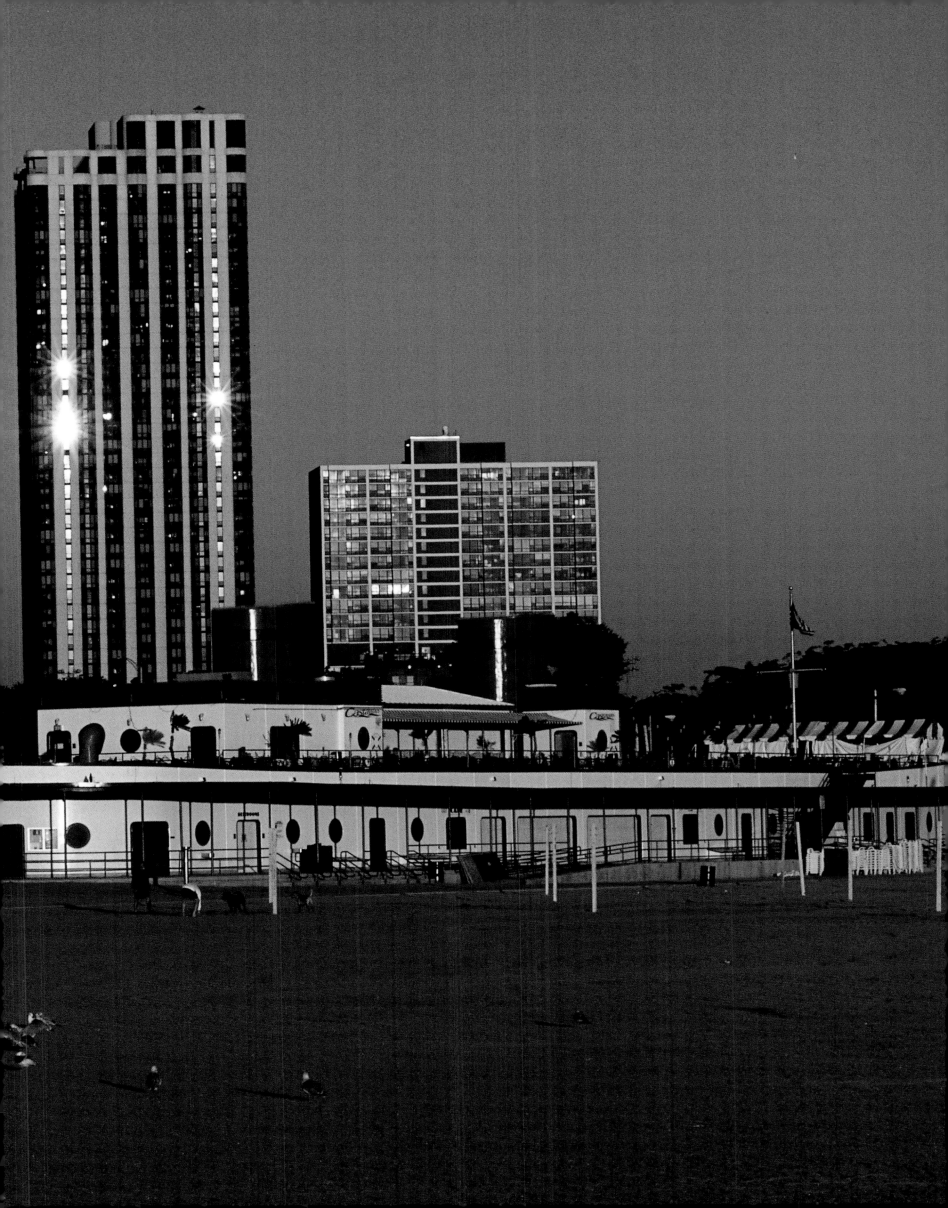

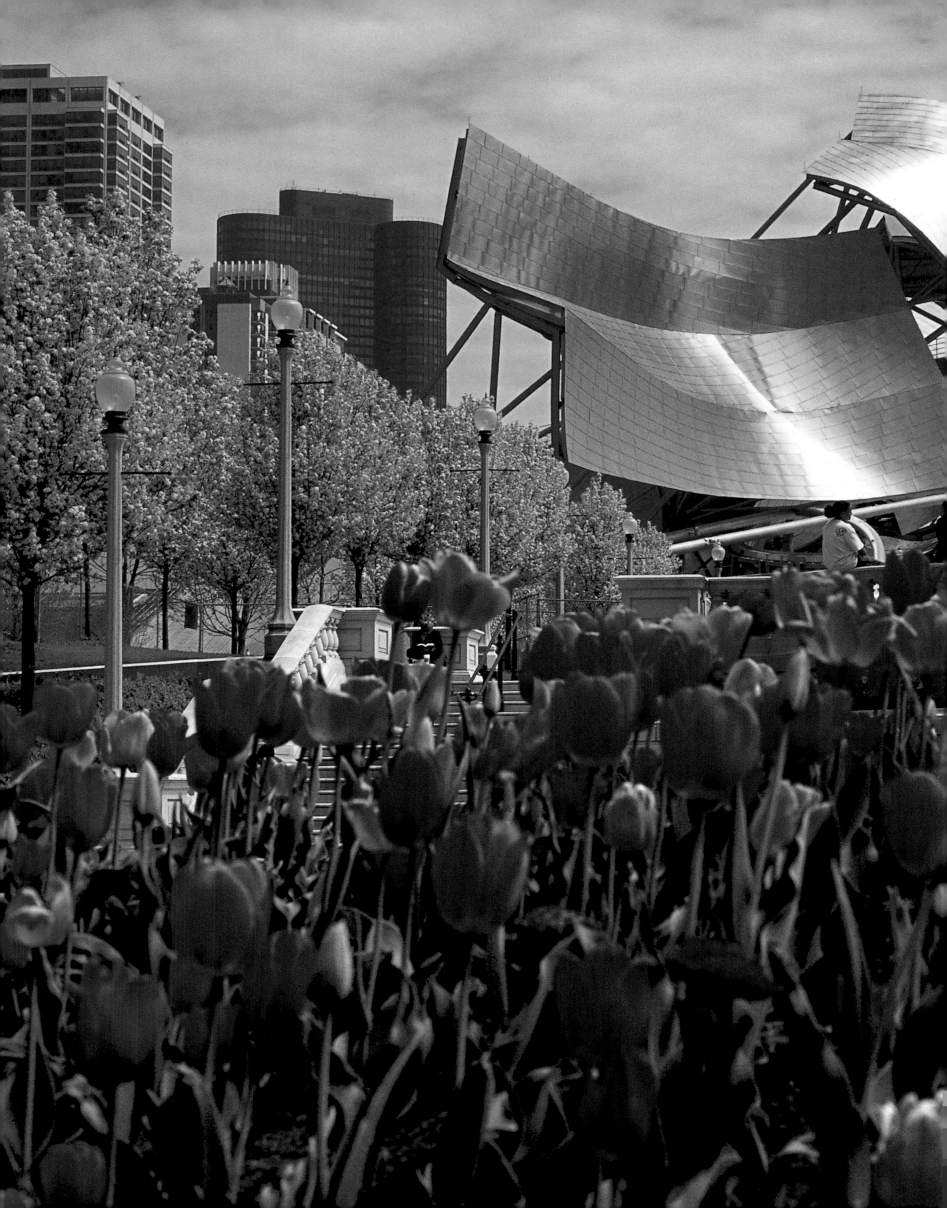

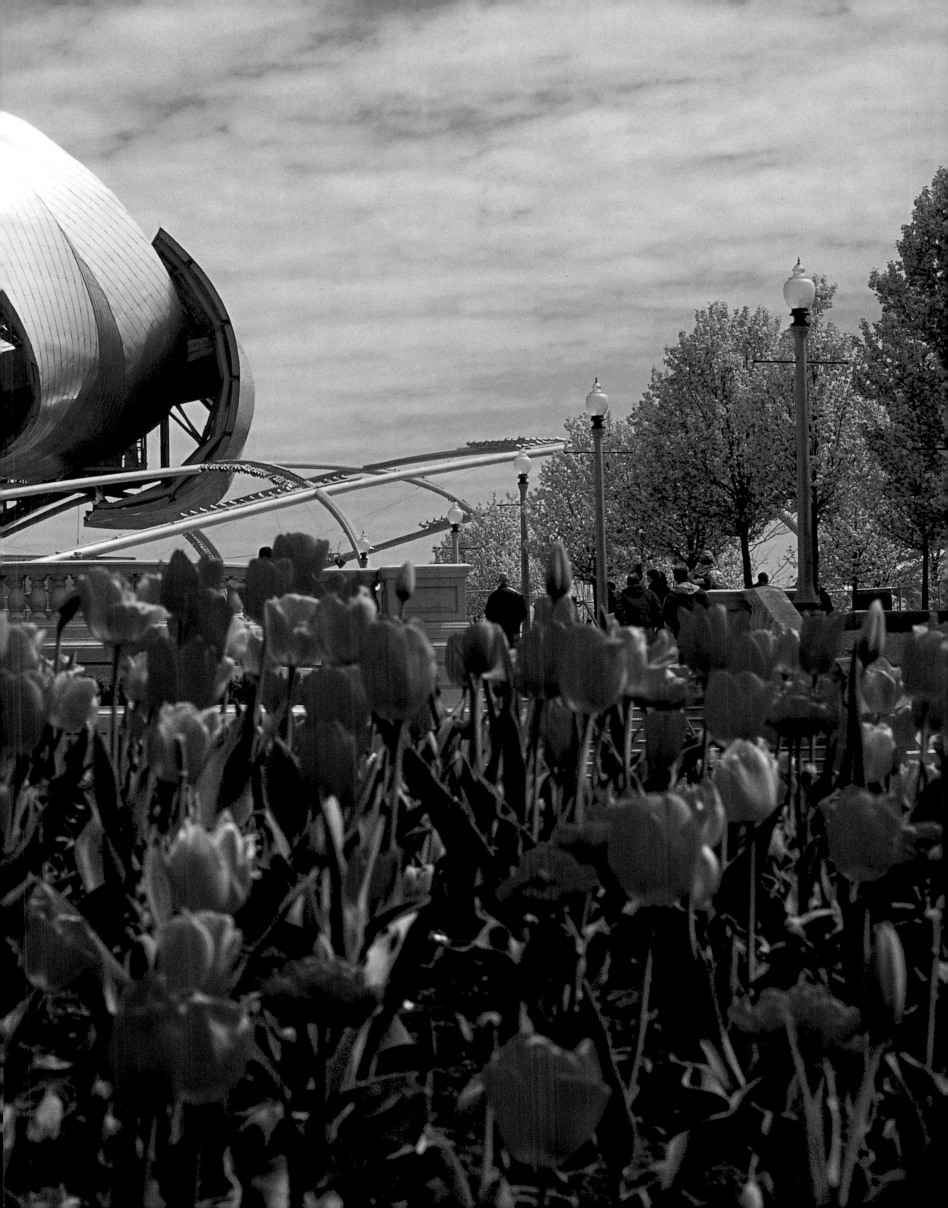

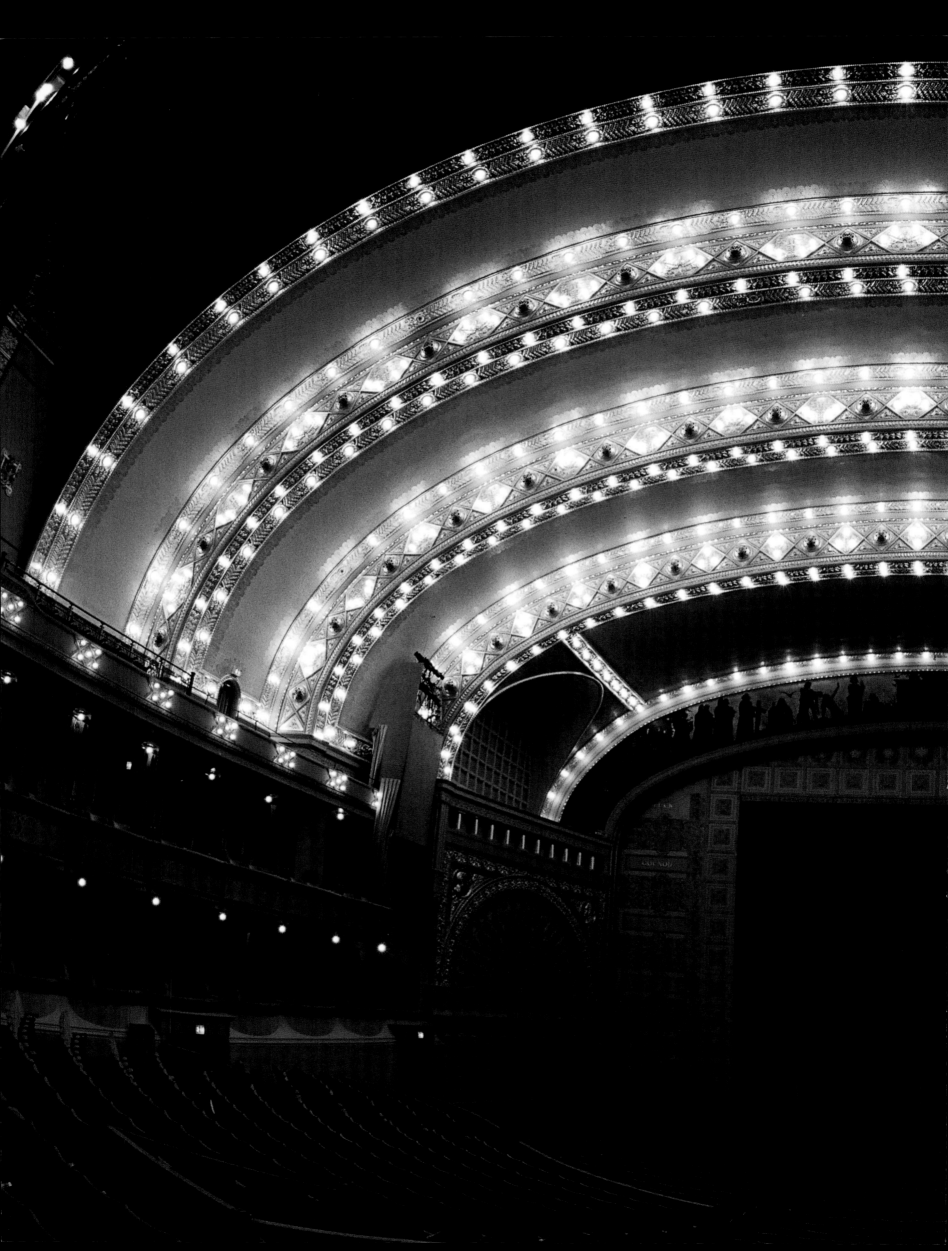

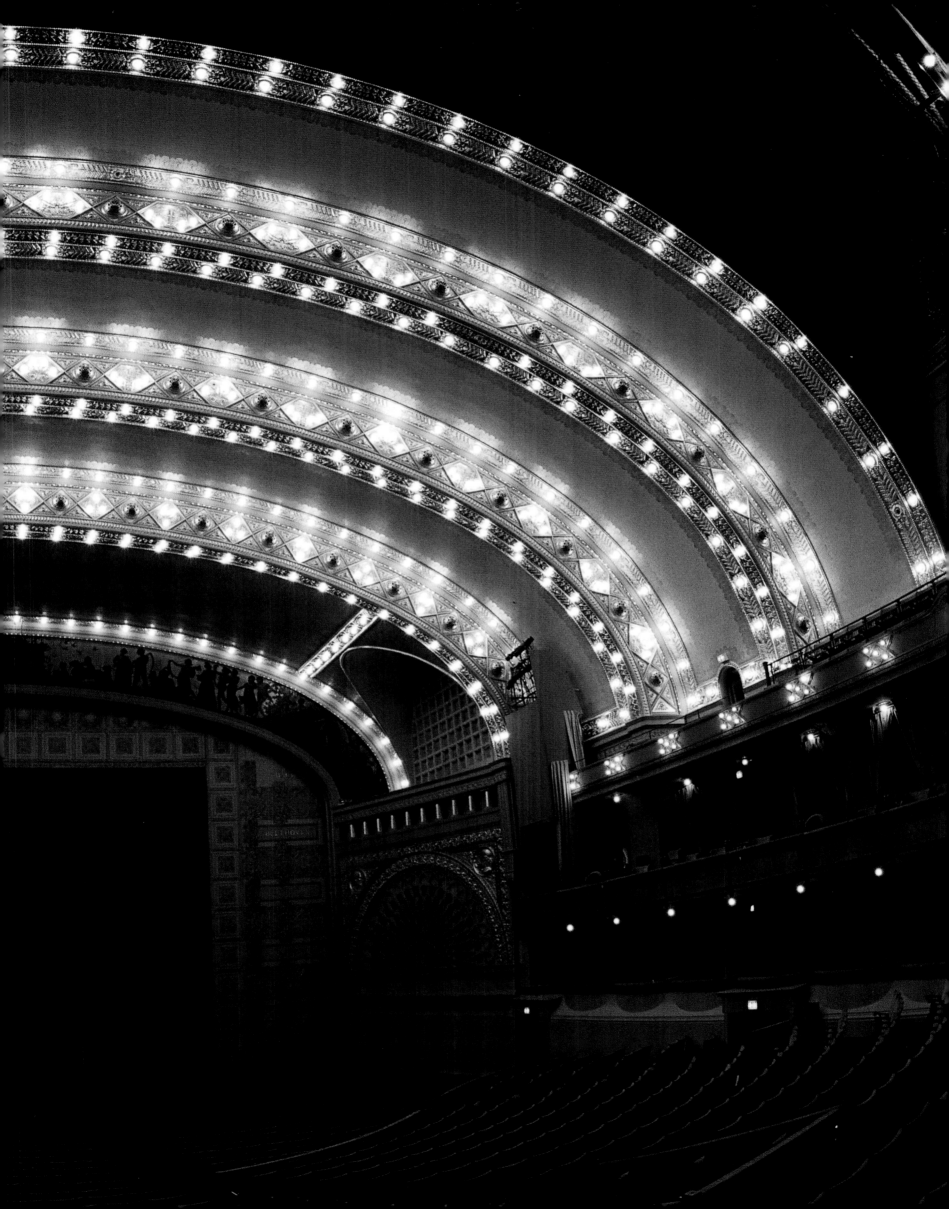

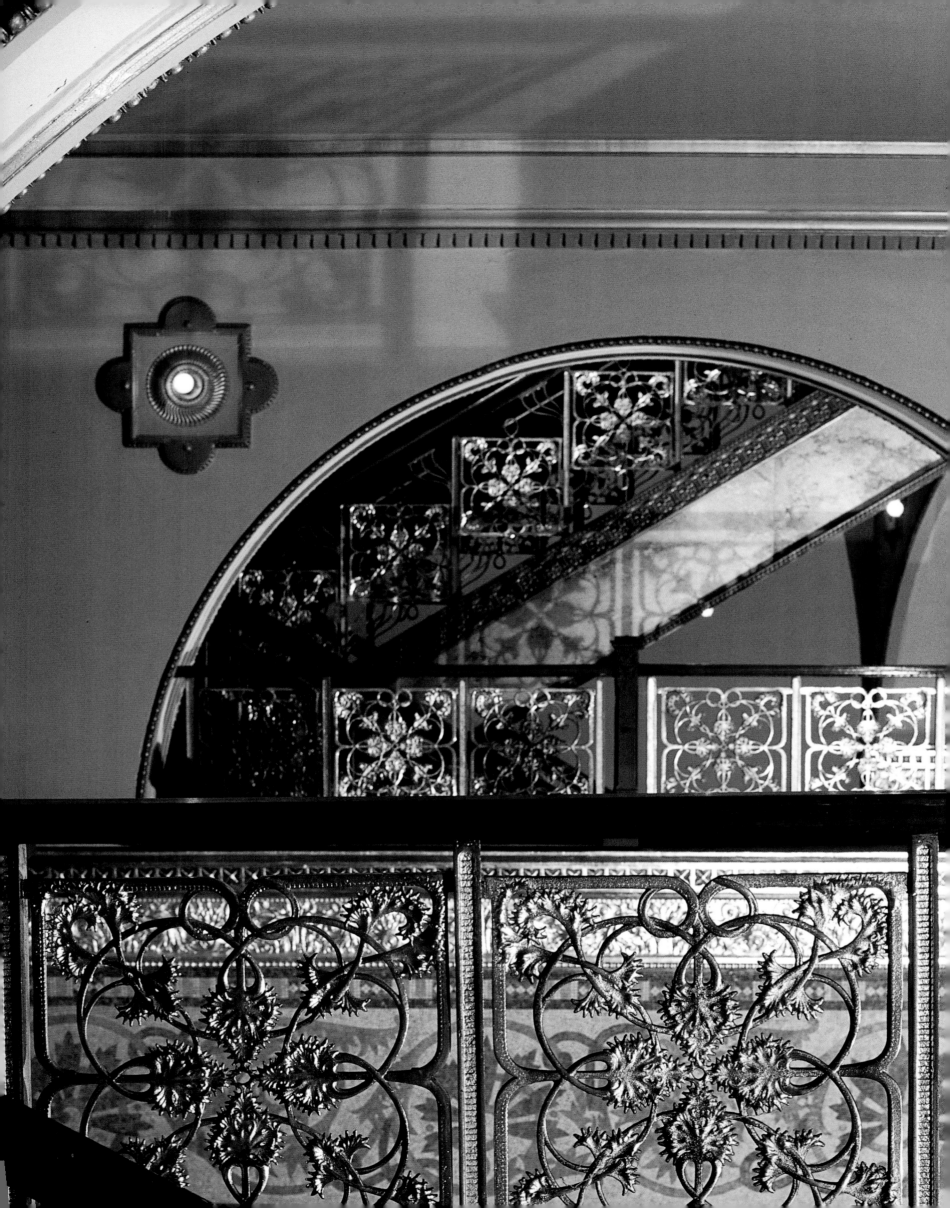

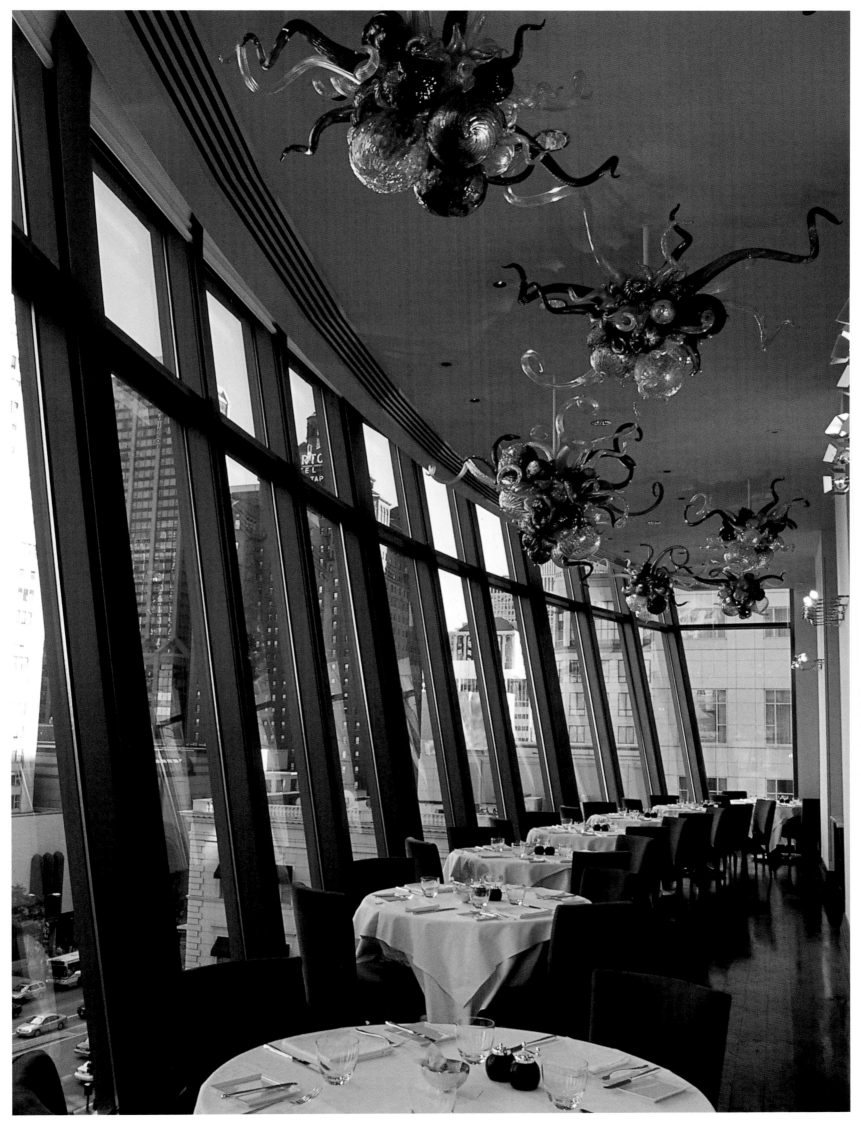

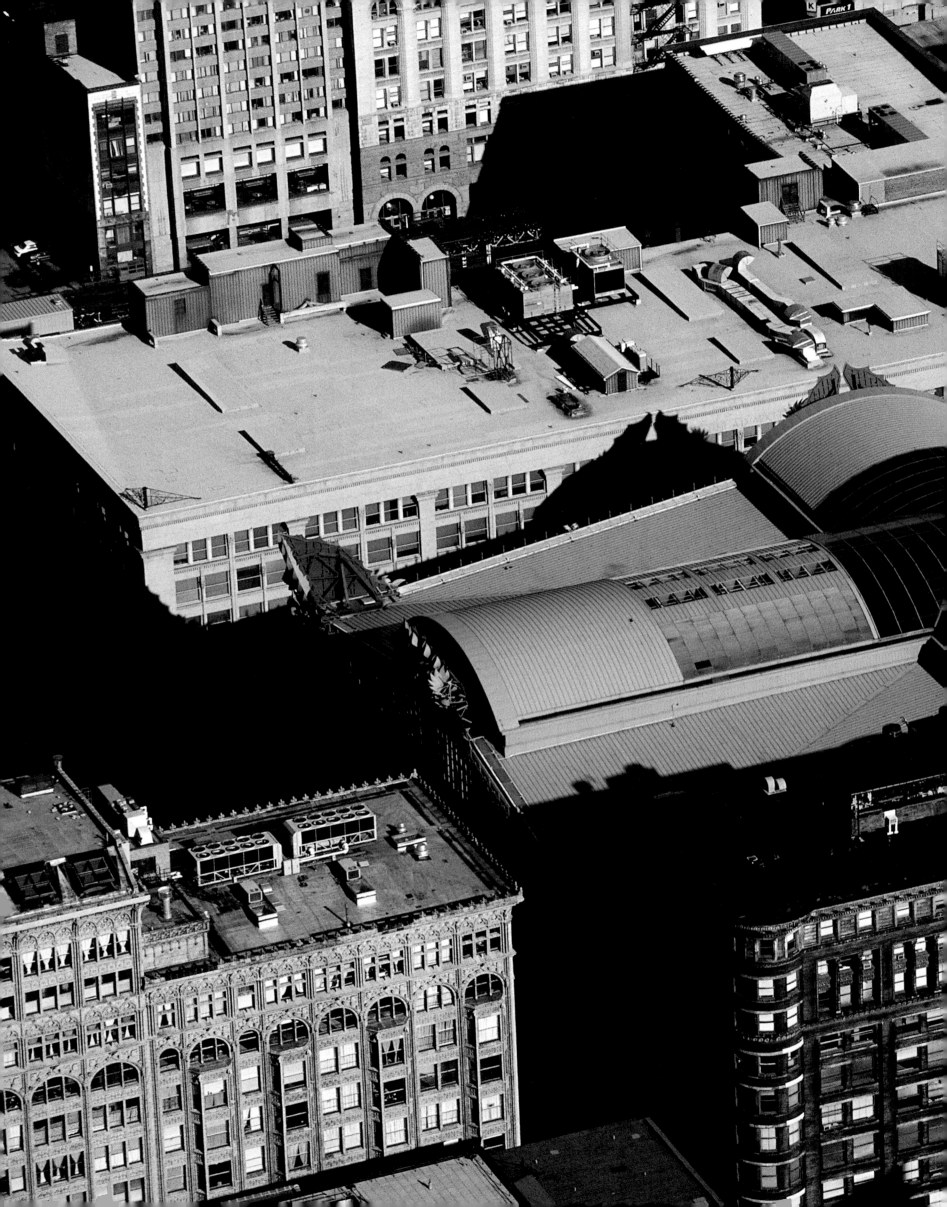

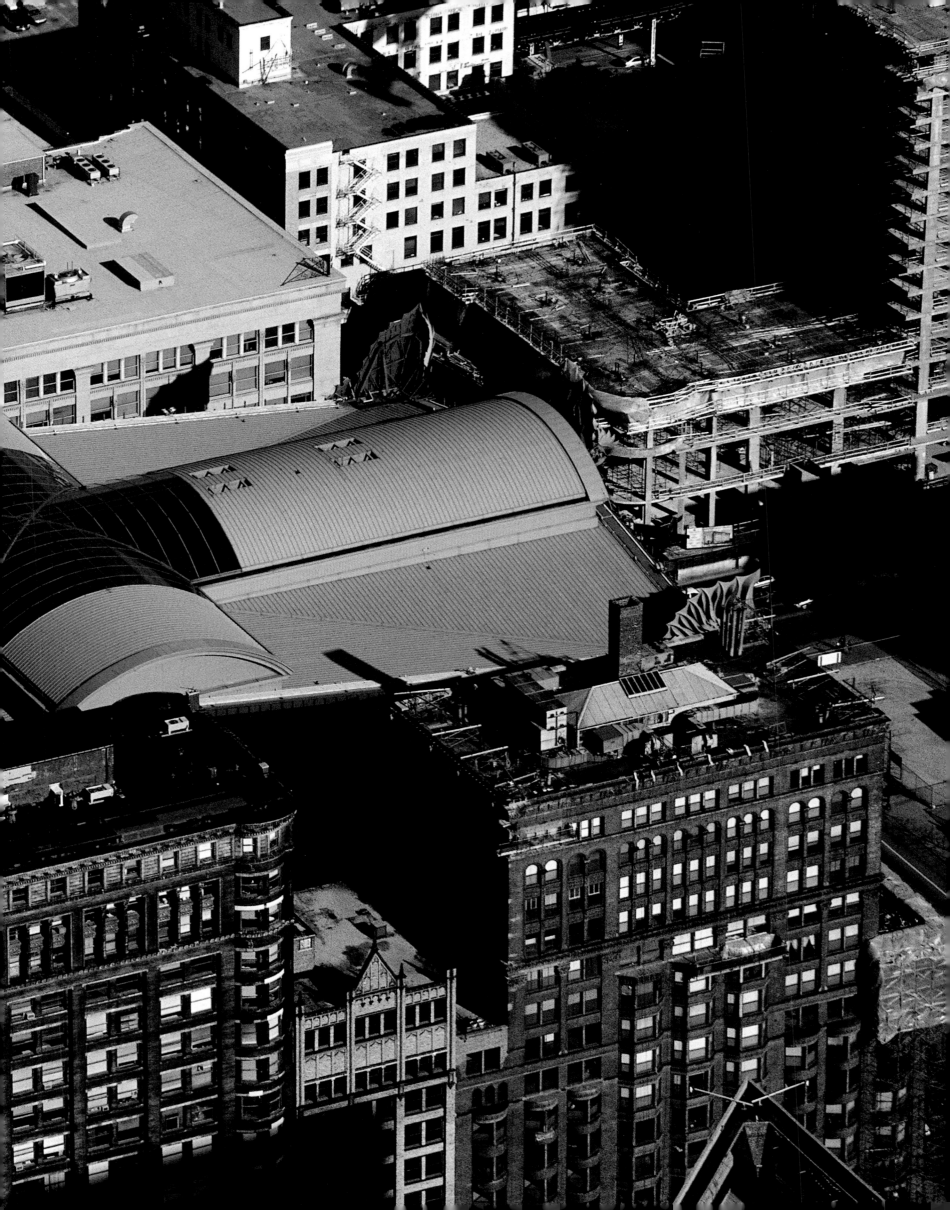

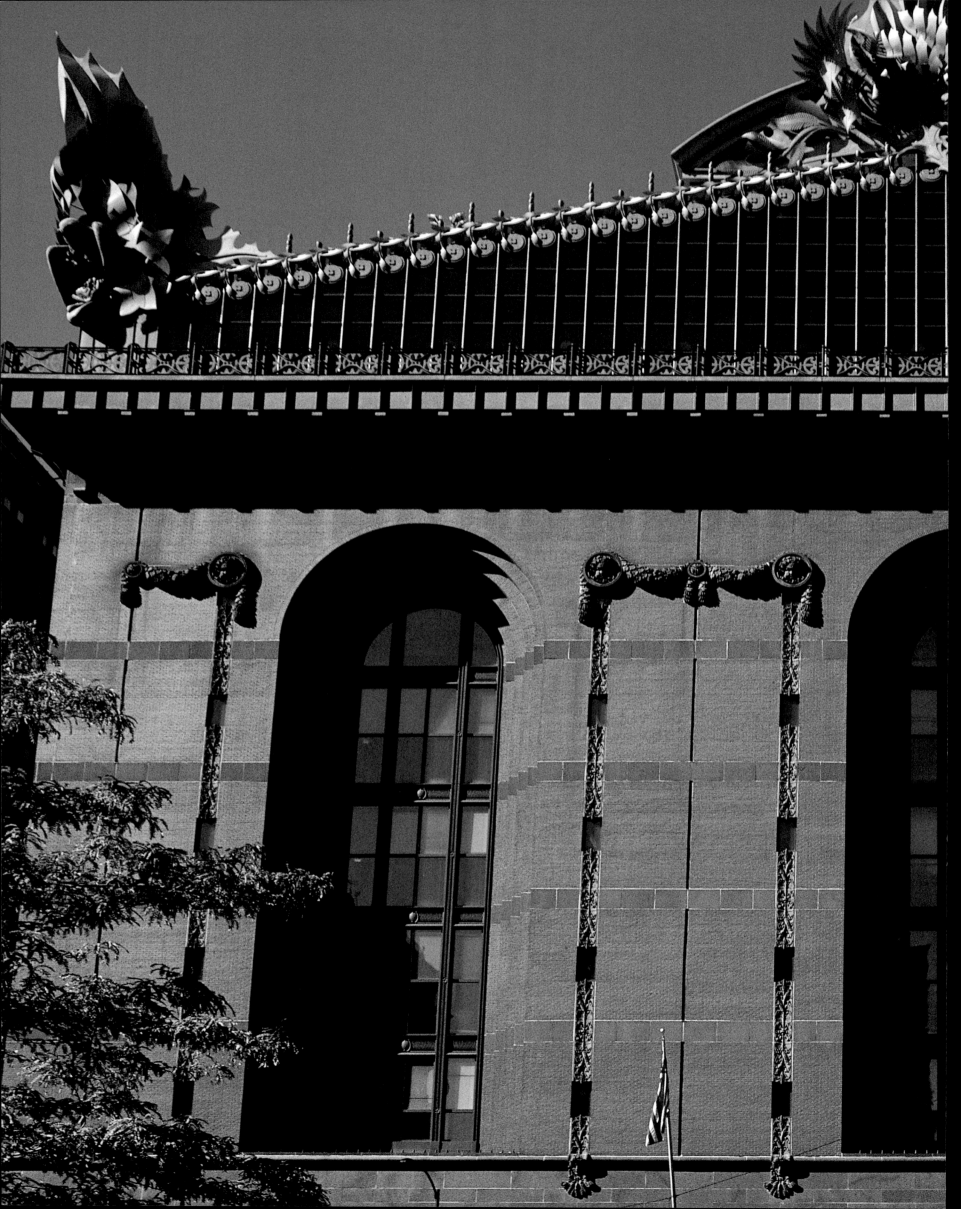

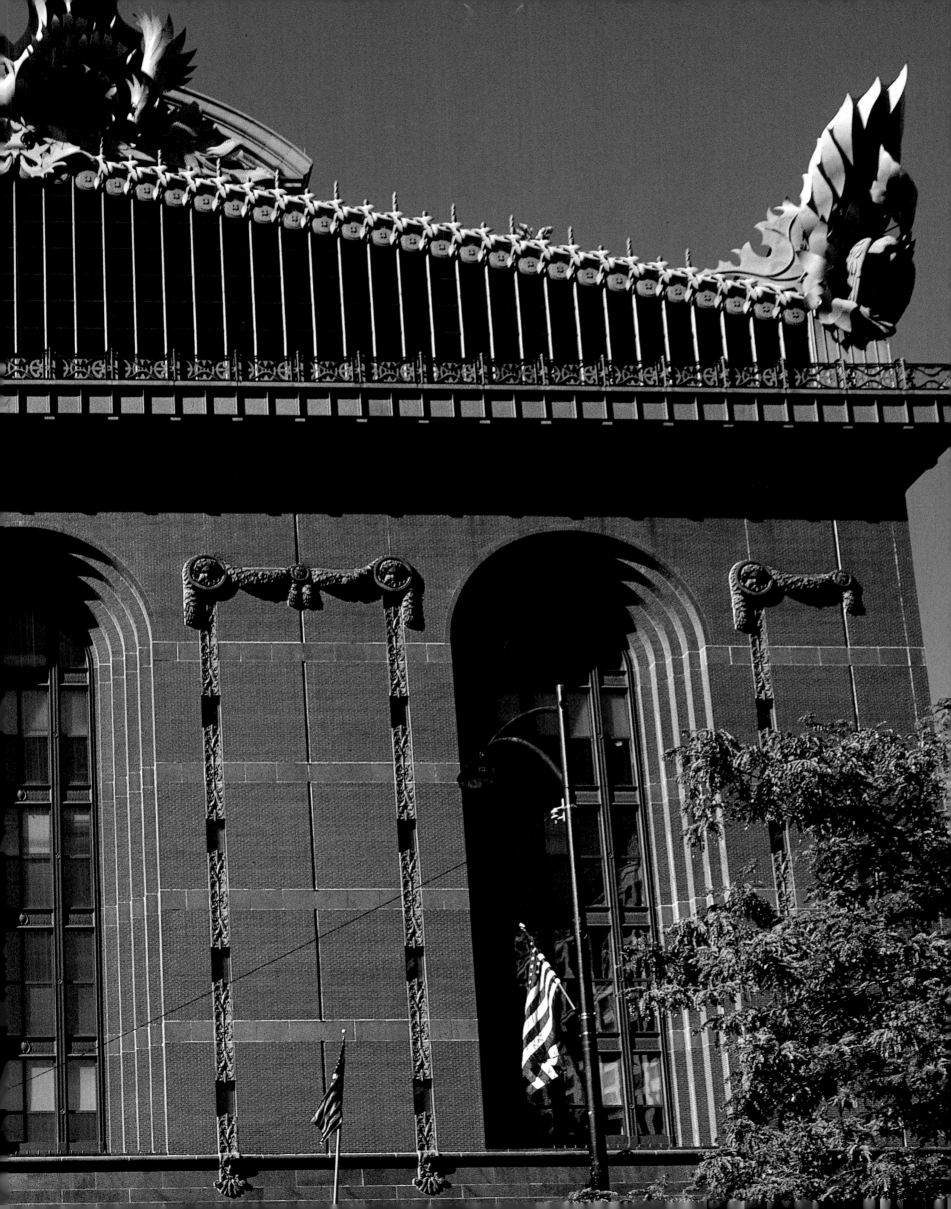

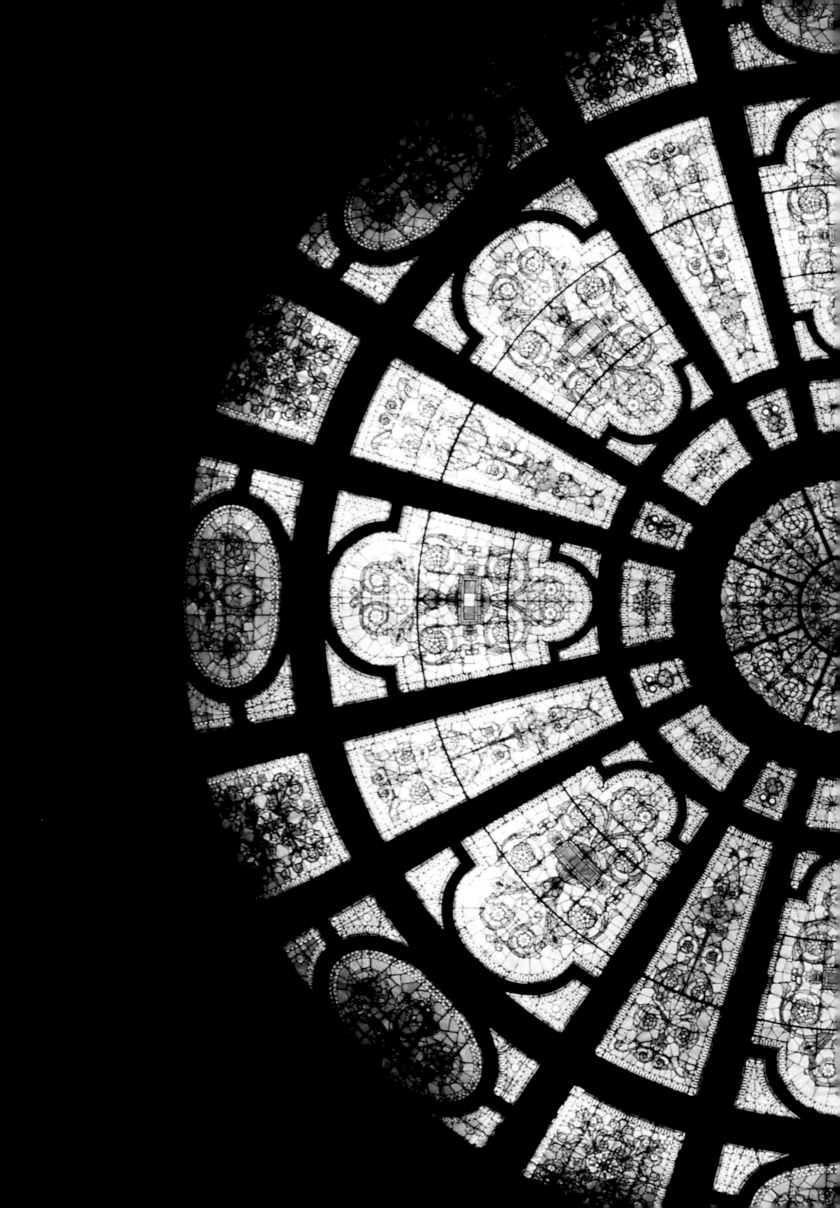

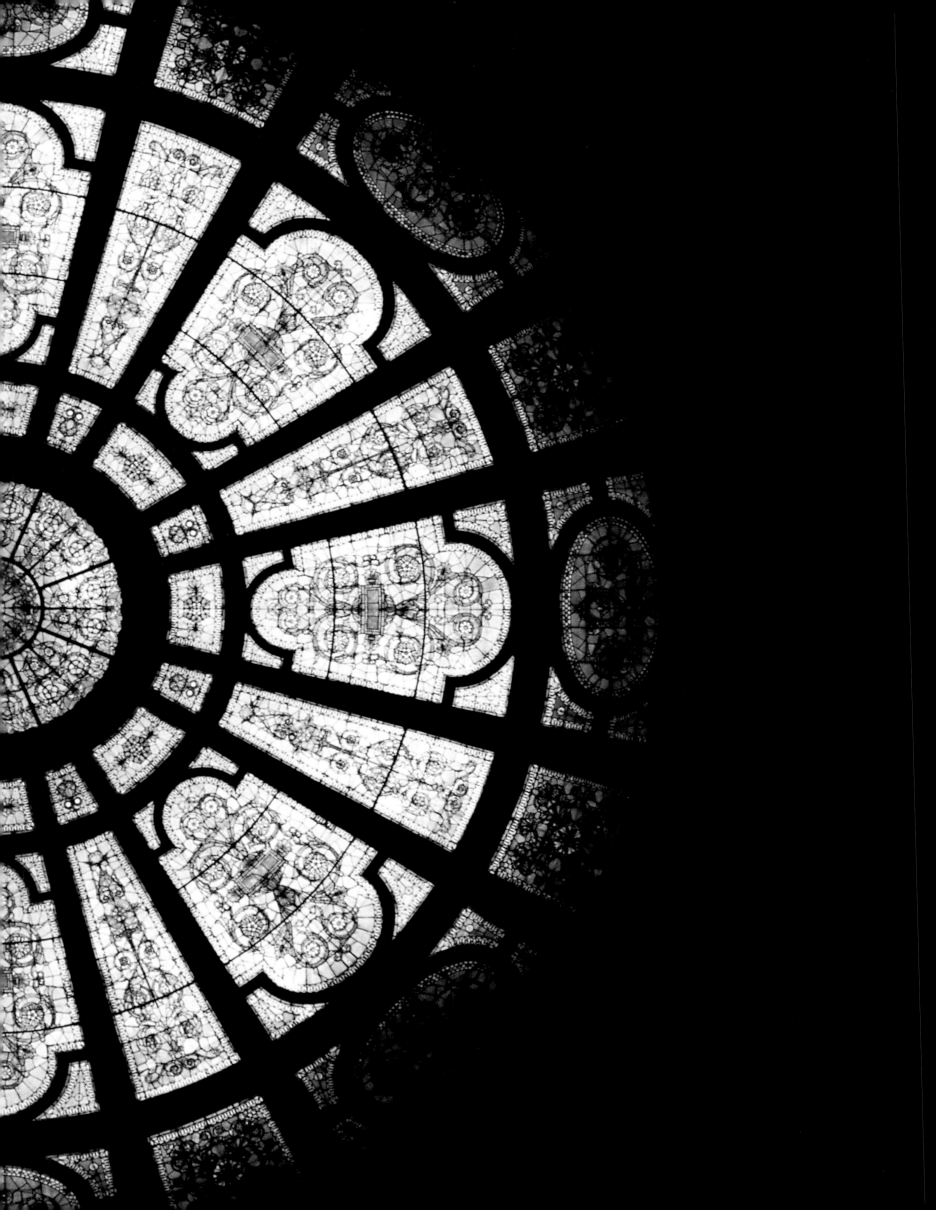

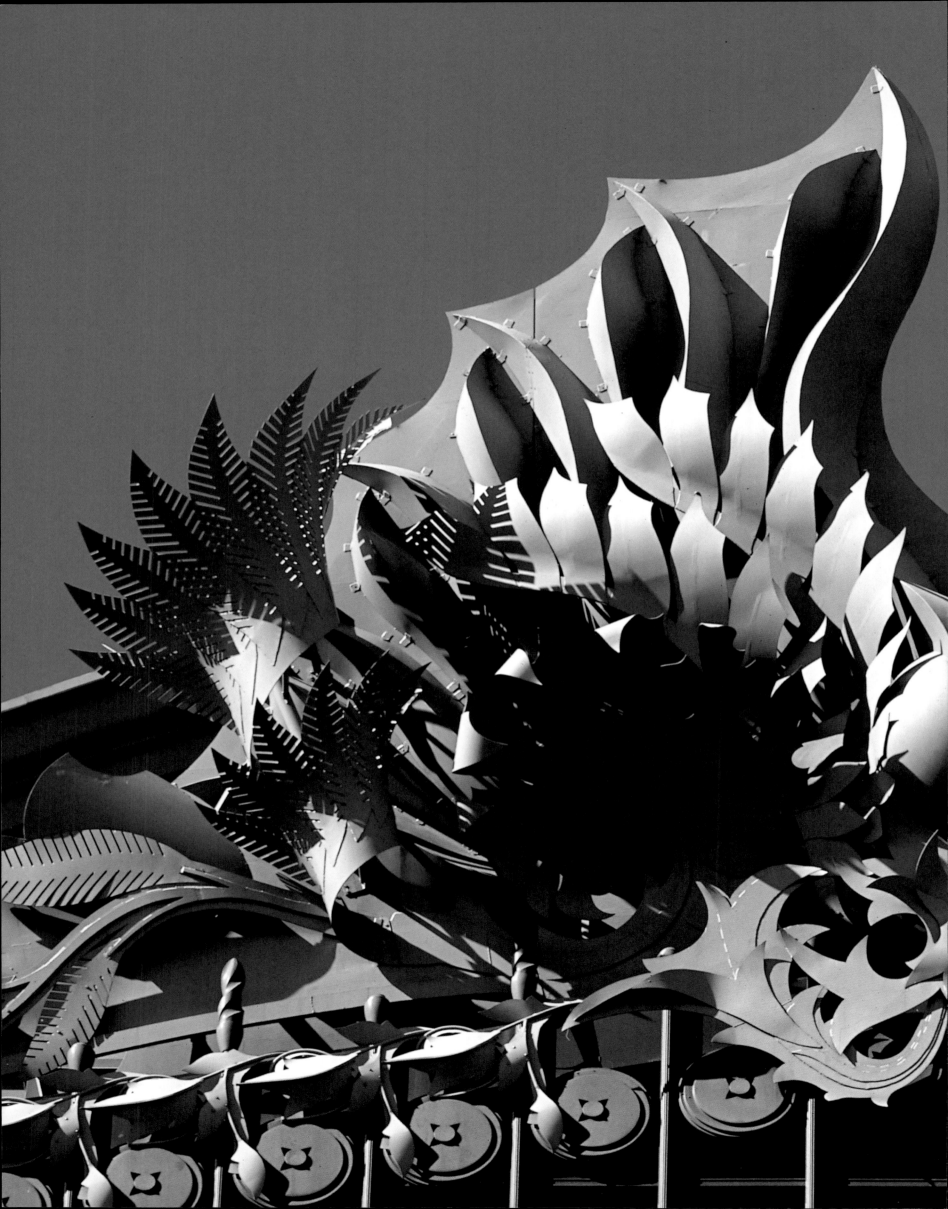

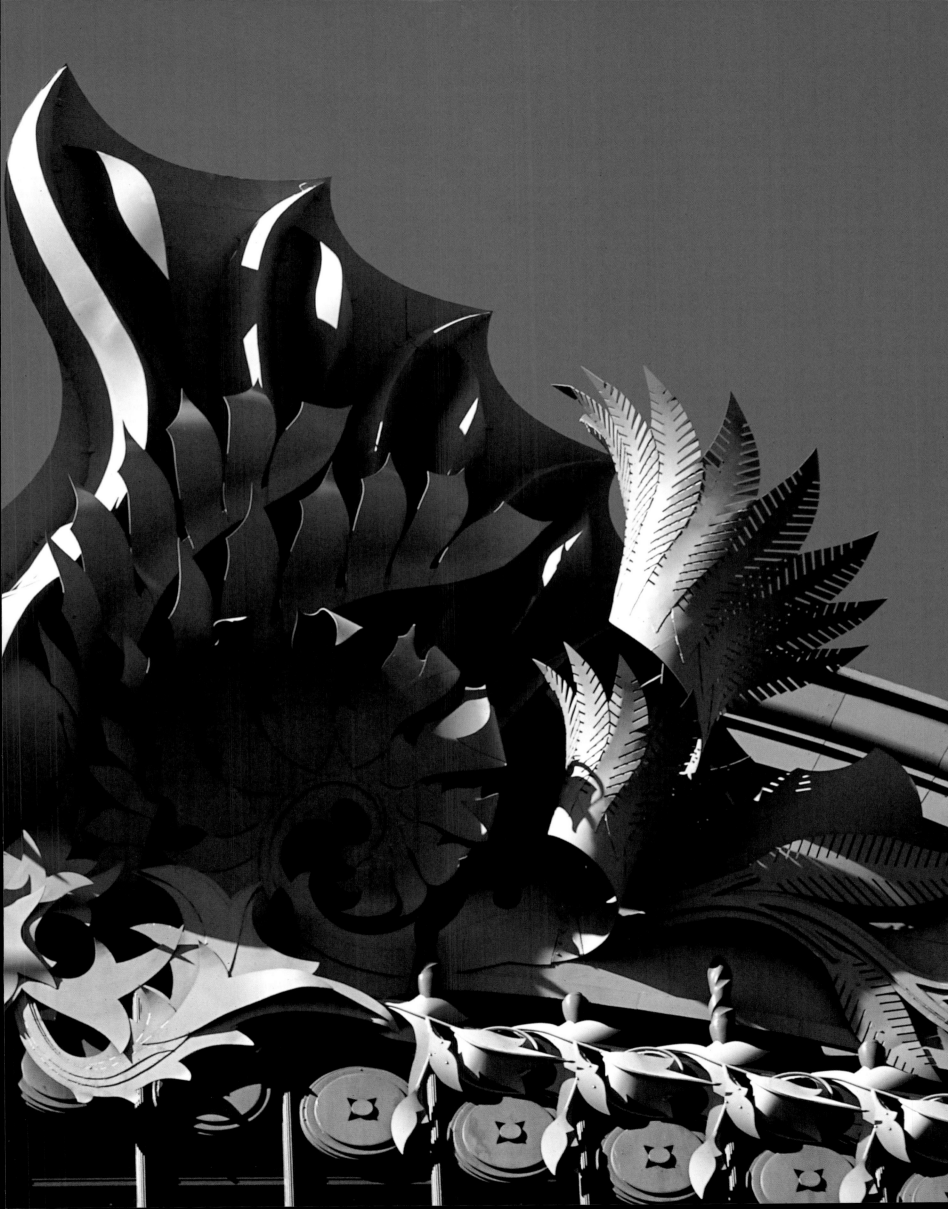

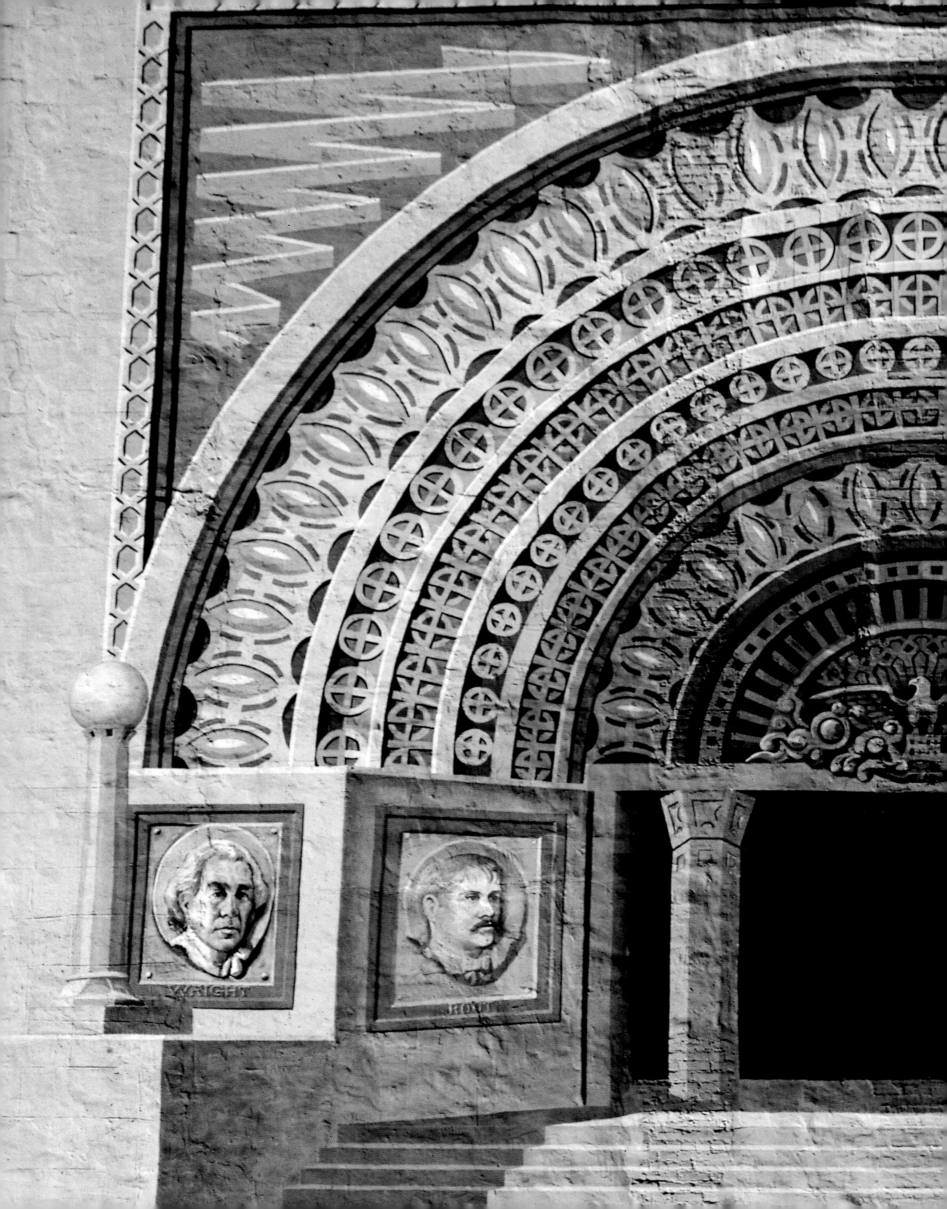

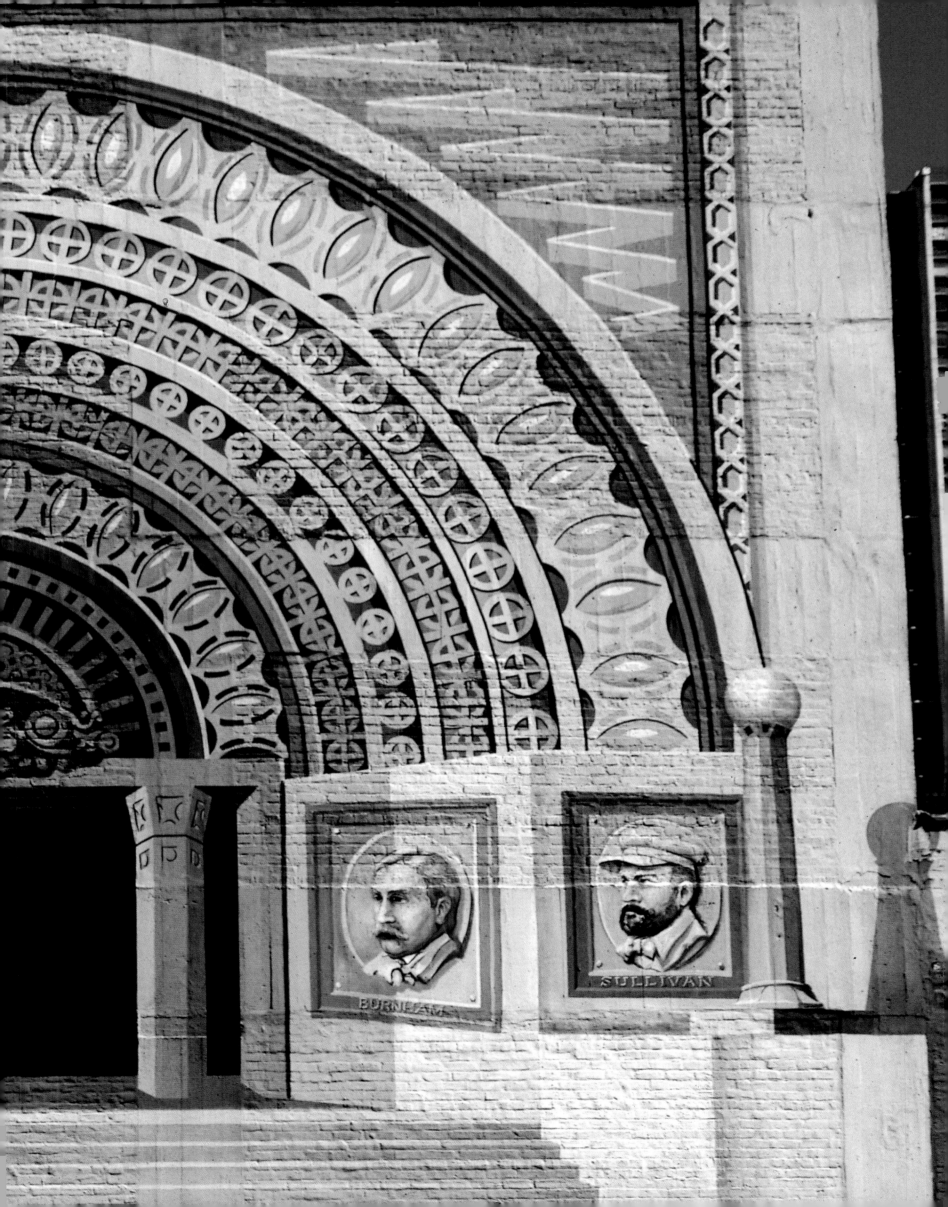

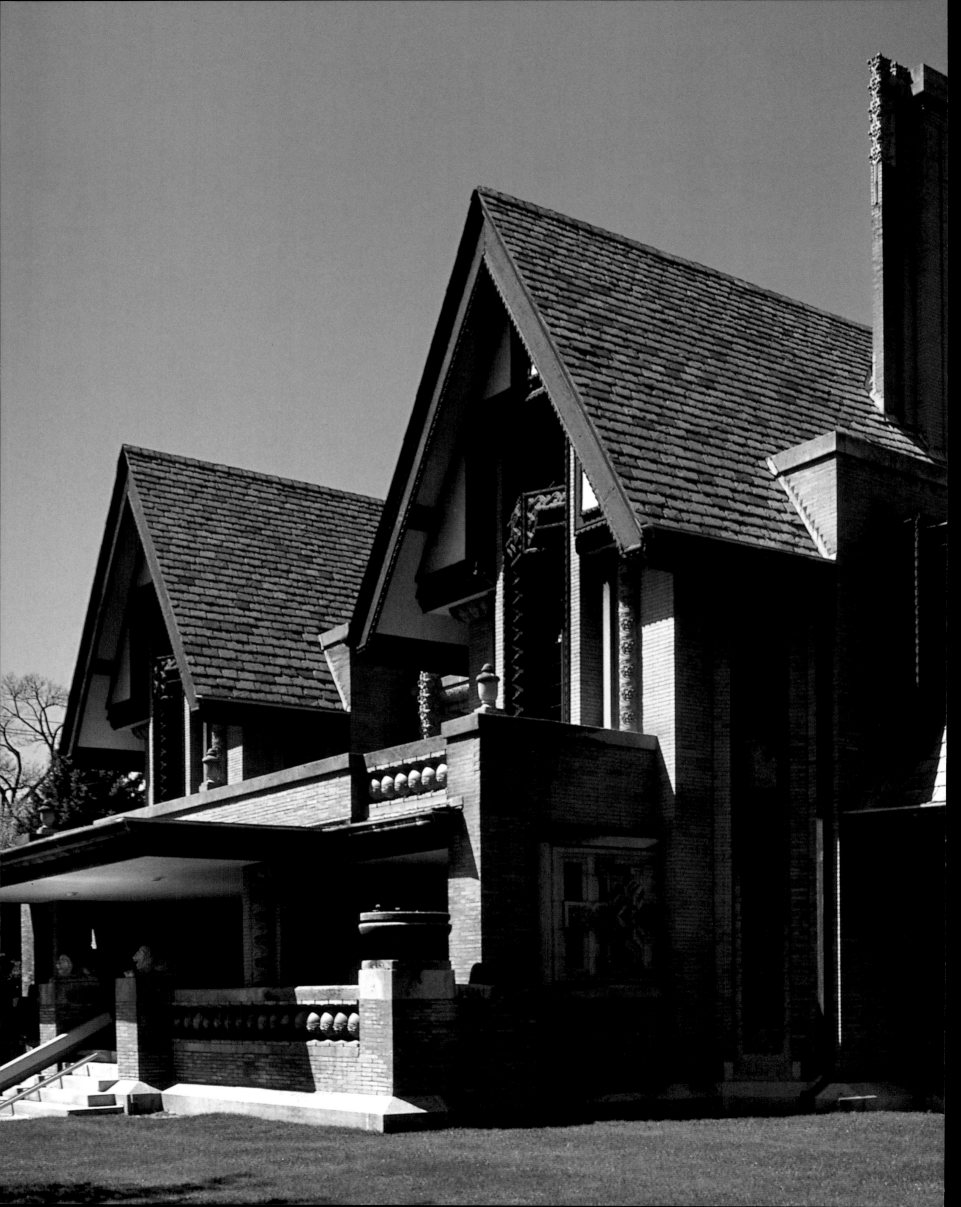

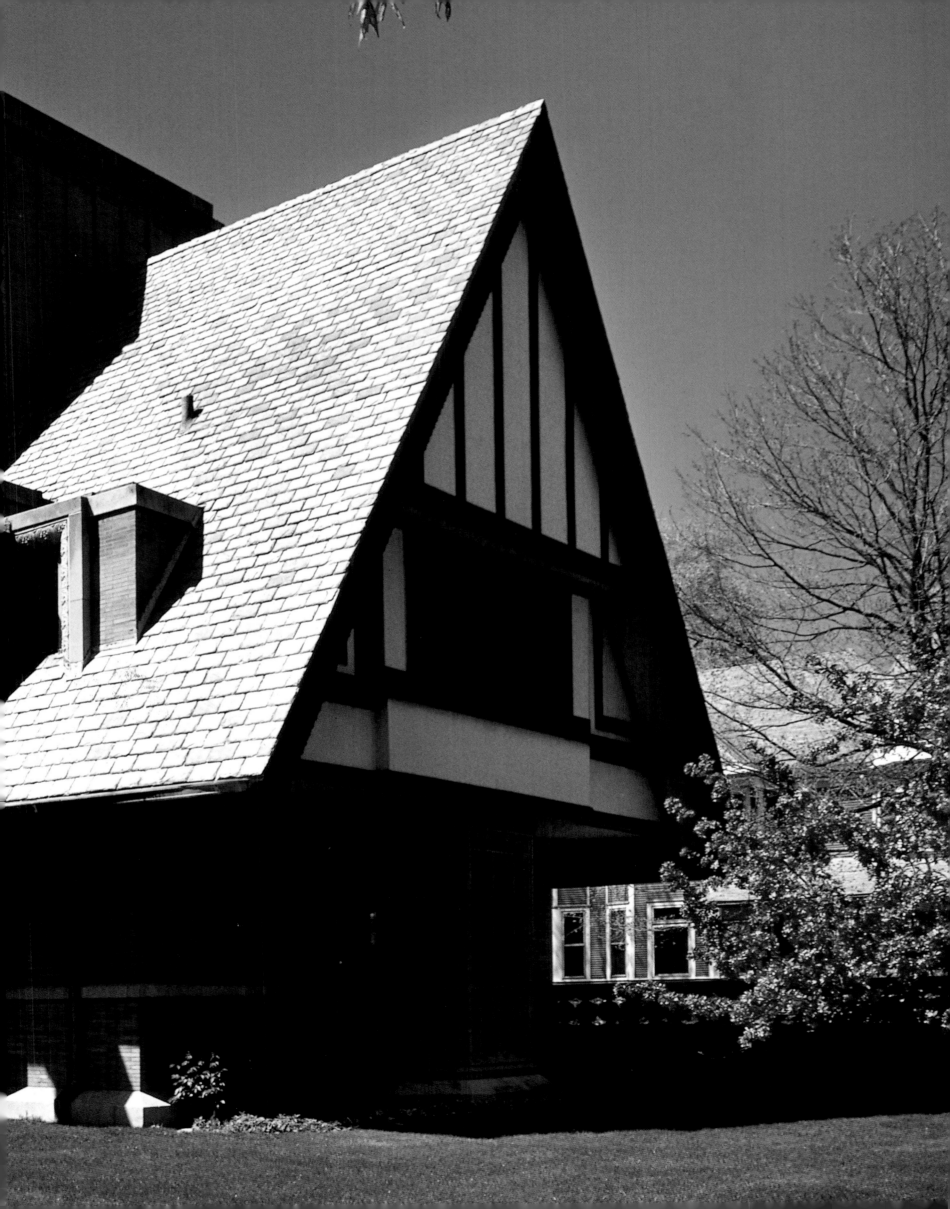

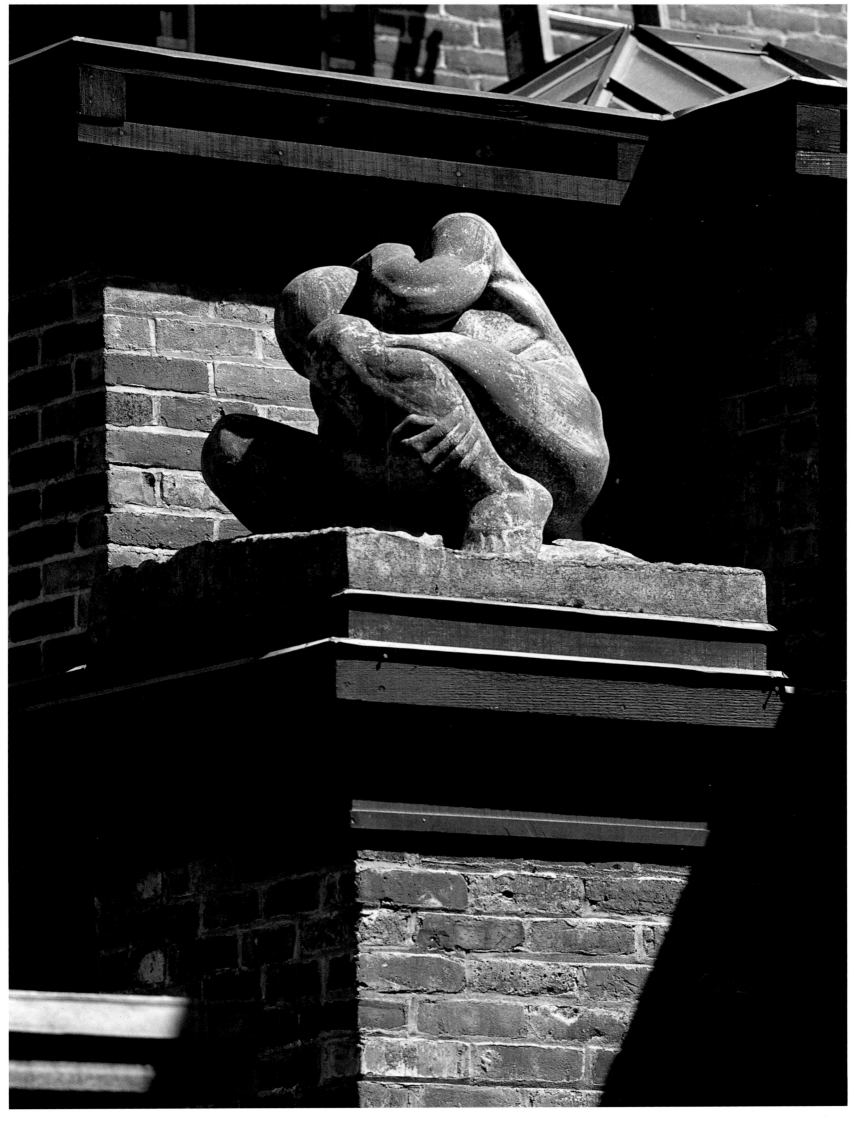

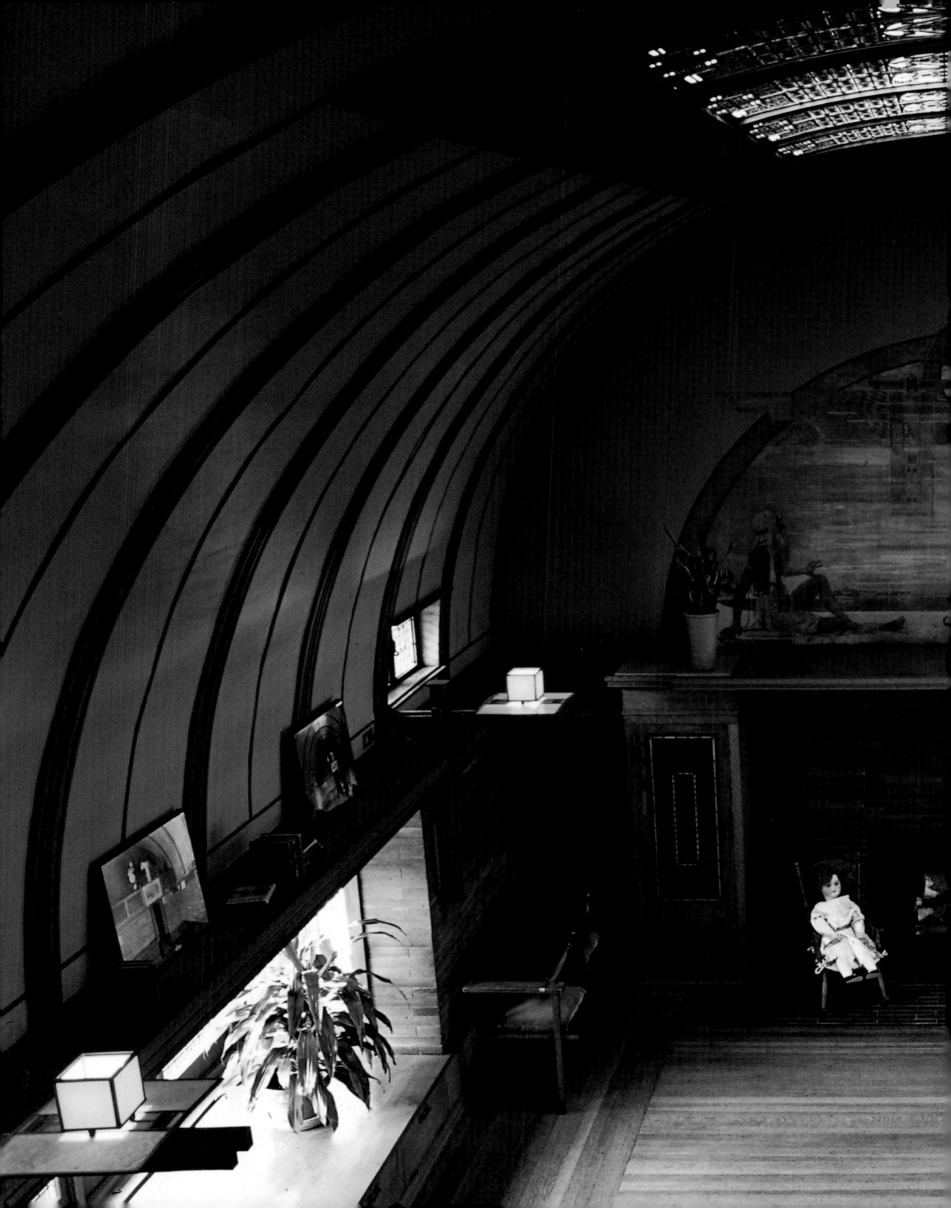

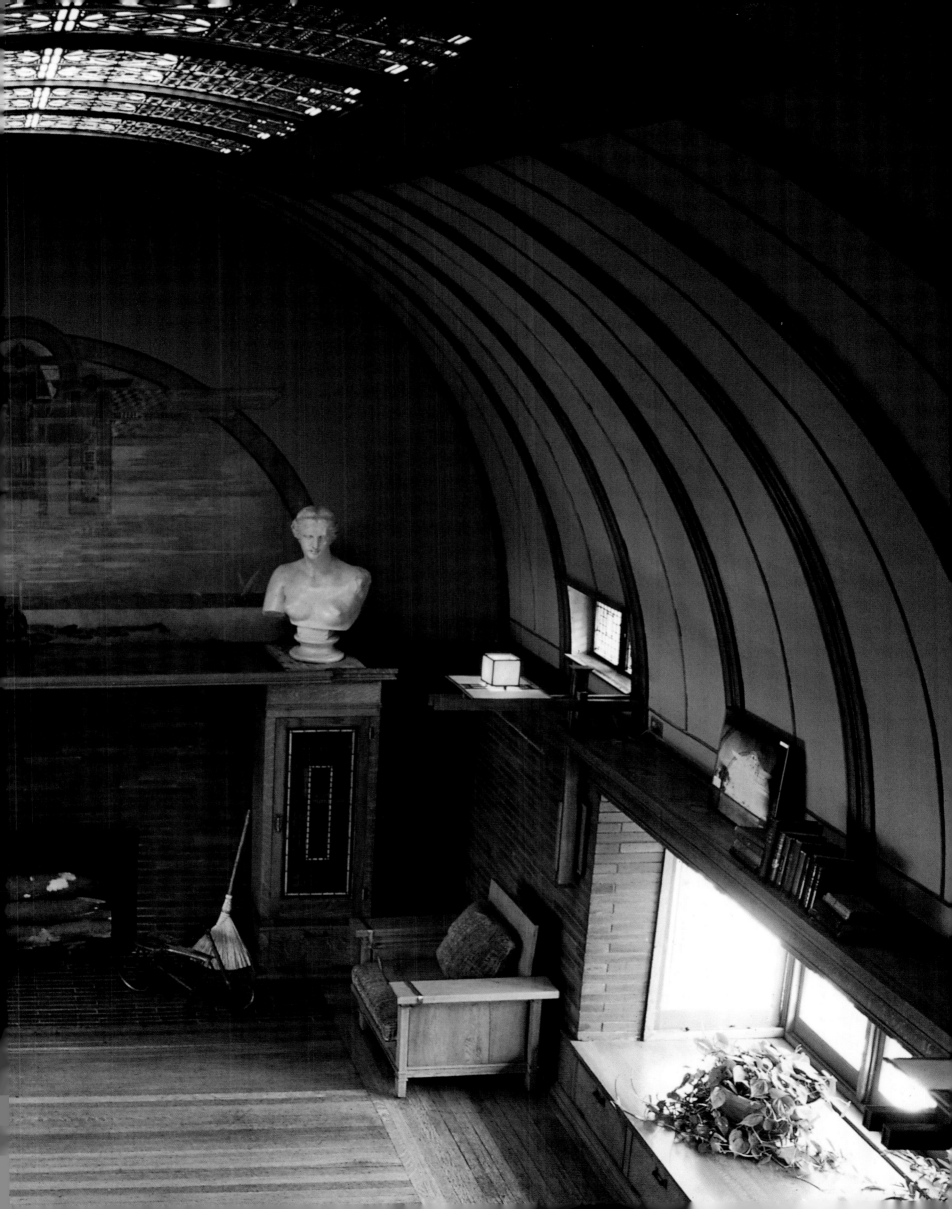

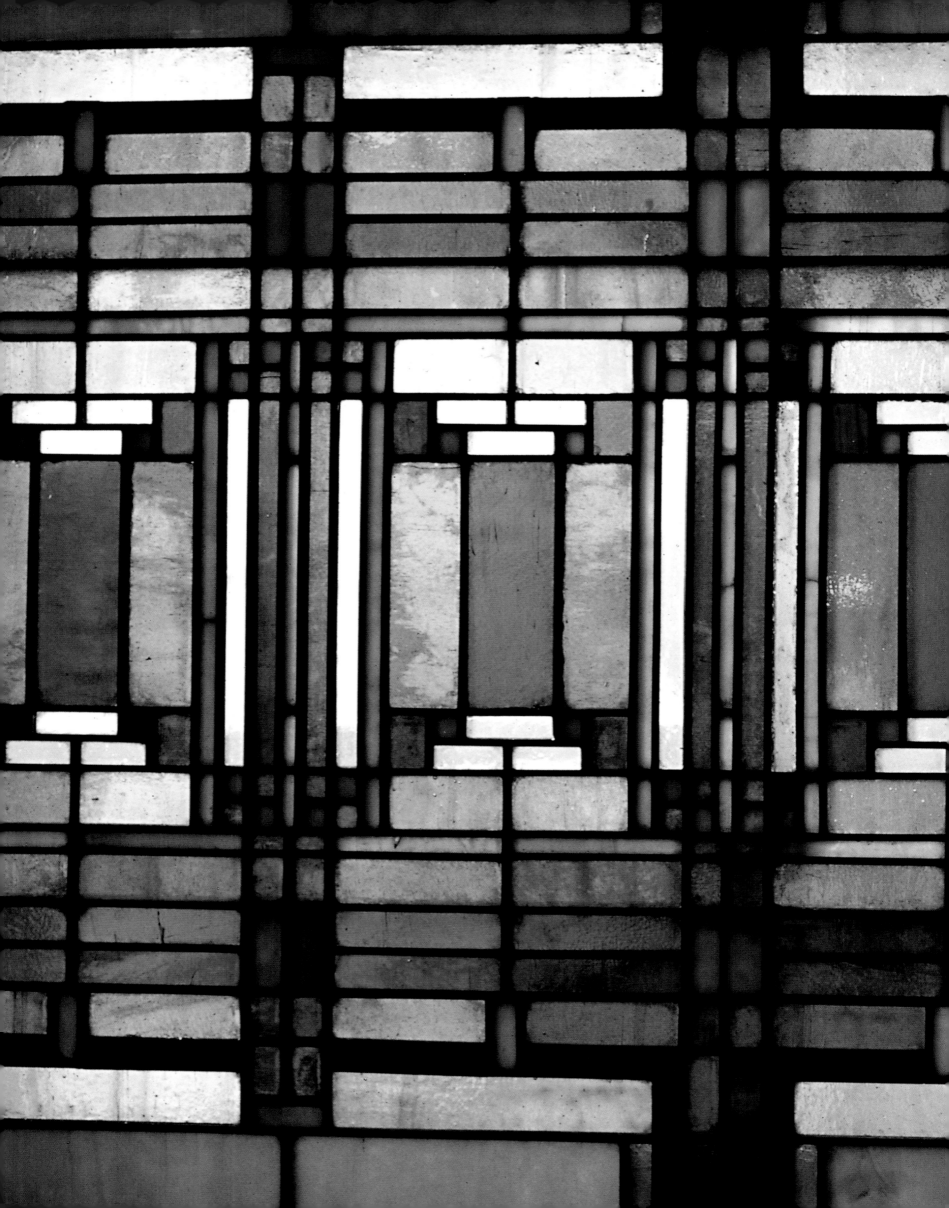

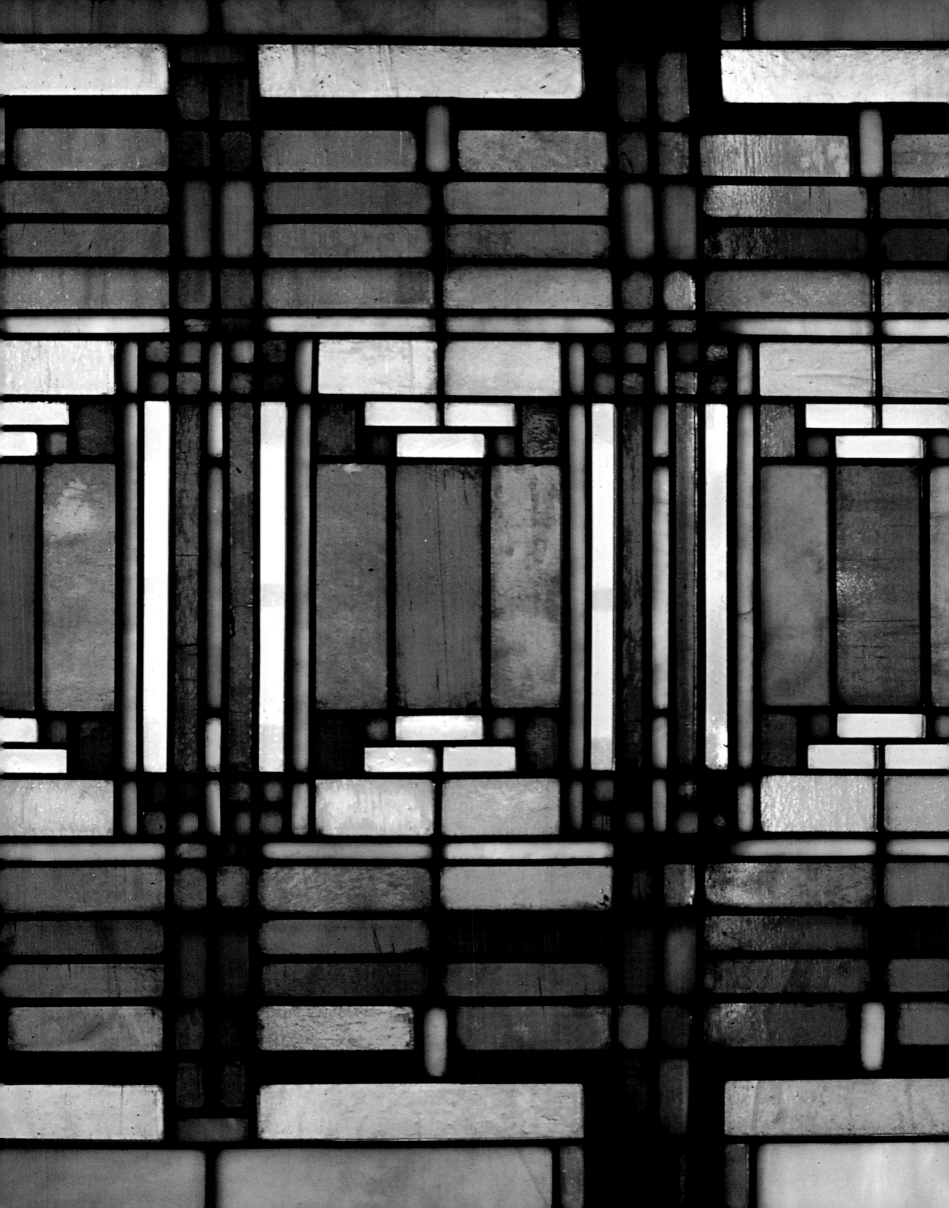

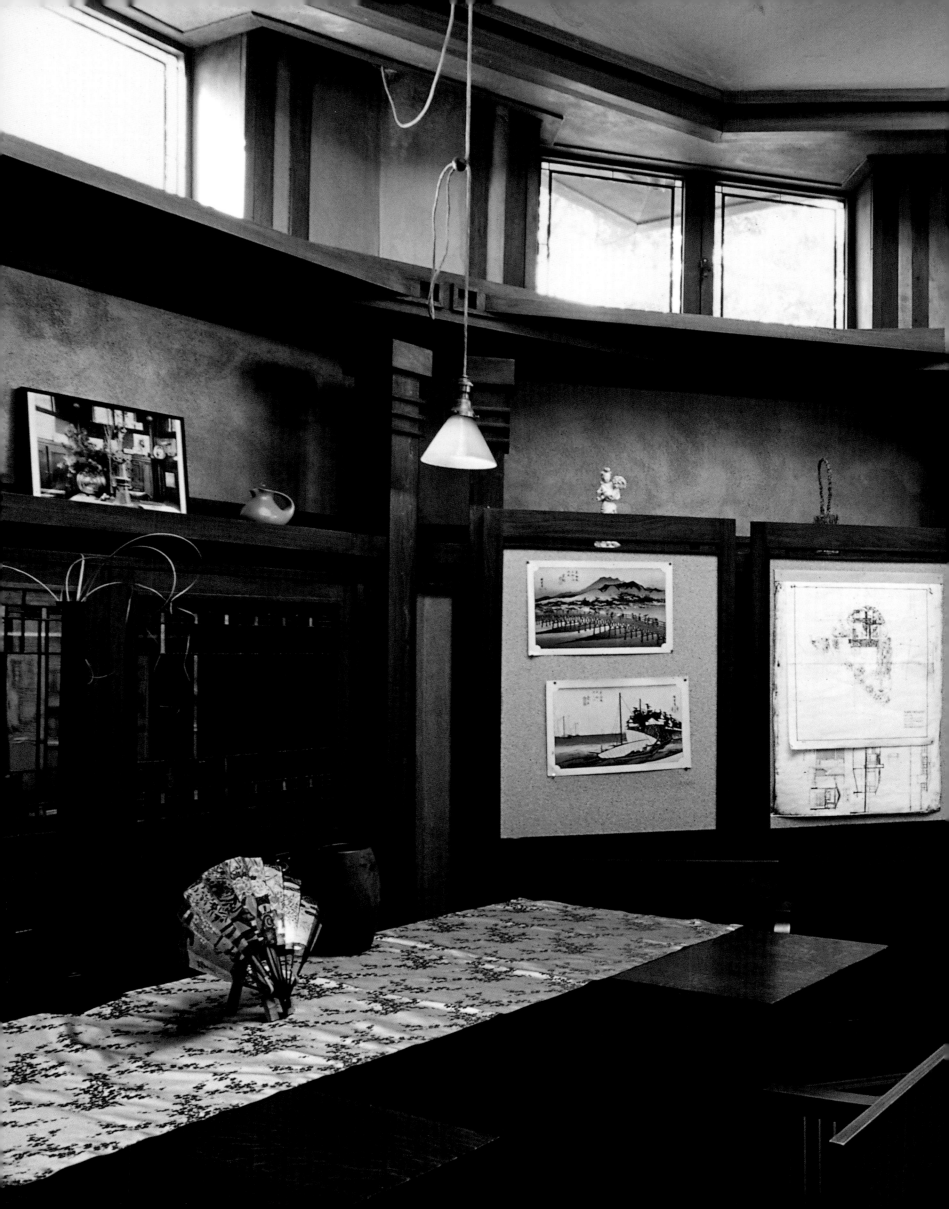

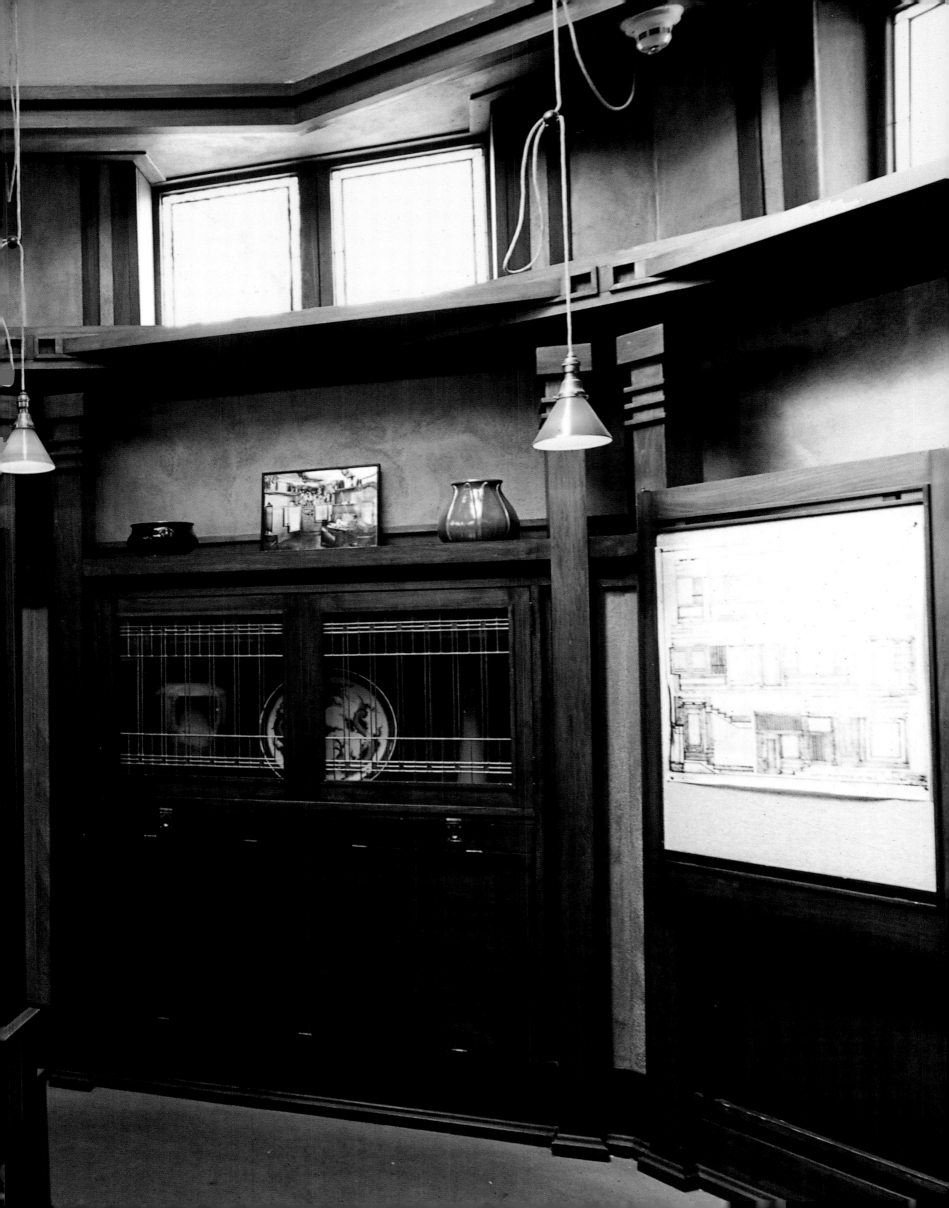

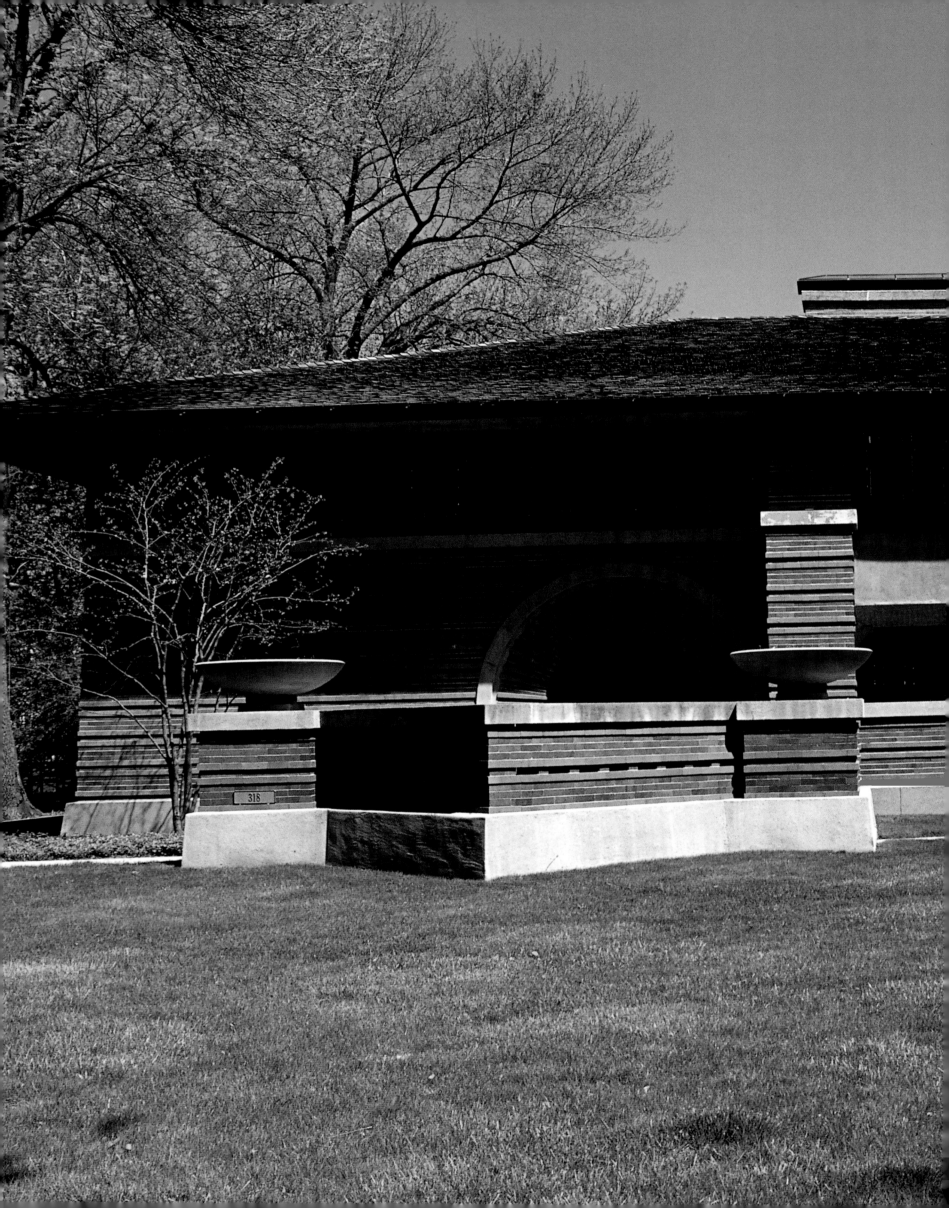

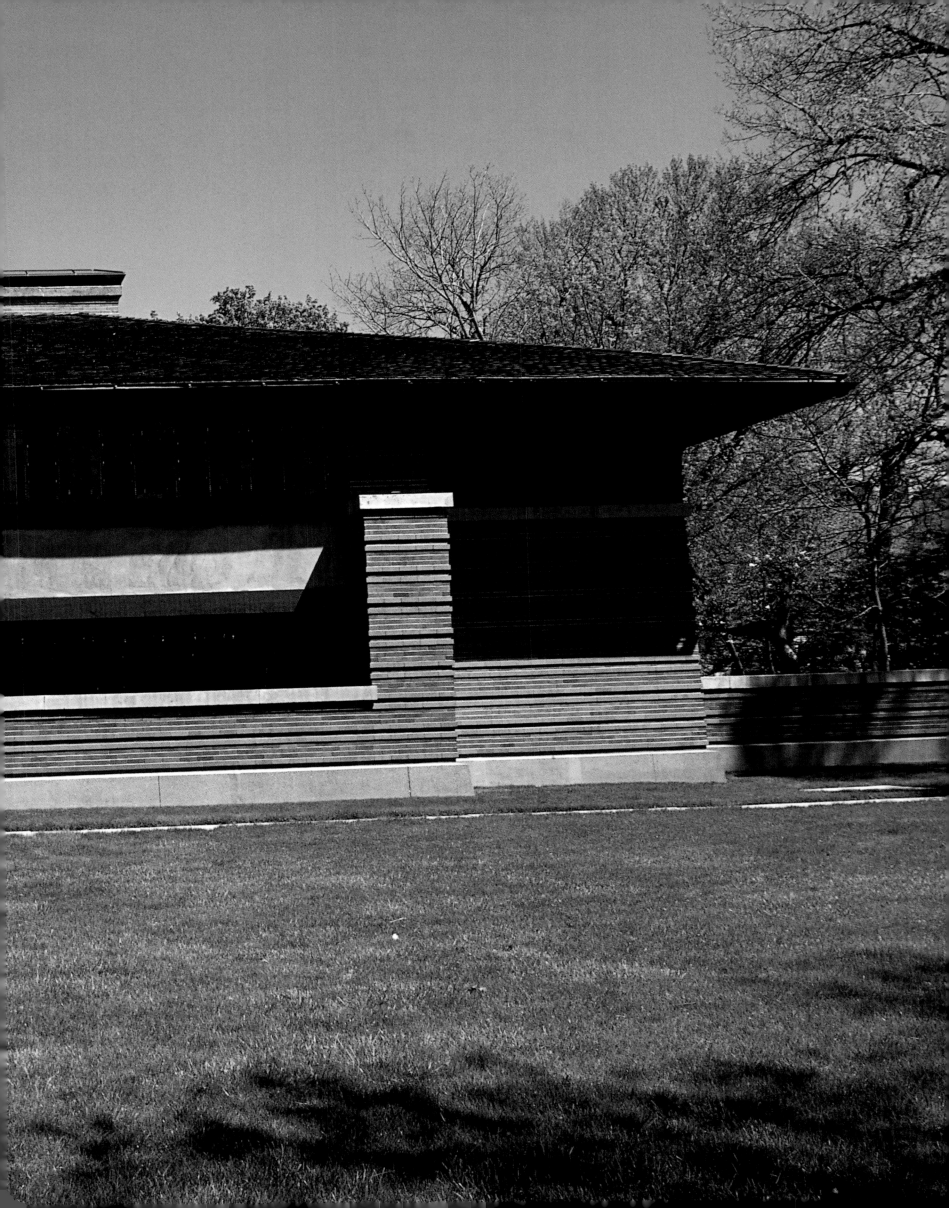

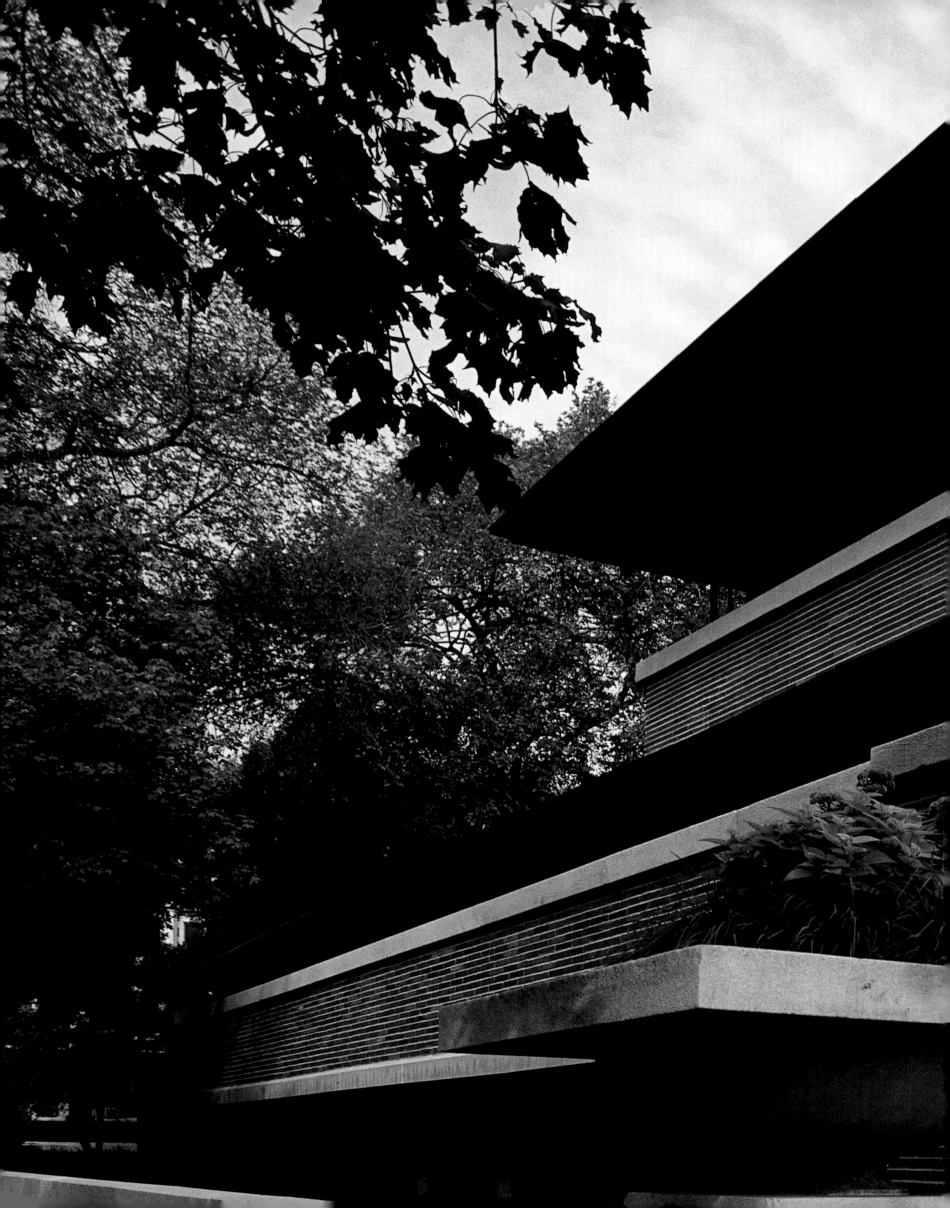

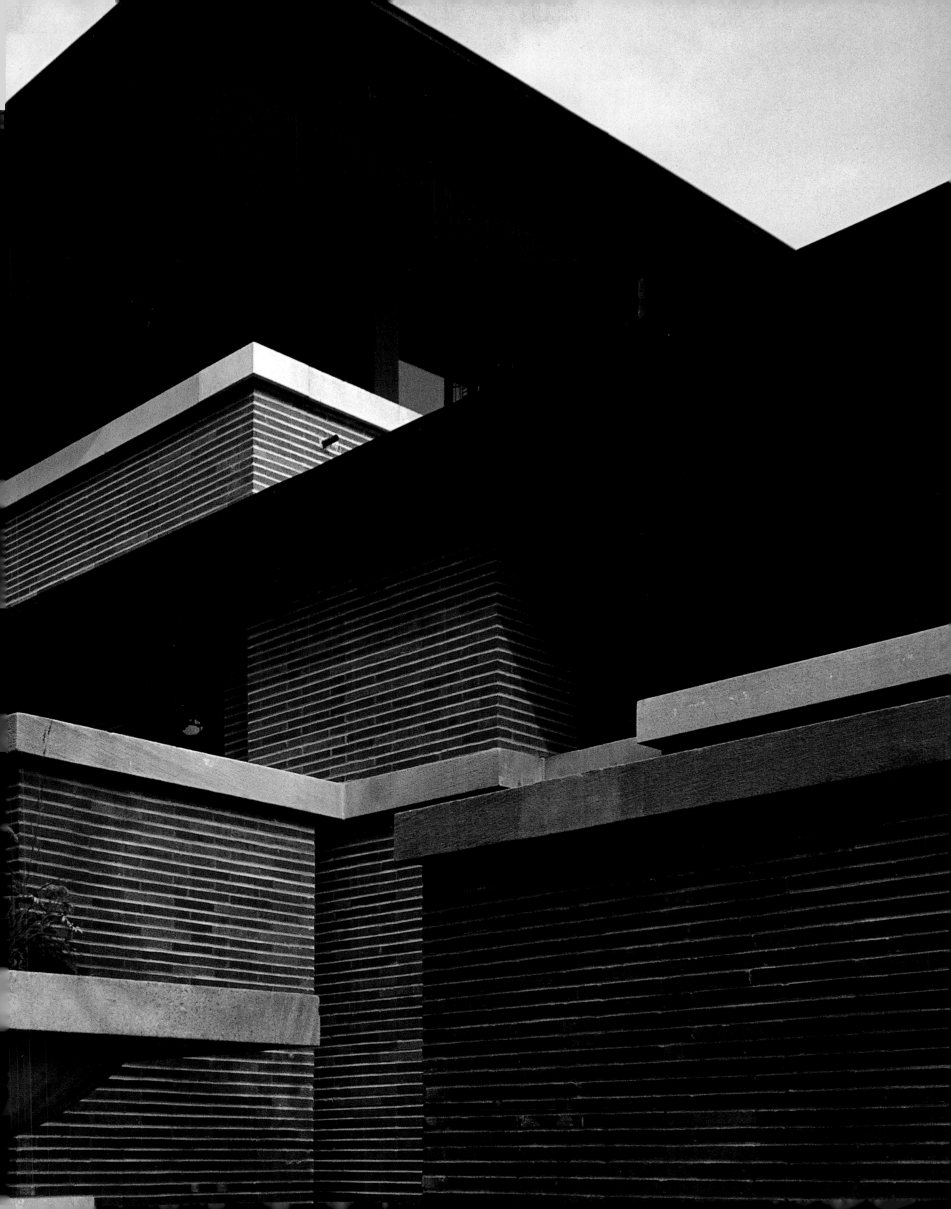

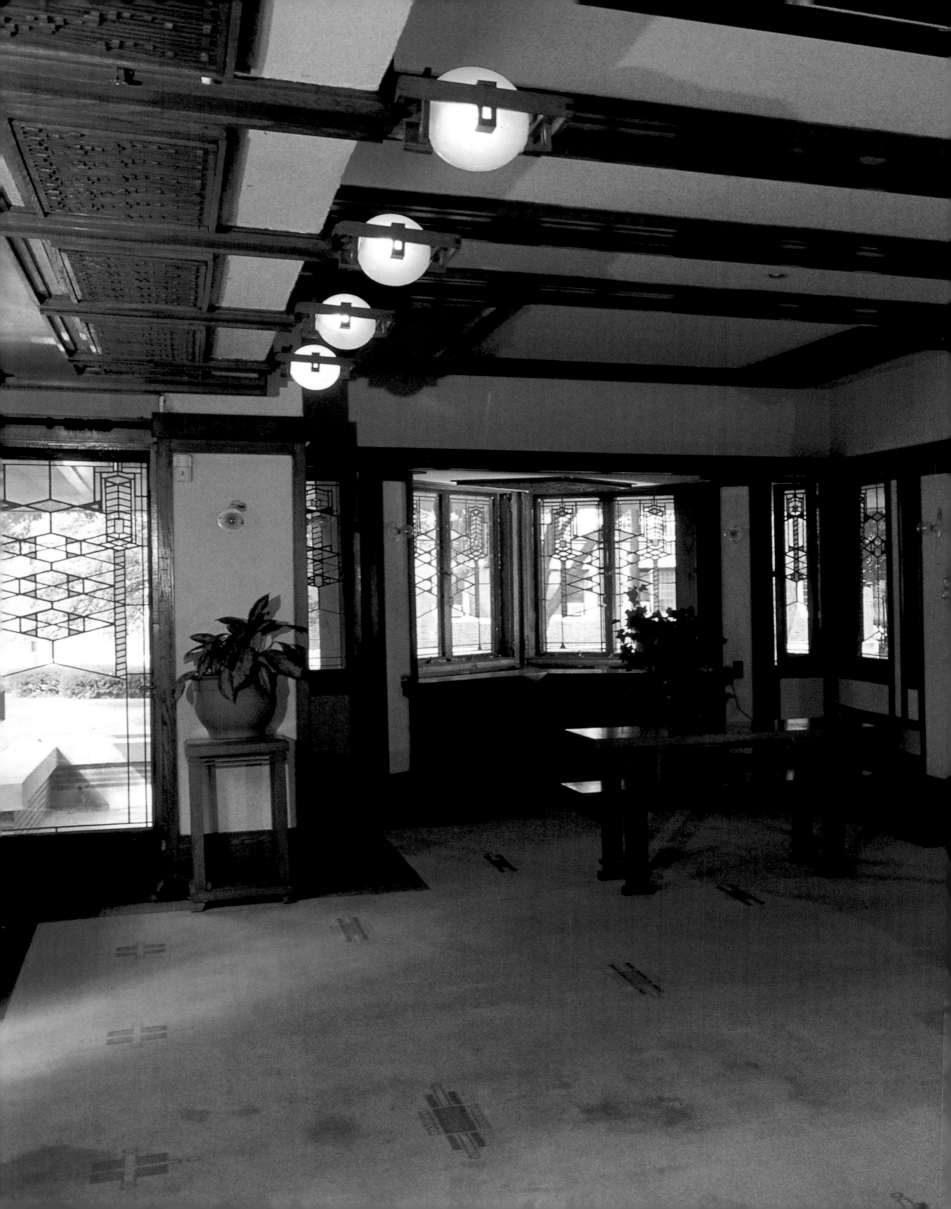

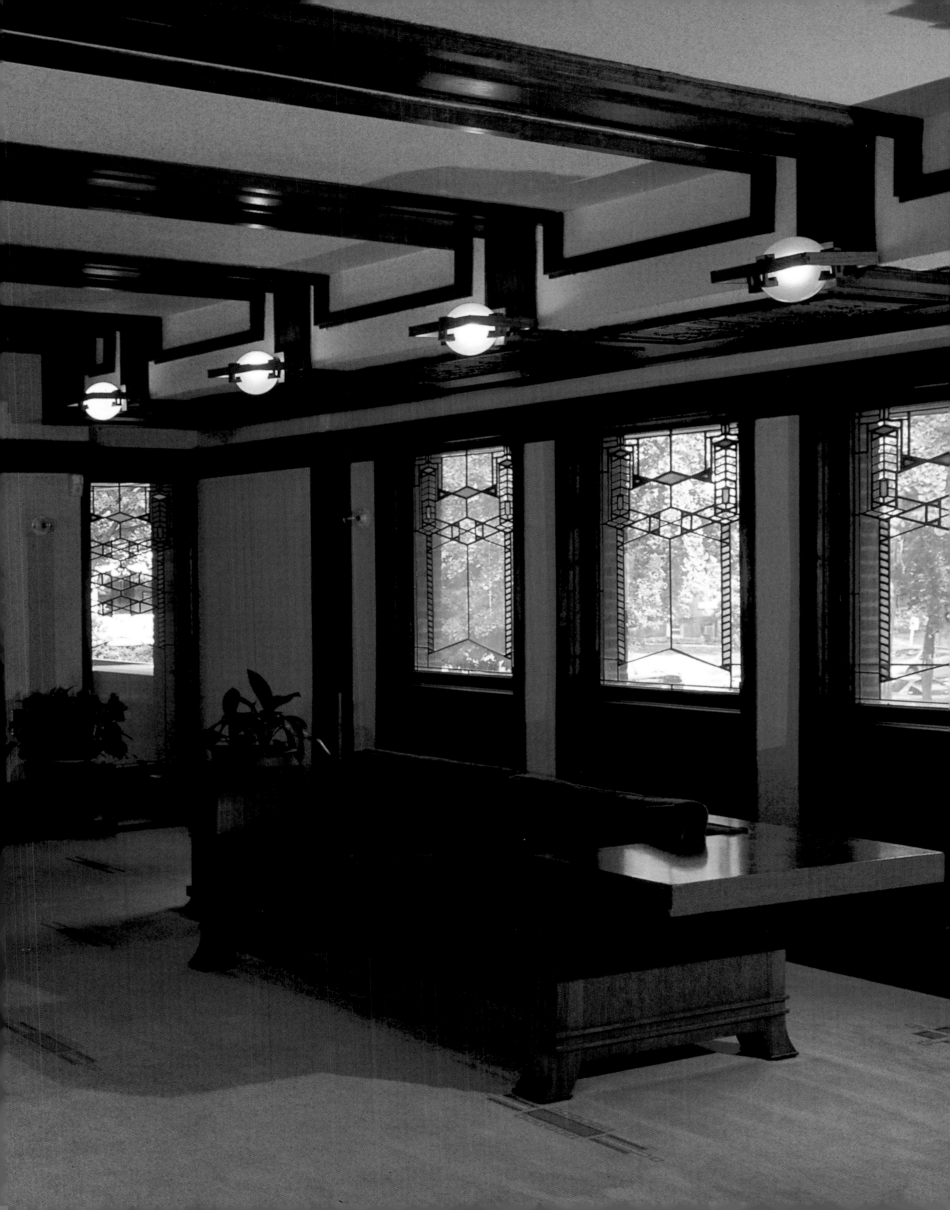

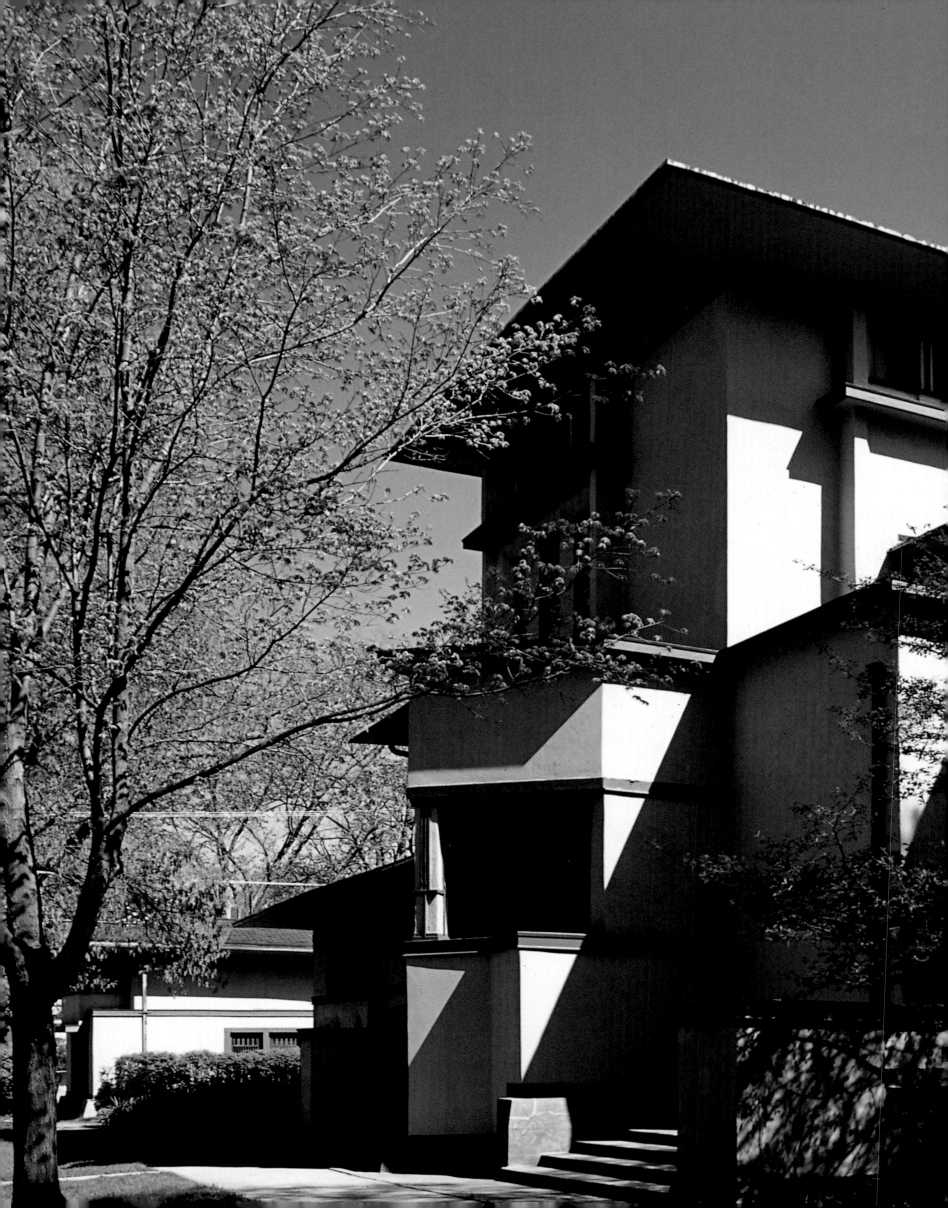

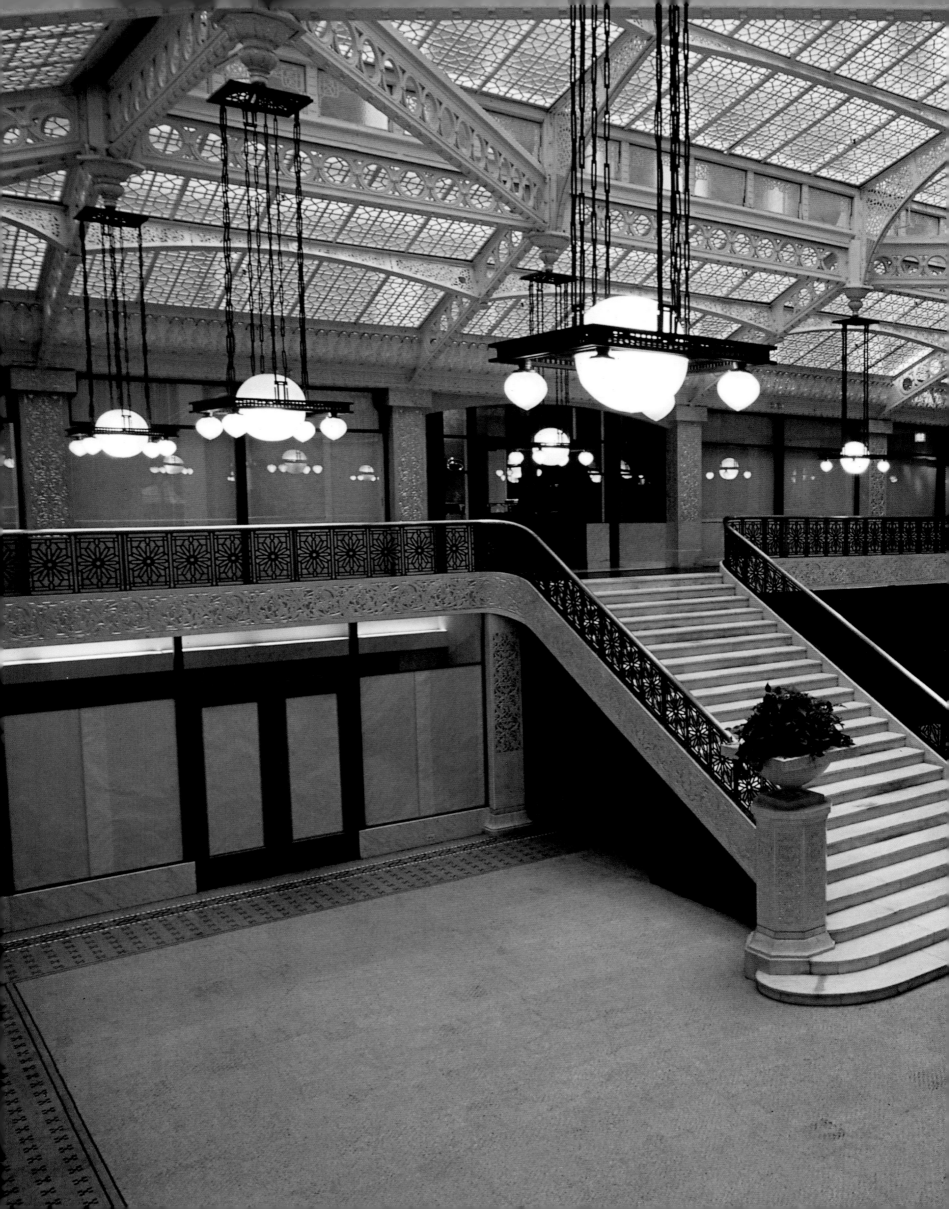

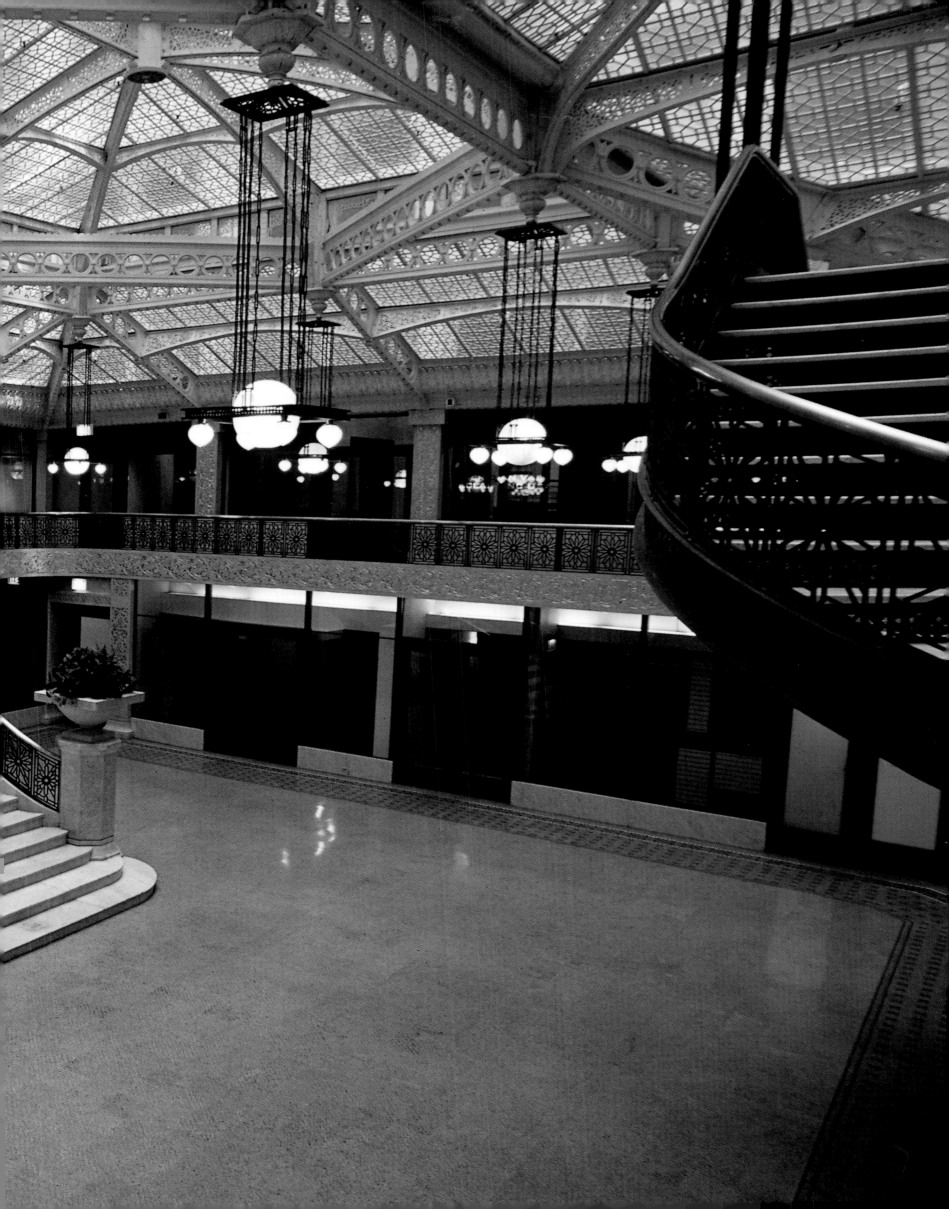

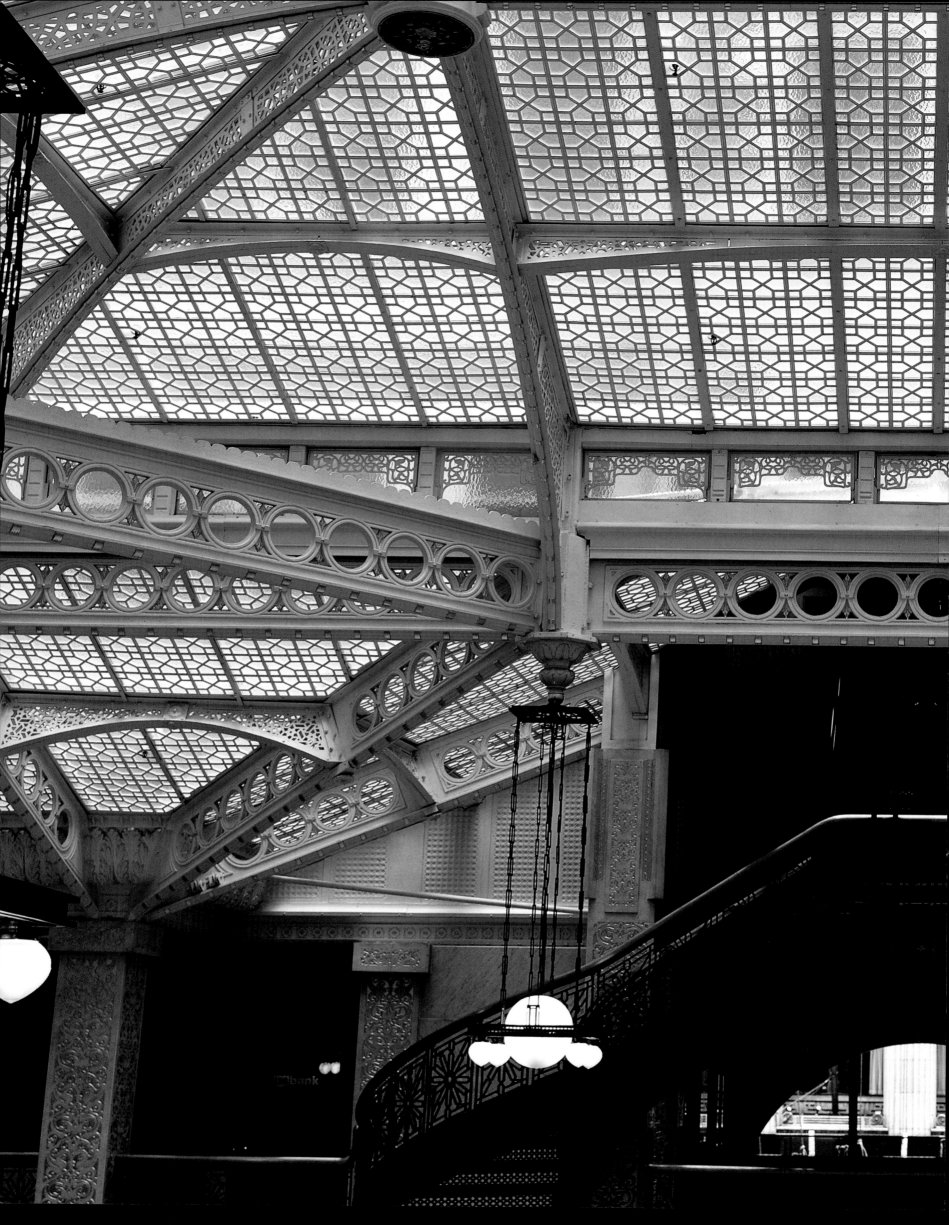

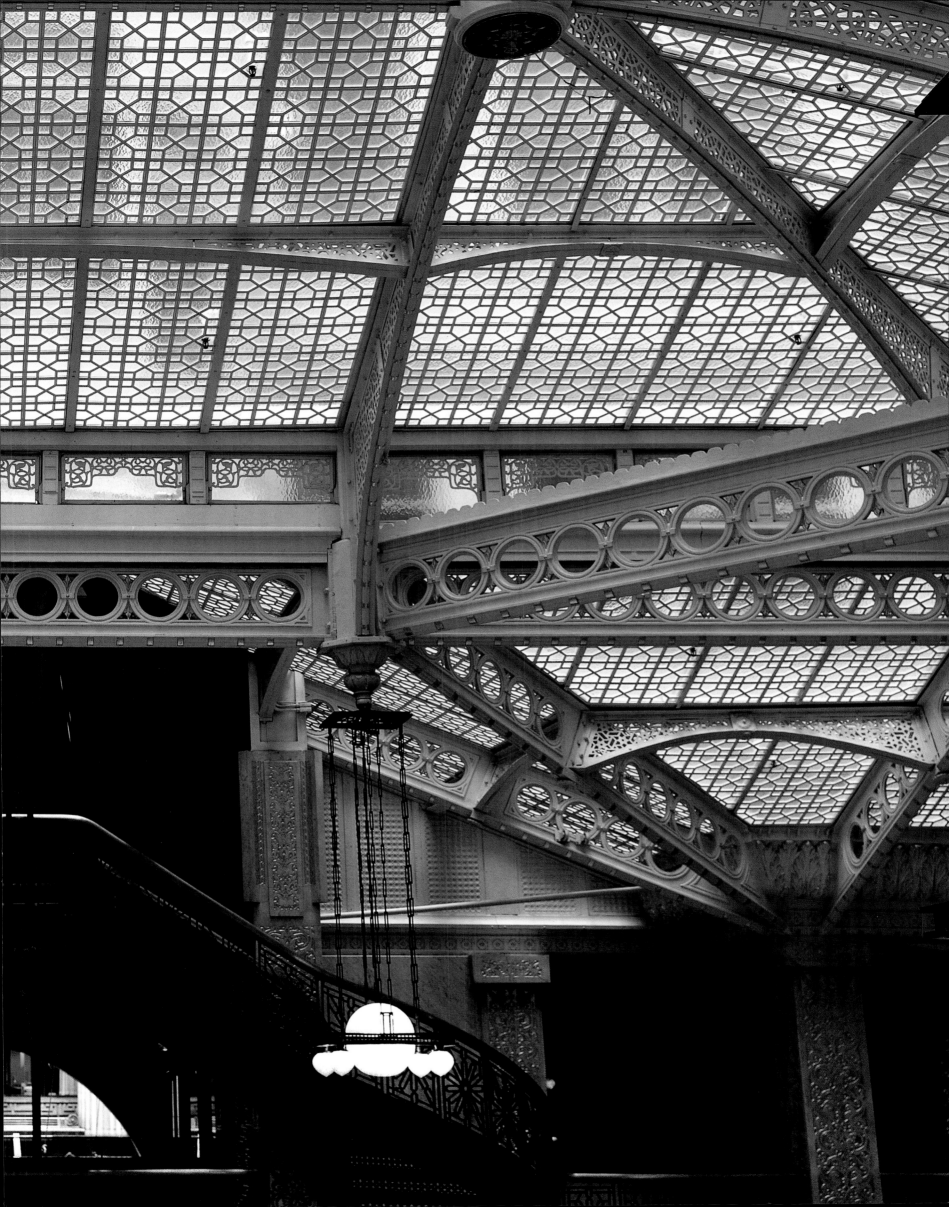

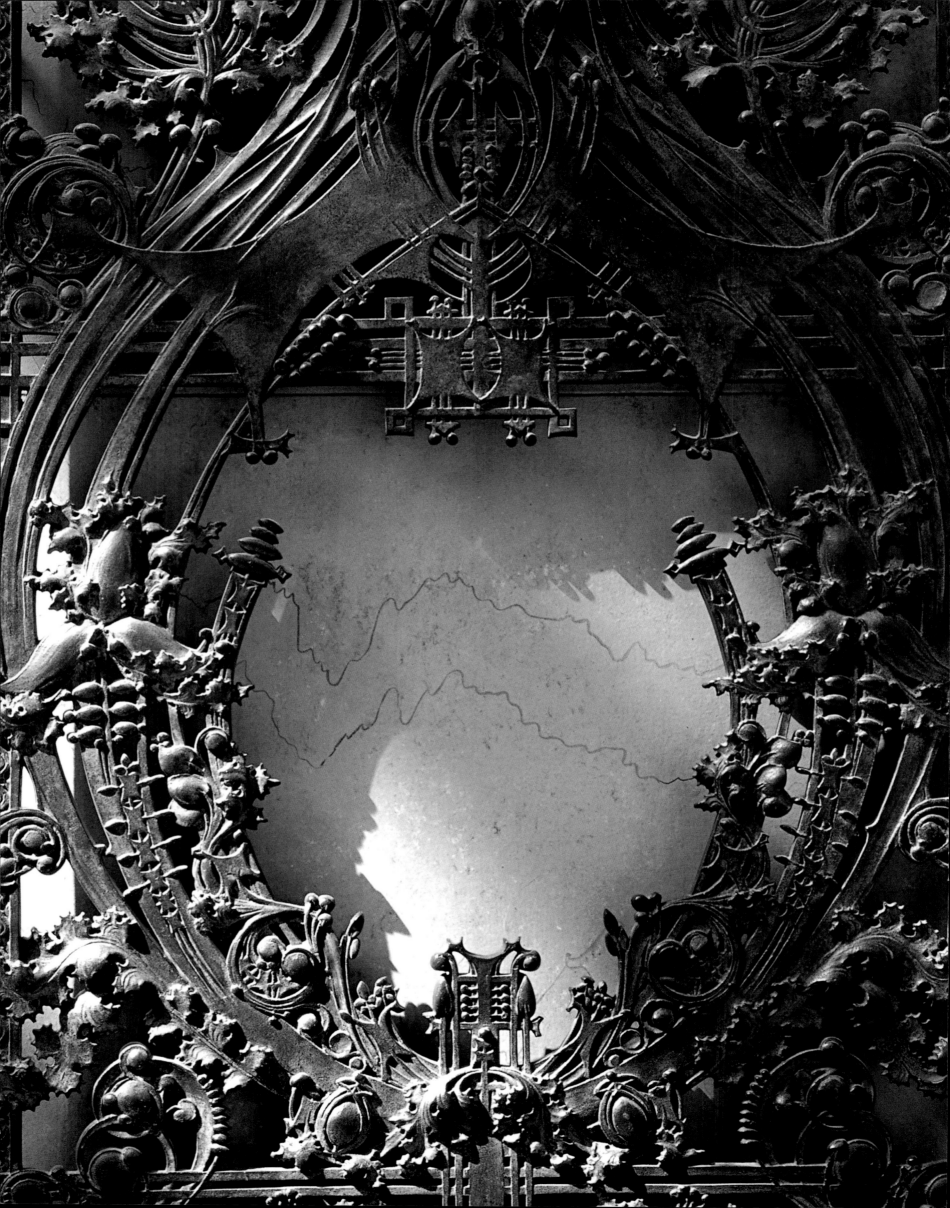

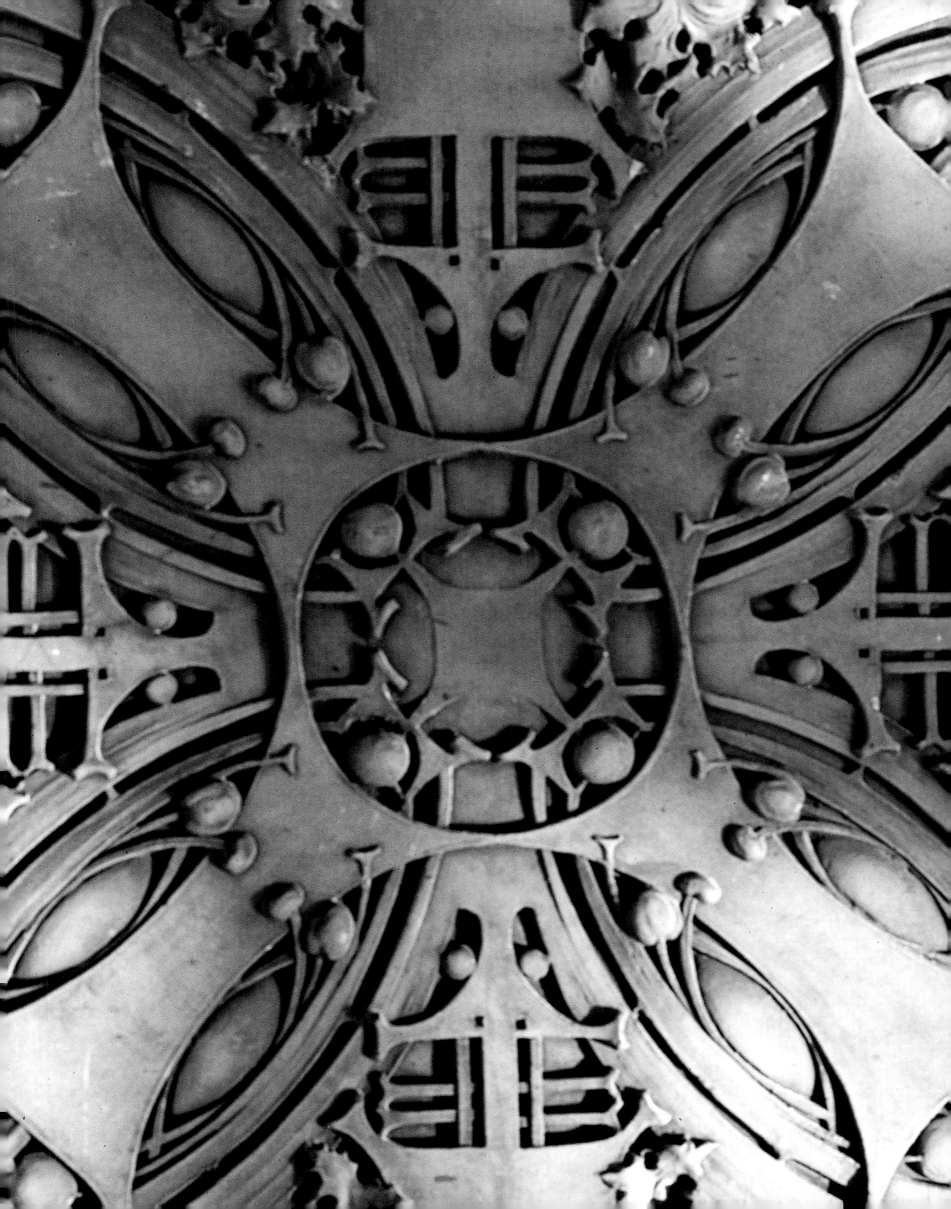

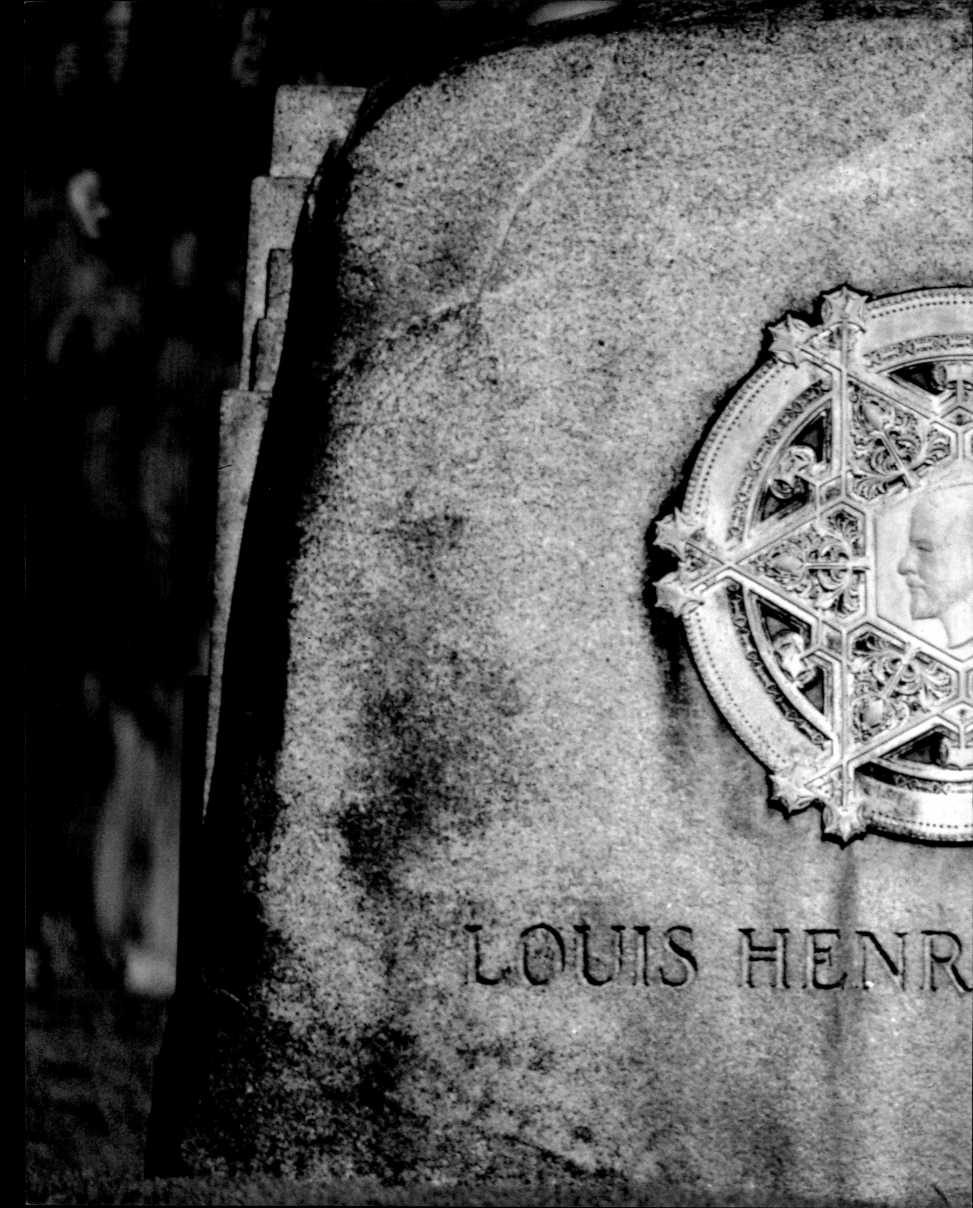

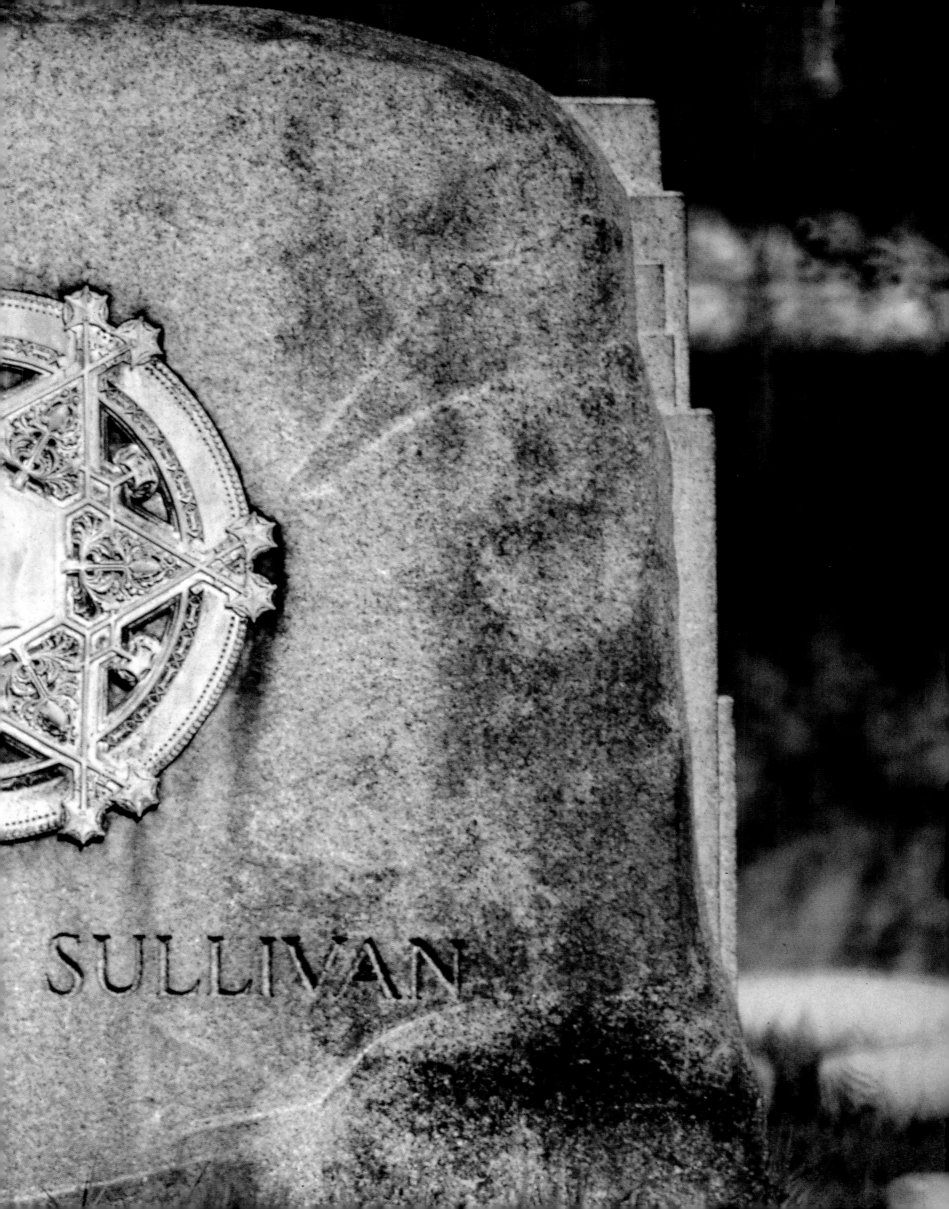

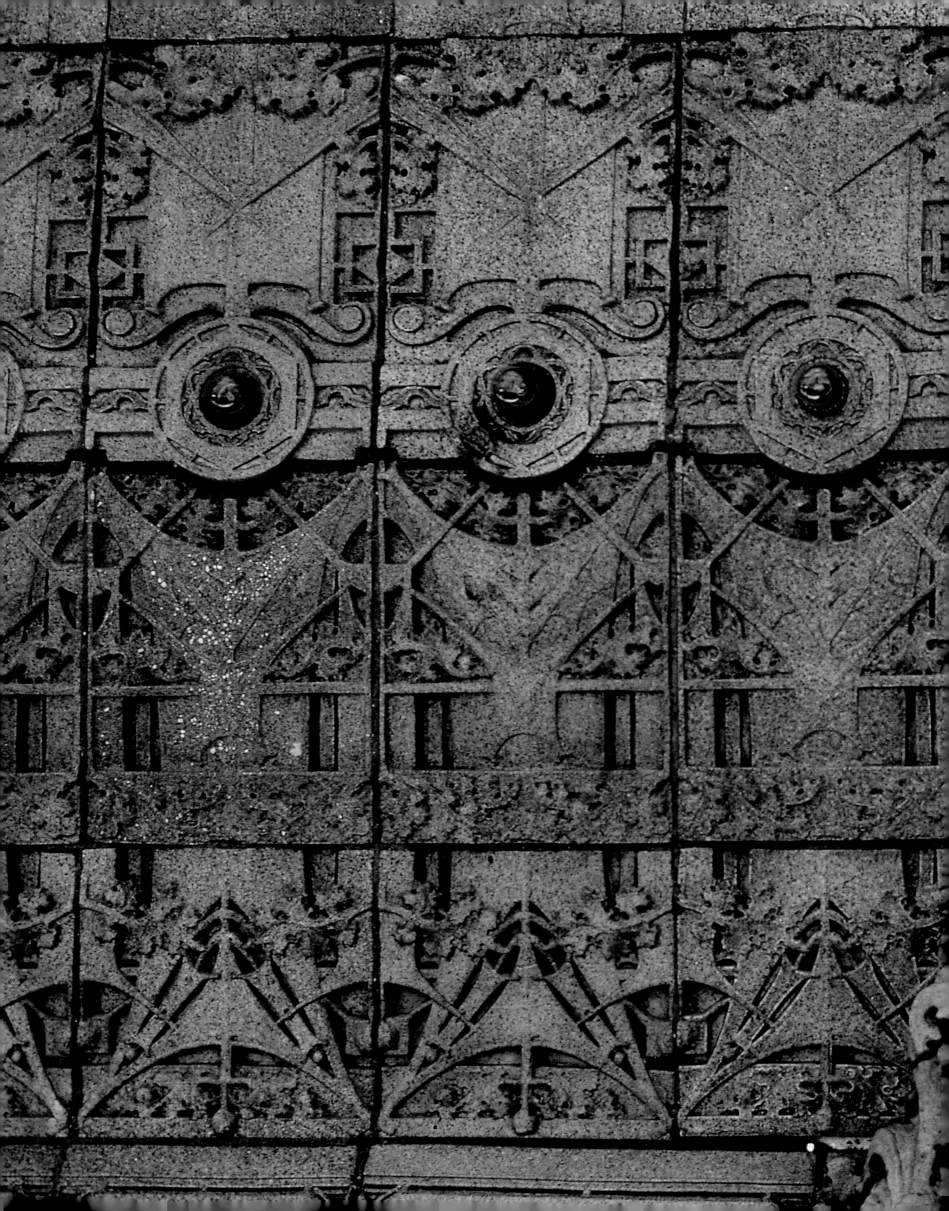

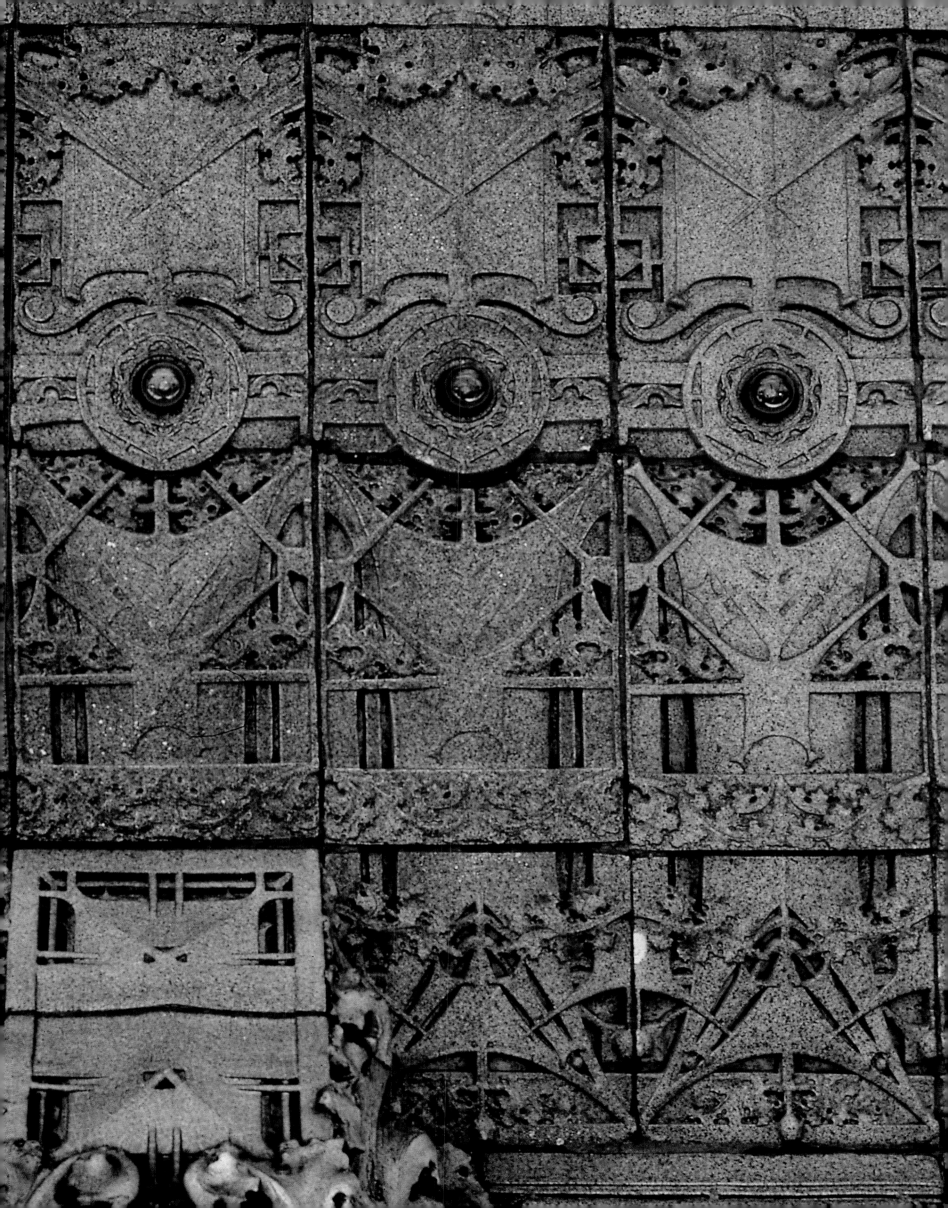

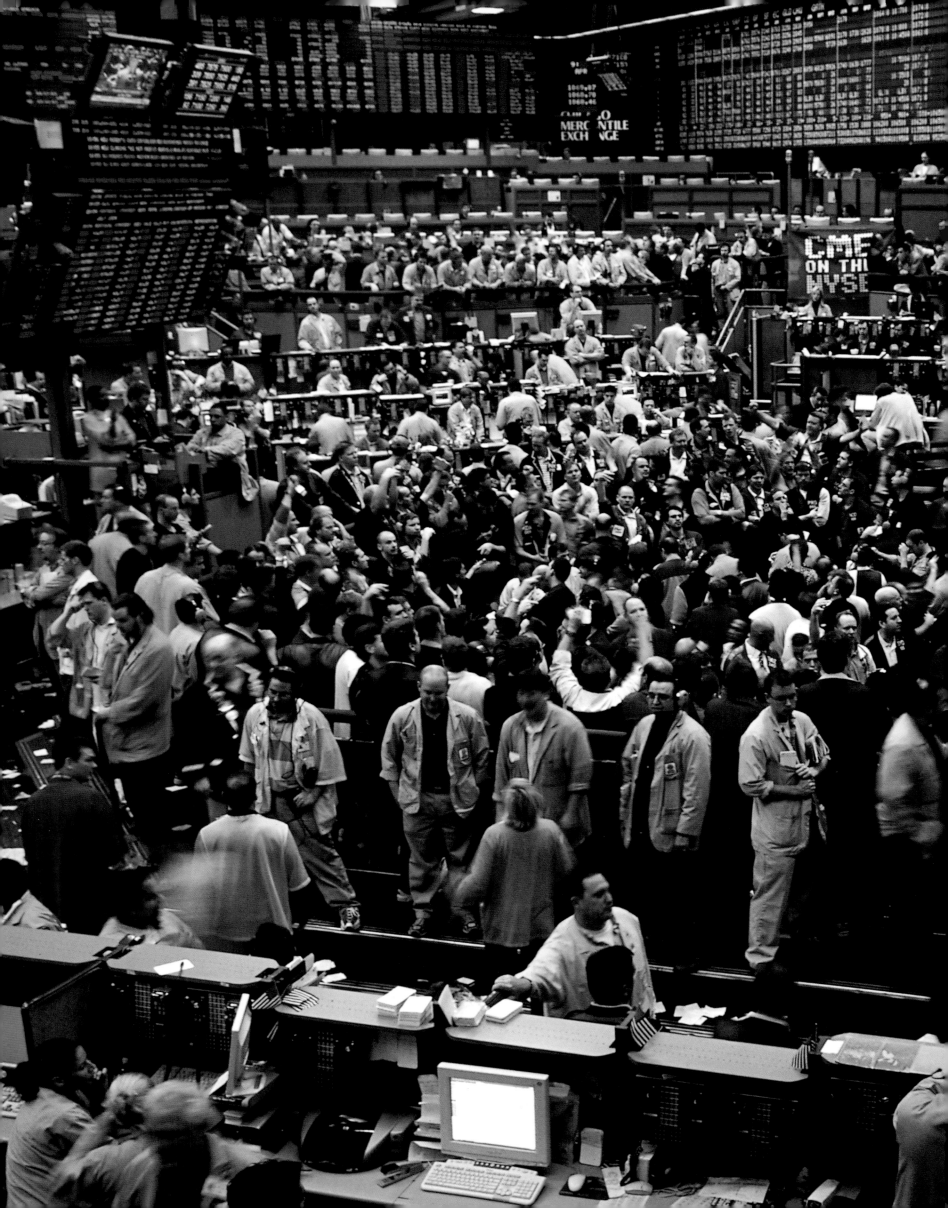

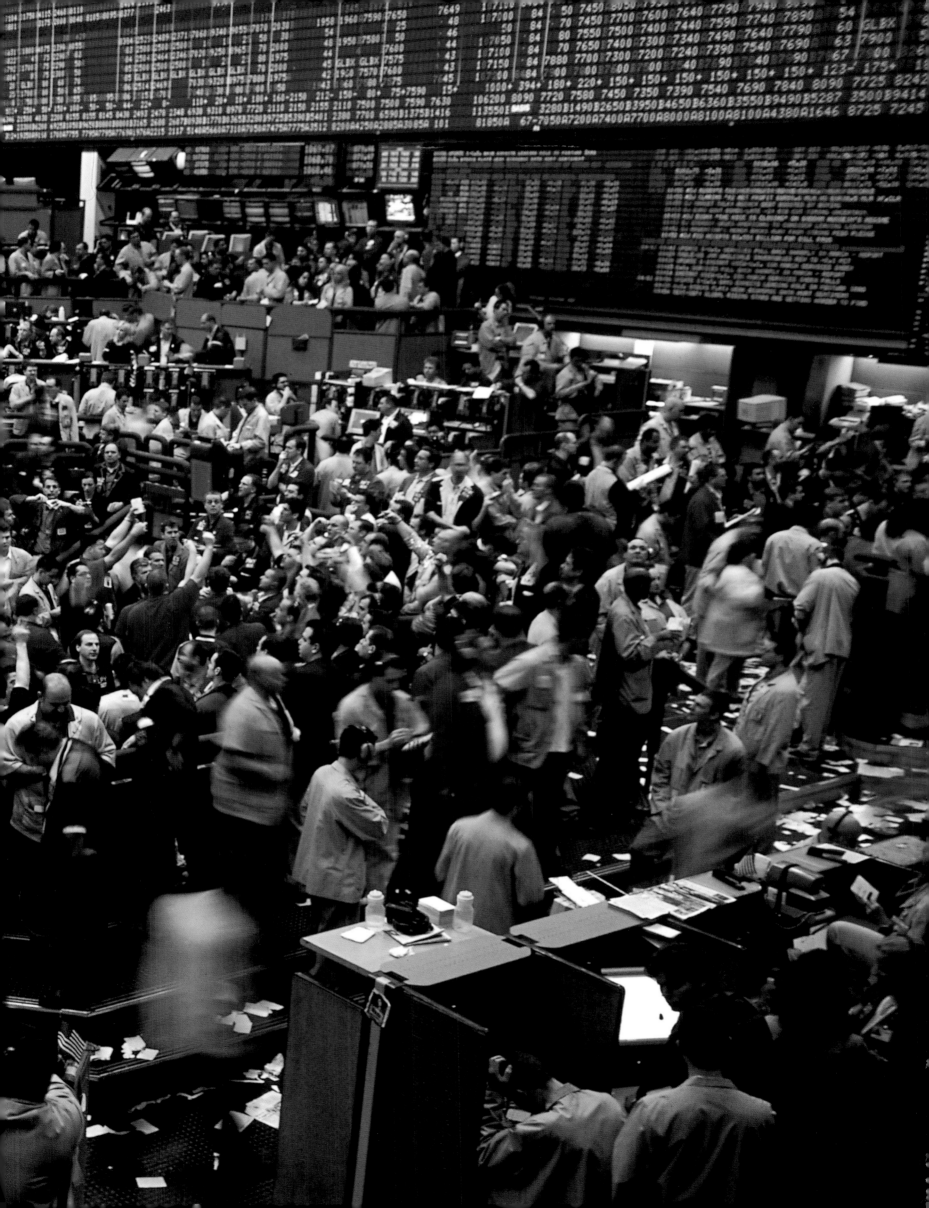

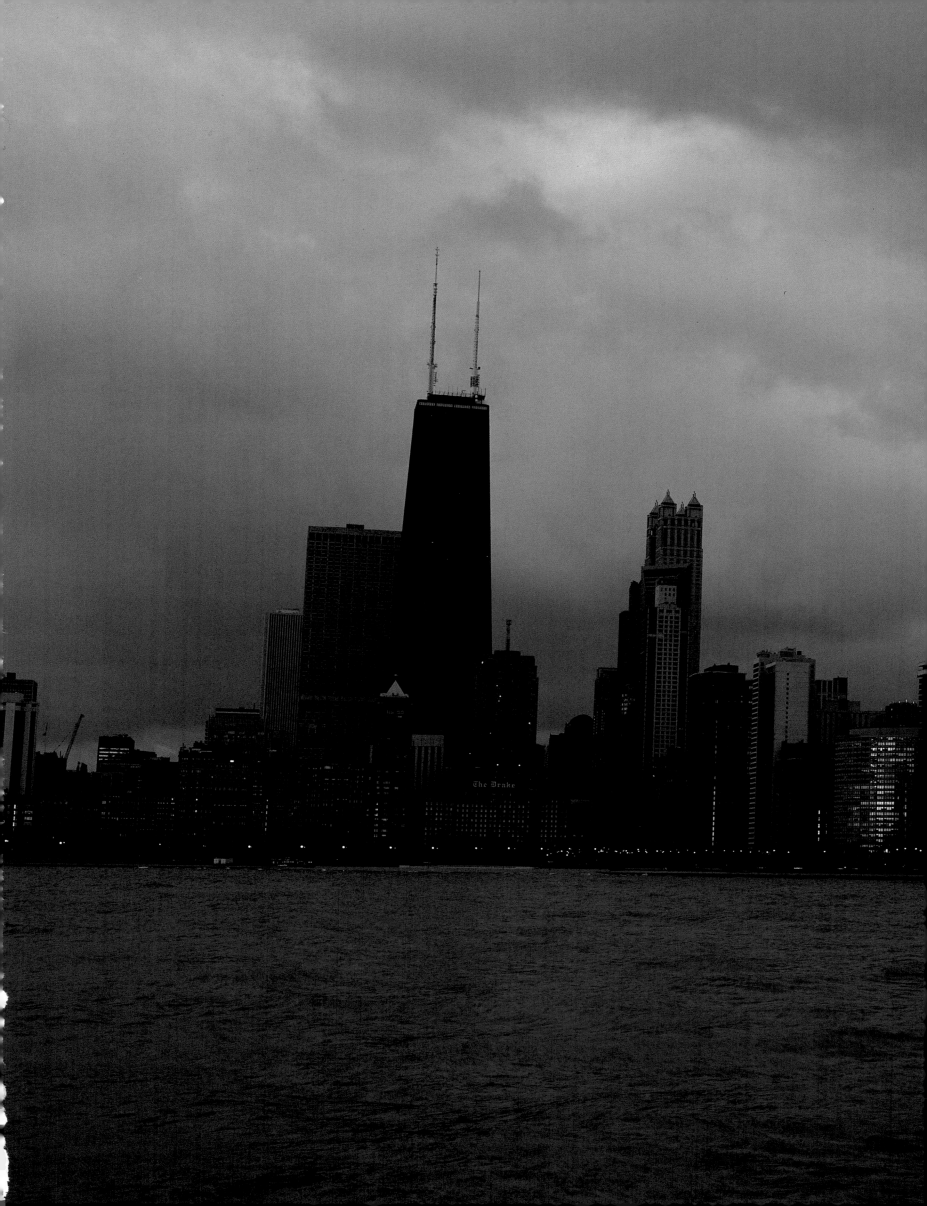

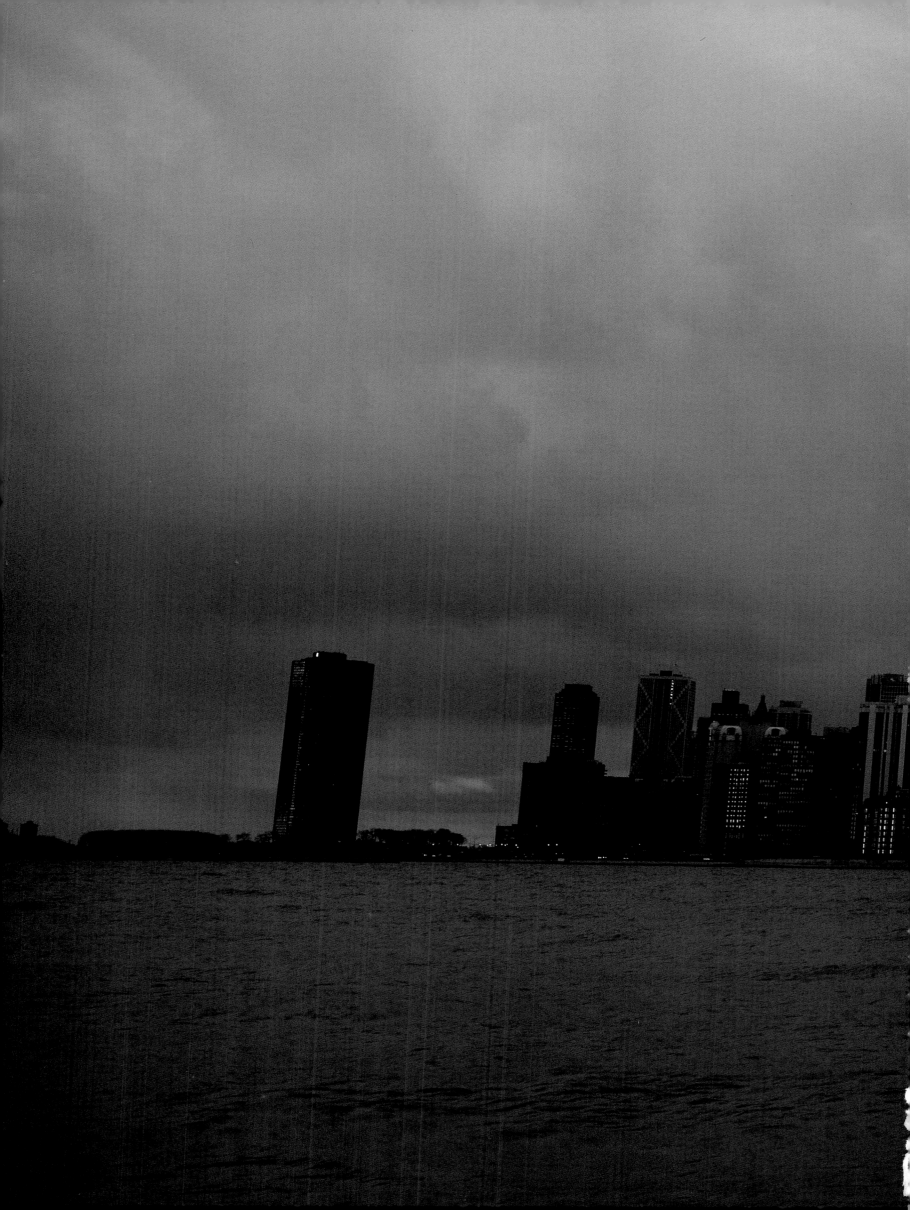

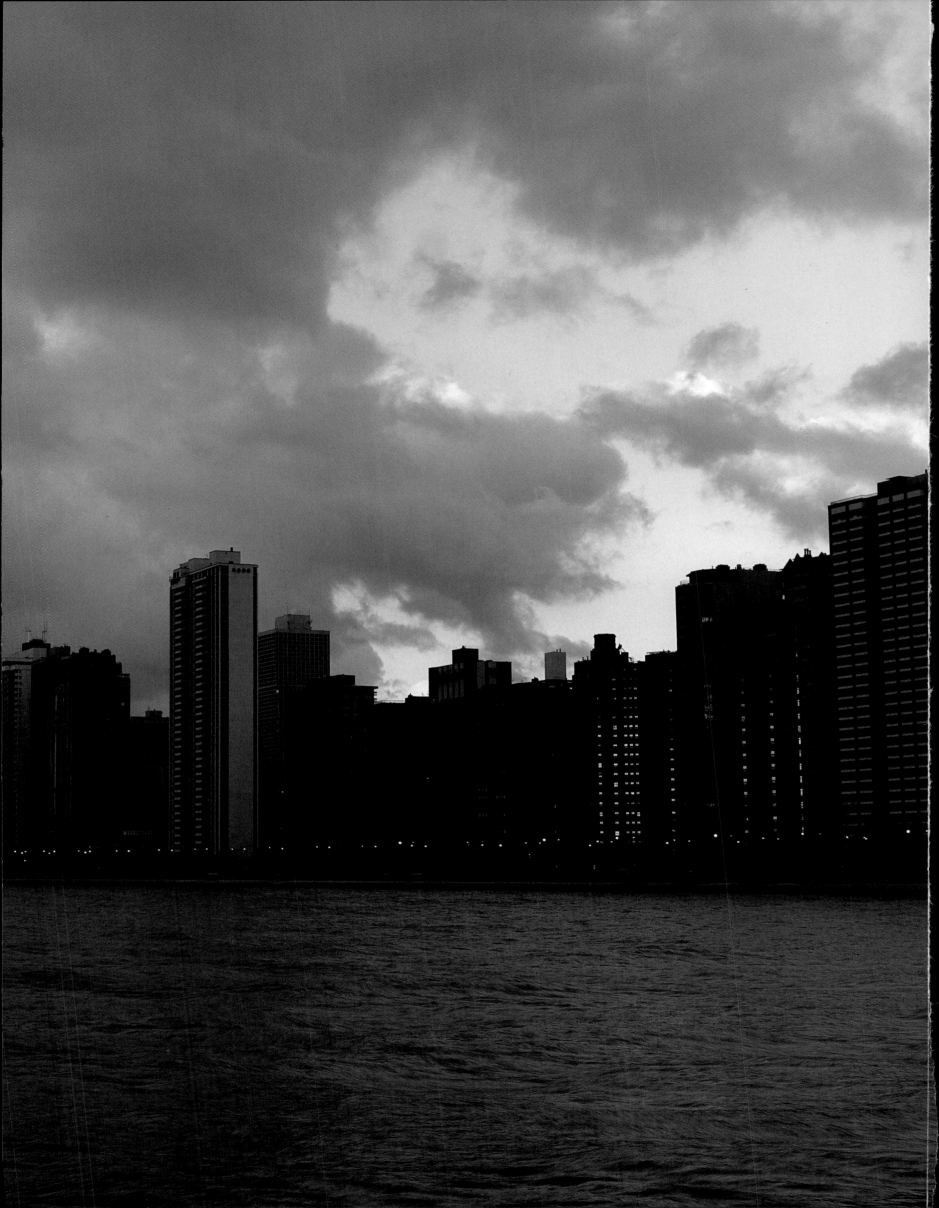

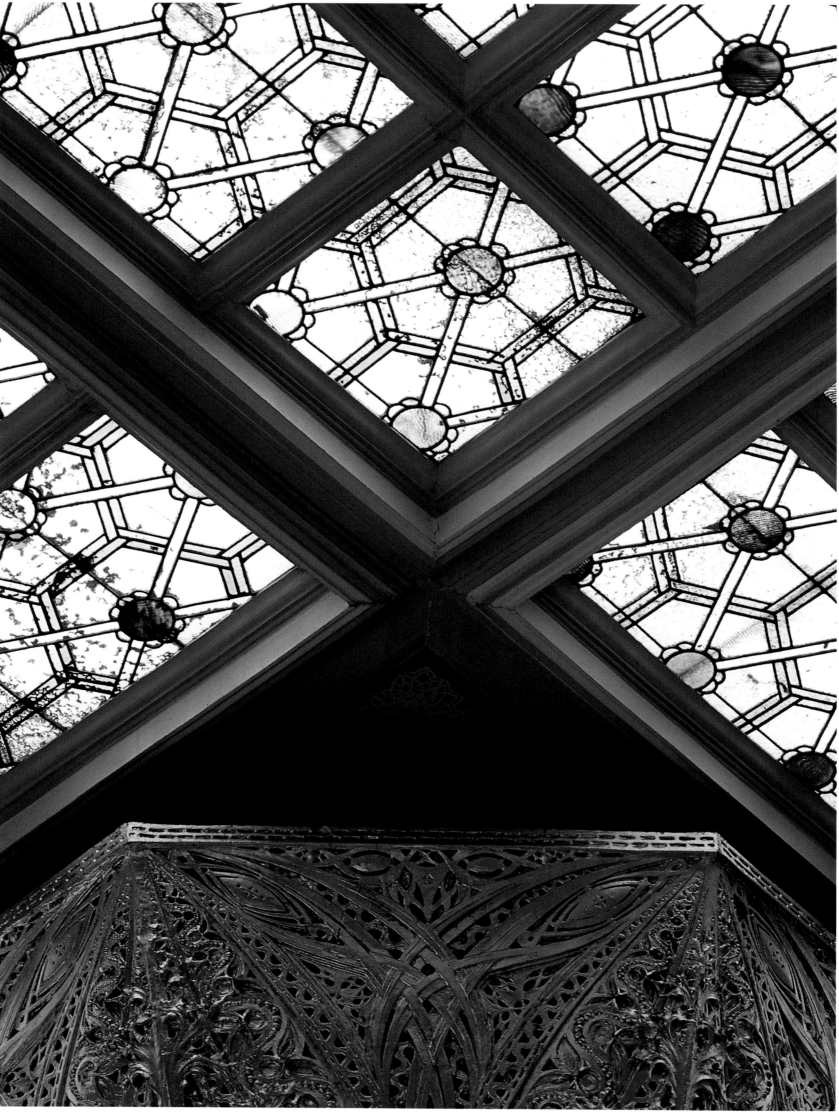

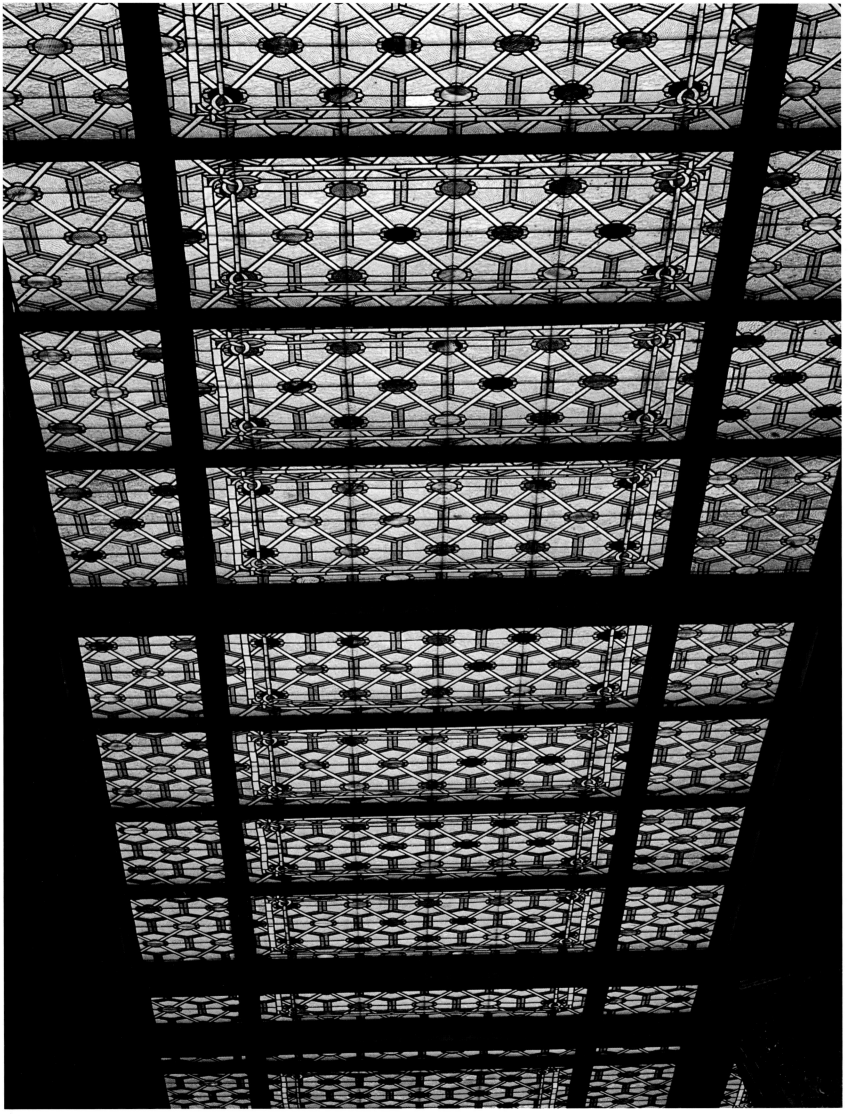

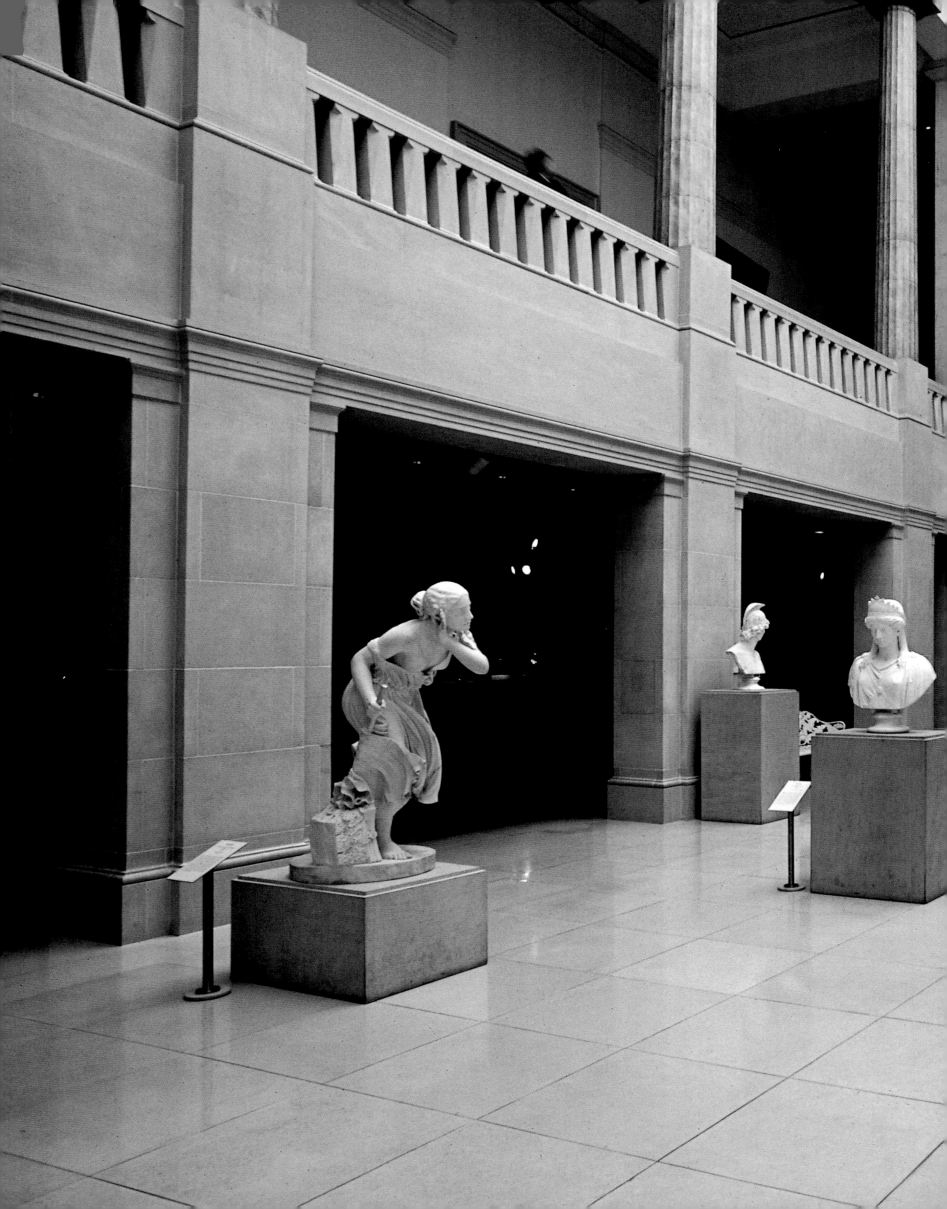

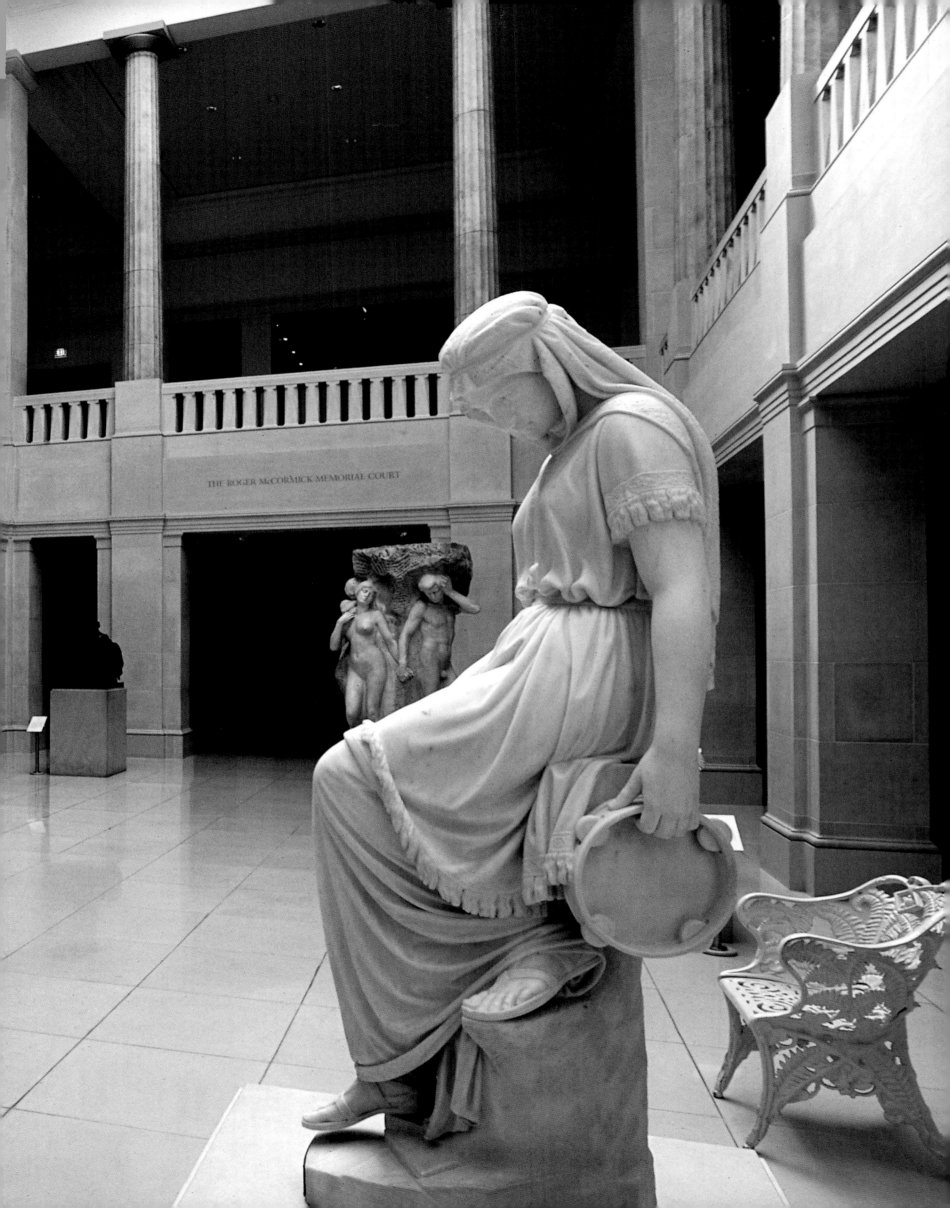

THE ROGER McCORMICK MEMORIAL COURT

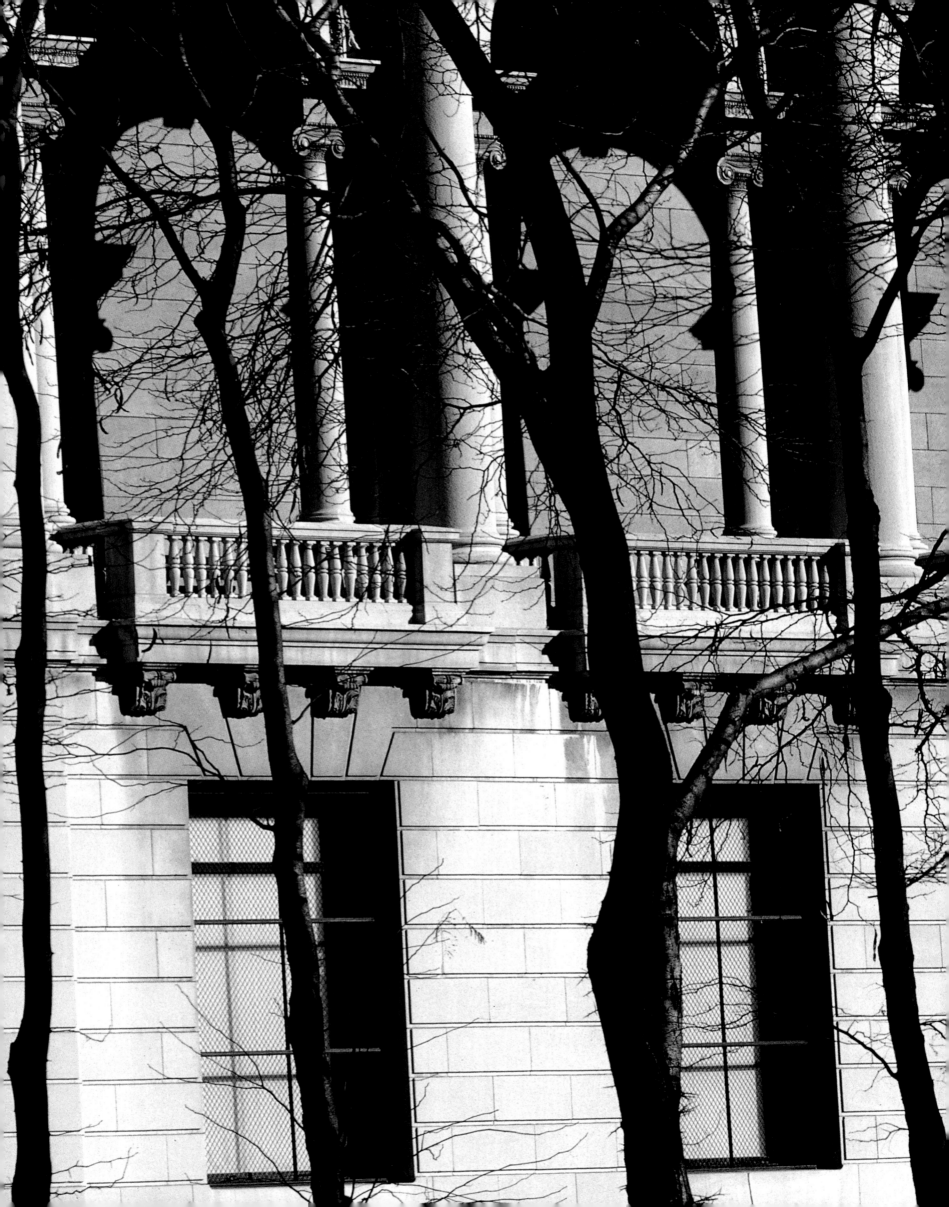

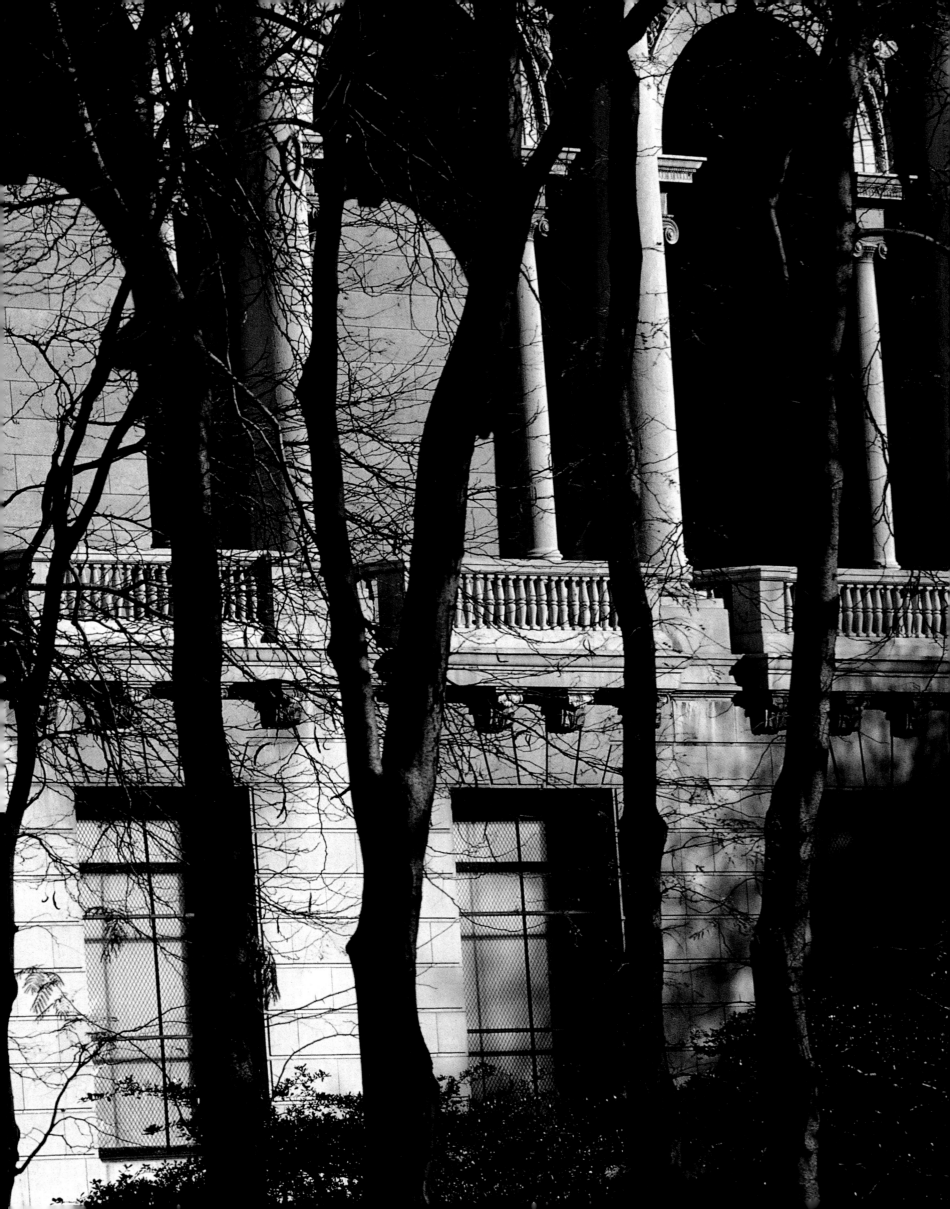

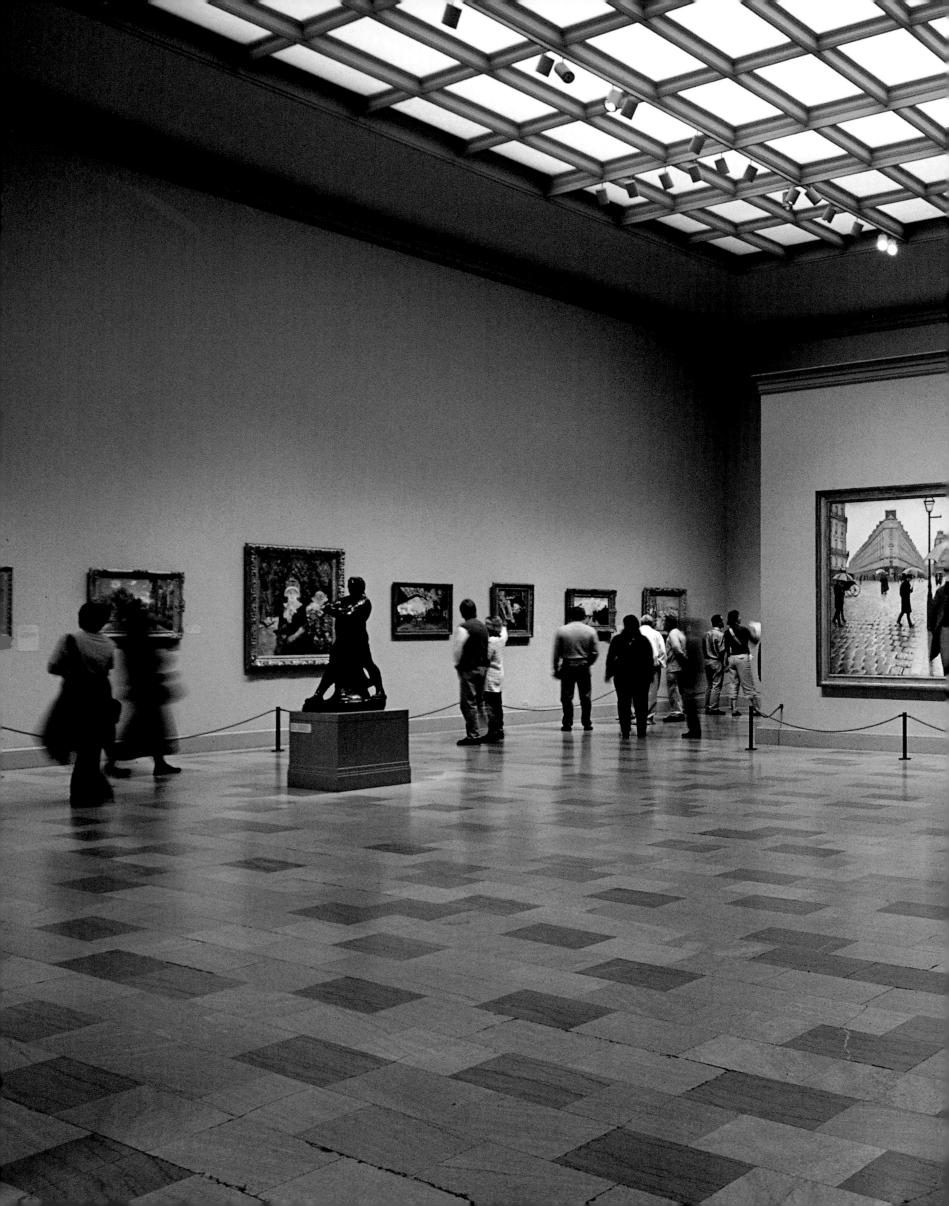

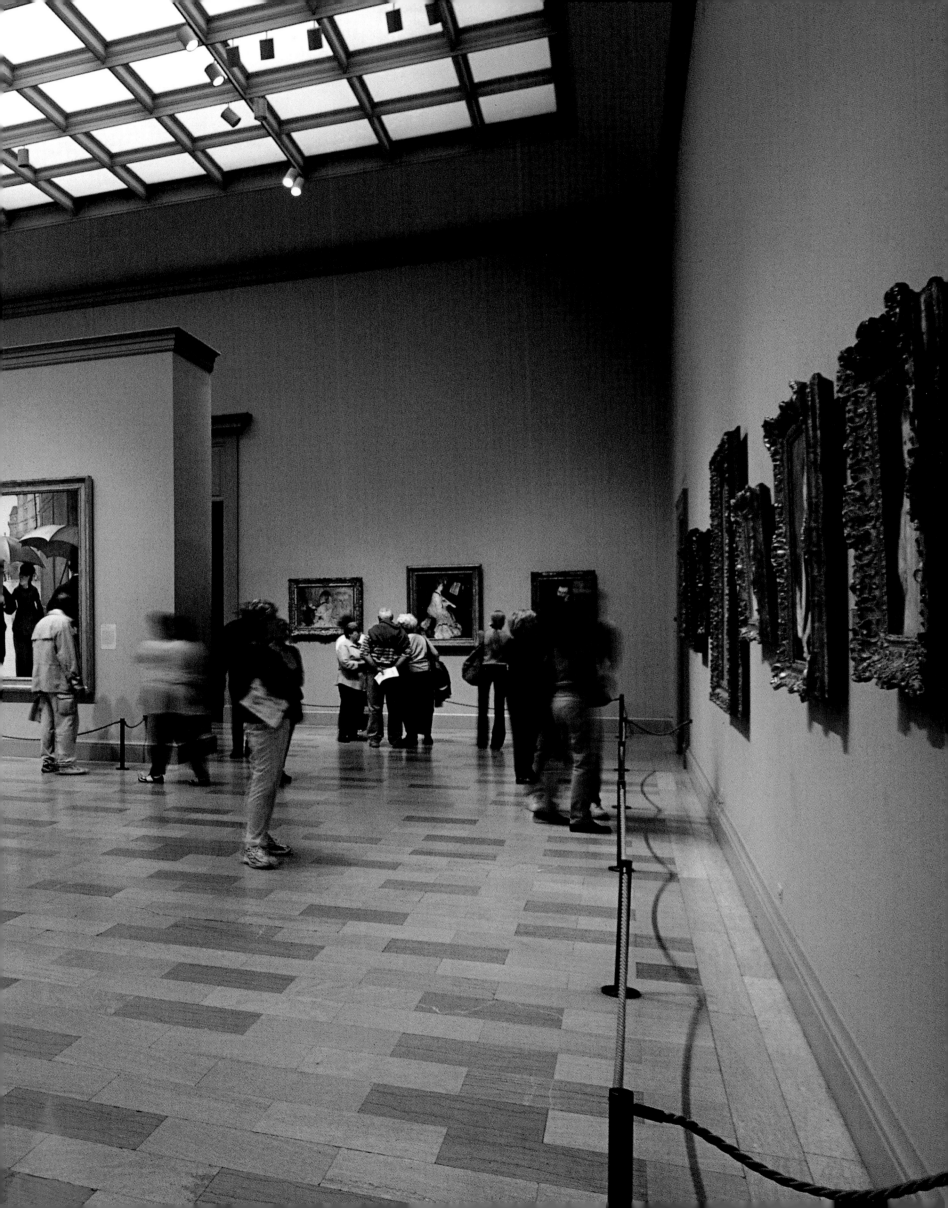

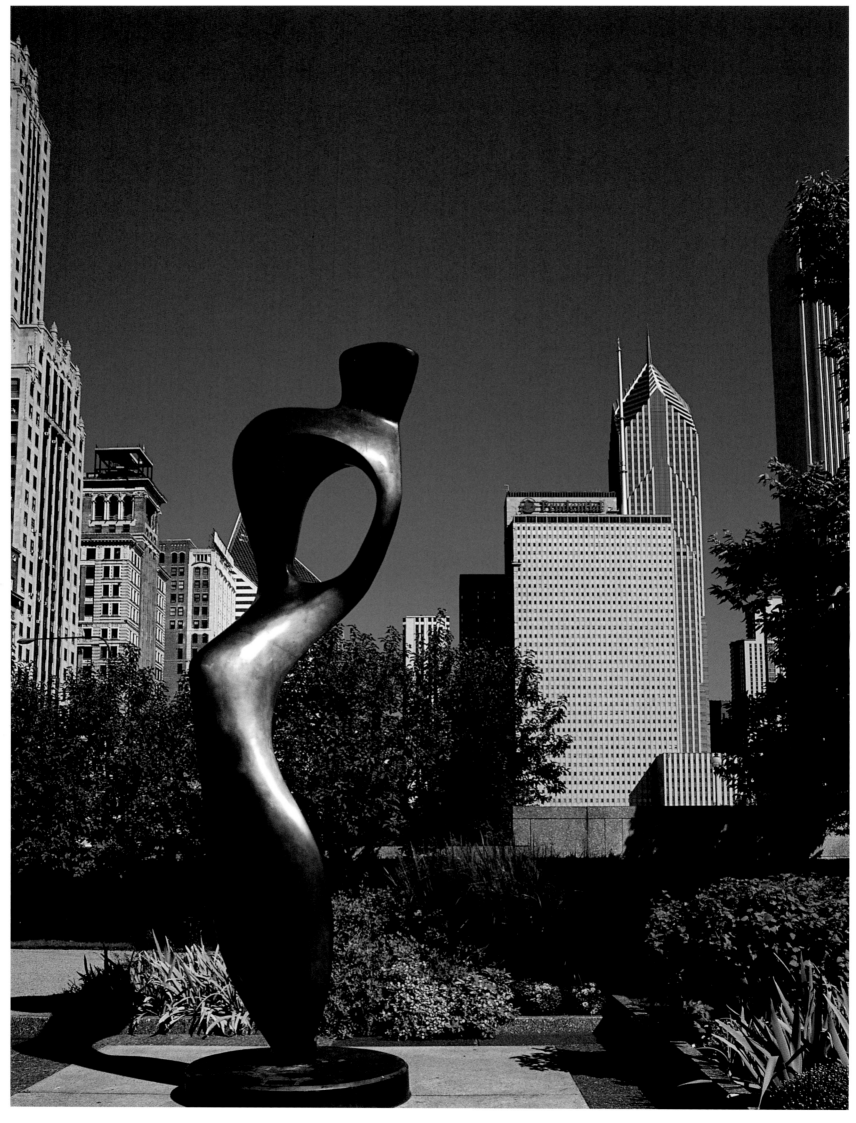

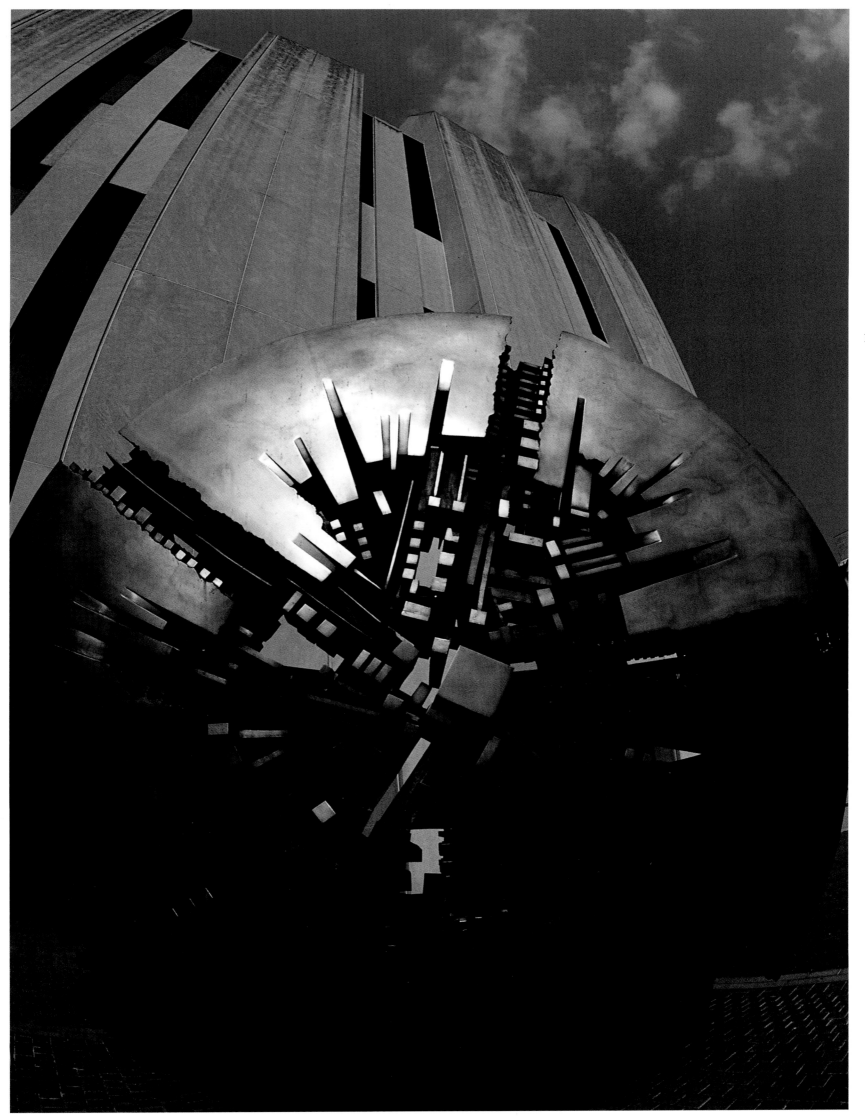

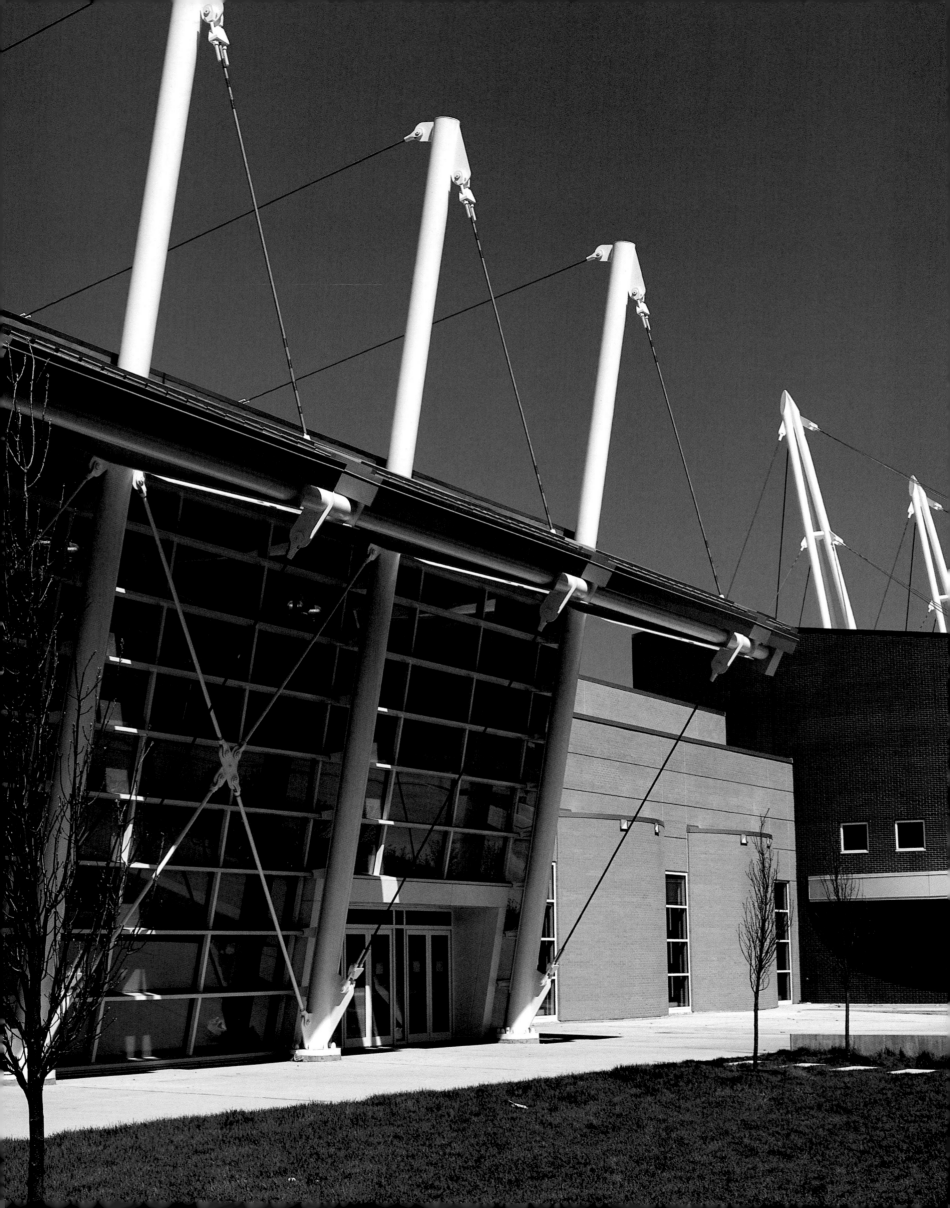

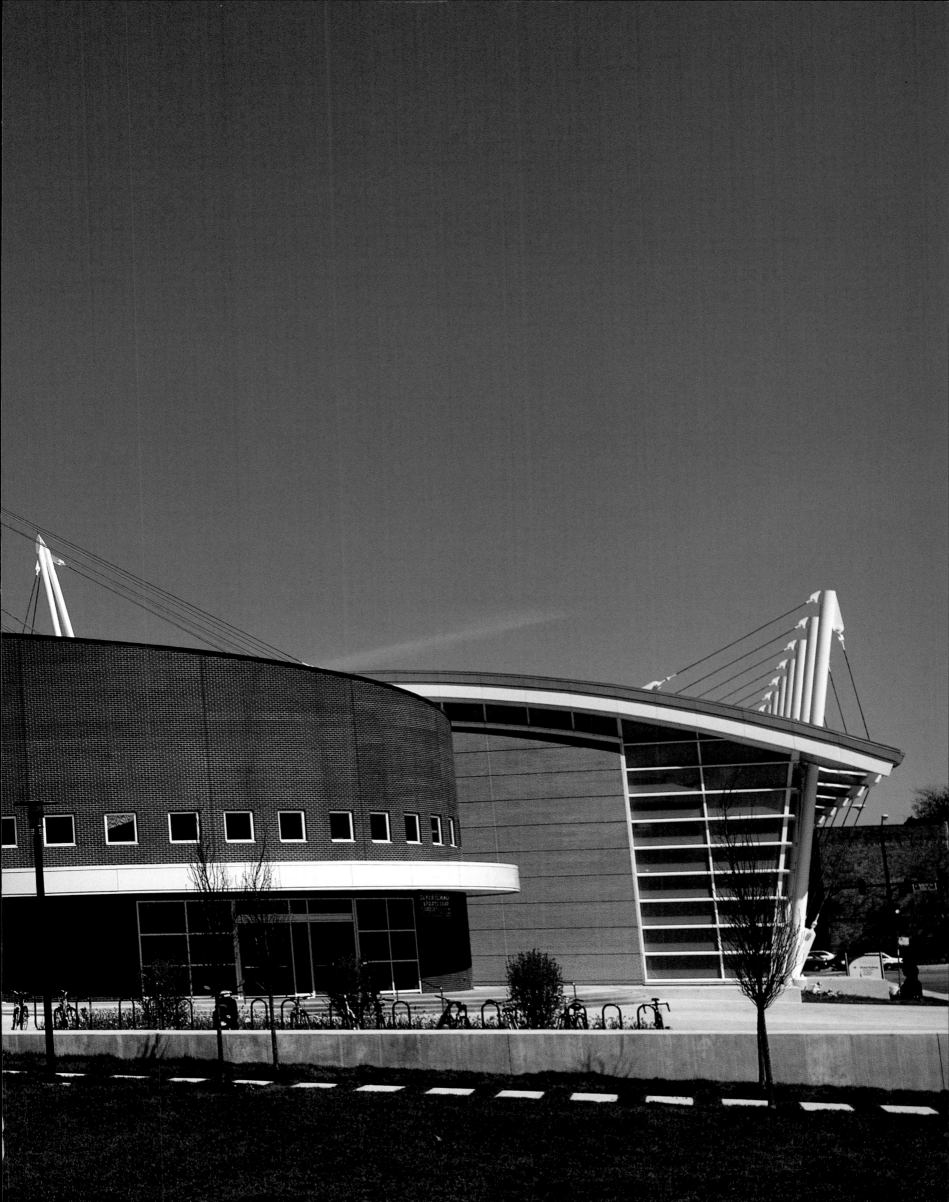

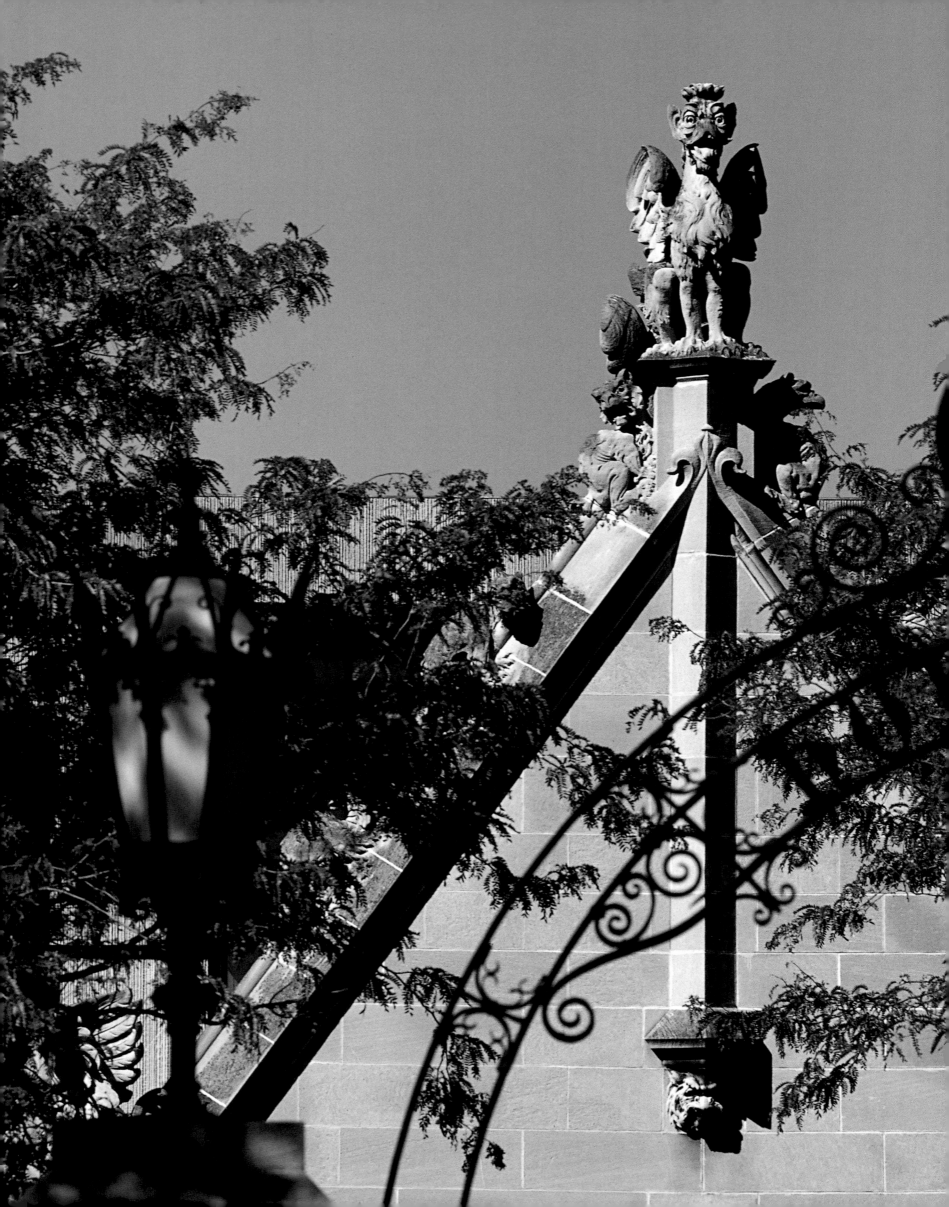

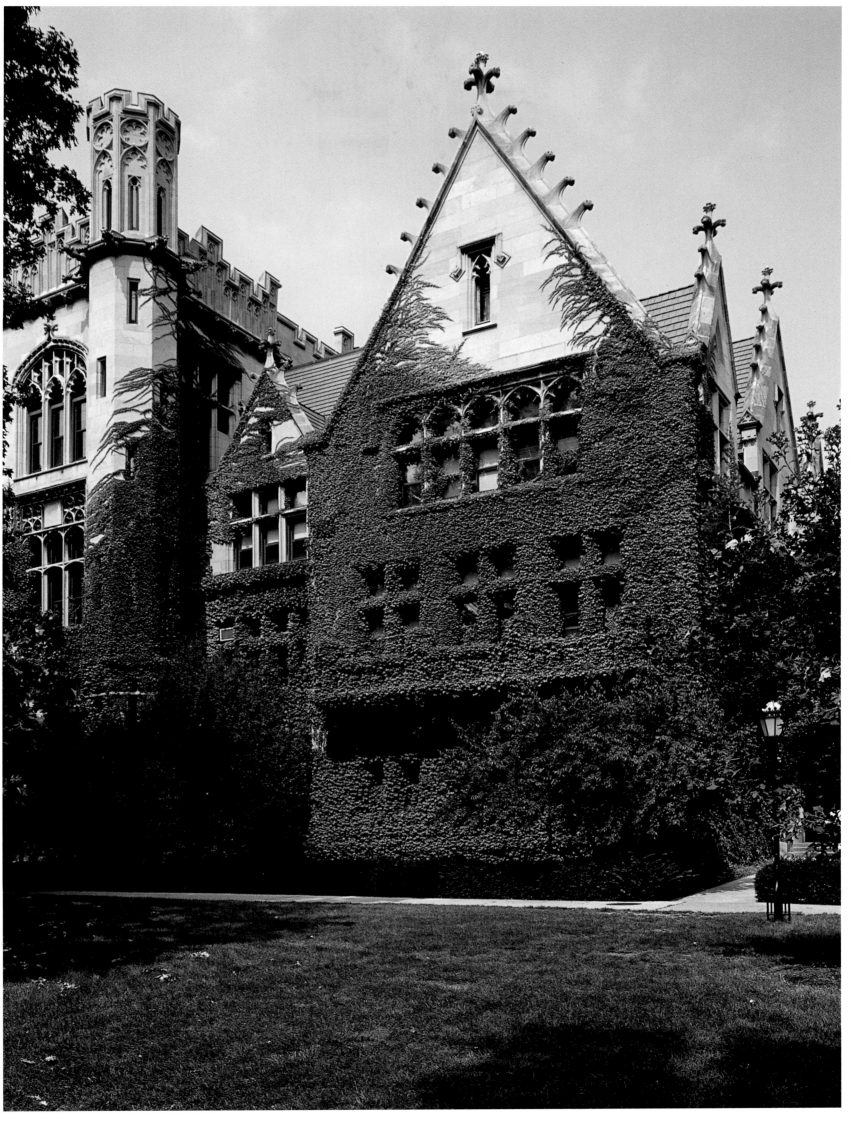

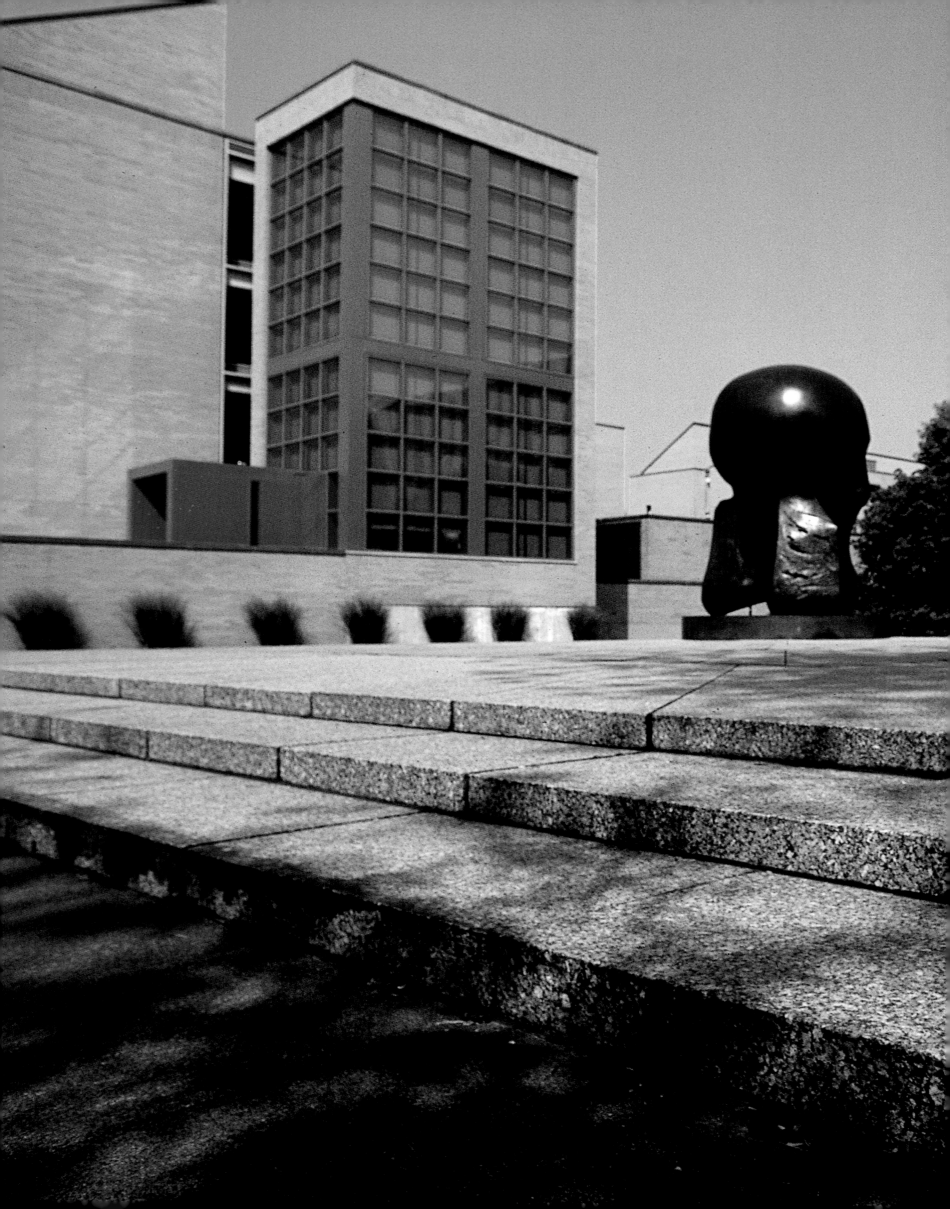

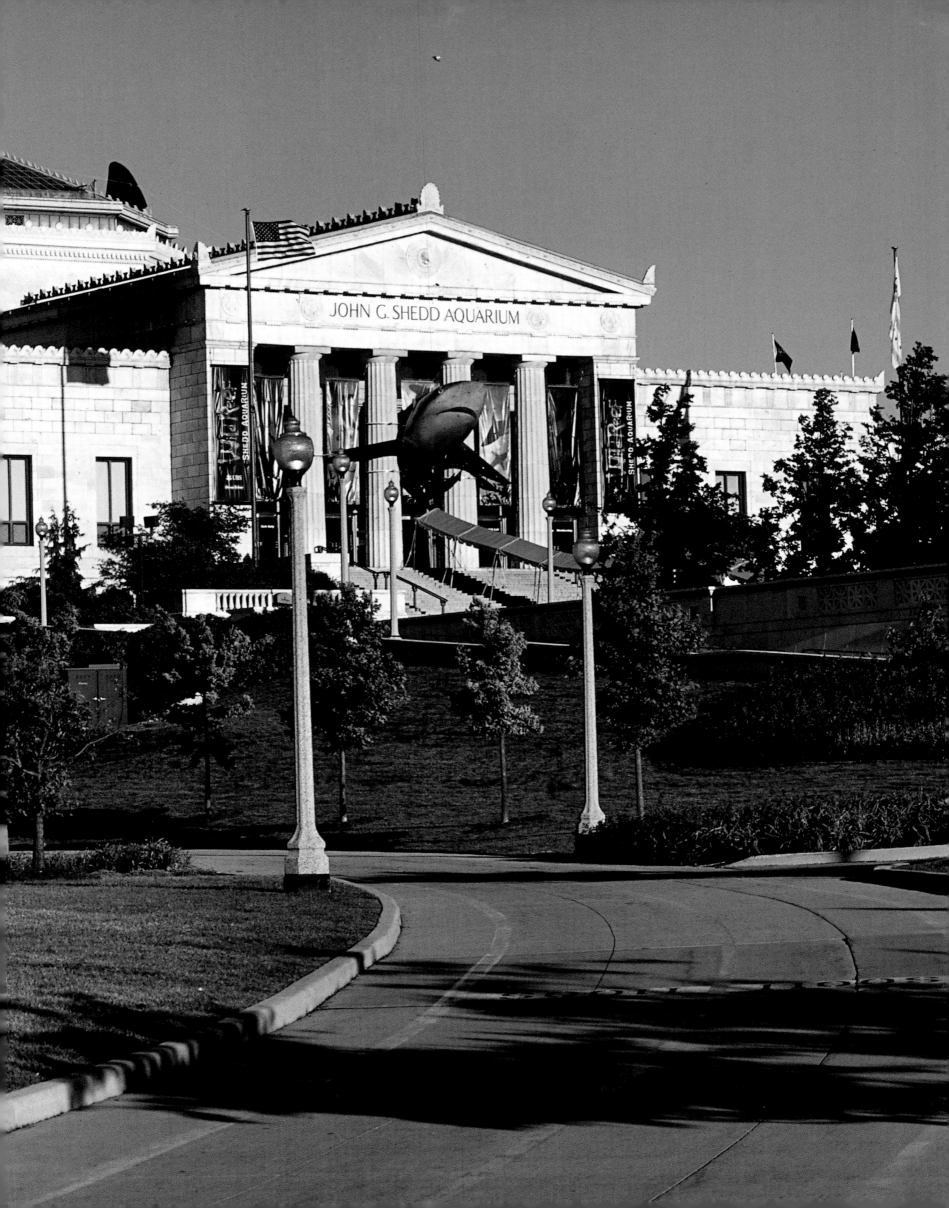

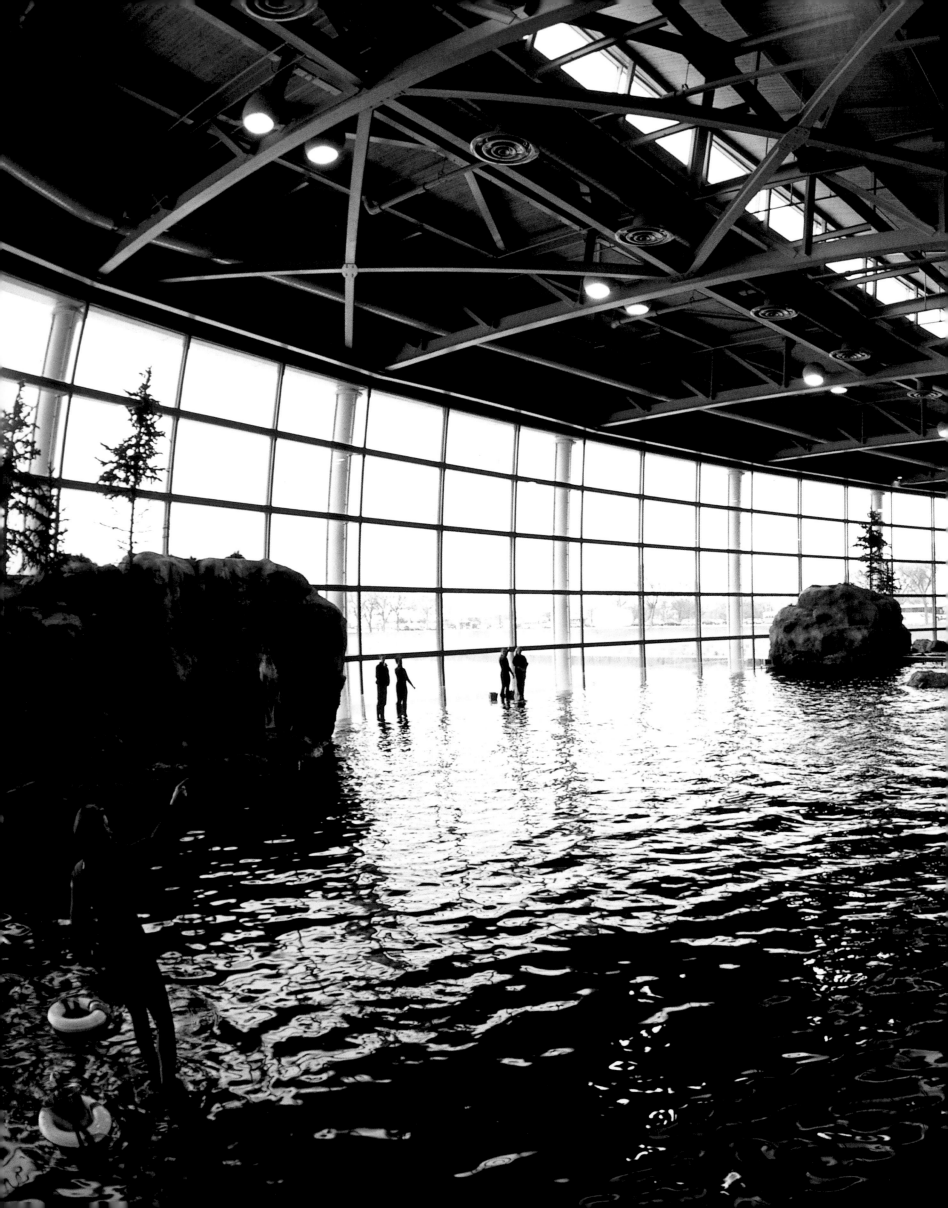

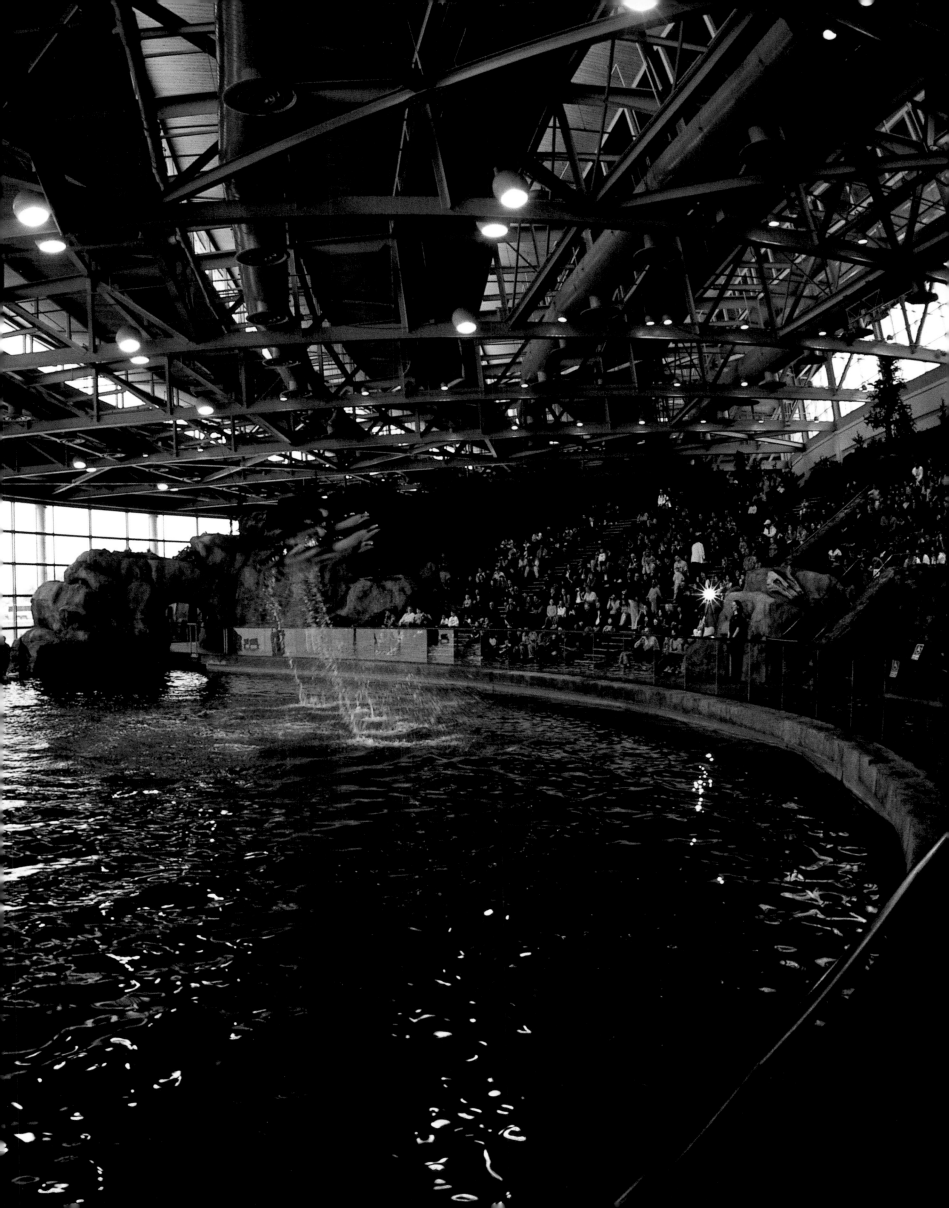

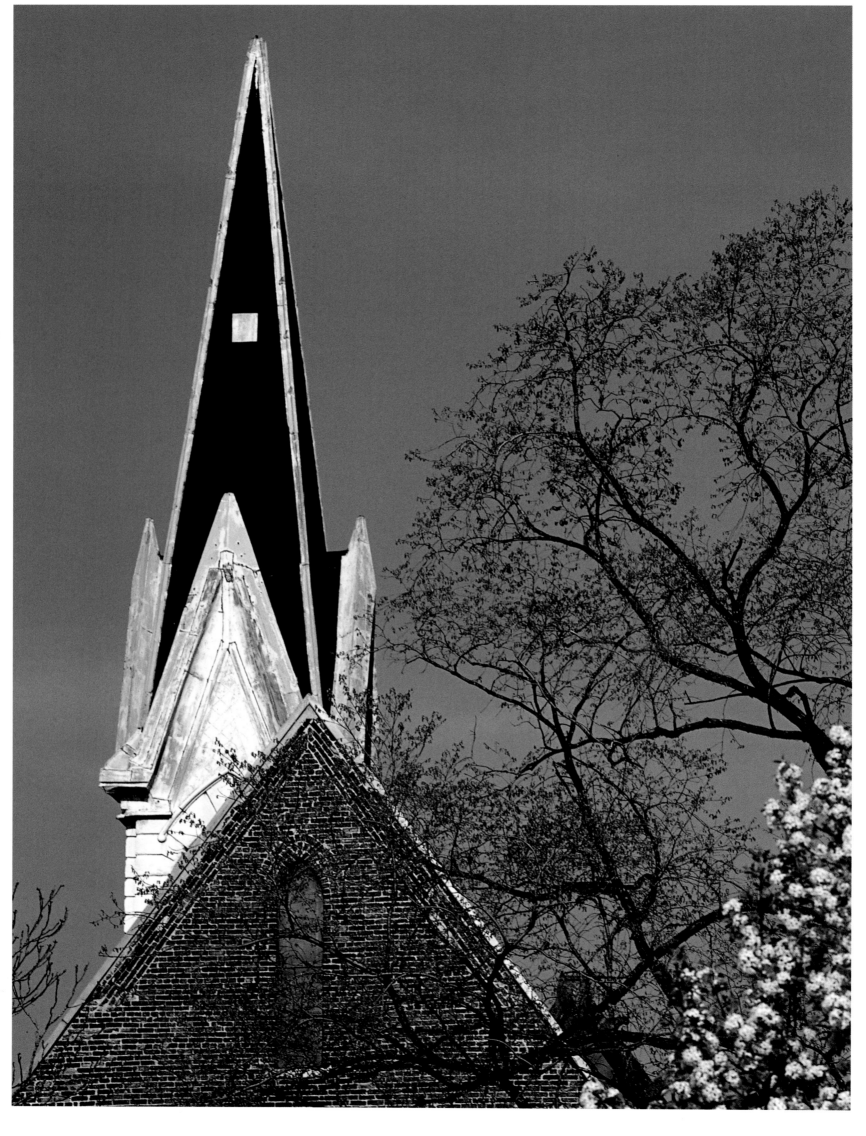

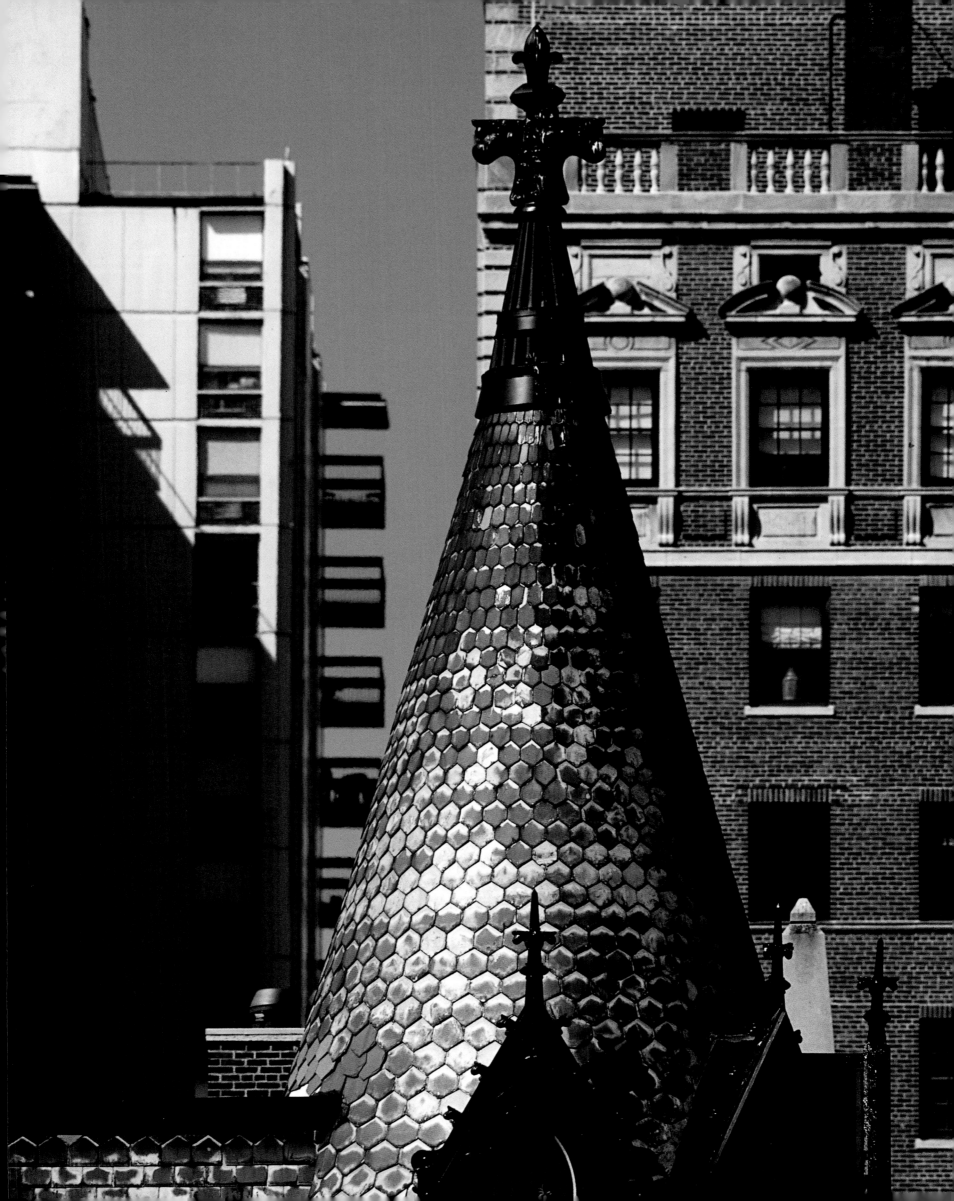

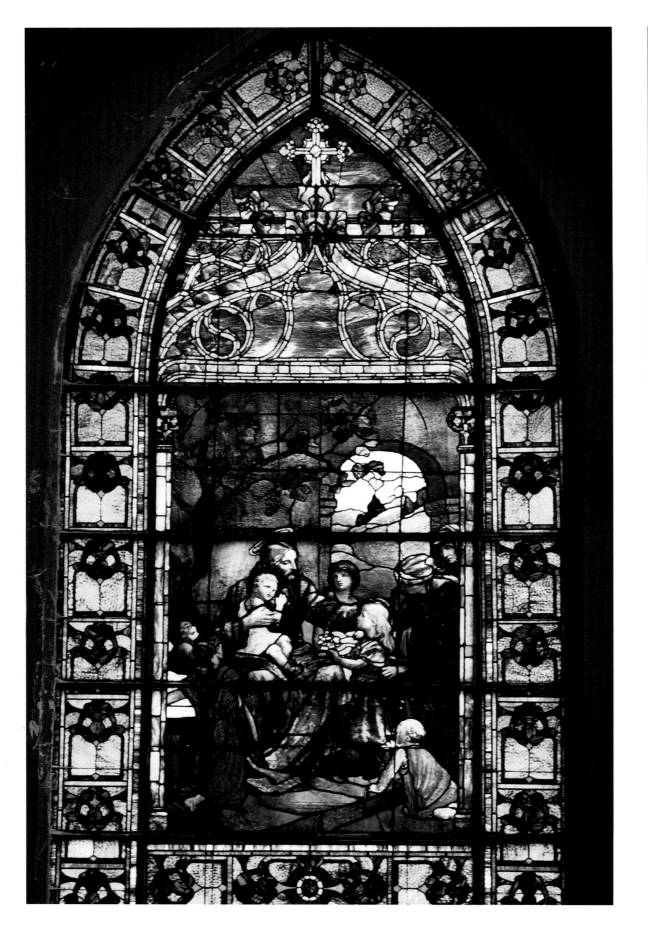
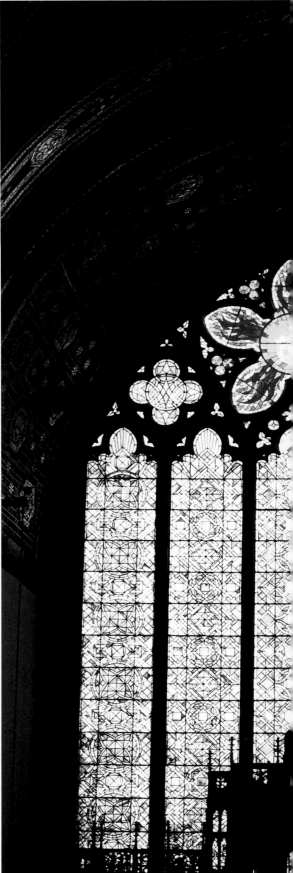

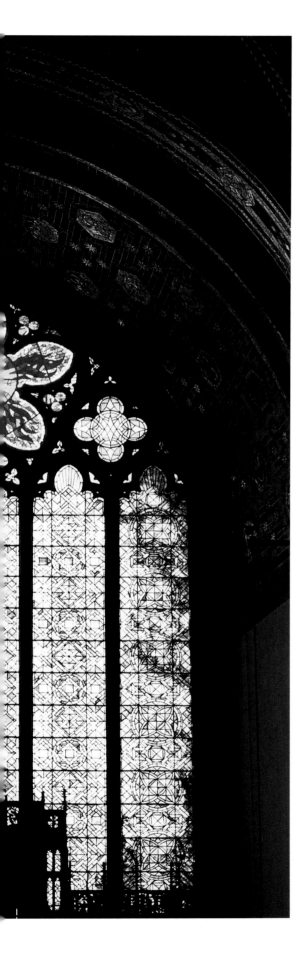

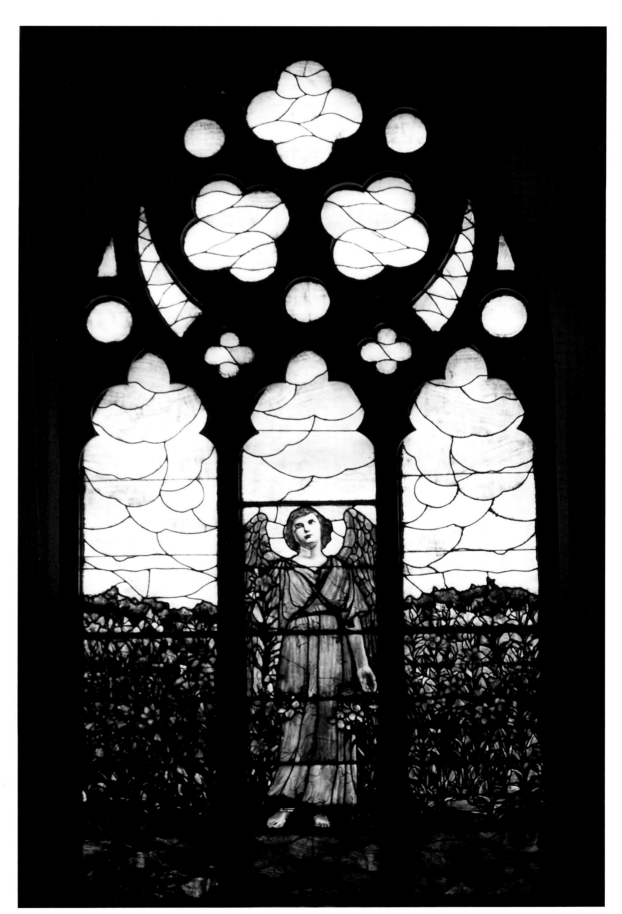

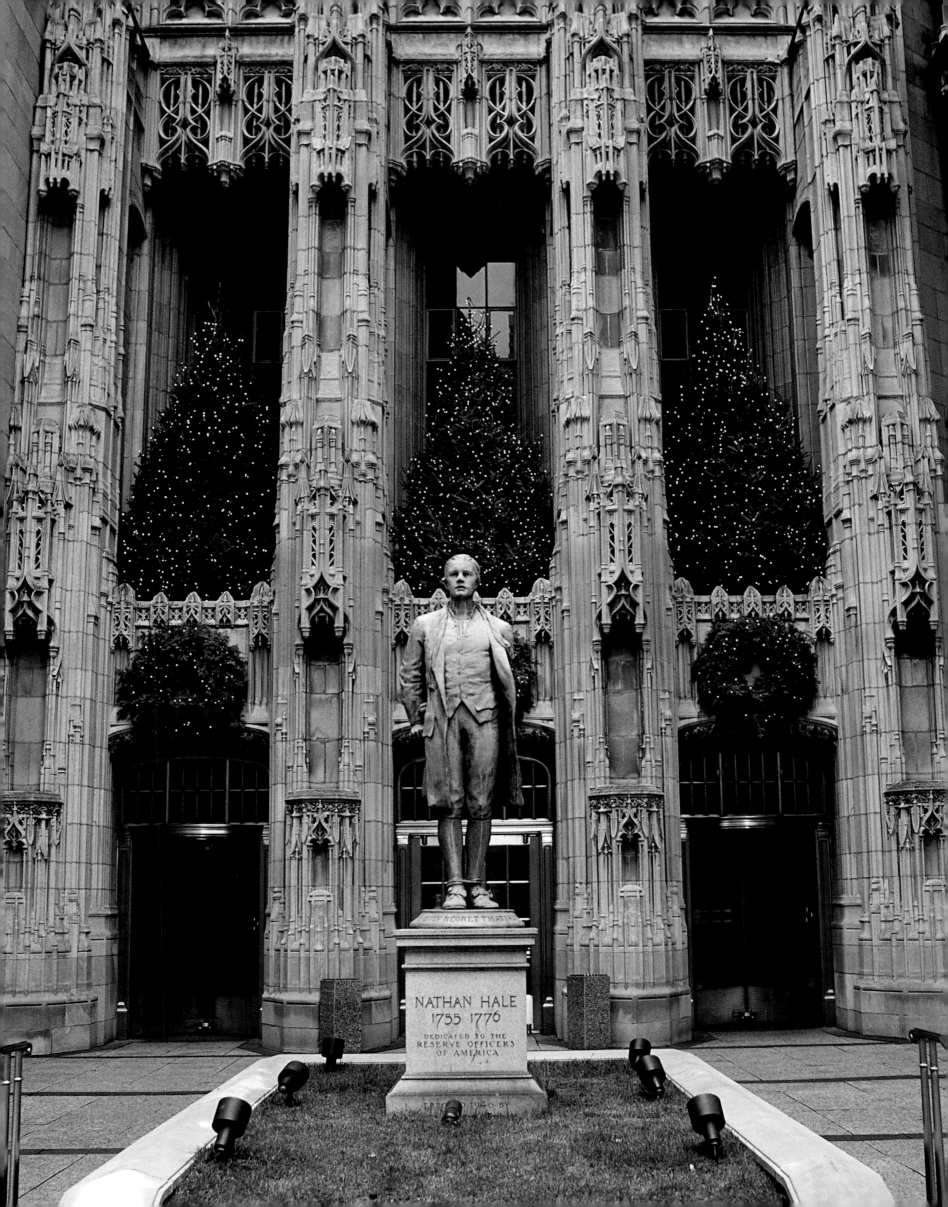

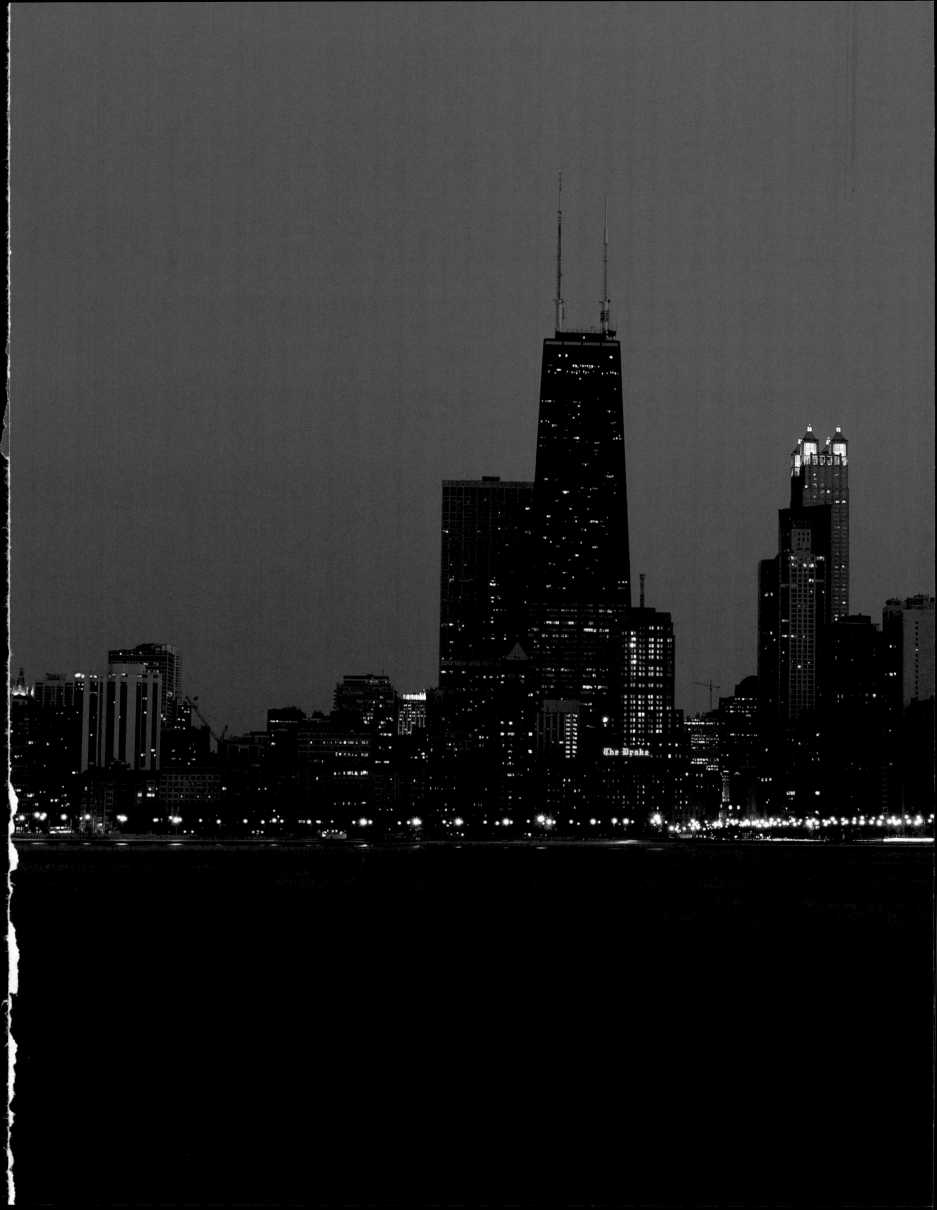

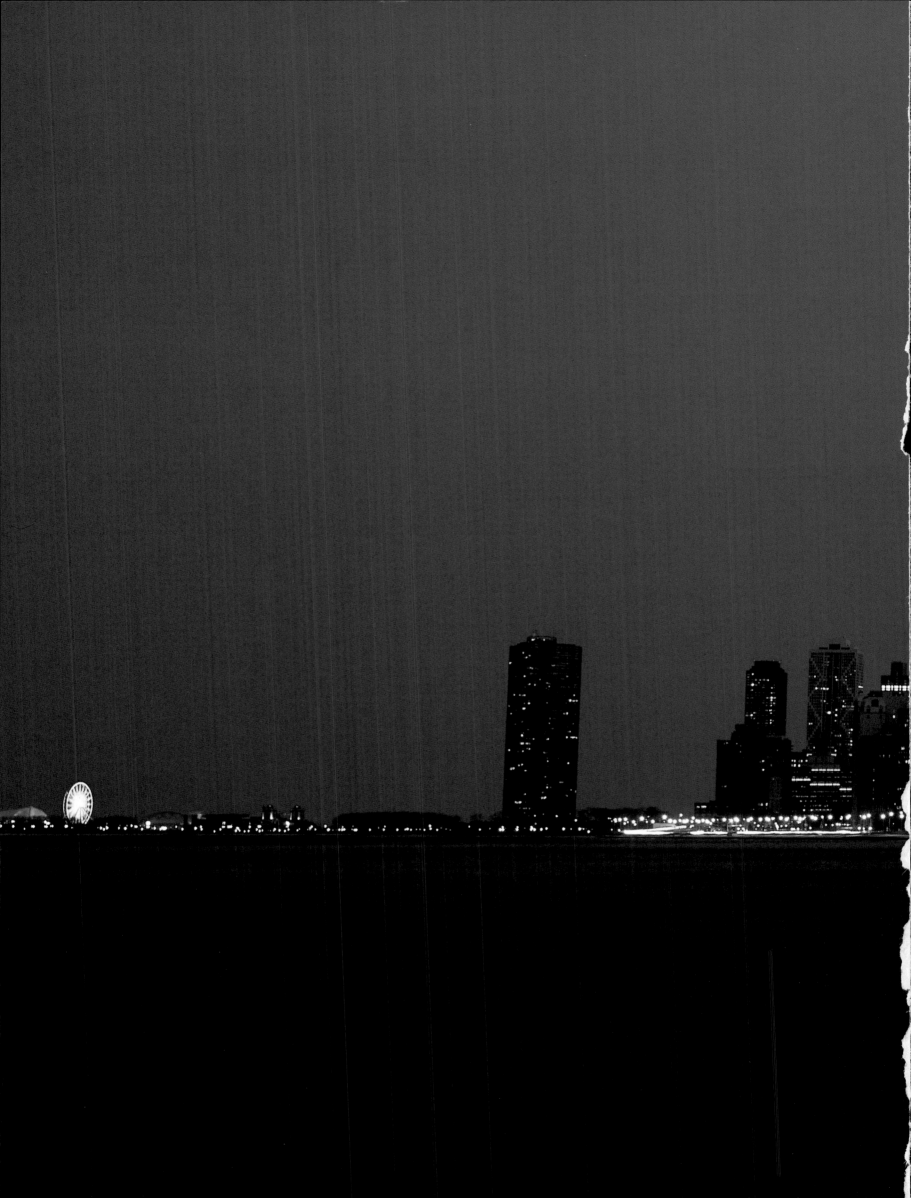

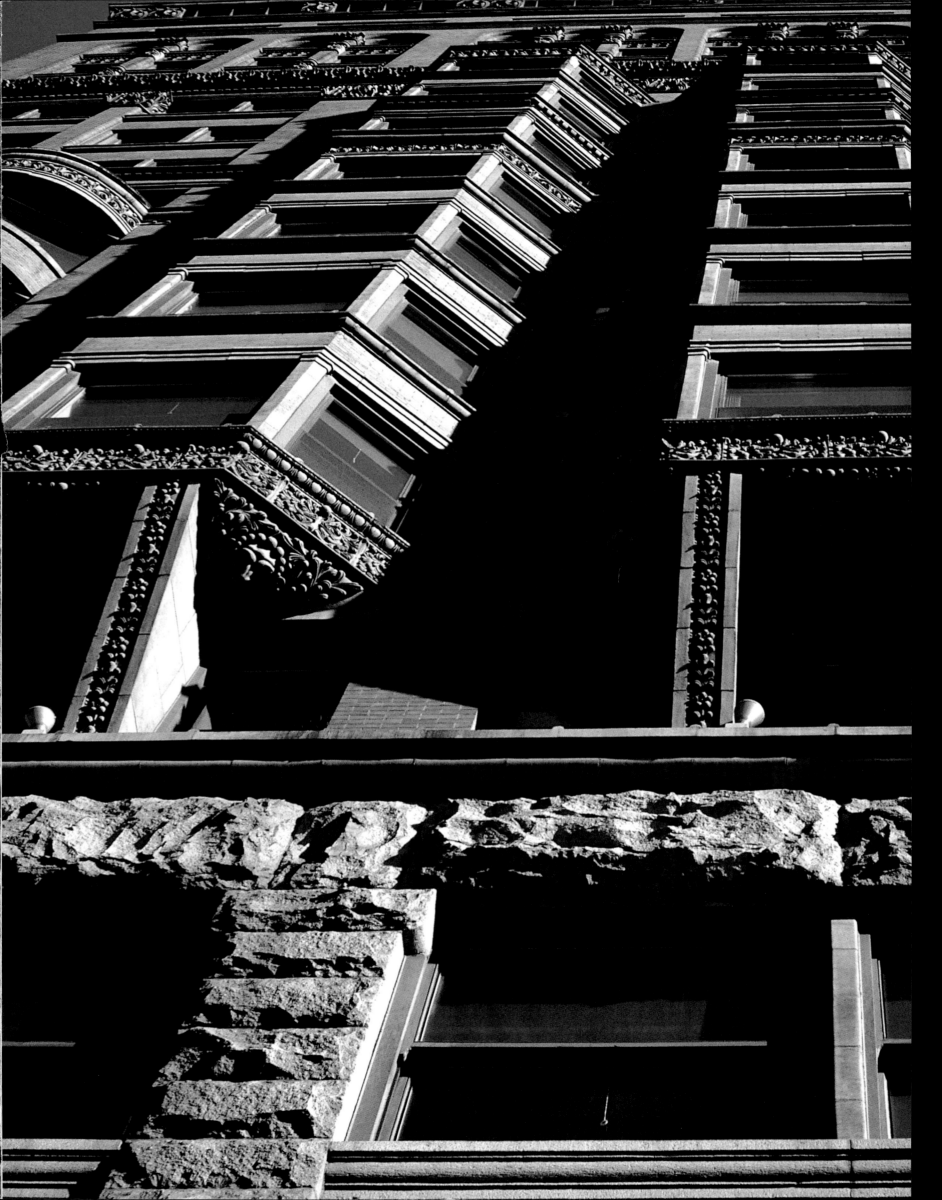

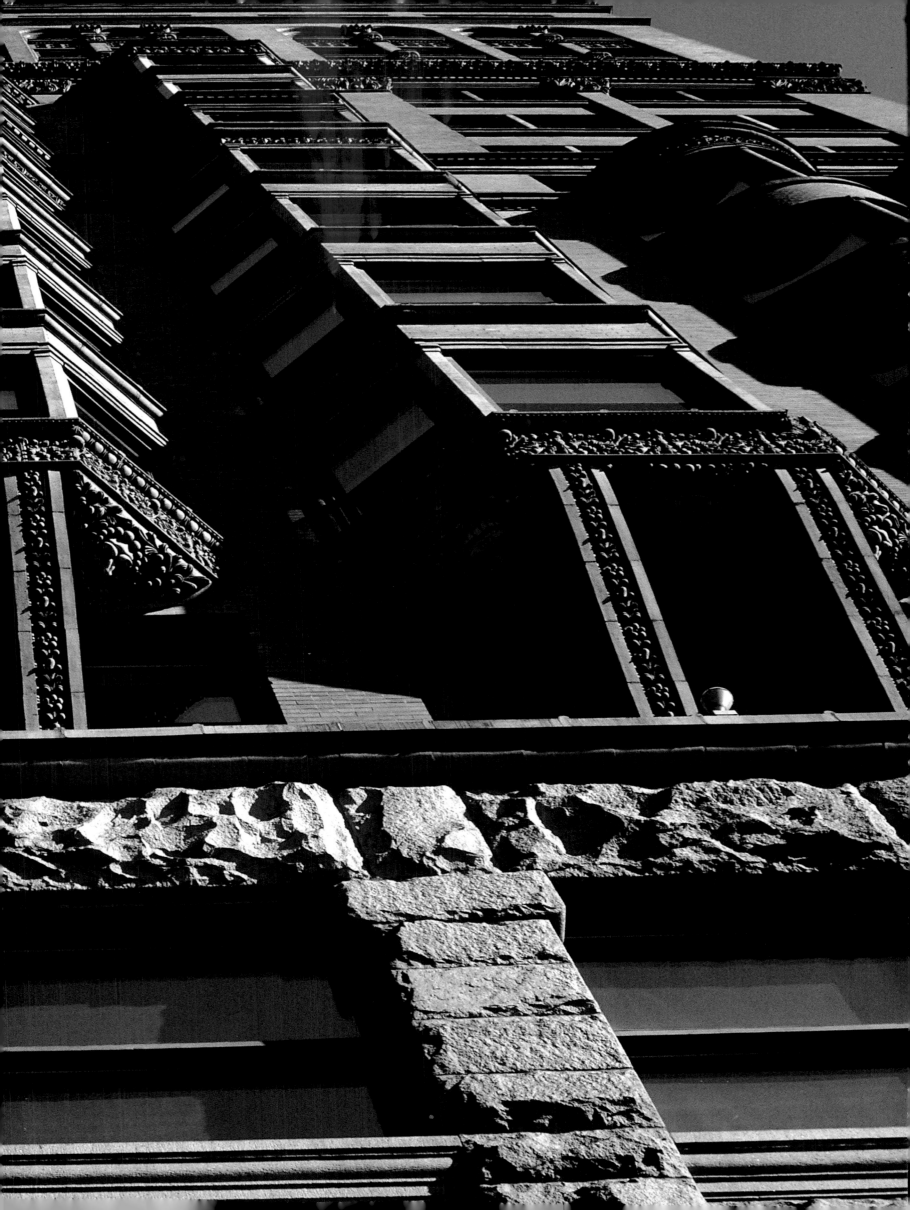

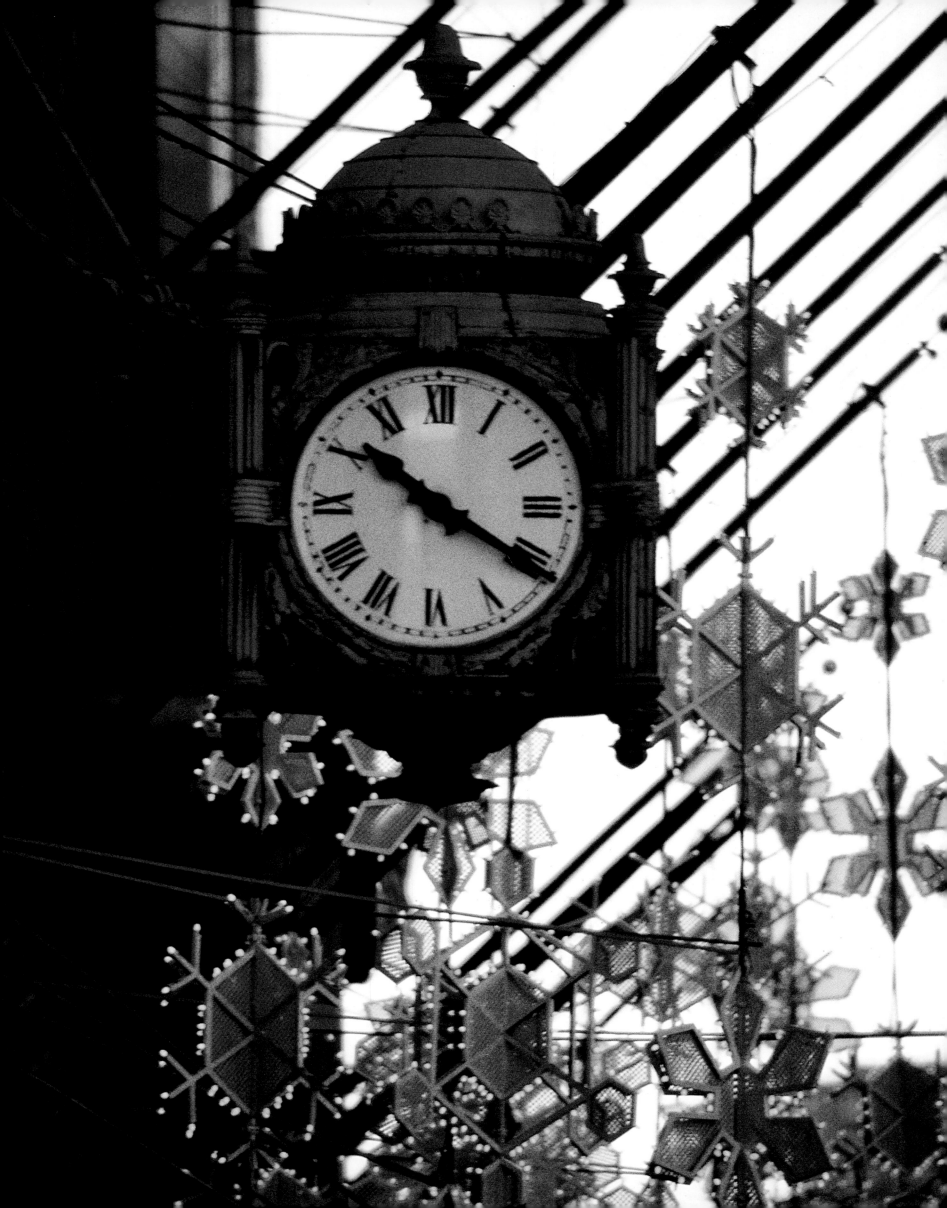

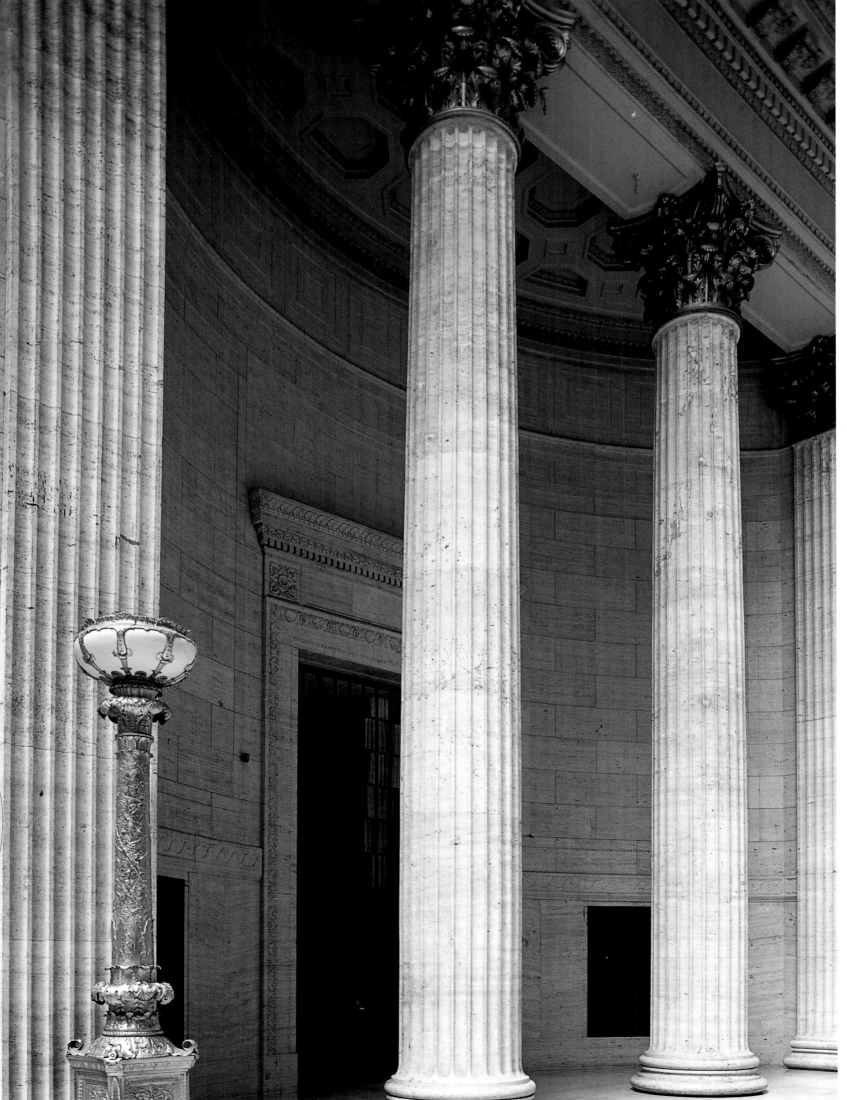

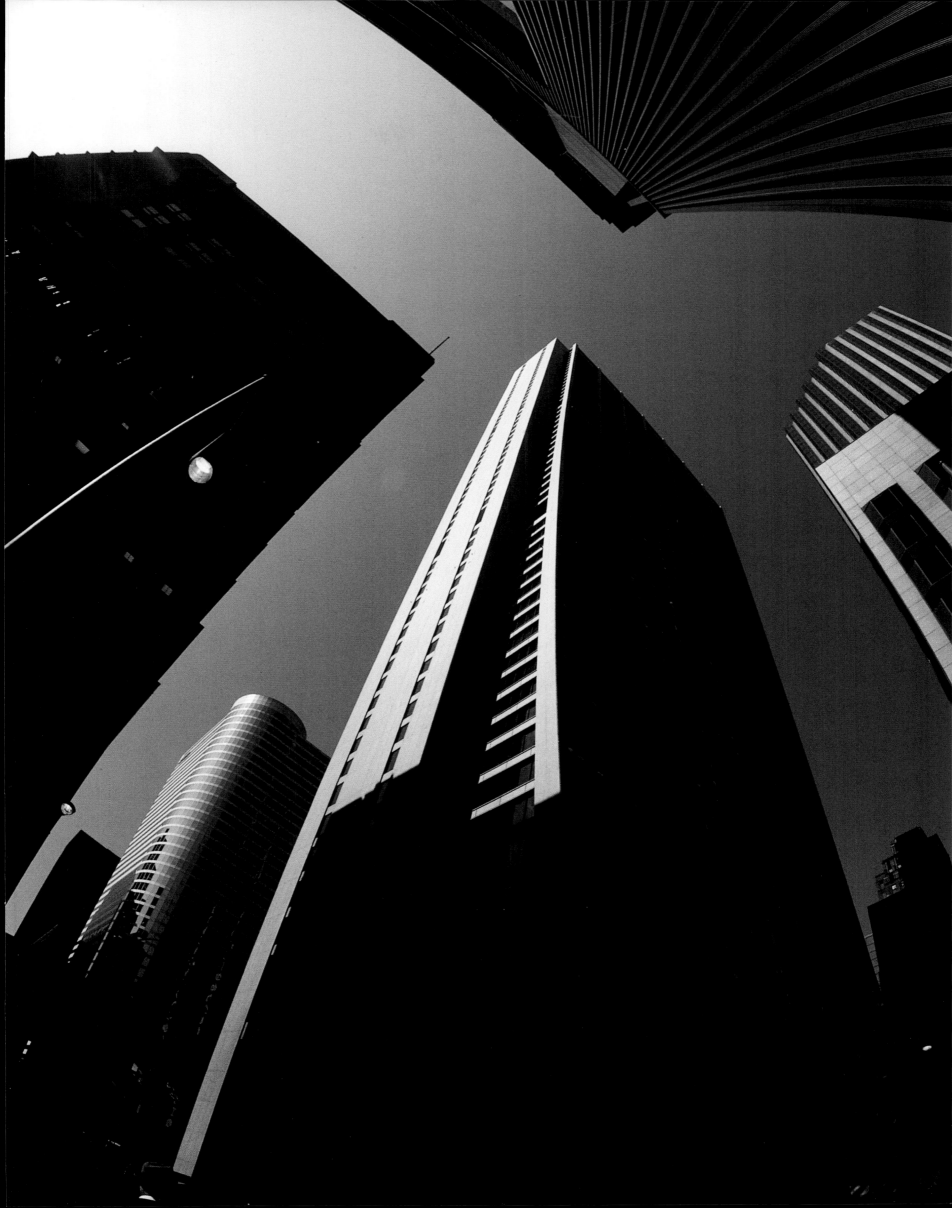

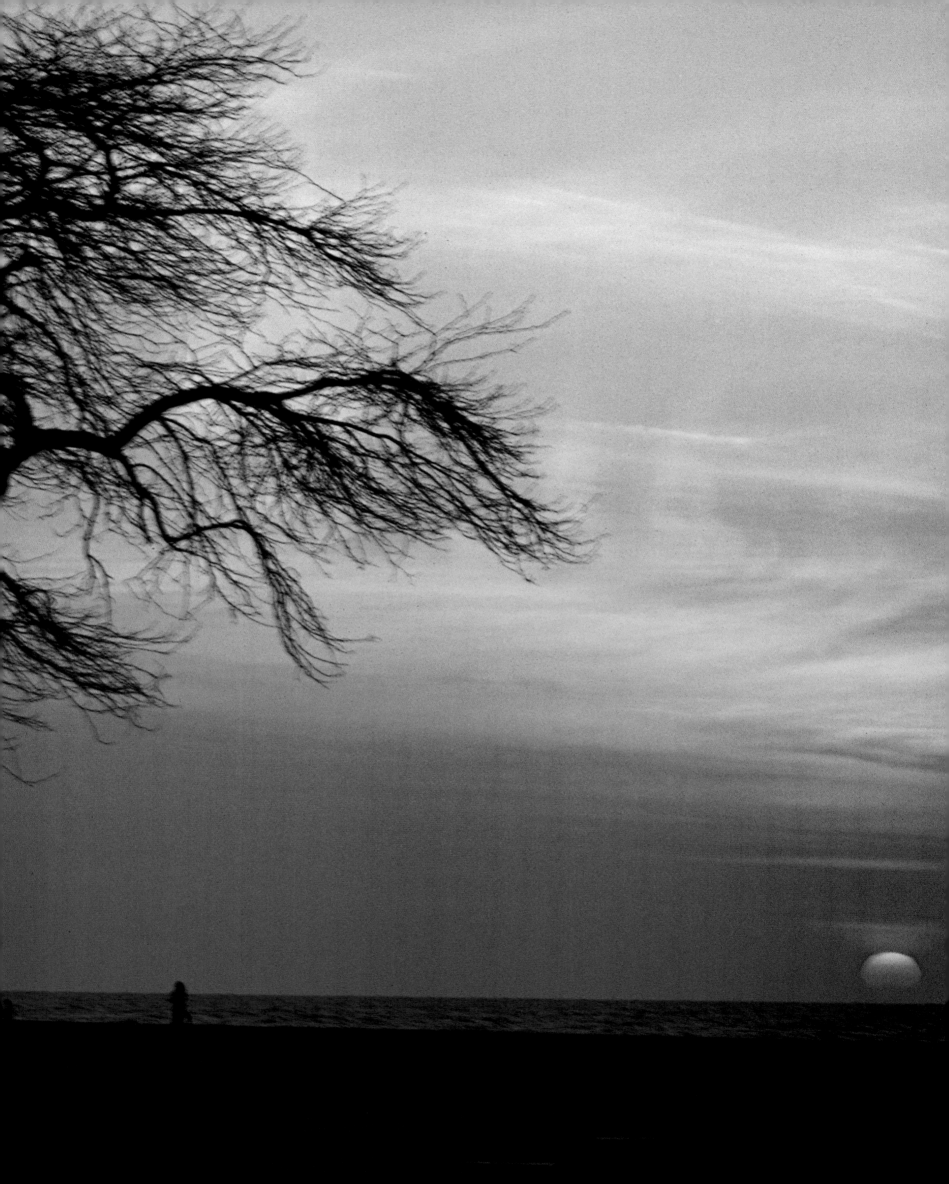

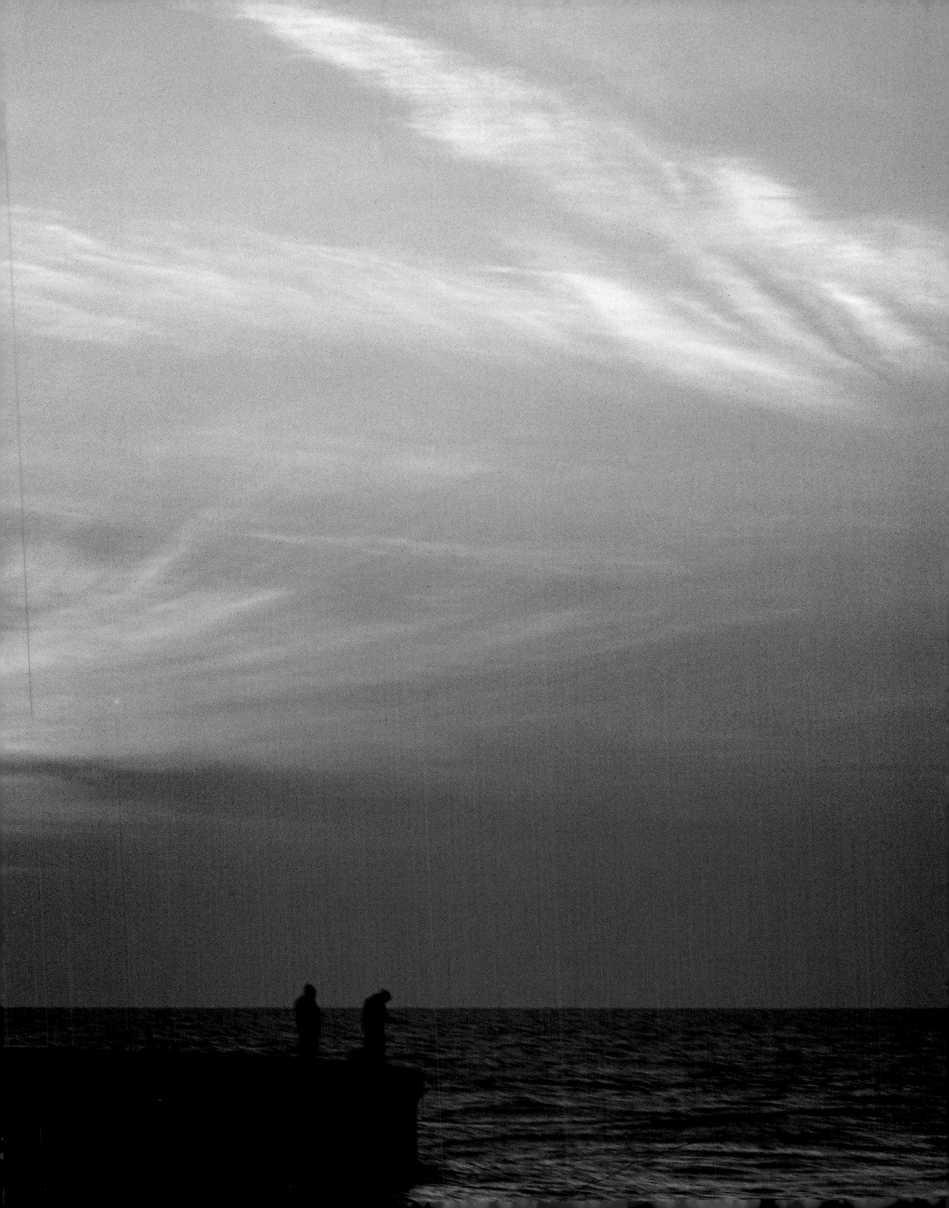

INDEX

234

2

3

4

5

8

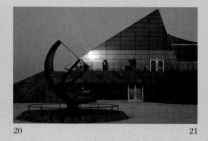
9

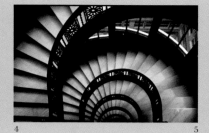
10 11

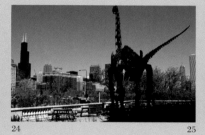
18 19

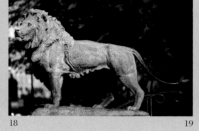
20 21

22 23

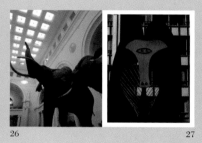
24 25

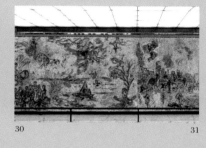
26 27

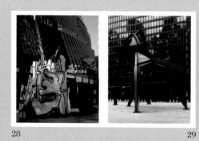
28 29

30 31

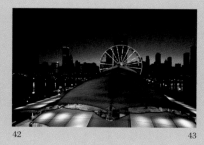
32 33

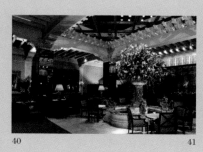
34 35

36 37

38 39

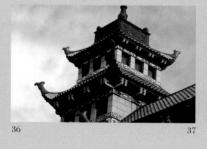
40 41

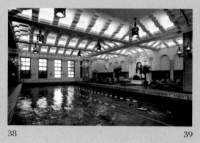
42 43

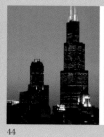

44 45

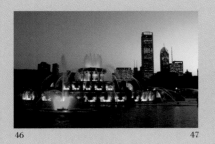
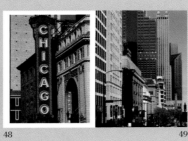

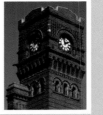

46 47 48 49 50 55

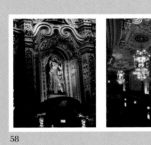
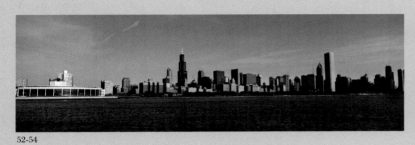

52-54 56 57

235

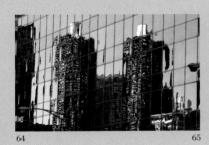
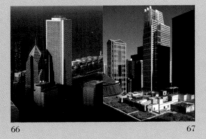
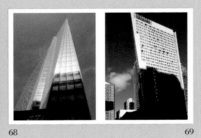

58 59 60 61 62 63

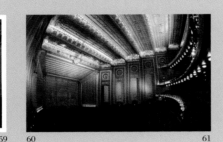
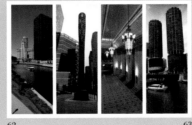
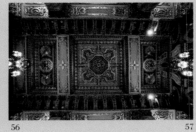

64 65 66 67 68 69

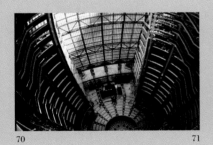
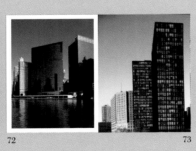

70 71 72 73 74 75

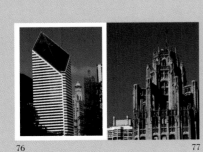

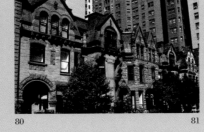

76 77 78 79 80 81

236

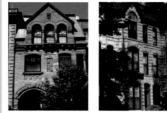

82 83

84 85

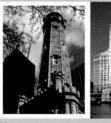
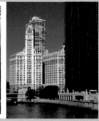
86 87

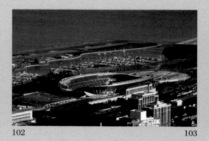
88 89

90 91

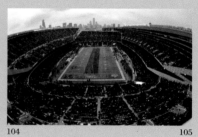
92 93

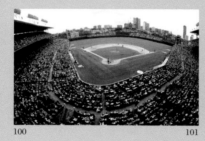
94 95

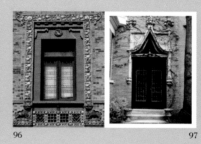
96 97

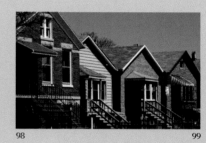
98 99

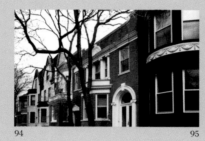
100 101

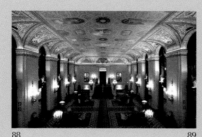
102 103

104 105

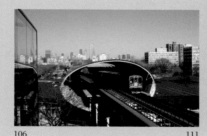
106 111

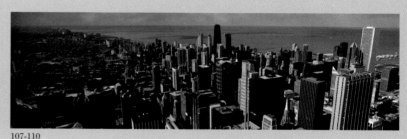
107-110

112 113

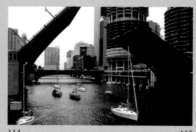
114 115

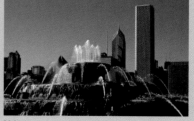
116 117

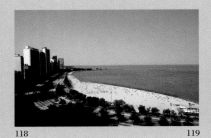 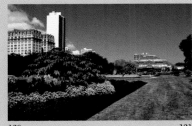 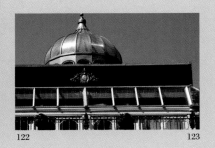

118 119 120 121 122 123

 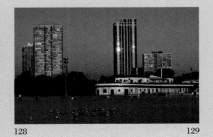

124 125 126 127 128 129

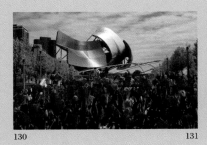 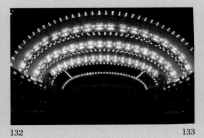 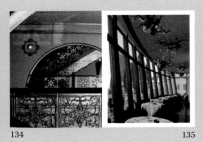

130 131 132 133 134 135

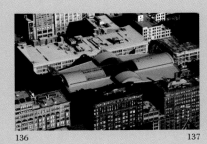 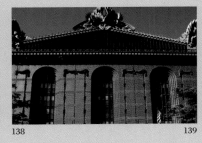 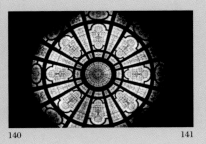

136 137 138 139 140 141

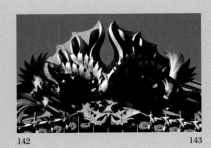 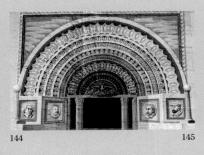 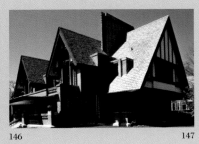

142 143 144 145 146 147

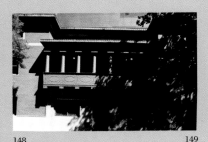 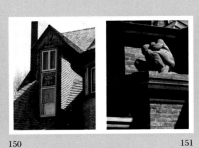 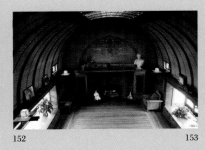

148 149 150 151 152 153

237

PAGE 118-119 Bathers enjoying the September sun at Oak Street Beach on Lake Michigan

PAGE 120-121 Lincoln Park Conservatory (1890-95), 2400 North Stockton Drive; Joseph L. Silsbee, architect

PAGE 122-123 Cupola on house at 79 East Cedar Street

PAGE 124-125 Dead trees in Grant Park decorated with rubber hoses

PAGE 126-127 Enjoying the late-summer sun at North Street Beach

PAGE 128-129 North Street Beach at sunset

PAGE 130-131 The spectacular Jay Pritzker Pavilion (2004) in Millennium Park, fashioned of stainless steel, designed by Frank Gehry

PAGE 132-133 The Auditorium Theater (1889), Adler & Sullivan, architects; one of the first public buildings in Chicago to use electric lighting and air conditioning

PAGE 134-135 *Left:* Staircase in the Auditorium Theater (1889) *Right:* Spectacular chandeliers by American glass sculptor, Dale Chihuli, adorn the ceiling of NoMi Restaurant at the Park Hyatt Hotel on Michigan Avenue.

PAGE 136-137 Center, the roof of the Harold Washington Library Center

PAGE 138-139 The Harold Washington Library Center, 400 South State Street, designed by Thomas Beeby of Hammond, Beeby, and Babka

PAGE 140-141 The Tiffany Dome in the Chicago Cultural Center (1897), 78 East Washington Street, which served for nearly 100 years as the central branch of the Chicago Public Library

PAGE 142-143 One of seven aluminum sculptures atop the Harold Washington Library Center

PAGE 144-145 Part of a mural that pays homage to the Chicago School of Architecture (1980) by Richard Haas, 1211 North La Salle Street; left to right, Frank Lloyd Wright, John W. Root, Daniel Burnham, Louis H. Sullivan

PAGE 146-147 Nathan G. Moore House (1895), 333 North Forest in Oak Park; Frank Lloyd Wright, architect

PAGE 148-149 James Charnley House (1892) at 1365 North Astor St., designed by Frank Lloyd Wright when he was working for Adler & Sullivan

PAGE 150-151 *Left:* Detail of the Walter H. Gale house (1892), 1031 West Chicago Street, Oak Park; Frank Lloyd Wright, architect, *Right:* Boulders, designed and executed by sculptor Richard Bock (c.1898) on roof of the Frank Lloyd Wright Home and Studio (1889/98); architect, Frank Lloyd Wright in Oak Park

PAGE 152-153 Children's playroom in Frank Lloyd Wright Home and Studio (1889/1898) in Oak Park

238

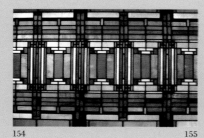
154

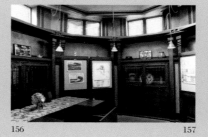
155

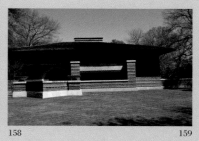
156
157

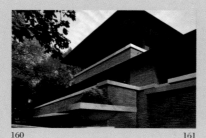
160

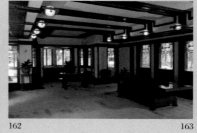
158
159

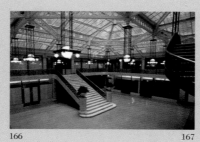
160

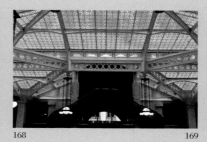
162
163

164
165

166
167

168
169

170
171

172
173

174
175

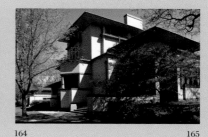
176
177

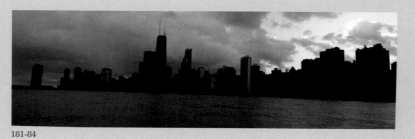
178
179
180
185

181-84

186
187

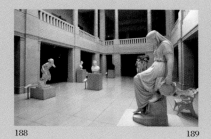

188 189

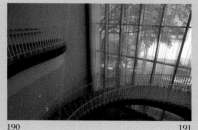

190 191

192 193

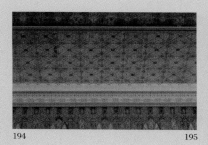

194 195

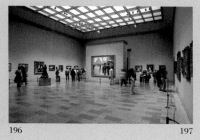

196 197

198 199

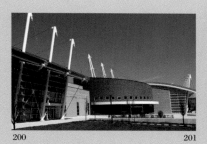

200 201

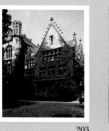

202 203

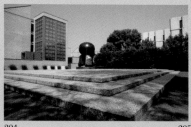

204 205

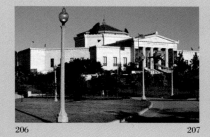

206 207

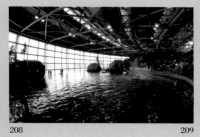

208 209

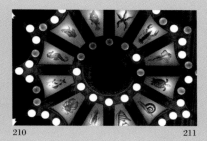

210 211

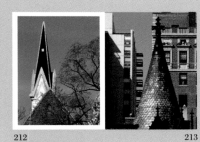

212 213

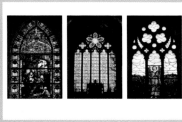

214 215

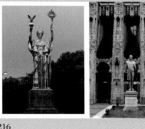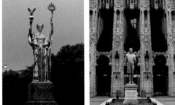

216 217

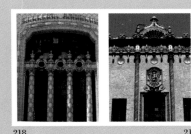

218 219

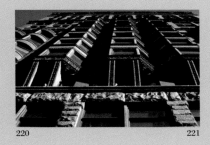

220 221

PAGE 188-189 Roger McCormick Memorial Court at the Art Institute of Chicago

PAGE 190-191 Staircase in the Smith Family Gallery at the Art Institute of Chicago

PAGE 192-193 South façade of the Art Institute of Chicago (1892), Shepley, Rutan and Coolidge, architects

PAGE 194-195 Replica of a wall of the Chicago Stock Exchange, installed at the Art Institute of Chicago

PAGE 196-197 Palmer Gallery of French Impressionists in the Art Institute of Chicago

PAGE 198-199 *Left:* Henry Moore statue *Large Interior Form* (1983) in the garden of the Art Institute of Chicago, *Right: Grande Disco* by Arnaldo Pomodoro in the Surgery-Brain Research Plaza in front of the University of Chicago Medical Center

PAGE 200-201 Gerald Ratner Athletics Center at the University of Chicago (2003); Cesar and Rafael Pelli, architects, in collaboration with O'Donnell, Wicklund, Pigozzi and Peterson Architects Inc.

PAGE 202-203 *Left:* Lamp post and gargoyle by the gate at the main entrance to the University of Chicago campus, *Right:* Fabled Gothic architecture of Ryerson Hall at the University of Chicago

PAGE 204-205 Statue by Henry Moore (1967), commemorating the first self-sustaining controlled nuclear chain reaction on December 2, 1942, by Enrico Fermi at the University of Chicago. The Max Palevsky residential commons (2001), designed by Ricardo Legorreta, is in the background.

PAGE 206-207 The John G. Shedd Acquarium, (1929); Graham, Anderson, Probst & White, architects

PAGE 208-209 Dolphin Show at the Shedd Aquarium, housed in a 1991 glass extension of the building

PAGE 210-211 Chandelier in the lobby of the Shedd Aquarium

PAGE 212-213 *Left:* Tower on La Salle Street Church in Old Town, *Right:* Tower on building at North State Parkway and Schiller street

PAGE 214-215 Windows, *left to right*, "Christ Blessing the Little Children" by Louis Tiffany in the Second Presbyterian Church on South Michigan; Rockefeller Chapel at the University of Chicago; "Angel in the Lilies" by John La Farge in the Second Presbyterian Church on South Michigan

PAGE 216-217 *Left:* Statue of the Republic (1918), created by sculptor Daniel Chester French, *Right:* Statue of Nathan Hale in front of the Tribune Building on North Michigan Avenue

PAGE 218-219 *Left:* The Uptown Theater on Broadway & Lawrence streets (1925), *Right:* The historic Aragon Ballroom on Lawrence Street near Broadway (1926)

PAGE 220 & 225 Façade of the Manhattan Building (1890), 431 South Dearborn Street, William LeBaron Jenney, architect

239

240

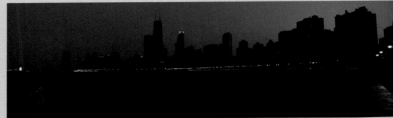

221-224

226

227

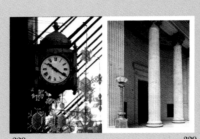

228

229

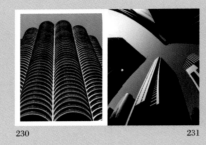

230

231

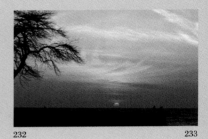

232

233

cover